YOU cAN DraW

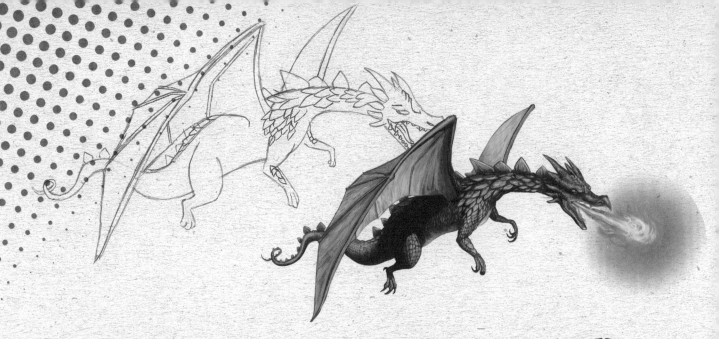

YOU CAN DRAW—ALL YOU NEED IS A PENCIL AND SOME PAPER.

Once you're comfortable with the basics, try other materials and work on your techniques. Even if your first drawing isn't a masterpiece, don't worry! The more you draw, the better you'll become. Look long and hard at whatever it is you want to draw, too. The more you look, the more you'll see!

Follow the steps to try the projects in this book, and then vary them how you like. Maybe try ink instead of paint, orange instead of blue, swirls instead of lines. It's up to you!

PICK UP A PENCIL, OPEN TO ANY PAGE, AND GET DRAWING!

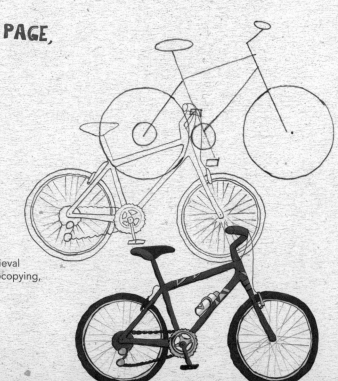

This edition published by Parragon Books Ltd in 2013 and distributed by

Parragon Inc.
440 Park Avenue South, 13th Floor
New York, NY 10016
www.parragon.com

ISBN 978-1-4723-3612-5

Printed in China

YOU cAN DraW

PaRragon

Bath • New York • Singapore • Hong Kong • Cologne • Delhi
Melbourne • Amsterdam • Johannesburg • Shenzhen

CONTENTS

Materials	6
Techniques	8
Portraits	10
Hedgehog	12
Hot-Air Balloons	14
Fashion Girls	16
Grizzly Bear	18
Race Car	20
Profile	22
Penguins	24
Electric Guitar	26
Rose	28
Fashion Boys	30
Meerkats	32
T-Shirts	34
Pirate Ship	36
Main Street	38
Statue of Liberty	40
Quad Bike	42
Mega Dessert	44
Ninja	46
Mustaches	48
Alien Invasion	50
Giraffe Face	52
Pop Star	54
Line Designs	56
Rock Star Drum Set	58
Alien UFO	60
Cartoon Monsters	62
Monkeys	64
Speech Bubbles	66
Skateboards	68
Diver	70
Bullet Train	72
Peacock	74
Eiffel Tower	76
Hairstyles	78
Aerial Display	80
Dancing Dog	82
Snowboarder	84
Fantasy Map	86
Sneakers	88
Spy Car	90
Rock Star	92
Belts	94
Superhero	96
Cartoon Explosions	98
Space Rocket	100
Elephant	102
Street Art	104
Skateboarder	106
Pizza	108

Geometric Patterns	110	Robot 168
T. rex	112	Pictures in Lights 170
Motorcycle Stunt Rider	114	Cartoon Cute Animals 172
Wild Hats	116	Surfer 174
Haunted House	118	Cool Shades 176
Manga Girl	120	Frankenstein's Monster 178
Urban Bridge	122	Woodland Animals 180
Cartoon Wild Animals	124	Mountain Bike 182
Jetpack	126	Straight Patterns 184
Monster Plant	128	Twisty Tree 186
World's Tallest Hamburger	130	Manga Boy 188
Circular Patterns	132	Submarine 190
Zombie	134	Troll 192
Candy Machine	136	Hockey Player 194
Shark!	138	Gyrocopter 196
Skyscrapers	140	Dragon 198
Basketball Player	142	Cartoon Expressions 200
Volcano	144	Spaceship Controls 202
Weird Beards	146	Superheroine 204
Speedboat	148	Animal Patterns 206
Frames	150	Fishbowl 208
Caricatures	152	Towering Buildings 210
Crocodile	154	French Café 212
Tornado	156	Optical Illusions 214
Monster Mash-up	158	Streetdancer 216
Ferris Wheel	160	Creepy Mansion 218
Scaredy-Cat	162	Index 220
Cyborg	164	About the Artists 222
Funky Cake	166	Acknowledgements 224

MATERIALS

THERE ARE LOTS OF SPECIAL MATERIALS THAT ARE FUN TO TRY OUT. BUT REALLY, ANYTHING THAT MAKES A MARK ON PAPER IS GREAT FOR DRAWING! YOU CAN GET THESE MATERIALS AT CRAFT STORES.

GRAPHITE PENCILS range from hard to soft. H pencil leads are hard and good for light sketching and fine lines. B pencil leads are softer and great for shading and thick lines. HB is in the middle.

PAPER textures can make a big difference to how your drawing looks. Smooth copy paper will give you a sharp, crisp line. Heavy drawing paper is thicker and more textured, so your line will look softer. Watercolor paper absorbs ink or watercolor paints. Colored paper gives an unusual effect and ready-made background.

WATERCOLOR PENCILS usually come in sets. There is a huge variety of colors available. They work like ordinary colored pencils, but can be blended together with a wet brush. Regular colored pencils are a great material, too, especially for animal fur.

ERASERS come in handy when you are happy with your final drawing lines and want to get rid of guidelines. Don't rub hard or the surface of the paper will suffer. Instead, gently roll a corner of the eraser on the paper to lift the pencil off.

PEN-AND-INK is a popular way to lift a drawing with heavy lines and give the picture character with varied line widths. Use a dip pen or a fine-tipped brush to apply various colors of ink. Practice first because once it's on, it won't come off! You can also use a cartridge pen for a similar effect.

PENS all have their individual quirks, which can add interest to a drawing. Felt-tip pens are great to add color quickly or vary the color of an outline. Marker pens and highlighters can add a zing to cartoons. The best way of finding out what suits your drawing style is to experiment!

CRAYONS are great for color lines and color texture. Try wax, chalk, or oil crayons in your drawings.

PAINTS—Whether you choose poster, watercolor, or acrylic will depend on what effect you want to achieve. Poster paints tend to be flat but easy to use. Watercolors blend well together to produce an interesting surface and soft look. Acrylics are very vibrant.

BRUSHES come in a variety of shapes and sizes. Round brushes are used for applying washes and are a good, all around paintbrush. Pointed brushes are good for line and detail. Flat brushes are ideal for painting stripes or applying larger areas of color evenly. Always wash your brushes between colors and when you have finished painting.

TECHNIQUES

HERE ARE A FEW SIMPLE TECHNIQUES THAT WILL HELP YOU GET THE MOST OUT OF YOUR DRAWING.

BASIC SHAPES AND GUIDELINES help you plan your drawing before you add any detail. They're a good way of checking proportions, direction of movement, and position on the page. Simple lines and rectangles can make up bodies and limbs, while circles and oval ellipses are useful stand-ins for heads and hands. A center line is useful if you are drawing anything symmetrical, where the drawing on one side of the line mirrors the details on the other side.

LIGHT AND SHADE add dimension and realism to your drawing. Think about your light source—where the light is coming from in your drawing—for where shadows will fall. Leave white highlights in the parts nearest to the viewer, and add shade where the shape is farthest from the viewer for depth.

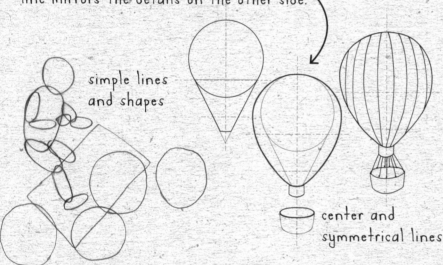

simple lines and shapes

center and symmetrical lines

rubbed edge effect

PENCIL STROKES can add character to a drawing. There are a number of shading techniques you could use. Try holding the pencil side-on to the paper for a rubbed effect. Or, use the point of the pencil to crosshatch lines in opposing directions, almost like a grid, to build up shading. Experiment with changing the pressure on the pencil as you make your marks, using short flicks or longer, sweeping strokes.

crosshatching

changing pressure of pencil to flick and sweep

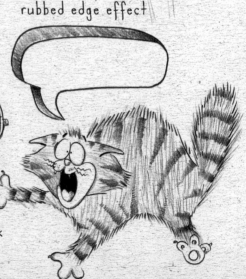

PROPORTION needs to be fixed at the earliest stage of your drawing. Check the sizes of your basic shapes in relation to each other, making adjustments as needed. This is especially useful when breaking down where to position face and body features.

body proportions

head proportions

WORKING DIGITALLY is very popular nowadays. You can scan your sketch into a computer and then open it using image-editing software. Use special tools in the software, such as paintbrushes or spray cans, to add color, do touch-ups, or even draw the whole thing on screen!

scan

spray cans

brush

colors

COLOR completes your picture and can add mood. Experiment with complementary colors, which go well together, such as red and green, or contrasting colors, such as red and yellow. Complementary colors are opposite each other on a color wheel. Two colors mixed together produce a new color tone. Adding white to a color produces a soft tint that is useful for highlights. Shades produced by mixing black to a color are good for shadows. Try tones of the same color for depth.

color wheel

PERSPECTIVE gives your drawing depth. Planning a horizon line (the place where the ground meets the sky) and vanishing points (where lines in the distance come together) will provide a clear foreground and background to your picture. Objects in the foreground will appear larger than objects in the background.

horizon line

vanishing point

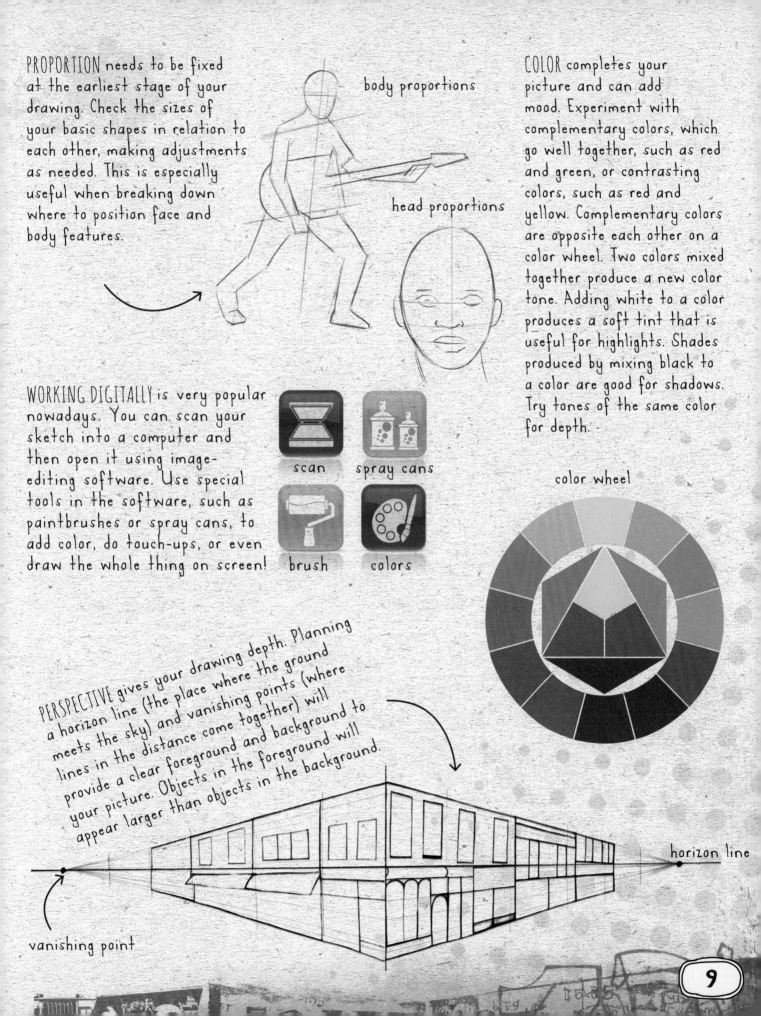

9

PORTRAITS

1 DRAW AN OVAL SHAPE FOR THE HEAD AND ROUGH GUIDELINES FOR THE POSITIONS OF THE EYES, NOSE, AND MOUTH, POSITIONED AS SHOWN. ADD A VERTICAL GUIDE, TOO.

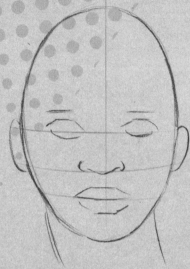

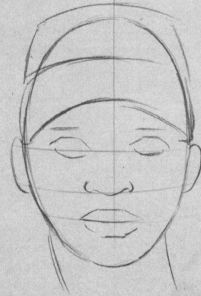

2 USING THE VERTICAL GUIDE TO HELP YOU WITH SYMMETRY, SKETCH SOME ROUGH SHAPES FOR THE EYES, EYEBROWS, AND EARS. USE CURVED LINES FOR THE NOSE, WITH LARGER CURVES FOR THE LIPS. ADD A NECK SHAPE.

3 SKETCH TWO CURVED RECTANGLES TO FORM A CAP SHAPE. MAKE THE TOP LINE A LITTLE HIGHER THAN THE TOP OF THE PERSON'S HEAD.

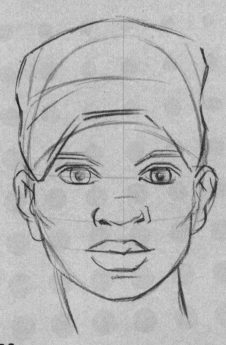

Add sketchy cheekbone lines for a chiseled cheek look.

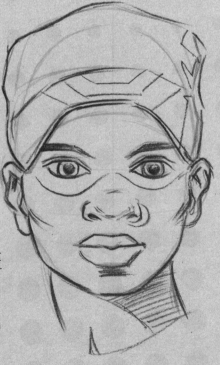

5 USING A HEAVY PENCIL SUCH AS A 4B, FIRM UP THE FEATURES A BIT MORE. IMAGINE THE LIGHT IS COMING IN FROM THE LEFT, AND DRAW A LINE UNDER THE EYES TO MARK THE SHADOW CAST BY THE BRIM. ADD MORE SHADOW LINES TO THE NECK AND THE SIDE OF THE NOSE.

4 SKETCH THE SHAPE OF THE BRIM, AND WORK UP THE FACIAL FEATURES. REFINE THE SHAPES OF THE EYES, ADDING CIRCLES FOR THE IRISES AND PUPILS. ADD NOSTRILS AND DETAILS TO THE EARS. DRAW A SLIGHTLY ANGULAR JAWLINE FOR AN OLDER BOY.

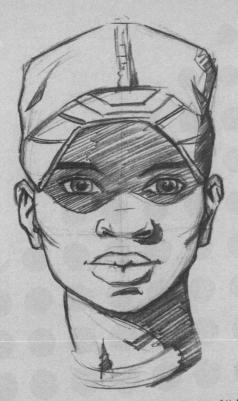

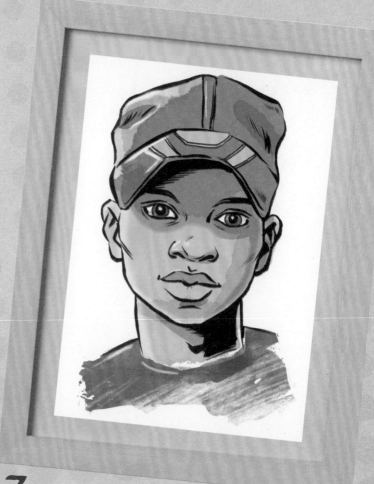

6 USING SLANTED PENCIL STROKES, SHADE IN THE FOREHEAD AND NECK AREAS YOU'VE JUST MARKED OFF. SHADE AROUND THE NOSE, AND ADD SHADING TO THE CAP TO SHOW THE CREASES IN THE MATERIAL.

7 ADD COLOR! NOW THE SHADING DETAIL CAN BE MORE SUBTLE. USE SLIGHTLY DARKER TONES FOR THE AREAS OF SKIN THAT ARE IN SHADOW, MAKING SOME AREAS COMPLETELY BLACK FOR DRAMATIC CONTRAST. ADD A FEW PALE HIGHLIGHTS TO THE CAP.

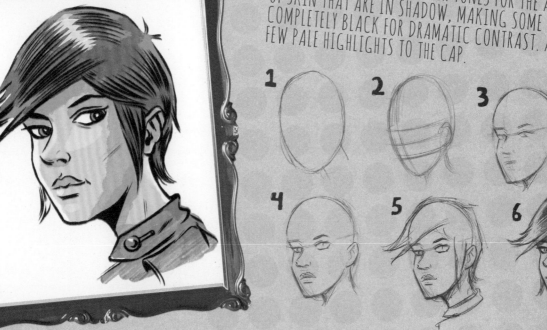

Once you've tried drawing someone face-on, follow these steps to try drawing a face at an angle. This can be more dynamic, visually interesting, and mischievous!

HEDGEHOG

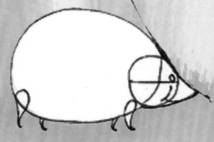

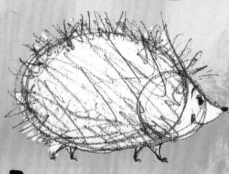

1

DRAW AN OVAL SHAPE FOR THE HEDGEHOG BODY. ADD AN OVERLAPPING SMALL CIRCLE FOR THE HEAD.

2

SHAPE THE HEAD ON A CURVE TO CREATE A SNOUT, AS SHOWN. ADD LEGS, AN EYE, AND A MOUTH.

3

ROUGHLY SKETCH THE REST OF THE HEDGEHOG DETAILS, INCLUDING PRICKLY LINES AND A LITTLE ROUND NOSE.

4

COLOR THE HEDGEHOG WITH THE BASE COLORS, THEN ADD LIGHT AND DARK AREAS FOR A REALISTIC EFFECT. ADD AN EYEBROW AND WHISKERS FOR PERSONALITY.

Build up the scene with little footprints, matching them to the placement of your hedgehog's legs.

1

FOR A HEDGEHOG IN A BALL, DRAW A ROUND SHAPE FOR THE BODY AND A SMALLER ROUND SHAPE INSIDE FOR THE HEAD.

2

ADD EARS, EYES, A SNOUT, A NOSE, AND LEGS FOLLOWING THE GUIDE FOR PLACEMENT BELOW.

3

ROUGHLY SKETCH THE REST OF THE HEDGEHOG, KEEPING IT LOOSE. SKETCH YOUR PRICKLES OUTWARD TO BUILD THE BALL EFFECT.

Use your imagination to vary the pose. Simply changing the eyes morphs an alert hedgehog into a sleeping one.

Tell a story and build character with your drawing, adding little touches such as a stuck-on leaf to this baby.

4

ADD COLOR AS BEFORE. THINK ABOUT WHERE THE LIGHT WOULD BE COMING FROM IN THE PICTURE TO ADD HIGHLIGHTS AND SHADOWS.

Hot-Air Balloons

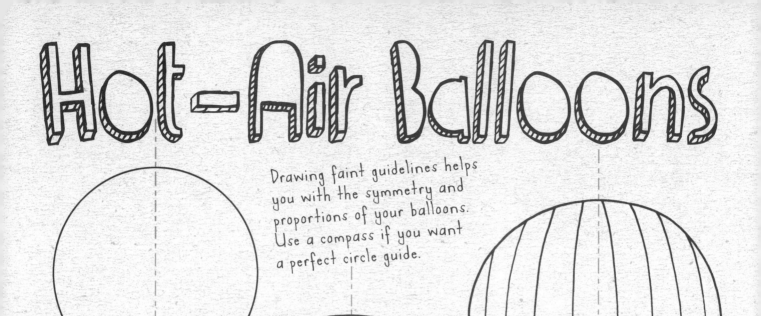

Drawing faint guidelines helps you with the symmetry and proportions of your balloons. Use a compass if you want a perfect circle guide.

1

USING A PENCIL, DRAW A CIRCLE FOR THE BALLOON, THEN DIVIDE IT IN HALF WITH A FAINT VERTICAL LINE. ATTACH A BIG V SHAPE, STARTING ABOUT THREE-QUARTERS OF THE WAY DOWN THE CIRCLE. ADD A HORIZONTAL GUIDE WHERE THE TWO SHAPES MEET, PLUS A PARALLEL GUIDELINE BELOW THAT.

2

USING THE BASIC SHAPES AS A GUIDE, DRAW A LARGER BALLOON OUTLINE. ADD A CYLINDER SHAPE AT THE BOTTOM AND A BASKET BELOW. WHEN YOU'RE HAPPY WITH YOUR SHAPES, TRACE OVER THE OUTLINES WITH WATERPROOF INK.

3

USING YOUR INK PEN, ADD CURVED, VERTICAL LINES TO YOUR BALLOON. THESE WILL HELP YOU DESIGN THE BALLOON'S PATTERN. DRAW MORE LINES CONNECTING THE CYLINDER SHAPE TO THE TOP EDGE OF THE BASKET.

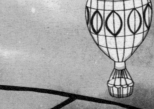

Use other shapes to decorate your balloon. This checkered design uses squares and curved lines.

4

USE THE VERTICAL LINES TO HELP YOU DRAW A ZIGZAG PATTERN. ADD TWO ROWS OF LEAF SHAPES. THEN USE CIRCLES AND ELLIPSES TO DRAW IN SOME SAND BAGS.

5

USE WATERCOLOR INKS OR WATERCOLOR PAINTS TO COLOR YOUR BALLOON. VARY THE TONES FROM LIGHT TO DARK TO HELP MAKE IT LOOK MORE 3-D. BRING OUT SOME OF THE SHAPES IN A CONTRASTING COLOR.

If you use a waterproof pen for your line work, it won't bleed or smudge when you add watery paint on top.

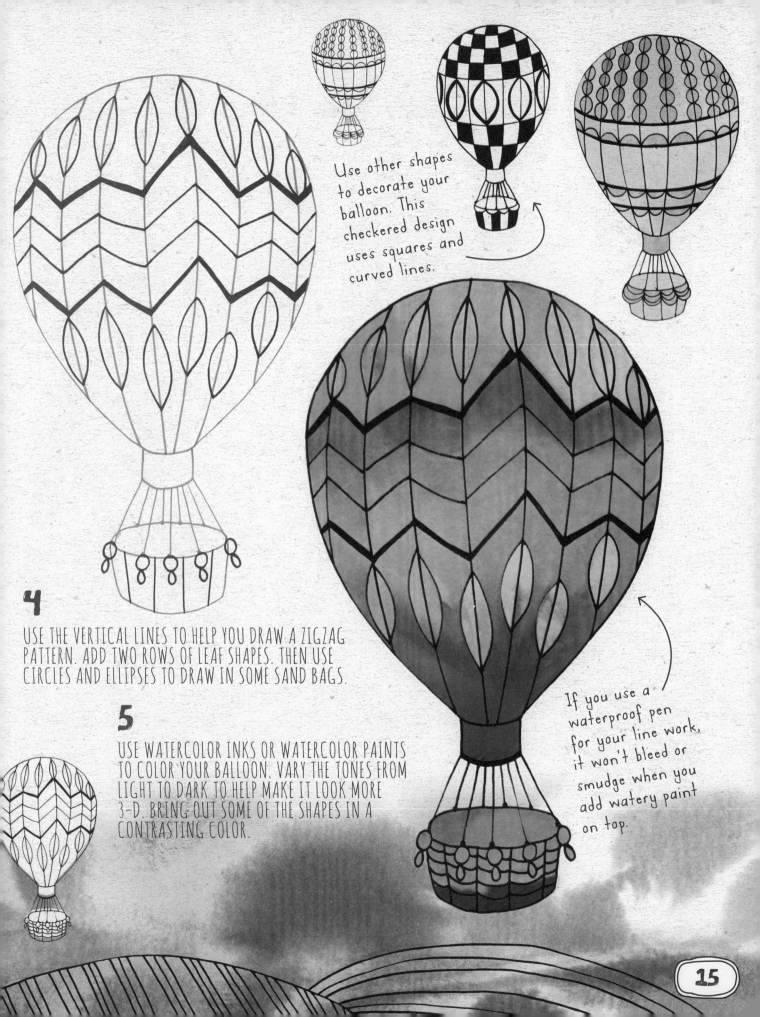

Fashion Girls

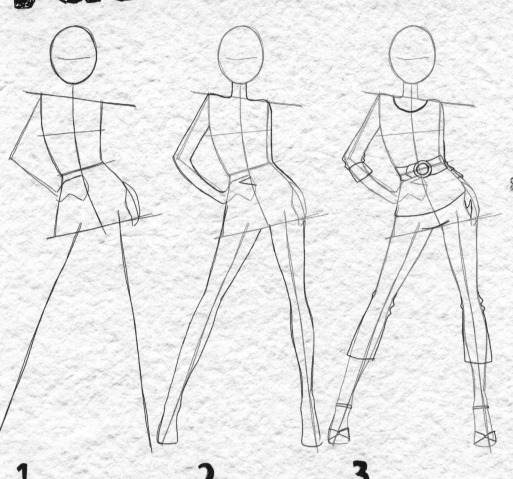

1
SKETCH A ROUND SHAPE FOR THE HEAD AND THEN GUIDELINES FOR THE TORSO, ARMS, AND LEGS.

2
DRAW ROUGH ARM AND LEG SHAPES AROUND YOUR GUIDELINES.

3
SKETCH A TOP, BELT, PANTS, AND SHOES TO ADD CLOTHES.

4
FINISH THE HANDS, AND SKETCH LONG HAIR AND A FACE. ERASE ANY ROUGH GUIDELINES. NOW ADD COLOR! USE ONLY ACCENTS TO KEEP THE DRAWING SOPHISTICATED.

Find inspiration for patterns and colors from magazines. You could even cut out some samples and glue them onto your model to make a collage effect.

OUT AND ABOUT

Use the technique on the opposite page to create a basic body, then change the outfits for different occasions.

Try drawing the girl standing side-on, and add accessories, such as an umbrella!

Add beachwear for a sunny-day pose!

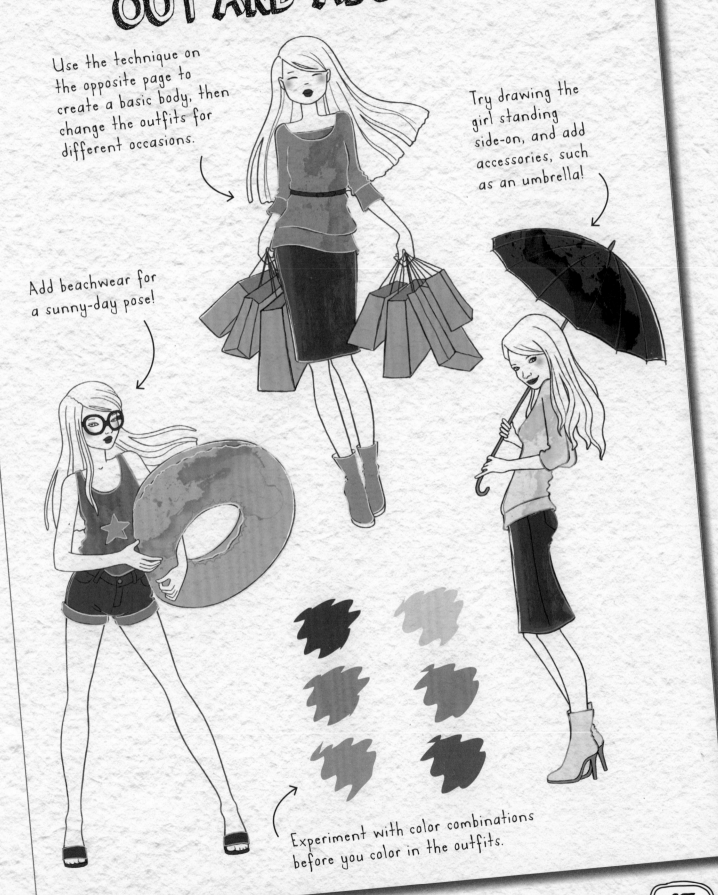

Experiment with color combinations before you color in the outfits.

GRIZZLY BEAR

TIPS

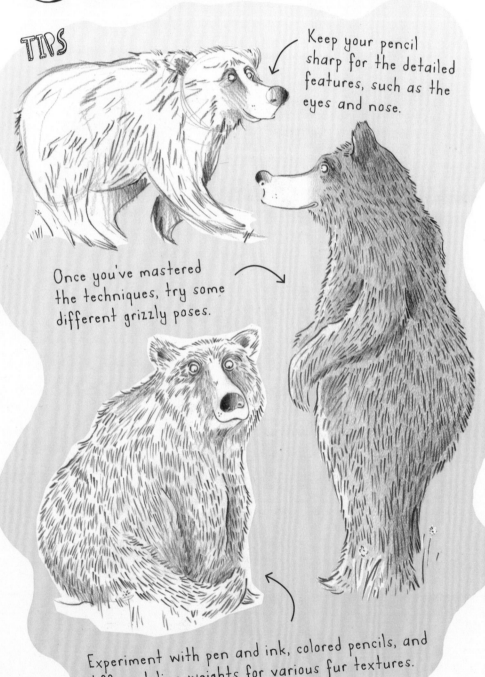

Keep your pencil sharp for the detailed features, such as the eyes and nose.

Once you've mastered the techniques, try some different grizzly poses.

Experiment with pen and ink, colored pencils, and different line weights for various fur textures.

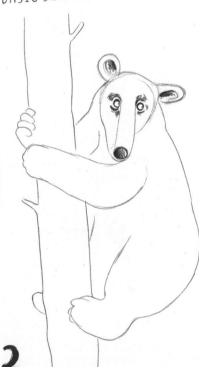

1

USING A SHARP, LIGHT PENCIL SUCH AS GRADE H, DRAW THE BASIC SHAPE OF A YOUNG BEAR.

2

USING A SHARP, HEAVIER GRADE PENCIL, DARKEN THE EYES AND EYEBROWS. FILL IN THE NOSE, USING A HEAVY PRESSURE ON THE LEFT-HAND SIDE AND GRADUALLY TAKING OFF PRESSURE TOWARD THE RIGHT. DARKEN THE INNER EARS.

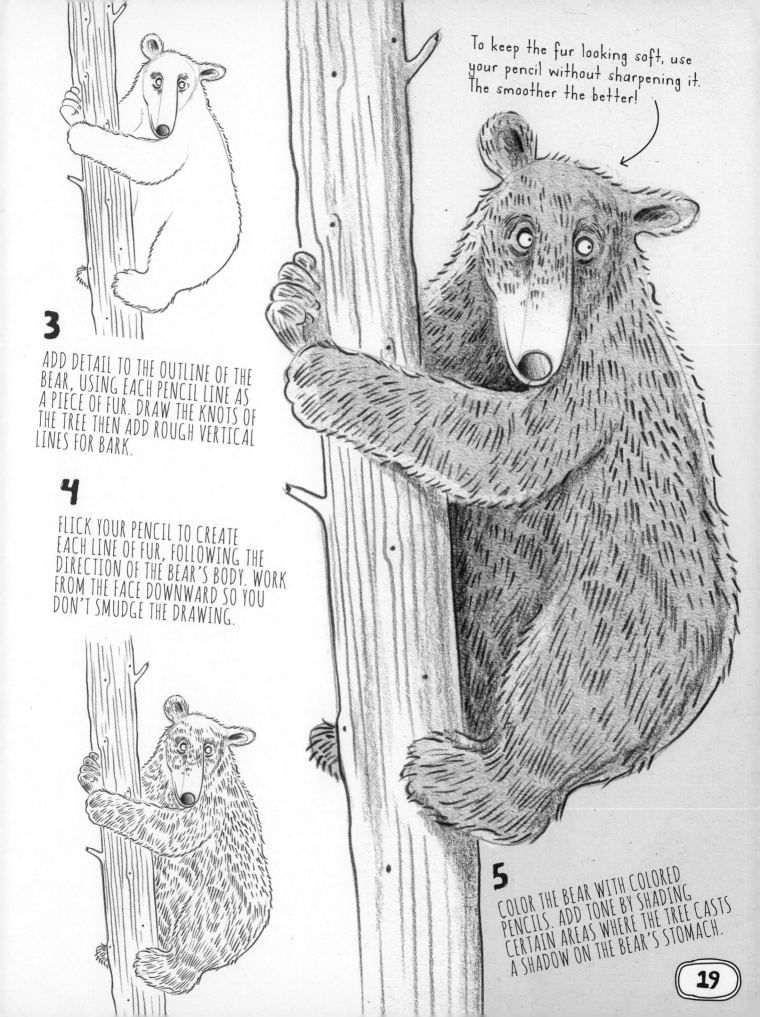

To keep the fur looking soft, use your pencil without sharpening it. The smoother the better!

3

ADD DETAIL TO THE OUTLINE OF THE BEAR, USING EACH PENCIL LINE AS A PIECE OF FUR. DRAW THE KNOTS OF THE TREE THEN ADD ROUGH VERTICAL LINES FOR BARK.

4

FLICK YOUR PENCIL TO CREATE EACH LINE OF FUR, FOLLOWING THE DIRECTION OF THE BEAR'S BODY. WORK FROM THE FACE DOWNWARD SO YOU DON'T SMUDGE THE DRAWING.

5

COLOR THE BEAR WITH COLORED PENCILS. ADD TONE BY SHADING CERTAIN AREAS WHERE THE TREE CASTS A SHADOW ON THE BEAR'S STOMACH.

RACE CAR

Draw light guidelines to help with the shape.

1 START WITH A SIMPLE OUTLINE. DON'T WORRY IF THERE ARE A FEW WOBBLES HERE AND THERE. IT ALL ADDS TO THE CHARACTER!

2 ADD A BUMPER AND SOME WHEELS. TRY SLOPING THEM TO GIVE THE IMPRESSION OF MOVEMENT.

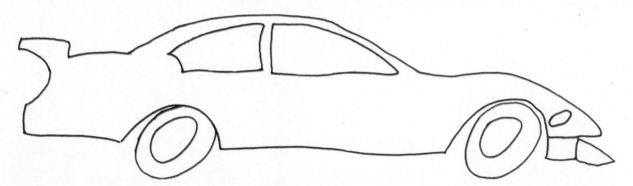

3 ADD THE DETAILS! HAVE FUN WITH THIS—IT'S HOW YOU CAN REALLY PERSONALIZE YOUR DRAWING.

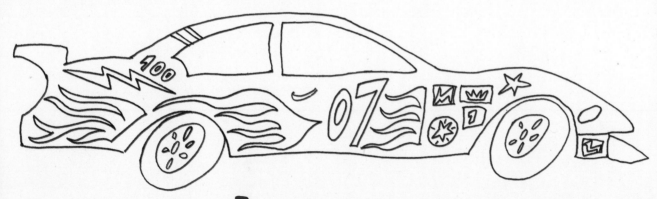

4 DRAW YOUR DRIVER—AND MAYBE EVEN A BEMUSED PASSENGER.

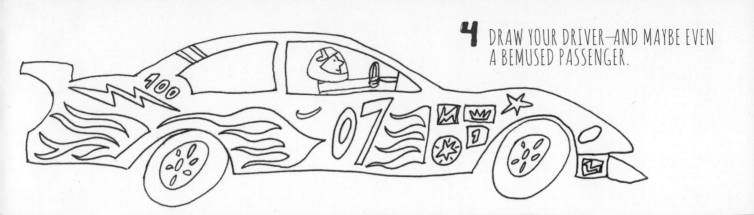

5 NOW ADD SOME HEAVIER LINES WITH INK AND A FINE BRUSH. THIS INDICATES WEIGHT AND SHADOWS. AGAIN, A FEW WOBBLES JUST ADD TO THE ENERGY OF THE LINE.

Don't be afraid to be really heavy with your ink.

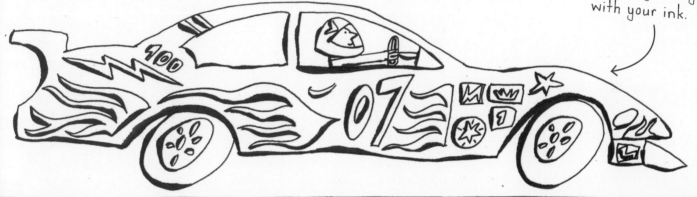

EMBLEM DESIGN IDEAS

Try designing your own emblems for your race car.

6 ADD COLOR! COMPLETE THE PICTURE WITH SPEED LINES AND SHADOWS BEHIND THE WHEELS, SO YOUR CAR ISN'T FLOATING.

Add a finish flag to make your car look like a winner.

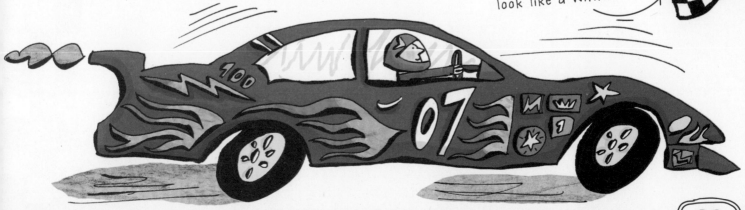

PROFILE

If you think of the shape of a skull, it will help you draw the shape of the head.

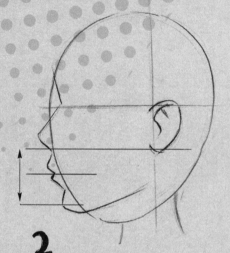

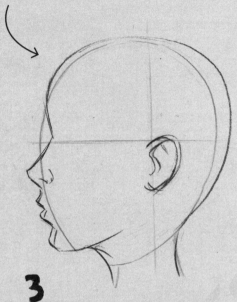

1

SKETCH AN OVAL FOR THE HEAD. MARK A HORIZONTAL LINE WHERE THE EYES SHOULD FALL AND A VERTICAL LINE WHERE THE EAR WOULD LIE. DRAW IN THE NECK.

2

DRAW THE TOP OF THE EAR IN LINE WITH THE EYE. DRAW A GUIDELINE FROM THE BOTTOM OF THE EAR TO LINE UP THE BOTTOM OF THE NOSE. SKETCH THE PROFILE AND JAW.

3

START TO DRAW THE PROFILE IN MORE DETAIL. LOOK CLOSELY AT THE OUTLINE AND DISTANCE BETWEEN THE FEATURES. KEEP USING A LIGHT PENCIL.

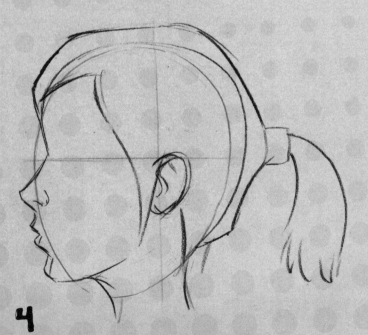

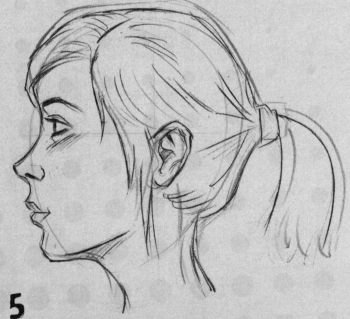

4

WHEN YOU'RE HAPPY WITH THE PROFILE, ADD THE SHAPE OF THE HAIR. HAIR NEARLY ALWAYS HAS VOLUME, SO DON'T MAKE IT TIGHT TO THE HEAD (UNLESS IT'S A CREW CUT!).

5

ADD THE EYE—IT SITS INSIDE A SOCKET, AND THE LIDS FOLD OVER TO PROTECT IT. BEGIN TO ADD DETAIL TO THE HAIR, LIPS, AND EARS. THINK ABOUT SHADING BELOW THE EYE, NOSE, AND CHIN.

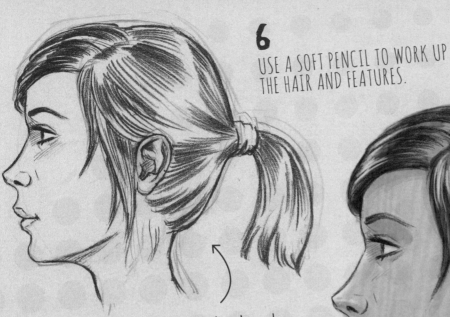

6

USE A SOFT PENCIL TO WORK UP THE HAIR AND FEATURES.

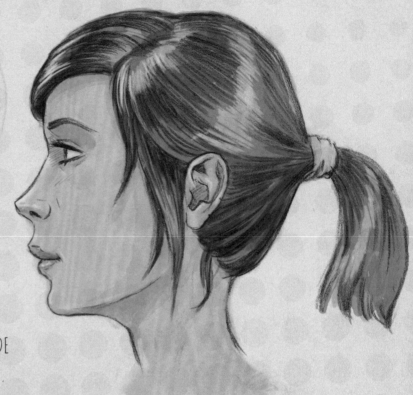

Remember to keep your wrist relaxed so that the drawing is flowing and alive.

7

WHEN YOU ARE READY TO COLOR YOUR PROFILE, VARY THE TONES TO REFLECT THE LIGHT AND SHADE IN THE DRAWING.

PROFILE FEATURES

EYES

The eyeball is exactly that— a ball that sits in the socket and is protected by folds of skin, or lids. It's easier to draw them when you understand what's going on under the surface.

NOSE AND MOUTH

Look how various areas of the face stick out in profile. Nudging these in or out changes the character of the face. The length and angle of the nose changes the profile. Look at whether the nose turns up or juts out. Look where the forehead and chin lie in relation to the nose, too.

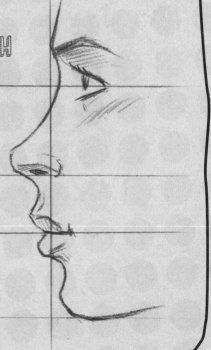

PENGUINs

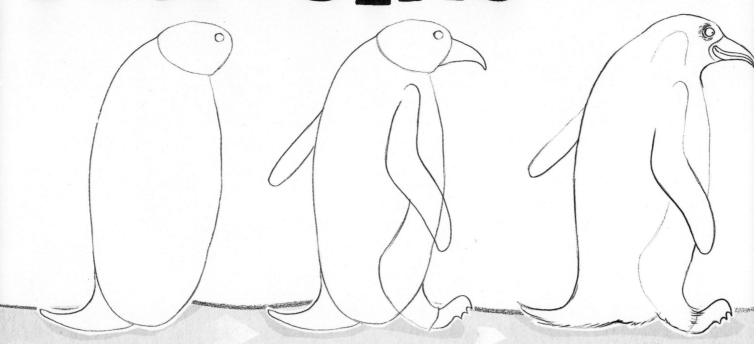

1 USING A LIGHT PENCIL SUCH AS A GRADE H, SKETCH A BASIC PENGUIN SHAPE: DRAW A SMALL ROUNDED SHAPE FOR THE HEAD AND A LARGE OVAL FOR THE BODY. ADD THE TAIL.

2 ADD SOME MORE BASIC SHAPES FOR YOUR PENGUIN'S LIMBS. DRAW A POINTED BEAK, SIMPLE FLIPPER SHAPES, A LEG, AND A CLAWED FOOT. DON'T FORGET THE BEADY EYE!

3 DEFINE THE OUTLINE. USE LOOSE LINES FOR THE BIRD'S BELLY. DRAW DETAIL ON THE BEAK AND HEAD. ADD SHADING AROUND THE EYE. ERASE ANY UNNEEDED GUIDELINES.

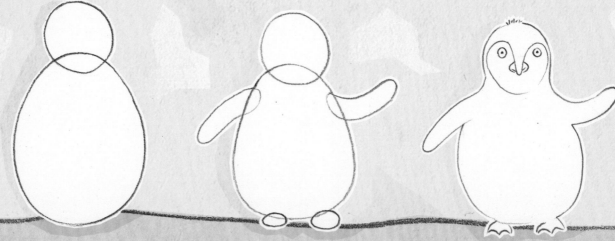

1 FOR A BABY PENGUIN, SKETCH ONE SMALL CIRCLE FOR THE HEAD AND AN OVERLAPPING EGG SHAPE FOR THE BODY. DRAW A LINE OF ICE TO GROUND HIM.

2 CONTINUE ADDING BASIC BODY SHAPES. SKETCH SOME SIMPLE SAUSAGE SHAPES FOR THE FLIPPERS AND SMALL OVALS FOR THE FEET. VARY THE FLIPPERS FOR PERSONALITY.

3 SKETCH THE FACE, WHICH IS SIMILAR TO A HEART SHAPE. DEFINE THE PENGUIN'S OUTLINE, ADDING FEET, EYES, AND A BEAK. ERASE UNNEEDED GUIDES.

Try holding your pencil at a 45-degree angle when shading the feathers. This will make your pencil marks appear smoother.

Use white painted marks to highlight the feathers on the belly and give a great 3-D effect.

4 SHADE THE BEAK AND HEAD WITH THE EDGE OF A PENCIL, THEN MOVE DOWN THE PENGUIN'S BODY, BACK, AND FLIPPERS. ADD PRESSURE TO YOUR PENCIL FOR THE DARKER AREAS.

5 ADD COLOR! USE A BLUE-GRAY PENCIL FOR THE PENGUIN'S BODY, WITH A LIGHT YELLOW FOR THE PATCH ON THE SIDE OF ITS HEAD. USE A CREAMY COLOR FOR THE BELLY, WITH BRIGHT ORANGE FOR THE BEAK AND FEET.

4 BEGIN THE TONAL WORK BY SHADING THE HEAD AND BEAK. GRADUATE THE SHADING FOR ADDED VISUAL INTEREST. THEN SHADE THE FEET AND EYE AREAS.

5 BABY PENGUINS ARE FLUFFY, SO USE SENSITIVE PENCIL STROKES TO ACHIEVE A SOFT, FURRY EFFECT. IT'S FINE TO DRAW OVER THE OUTLINE! USE DOWNWARD STROKES.

6 COLOR WITH A LIGHT-GRAY WASH FOR THE BODY AND GRAY FOR THE BEAK. TRY A DARK BLUE PENCIL FOR THE OUTLINE TO CONTRAST WITH THE GRAY. TRY VARYING THE FLIPPERS, TOO.

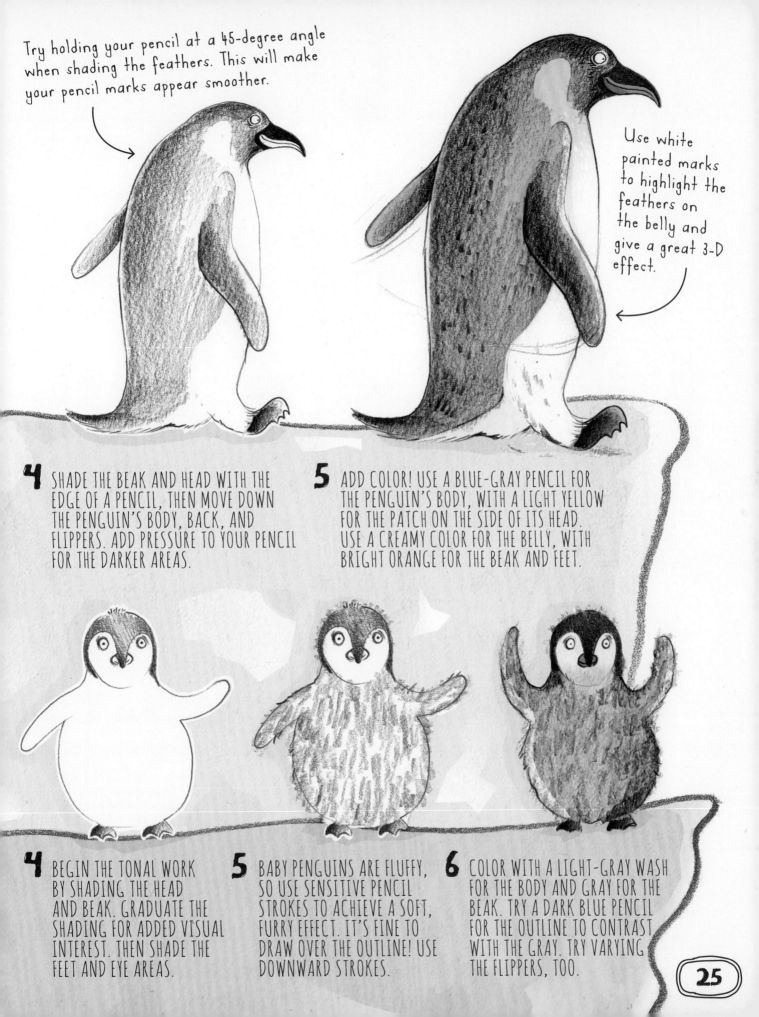

ELECTRIC GUITAR

1

DRAW TWO SIMPLE GUIDE SHAPES—
AN OVAL FOR THE BODY AND A LONG,
OVERLAPPING RECTANGLE FOR THE
GUITAR NECK.

Decide where your light source is coming from, then use shaded areas and highlights for visual interest. In this picture, the bottom edge of the guitar is very dark because the light is coming from the top right.

2

DRAW WAVY LINES
AROUND THE
OUTSIDE OF THE
OVAL SHAPE TO
GIVE THE EFFECT
OF FLAMES
FANNING DOWN
TO THE LEFT.
THEN ERASE THE
OVAL GUIDE SHAPE.

3

ADD MORE FLAME DESIGNS,
FOLLOWING THE OUTLINE OF THE
GUITAR BODY. MAKE SURE THE
FLAMES ARE POINTING IN THE SAME
DIRECTION. ADD MORE DETAILS TO
THE NECK, AND MAKE THE GUITAR
LOOK 3-D BY DRAWING EXTRA
WAVY LINES IN THE PLACES SHOWN.

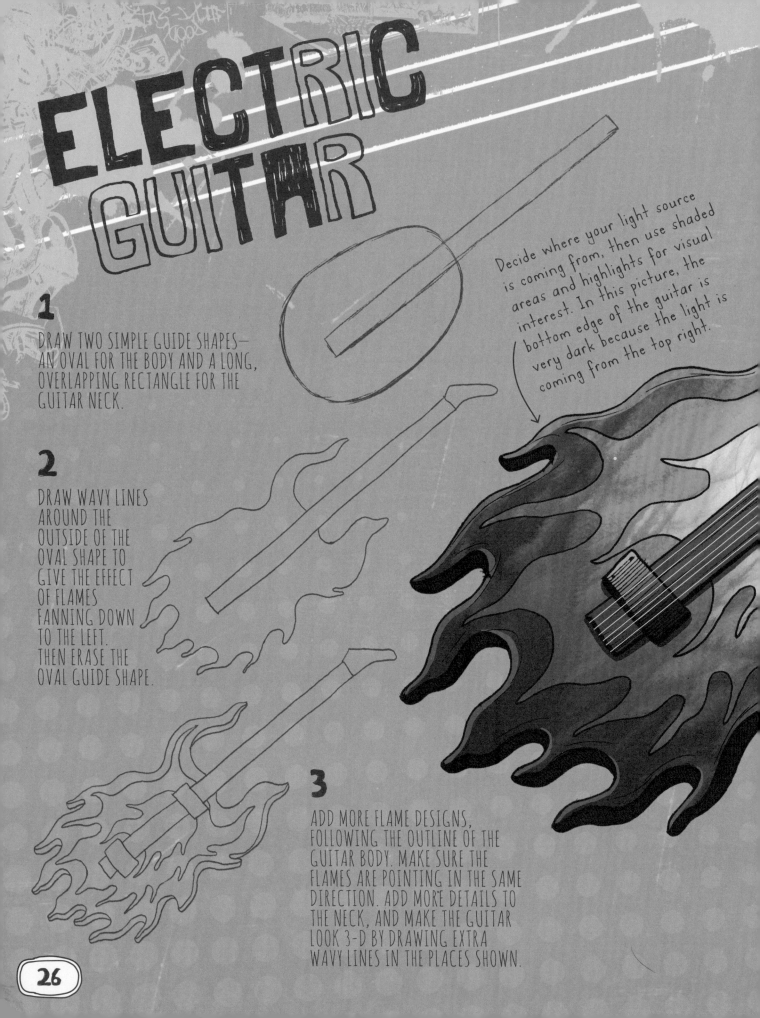

4

USE BRIGHT COLORS FOR THE BODY OF THE GUITAR AND A DARKER COLOR FOR THE NECK AND HEAD. DRAW FIVE DASHED LINES IN A LIGHT COLOR FOR THE STRINGS, THEN ADD TUNING PEGS AT THE TOP.

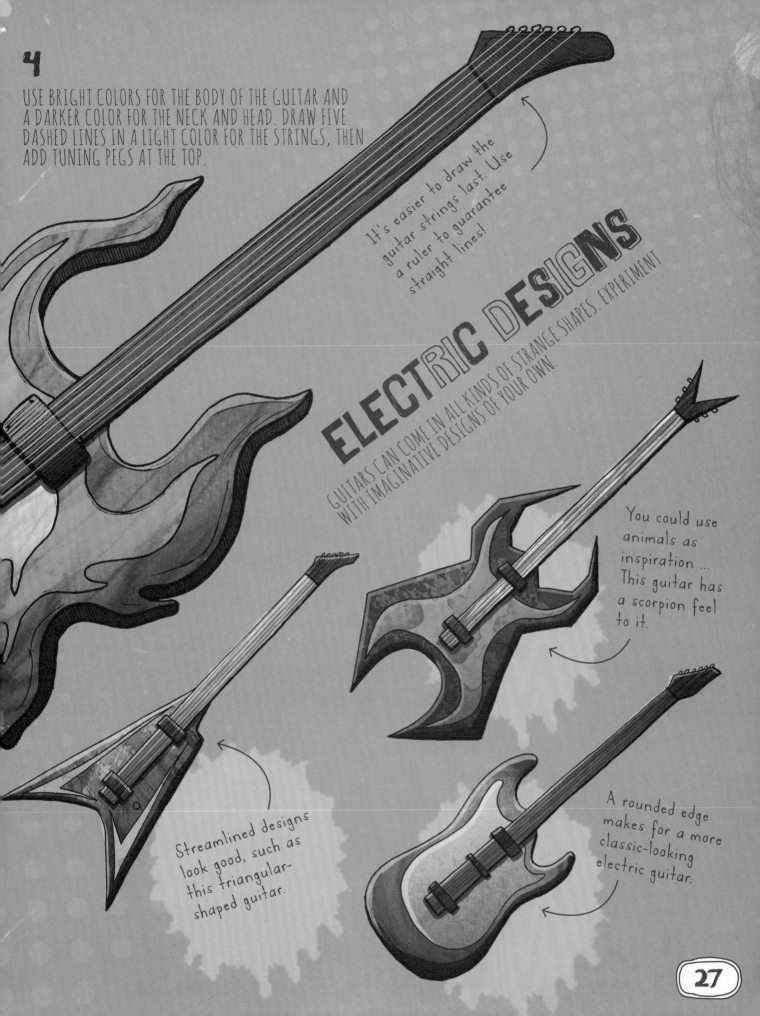

It's easier to draw the guitar strings last. Use a ruler to guarantee straight lines!

ELECTRIC DESIGNS

GUITARS CAN COME IN ALL KINDS OF STRANGE SHAPES. EXPERIMENT WITH IMAGINATIVE DESIGNS OF YOUR OWN.

You could use animals as inspiration ... This guitar has a scorpion feel to it.

Streamlined designs look good, such as this triangular-shaped guitar.

A rounded edge makes for a more classic-looking electric guitar.

ROSE

1 START BY CREATING THE BASIC STRUCTURE. DRAW A SIMPLE SPIRAL, KEEPING THE TOP TIGHTER THAN THE BOTTOM TO TILT THE ANGLE OF THE ROSE, THEN DRAW A HALF CIRCLE BELOW.

2 USING THE SPIRAL AS YOUR BASE, ADD SMALL PETALS, STARTING FROM THE CENTER. THESE CENTRAL PETALS SHOULD BE SMALL AND UPRIGHT.

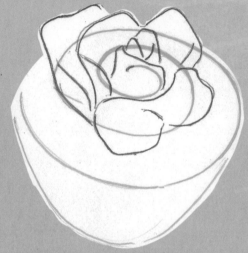

3 DRAW THE REST OF THE PETALS, FOLLOWING THE SPIRAL SHAPE. BUILD UP THE FLOWER FARTHER FROM THE CENTER, MAKING THE PETALS LARGER AND FLATTER TOWARD THE OUTER EDGE.

4 ADD SOME DETAILS TO THE PETALS. DEFINE THE LINES WITH A DARK PENCIL LINE, AND ADD VOLUME BY SHADING TOWARD THE BOTTOM OF EACH PETAL.

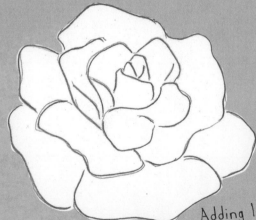

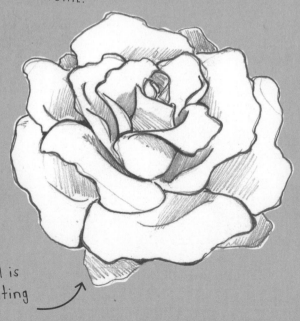

Adding lines at the edge of your shading will suggest the petal is folding outward, creating a rose in full bloom!

5 ADD SOME COLOR! THINK ABOUT YOUR LIGHT SOURCE AND WHERE IT WOULD FALL ON THE ROSE PETALS. TRY DIFFERENT SHADES OF RED TO DEFINE LIGHT ZONES AND SHADOWS.

Add a stem and leaves to finish your rose, and maybe even a few thorns if you're feeling brave.

CLOSED ROSE

1

2

3

Rose leaves have a spiky edge. Sketch a leaf shape first, then go over the outline, keeping the points of the zigzag facing toward the tip of the leaf.

Fashion Boys

1

SKETCH AN OVAL SHAPE FOR THE HEAD AND GUIDELINES FOR THE SHOULDERS, BODY, HIPS, ARMS, AND LEGS.

2

DRAW ARM AND LEG SHAPES AROUND YOUR GUIDELINES. ADD HANDS AND FEET.

3

ADD A HOODIE AND JEANS TO THE SHAPE. USE WAVY LINES TO SHOW CREASES AT THE ELBOWS AND KNEES.

Use light and dark shades of the same color to vary the texture. Try rubbing chalk or wash a damp paintbrush over a color.

You can add some texture to the clothes to make it more realistic.

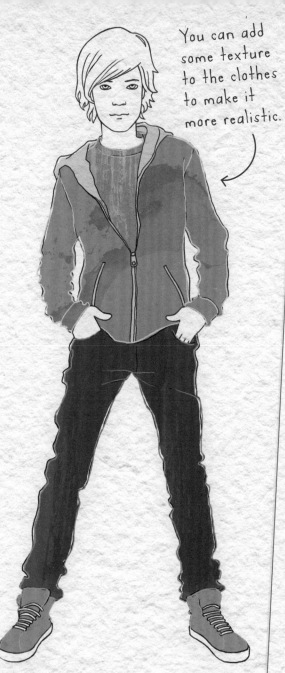

OUT AND ABOUT

Try drawing a figure holding a skateboard. Look at the way this boy's shoulders and hips are tilted and one foot is turned up.

4

ADD HAIR AND A FACE, AND FINISH THE DETAILS SUCH AS LACES, POCKETS, AND ZIPPERS. ERASE ANY GUIDELINES THAT ARE STILL SHOWING BEFORE COLORING THE FINISHED FIGURE.

Make up swatches of colors you think will look good together.

Add skater graphics to make your drawing more realistic. Make up your own, or take inspiration from your favorite brands and logos.

MEERKATS

3 SKETCH THE MEERKAT'S OUTLINE THEN ERASE THE CONSTRUCTION LINES. ADD THE FACIAL FEATURES. USE SHADING TO CREATE A FURRY TEXTURE AND TO SHOW WHERE THE SHADOWS FALL.

1 SKETCH A STICK FIGURE TO GIVE YOU THE BASIC POSE AND BODY PROPORTIONS OF YOUR MEERKAT. USE VERTICAL LINES FOR THE NECK AND BODY, WITH HORIZONTAL LINES TO MARK THE POSITIONS OF THE LEG JOINTS AND SHOULDERS.

2 ADD SOME GUIDE SHAPES TO FLESH OUT THE DIFFERENT PARTS OF THE MEERKAT'S BODY.

Set the scene for your characters by painting a background first. Try a light wash for the sand with darker shapes to suggest rocks and stones.

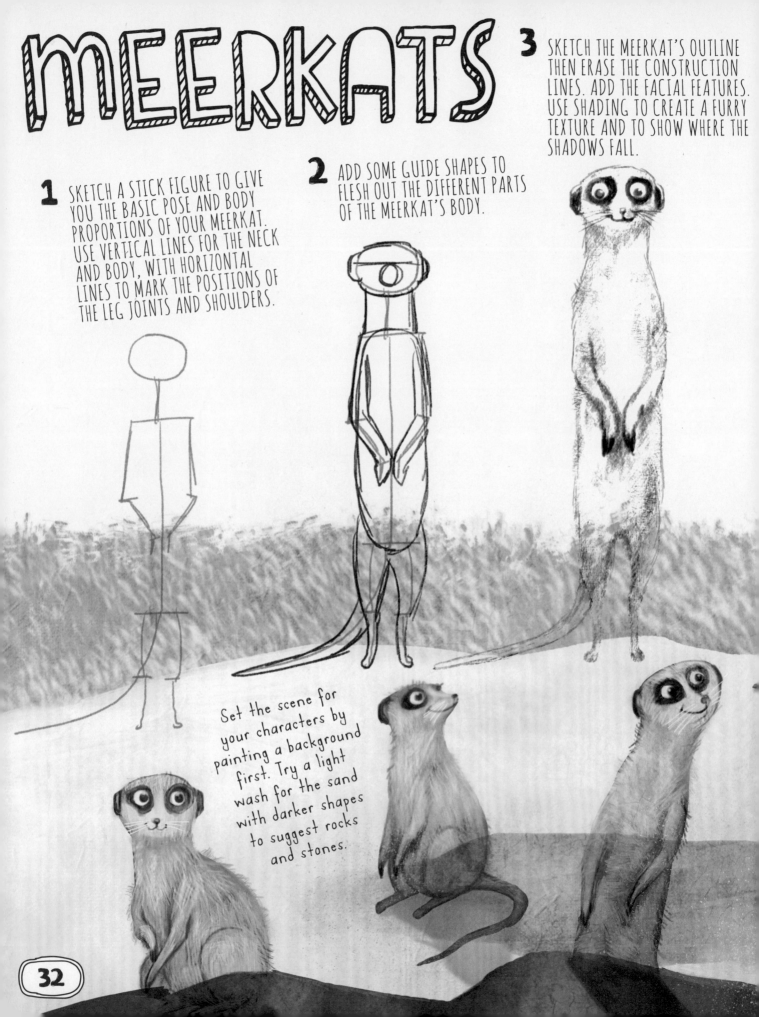

4 PAINT YOUR MEERKAT, STARTING WITH A FLAT, DARK BROWN FOR THE BODY THEN BUILDING UP THE FUR TEXTURE IN A LIGHTER COLOR USING SMALL BRUSHSTROKES.

Varying the orientation of each meerkat can create a quirky and comical effect.

5 ADD MORE MEERKATS TO THE SCENE. TRY SOME SIDE-ON VIEWS AND, HAVE OTHERS PEEPING OUT FROM BEHIND DIFFERENT OBJECTS OR GRASS.

To achieve the effect of sand-covered rocks, add specks of a contrasting color. Rub your finger across the end of a brush to flick tiny specks of paint onto the darker areas.

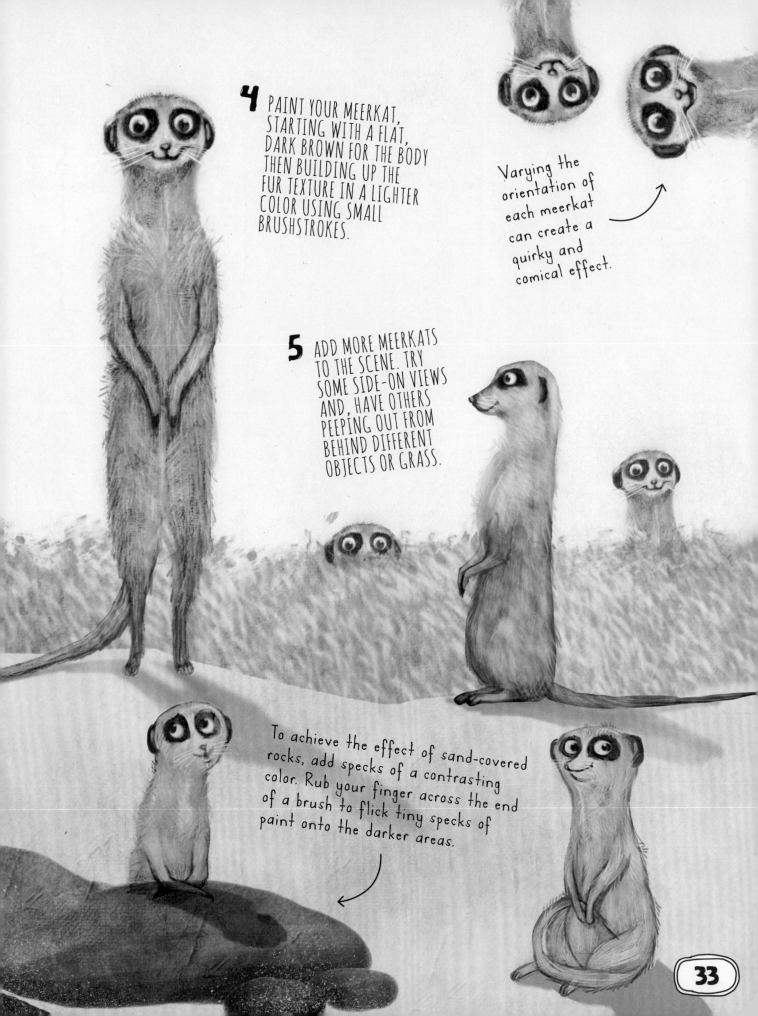

T-SHIRTS

A T-SHIRT IS THE PERFECT FASHION ITEM— A BLANK CANVAS FOR ANY KIND OF DESIGN YOU CAN IMAGINE. PRACTICE DRAWING THE BASIC SHAPES FIRST, THEN GET CREATIVE!

DRAW A BASIC CREW-NECK T-SHIRT SHAPE USING A PENCIL OR PEN AND INKS. ADD CREASES TO THE ARMPIT AREAS. DRAW EXTRA STITCHING LINES IF YOU LIKE, SUCH AS AROUND THE NECK AND SLEEVES.

FOR A TANK-STYLE TOP, LEAVE OFF THE ARMS AND DRAW LINES CURVING INWARD ON EACH SIDE AND AN EXTRA LINE FOR INTEREST.

FOR A MORE FEMININE-LOOKING DESIGN, DRAW A SHALLOW V-NECK WITH THIN, VERTICAL STRAPS ATTACHED TO THE TOP.

ANOTHER POPULAR T-SHIRT SHAPE IS THE V-NECK SHIRT.

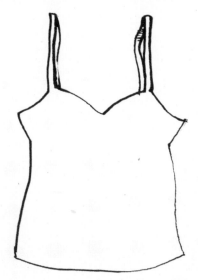

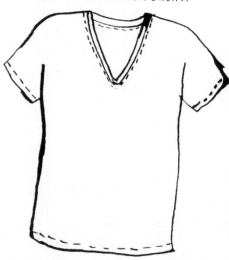

Draw simple dashed lines like these for the stitching detail. Add these lines around the base, neck, and sleeves.

DRAW A POCKET BY SKETCHING A SQUARE WITH A POINTED BASE. ADD EXTRA LINES OF DETAIL.

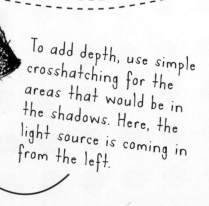

To add depth, use simple crosshatching for the areas that would be in the shadows. Here, the light source is coming in from the left.

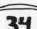

HERE ARE SOME T-SHIRT DESIGNS TO GIVE YOU INSPIRATION.

MUSIC

Draw objects hanging on either side of the neck, such as these cool headphones.

BEAR

A large image bleeding off the bottom of the T-shirt looks very striking. Big faces have a lot of impact as well!

PATTERNED NECK

Make a feature of the neckline by drawing an intricate pattern.

STRIPY

Pull out the pocket using different patterns and colors.

BLOCK STRIPE

Irregular-shaped bands of color are simple but highly effective.

ZIGZAG

Bold patterns in contrasting colors look cool and trendy.

POLKA DOT

To soften the impact of a strong pattern, try using a contrasting color for the edges.

PIRATE SHIP

1 DRAW THE OUTLINE OF THE SHIP'S HULL. IMAGINE IT AS A LONG BOX, WITH ANOTHER BOX BALANCED ON TOP OF IT AT THE FAR END. DRAW A BEAM AT THE FRONT AND THREE SETS OF PARALLEL LINES FOR THE MASTS.

To help you get the shape right, try looking at a boot or shoe with the toe end tilted slightly toward you. The ship is similar in shape.

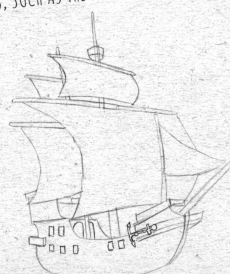

2 DRAW SOME BEAMS AT RIGHT ANGLES TO THE MASTS, THEN ADD THE VARIOUS SAILS. THE MAIN SAILS ARE LIKE RECTANGLES WITH CURVED EDGES. ADD A POINTED FLAG, A CROW'S NEST NEAR THE TOP, AND EXTRA DETAIL AT THE FRONT OF THE SHIP.

To get the shape of the sails right, bend a piece of paper and observe it at an angle that matches that of your ship.

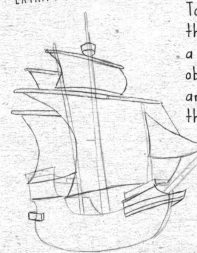

3 ADD CANNON PORTS TO THE HULL OF YOUR SHIP BY DRAWING SOME SMALL RECTANGLES. SKETCH AN ANCHOR ON ITS SIDE NEAR THE FRONT. ERASE THE PARTS OF THE SHIP THAT ARE VISIBLE THROUGH THE SAILS, SUCH AS THE MASTS.

4 USING LONG, WIGGLY LINES, ADD FLAGS TO THE TOP OF THE MIDDLE AND REAR MASTS. DRAW CANNONS PEEPING OUT OF THE HULL, AND ADD HORIZONTAL LINES TO CREATE THE PORT COVERS. SKETCH A LANTERN, ROPES AND A SKULL AND CROSSBONES.

Start shading darker areas, such as inside the cannon ports.

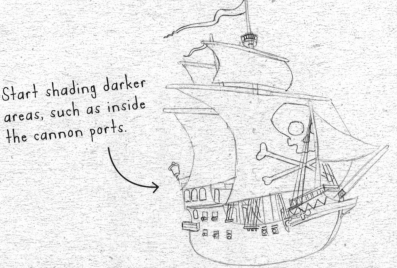

5 WORK ON THE FINE DETAILS. SKETCH A CROSSHATCH DESIGN ON THE REAR WINDOWS, AND ADD HORIZONTAL LINES TO THE RIGGING. DRAW THE SHIP'S WHEEL, AS WELL AS PATCHES AND TEARS ON THE SAILS.

Fine detail will add extra visual interest. Add extra lines to the hull, beams, and balconies.

6 USE DARK AND MUTED COLORS TO GIVE YOUR PIRATE SHIP AN OMINOUS AND MYSTERIOUS FEEL. THINK ABOUT WHERE THE SHADOWS WILL FALL, SUCH AS ON THE DECK AREA AND AT THE REAR OF THE SHIP.

Add slightly lighter areas of gray to the black sails to achieve the effect of creased material billowing in the wind.

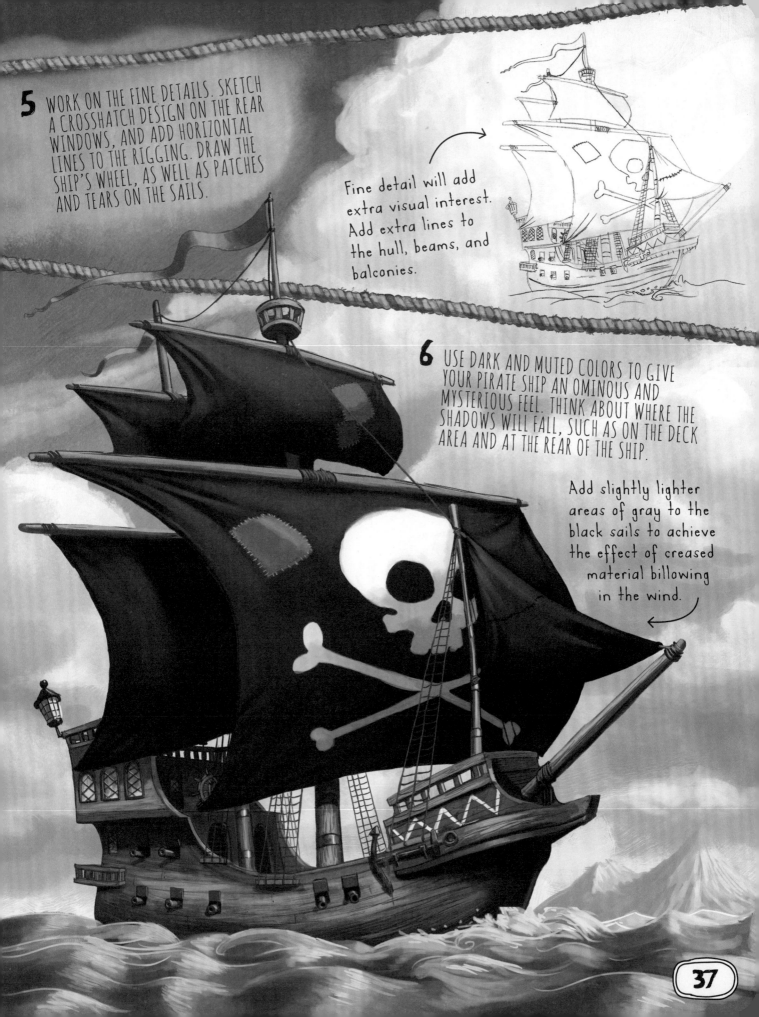

MAIN STREET

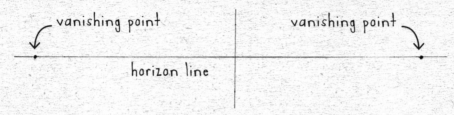

vanishing point vanishing point

horizon line

1

USE A RULER TO DRAW A HORIZONTAL LINE. DRAW A DOT AT EACH END OF THE LINE. THESE ARE THE VANISHING POINTS, WHERE ALL LINES WILL COME TOGETHER. NEXT, DRAW A VERTICAL LINE — THIS WILL BE THE HEIGHT OF THE BUILDINGS AT THE FRONT OF THE PICTURE.

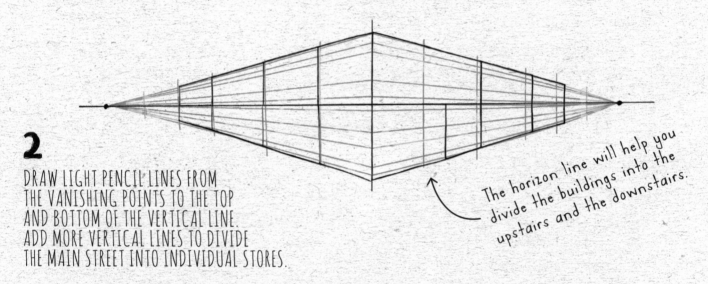

2

DRAW LIGHT PENCIL LINES FROM THE VANISHING POINTS TO THE TOP AND BOTTOM OF THE VERTICAL LINE. ADD MORE VERTICAL LINES TO DIVIDE THE MAIN STREET INTO INDIVIDUAL STORES.

The horizon line will help you divide the buildings into the upstairs and the downstairs.

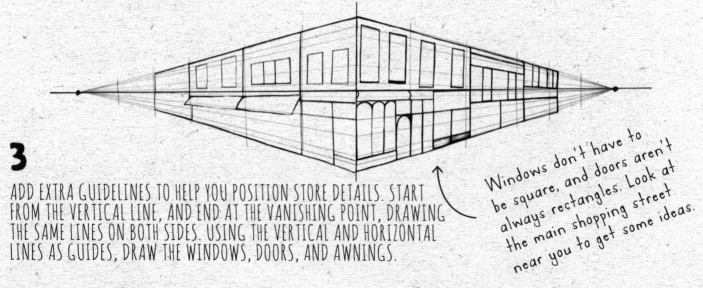

3

ADD EXTRA GUIDELINES TO HELP YOU POSITION STORE DETAILS. START FROM THE VERTICAL LINE, AND END AT THE VANISHING POINT, DRAWING THE SAME LINES ON BOTH SIDES. USING THE VERTICAL AND HORIZONTAL LINES AS GUIDES, DRAW THE WINDOWS, DOORS, AND AWNINGS.

Windows don't have to be square, and doors aren't always rectangles. Look at the main shopping street near you to get some ideas.

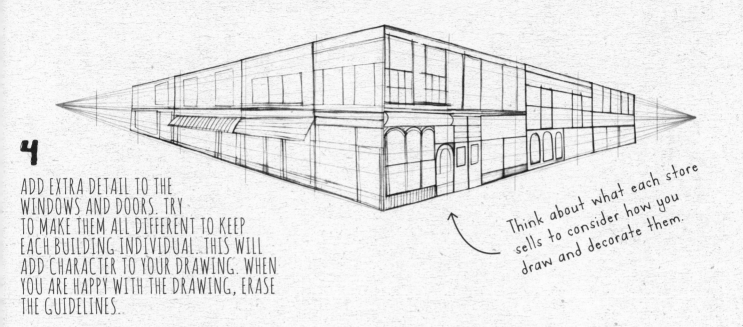

4

ADD EXTRA DETAIL TO THE
WINDOWS AND DOORS. TRY
TO MAKE THEM ALL DIFFERENT TO KEEP
EACH BUILDING INDIVIDUAL. THIS WILL
ADD CHARACTER TO YOUR DRAWING. WHEN
YOU ARE HAPPY WITH THE DRAWING, ERASE
THE GUIDELINES.

Think about what each store
sells to consider how you
draw and decorate them.

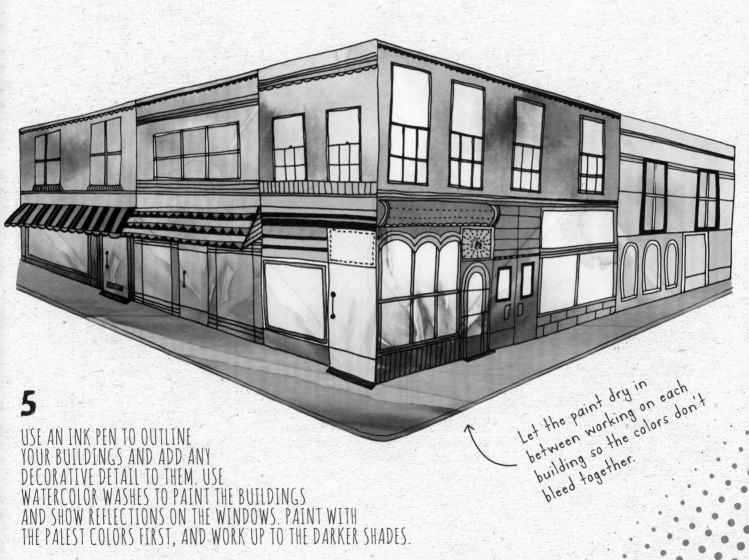

5

USE AN INK PEN TO OUTLINE
YOUR BUILDINGS AND ADD ANY
DECORATIVE DETAIL TO THEM. USE
WATERCOLOR WASHES TO PAINT THE BUILDINGS
AND SHOW REFLECTIONS ON THE WINDOWS. PAINT WITH
THE PALEST COLORS FIRST, AND WORK UP TO THE DARKER SHADES.

Let the paint dry in
between working on each
building so the colors don't
bleed together.

STATUE OF LIBERTY

1

USING A LIGHT PENCIL, SKETCH BASIC SHAPES. DRAW CIRCLES FOR THE HEAD AND FLAME AND LOOSE RECTANGLES FOR THE BODY, FOLLOWING THE LINE OF MOVEMENT OF THE STATUE.

2

ADD GUIDELINES TO PLAN THE FACE OF THE STATUE IN YOUR DRAWING. ADD THE CROWN OF RAYS FROM THE HEAD AND OUTLINE THE GOWN.

Find a photo of the Statue of Liberty for inspiration. This will help you decide which details are important to capture in your drawing.

Using darker colors on one side and lighter colors on the other gives the statue some dimension. White highlights in the center add form, too.

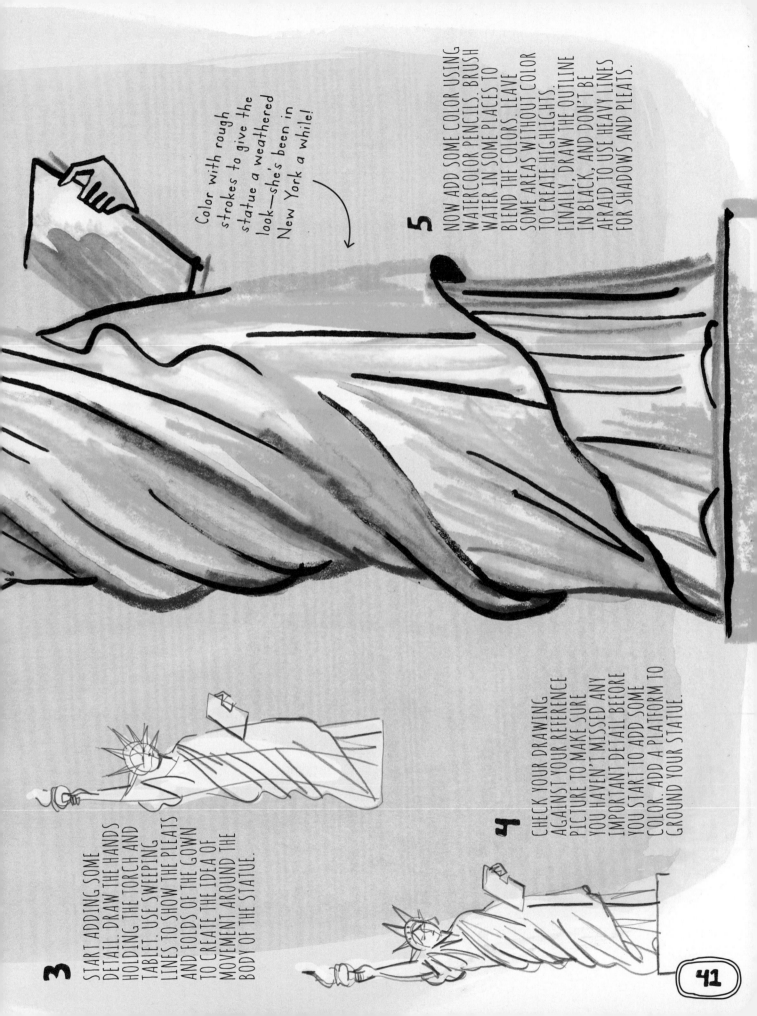

3

START ADDING SOME DETAIL. DRAW THE HANDS HOLDING THE TORCH AND TABLET. USE SWEEPING LINES TO SHOW THE PLEATS AND FOLDS OF THE GOWN TO CREATE THE IDEA OF MOVEMENT AROUND THE BODY OF THE STATUE.

4

CHECK YOUR DRAWING AGAINST YOUR REFERENCE PICTURE TO MAKE SURE YOU HAVEN'T MISSED ANY IMPORTANT DETAIL BEFORE YOU START TO ADD SOME COLOR. ADD A PLATFORM TO GROUND YOUR STATUE.

Color with rough strokes to give the statue a weathered look—she's been in New York a while!

5

NOW ADD SOME COLOR USING WATERCOLOR PENCILS. BRUSH WATER IN SOME PLACES TO BLEND THE COLORS. LEAVE SOME AREAS WITHOUT COLOR TO CREATE HIGHLIGHTS. FINALLY, DRAW THE OUTLINE IN BLACK, AND DON'T BE AFRAID TO USE HEAVY LINES FOR SHADOWS AND PLEATS.

QUAD BIKE

1 DRAW A ROUND SHAPE FOR THE BIKE RIDER'S HEAD, AND THEN USE OVAL SHAPES FOR HIS TORSO, ARMS, HANDS, LEGS, AND FEET, LIKE THIS.

2 SKETCH A LARGE, ANGLED RECTANGLE SHAPE IN FRONT OF THE RIDER FOR THE MAIN BODY OF THE BIKE. THEN DRAW FOUR BIG CIRCLES FOR THE WHEELS.

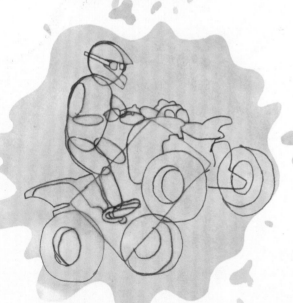

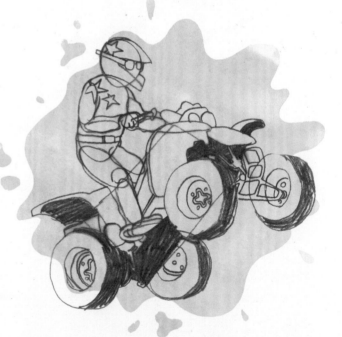

3 ADD DETAIL TO THE SKETCH BY DRAWING THE TOP OF THE RIDER'S HELMET AND A PAIR OF GOGGLES. THEN ADD MORE DETAIL TO THE QUAD BIKE, AS SHOWN.

4 SHADE THE DARKER SECTIONS UNDERNEATH THE BIKE. CONTINUE TO ADD DETAIL TO THE DRAWING. ADD THE STAR DESIGN ONTO THE SUIT AND HELMET.

5 TRACE OVER THE PENCIL WITH INK. ONCE THE INK IS DRY, CAREFULLY ERASE ANY REMAINING PENCIL. ADD PLENTY OF EXTRA DETAIL IN INK, SUCH AS HANDLEBARS AND SHADOWS.

Add shading under the rider's arms and knees to give him more depth.

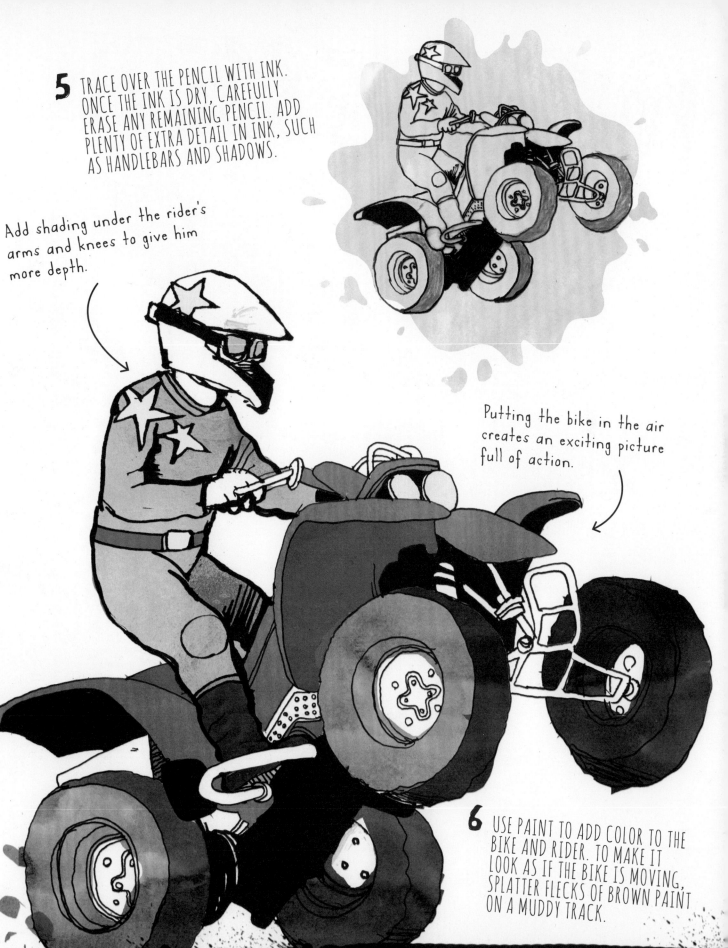

Putting the bike in the air creates an exciting picture full of action.

6 USE PAINT TO ADD COLOR TO THE BIKE AND RIDER. TO MAKE IT LOOK AS IF THE BIKE IS MOVING, SPLATTER FLECKS OF BROWN PAINT ON A MUDDY TRACK.

MEGA DESSERT

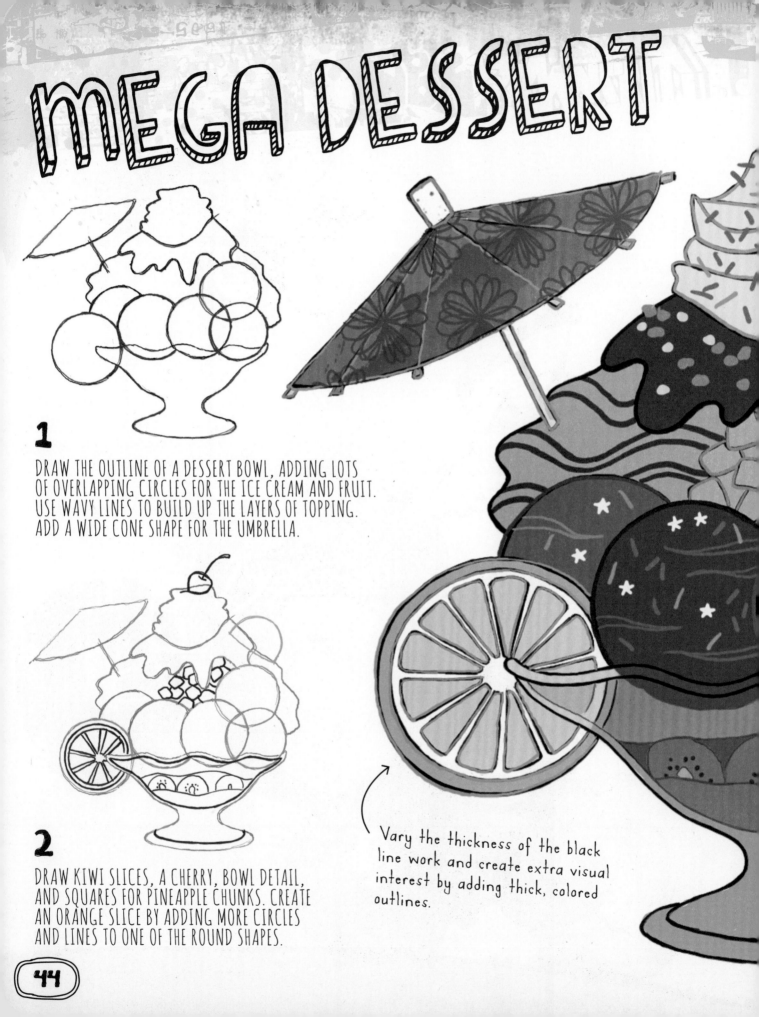

1

DRAW THE OUTLINE OF A DESSERT BOWL, ADDING LOTS OF OVERLAPPING CIRCLES FOR THE ICE CREAM AND FRUIT. USE WAVY LINES TO BUILD UP THE LAYERS OF TOPPING. ADD A WIDE CONE SHAPE FOR THE UMBRELLA.

2

DRAW KIWI SLICES, A CHERRY, BOWL DETAIL, AND SQUARES FOR PINEAPPLE CHUNKS. CREATE AN ORANGE SLICE BY ADDING MORE CIRCLES AND LINES TO ONE OF THE ROUND SHAPES.

Vary the thickness of the black line work and create extra visual interest by adding thick, colored outlines.

3

ADD DETAIL AND TEXTURE. DRAW STRAIGHT LINES ON THE UMBRELLA, RADIATING OUTWARD FROM THE CENTER. DRAW CURVED LINES ON THE TOP LAYER TO MAKE LAYERS OF WHIPPED CREAM. SKETCH WAVY LINES ON THE BLOBS OF ICE CREAM.

Use contrasting tones to bring out the texture and shape of the ice cream.

4

NOW FOCUS ON THE FINE DETAIL. DRAW LOTS OF TINY DOTS, STARS AND NUGGET SHAPES FOR THE JIMMIES. ERASE ANY UNWANTED OVERLAPPING LINES.

5

USE A RANGE OF BRIGHT COLORS TO MAKE YOUR DESSERT LOOK AS APPETIZING AS POSSIBLE! CREATE A FLOWERY PATTERN FOR THE UMBRELLA USING LOTS OF OVERLAPPING ELLIPSES.

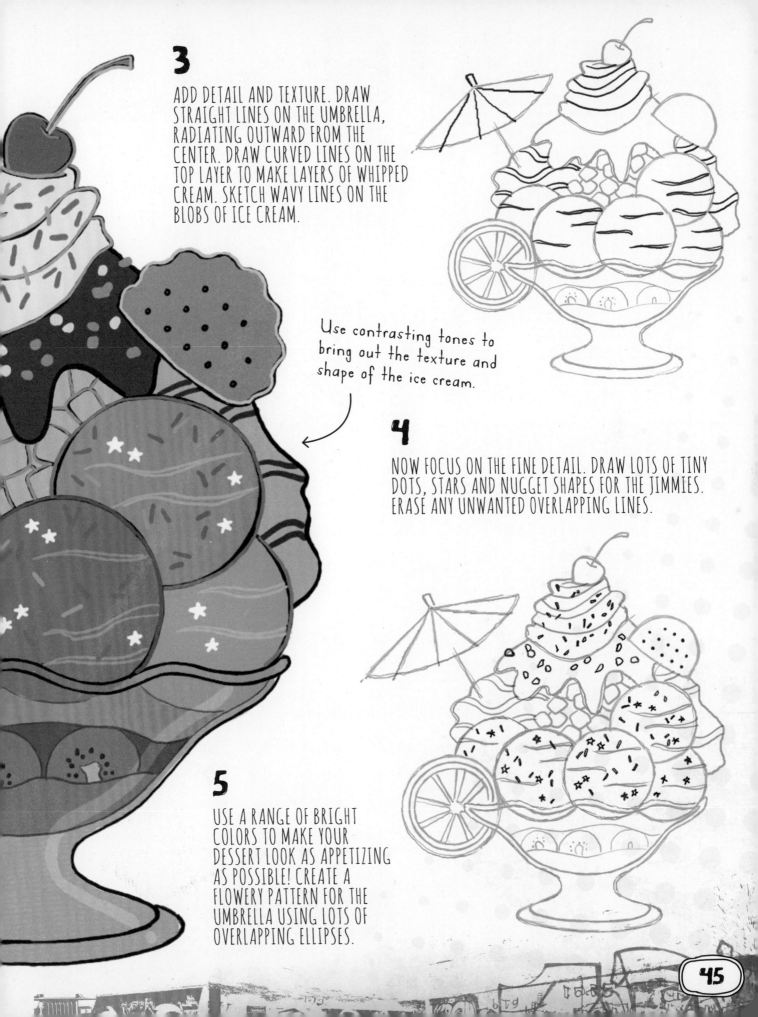

NINJA

1 DRAW A SIMPLE SKELETON SHAPE, SHOWING YOUR NINJA IN AN ACTION POSE. DRAW STRAIGHT LINES FOR HIS OUTSTRETCHED ARM AND LEG, WITH ANGLED LINES FOR HIS OTHER LIMBS.

2 DRAW ROUNDED SHAPES FOR THE CHEST, PELVIS, AND JOINTS. FLESH OUT THE NINJA'S BODY, USING YOUR GUIDES TO GET THE PROPORTIONS RIGHT. MAKE HIS LEFT ARM AND LEG LOOK BULKIER, SINCE THEY ARE IN A BENT POSITION—THE MUSCLES WILL BE BULGING!

3 DRAW LOOSE CLOTHING ON THE NINJA'S BODY. ADD A SLIT TO HIS MASK, AND REFINE THE SHAPES OF HIS HANDS AND FEET. DRAW HIS HEADBAND TRAILING BEHIND HIM, AS IF HE'S FLYING THROUGH THE AIR.

Add more ninjas to your scene. Try and think of poses that contrast with the typical high-kicking main action pose. For example, this ninja is crouching down, ready to pounce!

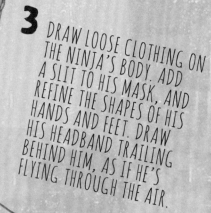

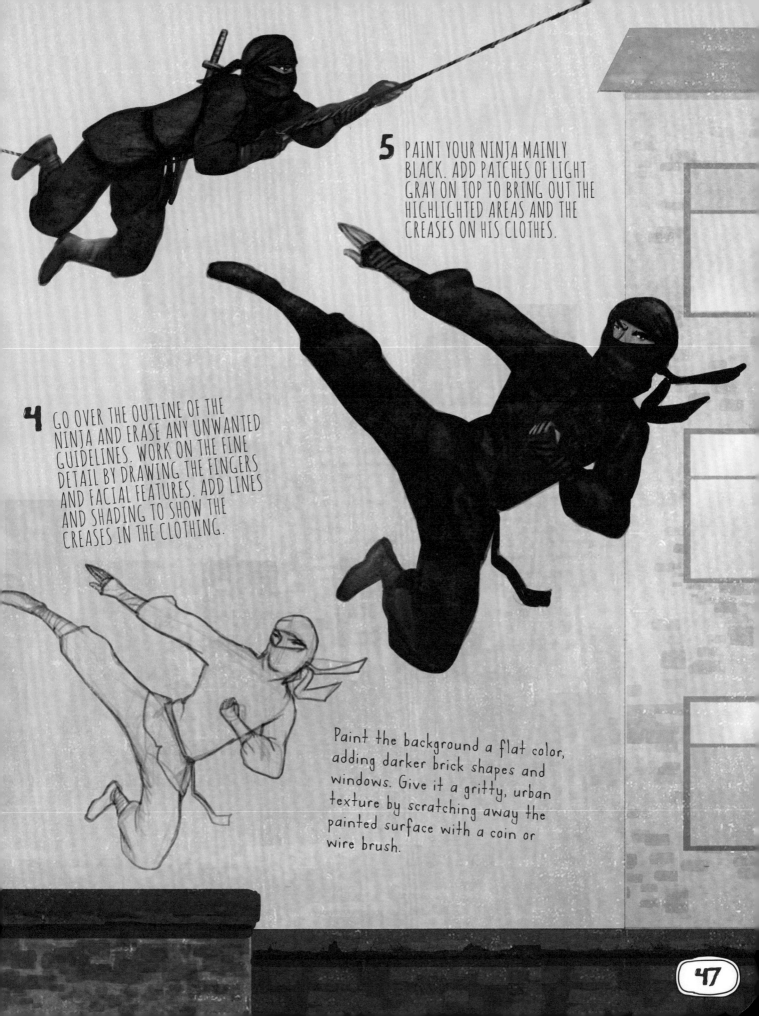

5 PAINT YOUR NINJA MAINLY BLACK. ADD PATCHES OF LIGHT GRAY ON TOP TO BRING OUT THE HIGHLIGHTED AREAS AND THE CREASES ON HIS CLOTHES.

4 GO OVER THE OUTLINE OF THE NINJA AND ERASE ANY UNWANTED GUIDELINES. WORK ON THE FINE DETAIL BY DRAWING THE FINGERS AND FACIAL FEATURES. ADD LINES AND SHADING TO SHOW THE CREASES IN THE CLOTHING.

Paint the background a flat color, adding darker brick shapes and windows. Give it a gritty, urban texture by scratching away the painted surface with a coin or wire brush.

MUSTACHES

LEARN HOW TO DRAW SOME SIMPLE TWIRLY MUSTACHES, THEN TRY CREATING YOUR OWN STYLES—THE MORE OUTLANDISH, THE BETTER!

SHORT STROKES

1 DRAW THE BASIC OUTLINE OF A MUSTACHE. THINK OF IT AS A WIDE, SOFT 'M' SHAPE WITH CURLS ON EACH SIDE.

2 USING A SOFT-GRADE PENCIL, ADD LOTS OF SHORT MARKS FOLLOWING THE CURVED SHAPE OF THE MUSTACHE. START WITH THE OUTLINE, THEN FILL IN THE MIDDLE. THE MARKS WILL LOOK LIKE INDIVIDUAL HAIRS.

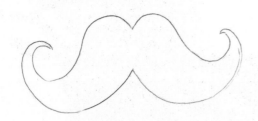

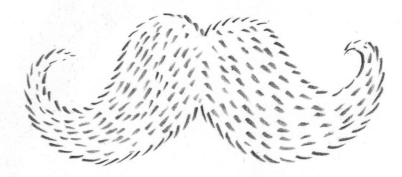

CONTOUR LINES

1 DRAW A CURLIER MOUSTACHE—THE KIND AN OLD-FASHIONED CIRCUS RINGMASTER MIGHT HAVE HAD! USE LONG, CURVED LINES TO DRAW THE LEFT SIDE FIRST, THEN SKETCH THE OTHER HALF TO MATCH. DON'T WORRY IF IT'S NOT EXACTLY SYMMETRICAL. IT WILL LOOK EVEN QUIRKIER IF IT'S NOT COMPLETELY PERFECT.

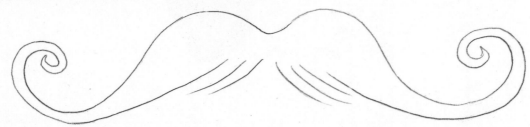

2 ADD SOFTER CURVED LINES, FLOWING FROM THE MIDDLE OF THE MUSTACHE ALMOST TO THE END OF EACH CURL. VARY THE PRESSURE ON YOUR PENCIL TO CREATE THE IMPRESSION OF DEPTH IN YOUR DRAWING.

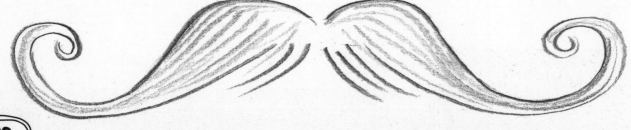

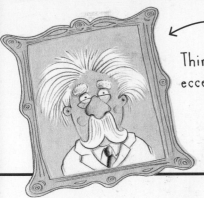

Think about how your mustache designs can be used on faces. This eccentric professor is wearing a suitably mad-looking mustache!

AFTER YOU'VE MASTERED THE BASIC MUSTACHE, TRY VARYING THE SHAPES, AND EXPERIMENT WITH DIFFERENT TECHNIQUES FOR ADDING TEXTURE.

PENCIL STROKES

USE DIFFERENT PENCIL STROKES FOR THESE MUSTACHES, AND USE PENCIL CRAYONS TO COLOR THEM IN.

Mimic the mustache contours with a number of heavier lines. Then add softer shading between them.

Draw each of these short lines with a quick flick of the pencil to make the mustache look bristly.

This simple crescent-shaped mustache looks quite neat. Fill the shape with dashed marks to create a uniform pattern.

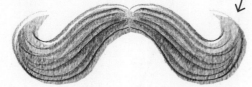

THE HANDLEBAR

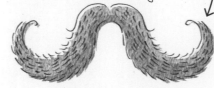

THE SERGEANT MAJOR

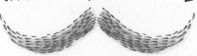

THE VILLAIN

PATTERNED

FILL YOUR MUSTACHE DESIGNS WITH DOODLES AND PATTERNS. THESE DESIGNS WERE CREATED USING FINE-LINE MARKER PENS.

THE POLKA DOT

THE SWIRLY

THE CONNECT-THE-DOTS

WACKY STYLES

MUSTACHE DESIGNS CAN BE AS STRANGE AND OVER-THE-TOP AS YOU WANT. LET YOUR IMAGINATION GO WILD!

Draw multiple swirls, then fill them with long, sweeping curves.

This curved design has a handy gap in the middle for the person's mouth.

THE HEXOPUS

THE MUTTONCHOPS

THE MAD PROFESSOR

ALIEN INVASION

1 TO START YOUR BASIC ALIEN, DRAW THREE OVERLAPPING SHAPES, INCLUDING A CIRCLE FOR THE HEAD.

2 DRAW SOME LONG, CURVED LIMBS, PLUS WAVY TENTACLES AND CIRCULAR EYES. ADD LIPS TO THE ALIEN'S BIG MOUTH.

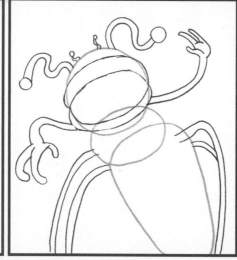

3 DRAW A BIG TONGUE AND LOTS OF SHARP, JAGGED TEETH. ADD SUCKER SHAPES TO THE FINGERS AND TENTACLES.

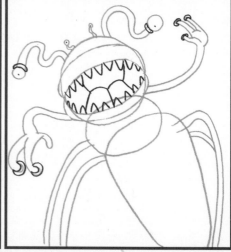

4 TO DRAW THE BUILDINGS, FIRST SKETCH SOME ANGLED RECTANGLES, AS IF YOU'RE LOOKING DOWN ON SKYSCRAPER ROOFS. THEN DRAW VERTICAL GUIDELINES DOWN FROM EACH CORNER.

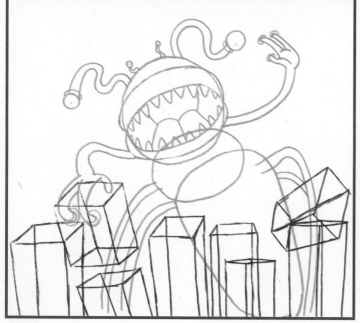

5 ADD WINDOWS USING A VARIETY OF SQUARE AND RECTANGULAR SHAPES. DRAW JAGGED LINES AT THE ENDS OF SOME OF THE BUILDINGS TO SHOW WHERE THE ALIEN HAS RIPPED THEM APART!

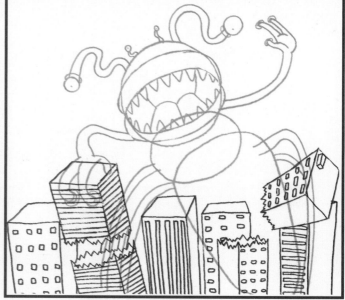

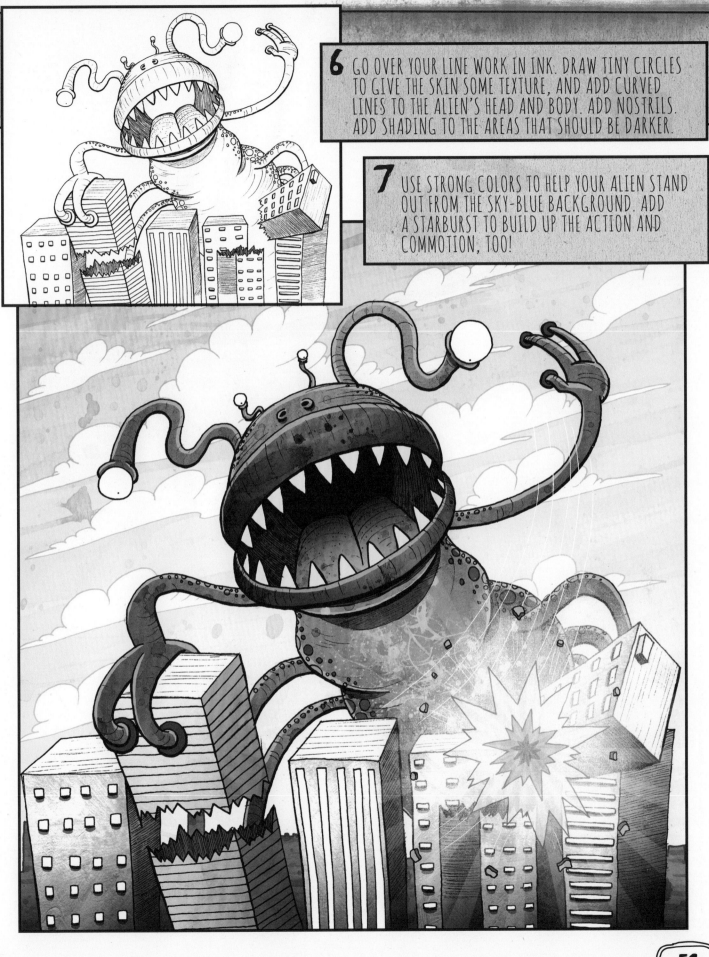

6 GO OVER YOUR LINE WORK IN INK. DRAW TINY CIRCLES TO GIVE THE SKIN SOME TEXTURE, AND ADD CURVED LINES TO THE ALIEN'S HEAD AND BODY. ADD NOSTRILS. ADD SHADING TO THE AREAS THAT SHOULD BE DARKER.

7 USE STRONG COLORS TO HELP YOUR ALIEN STAND OUT FROM THE SKY-BLUE BACKGROUND. ADD A STARBURST TO BUILD UP THE ACTION AND COMMOTION, TOO!

GIRAFFE FACE

1

START BY SKETCHING THREE BASIC SHAPES: A SKEWED RECTANGULAR SHAPE FOR THE NECK, A LARGE CIRCLE FOR THE HEAD, AND A SMALLER ONE FOR THE EYE.

2

ADD MORE SIMPLE SHAPES: A ROUGH SEMICIRCLE FOR THE MOUTH AND SAUSAGE SHAPES FOR THE HORNS AND EARS.

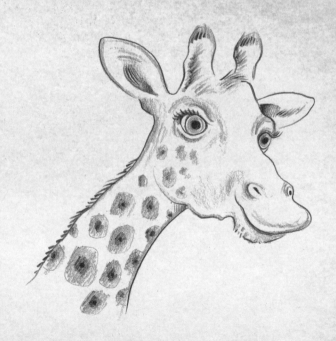

3

USING THE BASIC SHAPES AS A GUIDE, SKETCH THE OUTLINE OF THE GIRAFFE. GIVE HER SOME LOVELY UPTURNED EYELASHES—THE EYES ON A GIRAFFE ARE A BIG FEATURE! ERASE YOUR GUIDELINES.

4

USE SUBTLE SHADING TO BRING OUT THE FACIAL FEATURES. FOR THE PATTERN, DRAW SOME ROUGH CIRCULAR SHAPES, THEN SHADE EACH AREA, ADDING DARKER TONES TO THE CENTER OF EACH ONE.

5

PAINT AN ORANGEY WATERCOLOR WASH ALL OVER YOUR SKETCH. USE A BROWN COLORED PENCIL TO TRACE OVER THE OUTLINE, AND ADD SHADING, INCLUDING IN THE EARS AND ON THE HORNS AND NOSTRILS.

To create expressive, lifelike eyes, color the pupils dark, then add two spots of white paint on top—one larger than the other for glints.

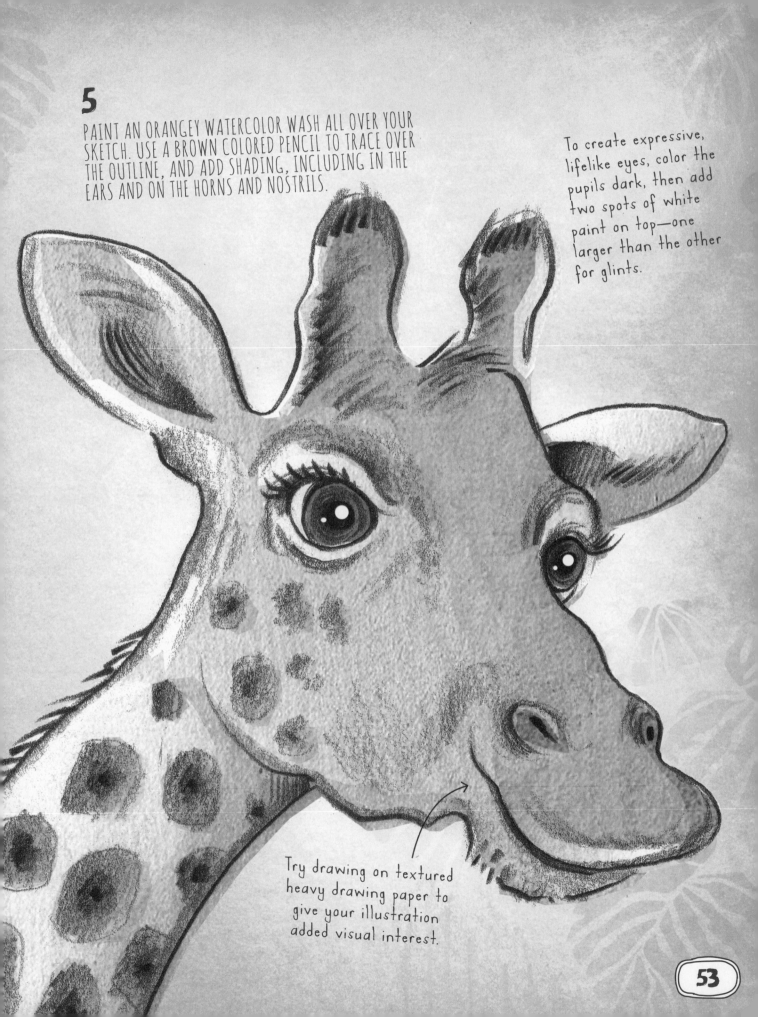

Try drawing on textured heavy drawing paper to give your illustration added visual interest.

POP STAR

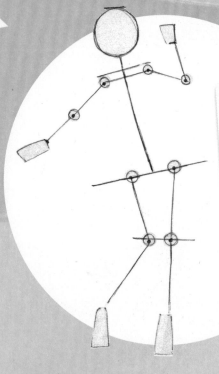

1

SKETCH A CIRCLE FOR THE HEAD AND A STRAIGHT, VERTICAL LINE FOR THE NECK AND SPINE. ADD A PERPENDICULAR LINE FOR THE HIPS AND MORE LINES FOR THE ARMS AND LEGS. DRAW CIRCLES FOR THE JOINTS AND RECTANGLES FOR THE HANDS AND FEET, AS SHOWN.

2

DRAW A TAPERED RECTANGULAR SHAPE FOR THE TORSO. ADD A SMALLER RECTANGULAR SHAPE BELOW IT TO FORM THE LOWER PART OF THE BODY.

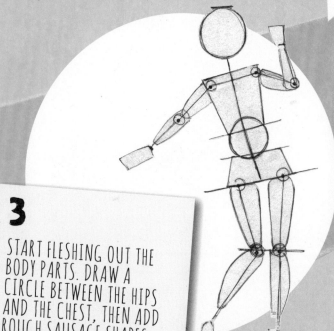

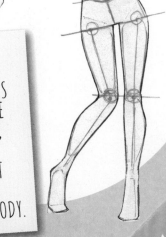

3

START FLESHING OUT THE BODY PARTS. DRAW A CIRCLE BETWEEN THE HIPS AND THE CHEST, THEN ADD ROUGH SAUSAGE SHAPES FOR THE ARMS AND LEGS.

4

JOIN THE LIMB SHAPES TOGETHER WITH MORE DISTINCT OUTLINES, AND DRAW STRONG LINES TO BRING OUT THE CURVES AND CONTOURS OF THE BODY.

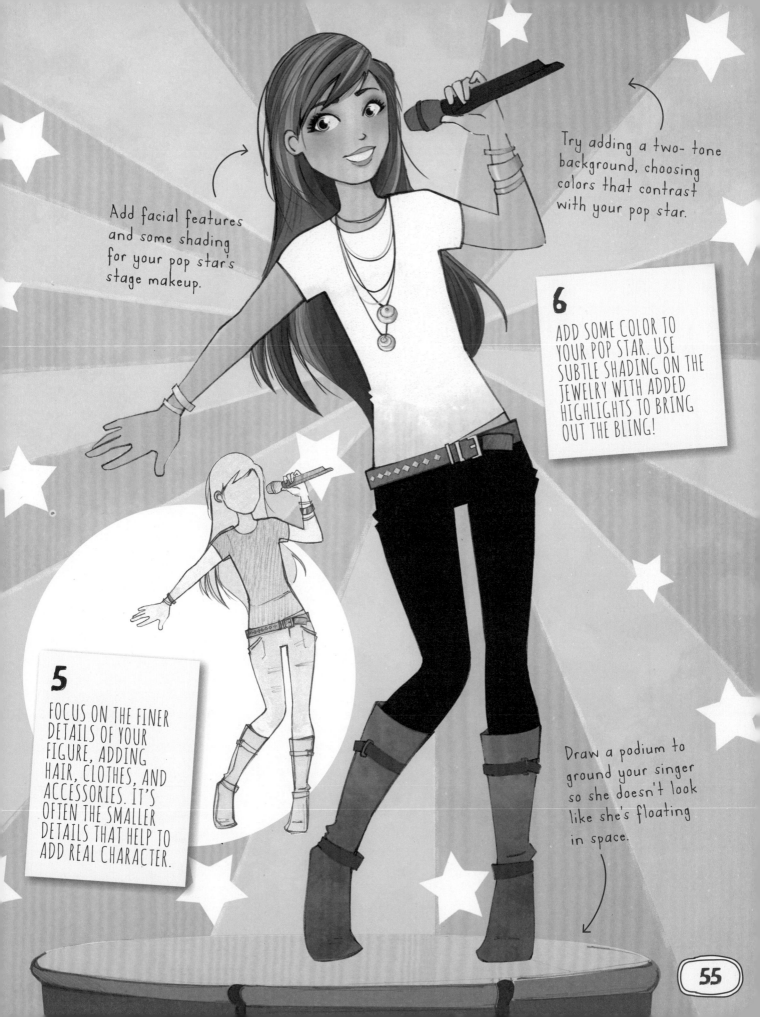

Add facial features and some shading for your pop star's stage makeup.

Try adding a two-tone background, choosing colors that contrast with your pop star.

6

ADD SOME COLOR TO YOUR POP STAR. USE SUBTLE SHADING ON THE JEWELRY WITH ADDED HIGHLIGHTS TO BRING OUT THE BLING!

5

FOCUS ON THE FINER DETAILS OF YOUR FIGURE, ADDING HAIR, CLOTHES, AND ACCESSORIES. IT'S OFTEN THE SMALLER DETAILS THAT HELP TO ADD REAL CHARACTER.

Draw a podium to ground your singer so she doesn't look like she's floating in space.

LINE DESIGNS

1

USE A PENCIL TO DRAW TWO WAVY LINES OF SIMILAR LENGTHS. THE LINES WILL LOOK LESS WOBBLY IF YOU DRAW THEM QUICKLY. A LINE DESIGN SHOULD BE POWERFUL, DRAMATIC, AND MEMORABLE!

2

GIVE YOUR TWO LINES A BIT MORE DEPTH BY ADDING ANOTHER TWO PENCIL LINES BENEATH THEM, LIKE THIS, MAKING THE LINES LOOK AS IF THEY HAVE BEEN CREATED WITH TWO CLEAN, SWEEPING BRUSHSTROKES.

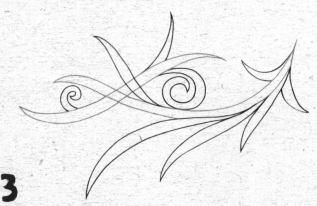

3

ADD SOME SPIRALS AND MORE SWEEPING LINES INTO YOUR DESIGN. MAKE IT LOOK NATURAL. AGAIN, DO THIS QUICKLY AND CONFIDENTLY.

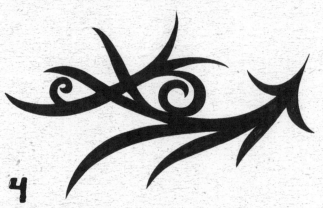

4

USE AN INK PEN TO FILL IN THE DESIGN. A SOLID BLACK COLOR CREATES A VERY STRIKING IMAGE.

MORE!

Be as creative and imaginative as you like with line designs, and come up with your own to draw on your things. These ones are spiky, dramatic, and memorable!

SYMMETRICAL

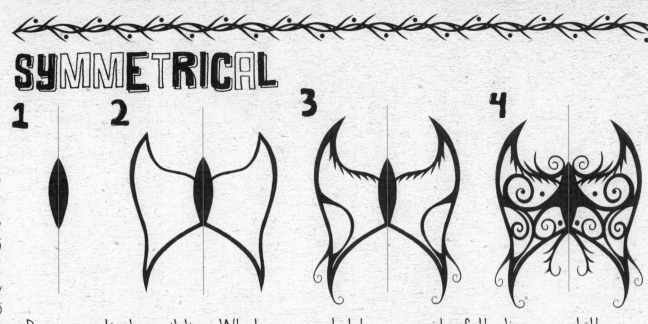

1 2 3 4

Draw a vertical pencil line. Whatever you sketch on one side of the line, repeat the mirror image on the other side. For this butterfly design, build up the image gradually, until you have a striking set of symmetrical swirls and patterns.

SPIRAL

1

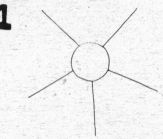

Use a pencil to sketch a small circle, then draw five lines, like this.

2

On each line, roughly draw in the outline of the same little leg shapes.

3

In the five spaces between the legs, draw in a slightly different pattern.

4

Add a spiky design to the circle in the middle of your pattern.

5

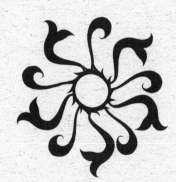

Using ink, color in your design. Doing this quickly creates a bolder image.

6

Finally, add some little dots to the image to complete your cool spiral design.

ROCK STAR DRUM SET

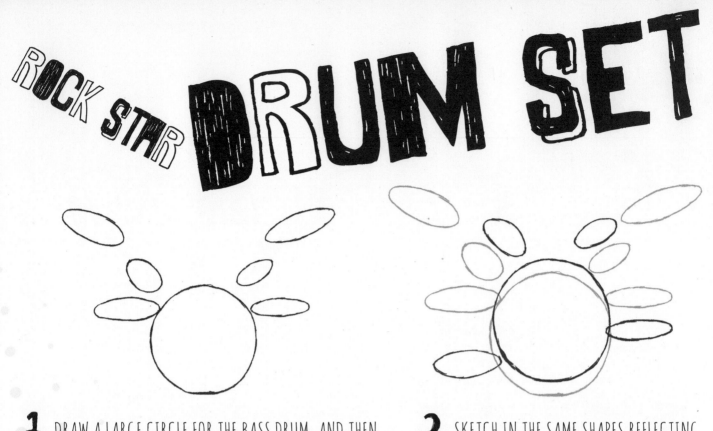

1 DRAW A LARGE CIRCLE FOR THE BASS DRUM, AND THEN SKETCH IN SOME SMALLER OVAL SHAPES FOR THE OTHER PARTS OF THE DRUM SET AROUND THE BIGGER CIRCLE.

2 SKETCH IN THE SAME SHAPES REFLECTING THE ORIGINAL ONES. THIS IS GOING TO HELP MAKE THE DRUMS LOOK 3-D.

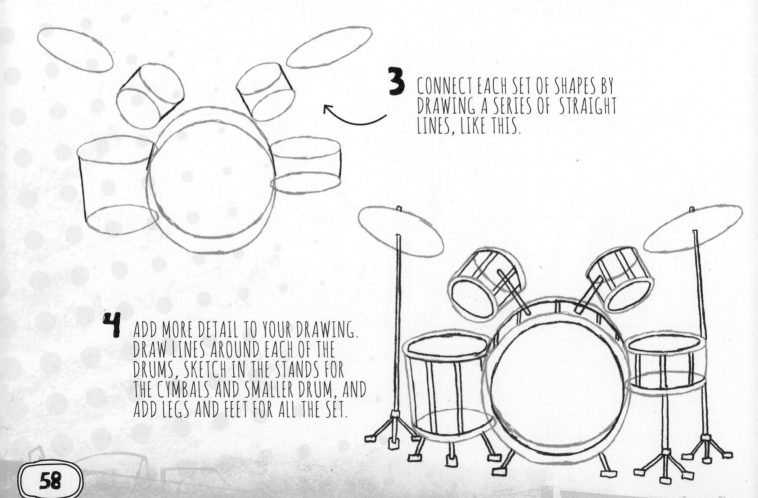

3 CONNECT EACH SET OF SHAPES BY DRAWING A SERIES OF STRAIGHT LINES, LIKE THIS.

4 ADD MORE DETAIL TO YOUR DRAWING. DRAW LINES AROUND EACH OF THE DRUMS, SKETCH IN THE STANDS FOR THE CYMBALS AND SMALLER DRUM, AND ADD LEGS AND FEET FOR ALL THE SET.

5 TO MAKE THE DRUM SET STAND OUT, DESIGN YOUR OWN BLACK LINE DRAWING ON THE FRONT OF THE BASS DRUM. OR, GIVE YOUR BAND A NAME, AND ADD A SPECIAL LOGO WITH THE NAME IN THE SAME SPACE.

6 COLOR YOUR FINISHED PICTURE WITH GOLDEN COLORS FOR THE CYMBALS AND WOODEN COLORS FOR THE DRUMS. ADD DARK STANDS AND A COOL ROCK STAR BACKGROUND.

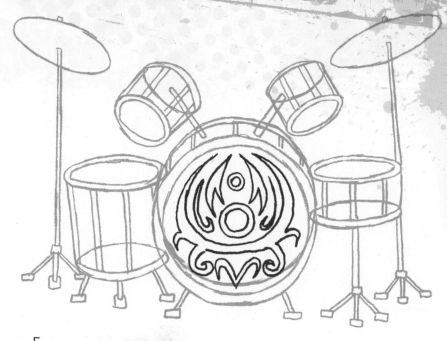

For inspiration for the line design, see pages 56 and 57.

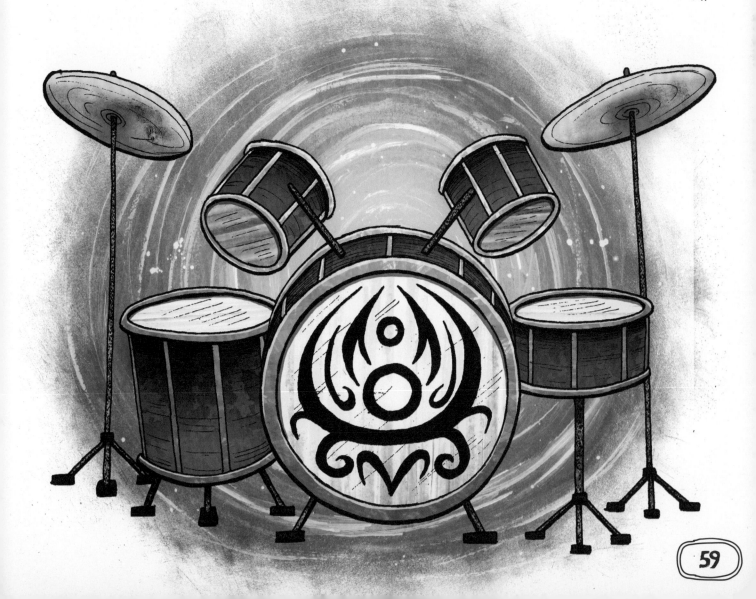

ALIEN UFO

1 DRAW THREE PAIRS OF ELLIPSES, MAKING EACH NEW PAIR NOTICEABLY BIGGER AS YOU MOVE DOWNWARD. DRAW THE SHAPES AT A SLIGHT ANGLE.

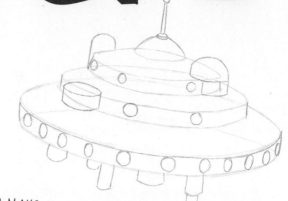

2 TO MAKE THREE SHALLOW CYLINDRICAL SHAPES, USE VERTICAL LINES TO JOIN EACH PAIR OF ELLIPSES AT THE FAR EDGES. FOR WINDOWS, ADD A ROW OF SMALL CIRCLES TO THE SIDE OF EACH CYLINDER. DRAW MORE CYLINDERS UNDERNEATH THE UFO'S BODY TO FORM THE BOOSTERS. ADD MORE DOMES AND CYLINDERS AS SHOWN.

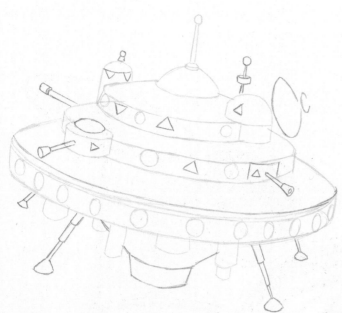

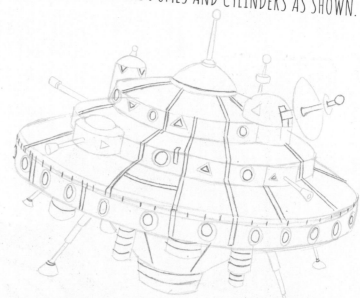

3 ADD MORE WINDOWS BY SKETCHING SOME TRIANGULAR SHAPES. ADD LEGS AND ARMS USING LONG RECTANGLES WITH TRIANGULAR OR 3-D CONE SHAPES AT THE ENDS. ADD AN ELLIPSE TO FORM THE BASIC SHAPE OF A SATELLITE DISH. DRAW A LARGE CYLINDER UNDERNEATH THE UFO.

4 ADD EXTRA BODY DETAIL. DRAW MORE CIRCLES AND TRIANGLES AROUND THE WINDOWS. EMPHASIZE THE SENSE OF PERSPECTIVE BY DRAWING PAIRS OF PARALLEL LINES THAT FOLLOW THE STEPPED SHAPE OF THE UFO, SEPARATING SLIGHTLY AS THEY APPROACH THE VIEWER. ADD EXTRA CURVES TO THE BOOSTERS, LEGS, AND POLES.

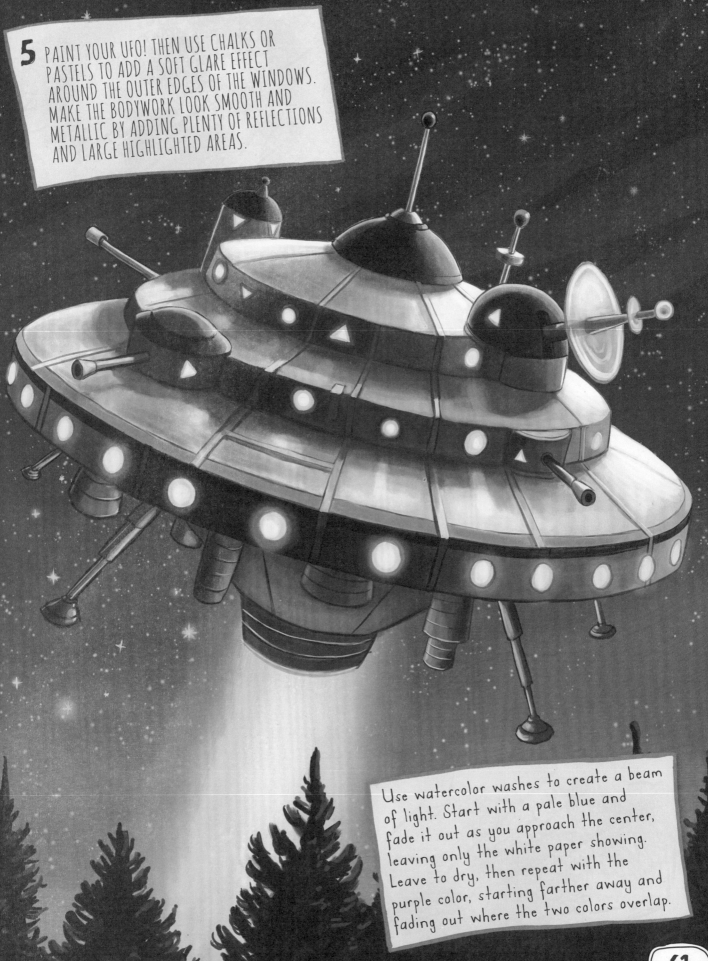

5 PAINT YOUR UFO! THEN USE CHALKS OR PASTELS TO ADD A SOFT GLARE EFFECT AROUND THE OUTER EDGES OF THE WINDOWS. MAKE THE BODYWORK LOOK SMOOTH AND METALLIC BY ADDING PLENTY OF REFLECTIONS AND LARGE HIGHLIGHTED AREAS.

Use watercolor washes to create a beam of light. Start with a pale blue and fade it out as you approach the center, leaving only the white paper showing. Leave to dry, then repeat with the purple color, starting farther away and fading out where the two colors overlap.

CARTOON MONSTERS

EXPRESSIVE EYES

SAD
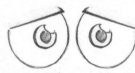

ANGRY
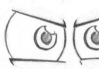

HAPPY
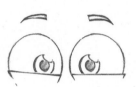

PUZZLED
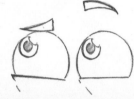

SURPRISED

CRAZY

Eye shapes can completely change a monster's mood! Use eyebrows to create even more expression.

FUR TEXTURE

FUR FALLS IN ONE DIRECTION. SKETCH A RAGGED OUTLINE AND ADD CLUMPS INSIDE.

CREATE TEXTURE WITH LIGHT AND SHADOWS BETWEEN THE CLUMPS OF FUR. USE LINES IN ONE DIRECTION.

MONSTER MOUTHS

Now put them together!

STOCKY AND SQUARE

I'M MELTING!

SMALL SPIKES

LOTS OF SPOTS

Draw eyes pointing in different directions for a goofy monster.

Experiment with different monster bodies—tall, short, four arms, or none!

STRIPE FRIGHT

FOUR-ARMED

TINY TONGUE

HAIRY HORROR

Add stripes, spots, blobs, and more to give each monster its own personality.

ANGRY LEGS

BLOB BEAST

63

MONKEYS

1

DRAW A BASIC STICK FIGURE SHOWING YOUR MONKEY IN AN ACTION POSE. USE SHORT LINES TO SHOW THE POSITIONS OF THE SHOULDER AND ARM JOINTS.

2

SKETCH THE OUTLINE OF YOUR MONKEY'S BODY USING THE STICK FIGURE AS A GUIDE.

Note how the monkey's body and his right leg follow one continuous line of action. Since the line is curved rather than straight, it makes the overall pose feel dynamic and interesting.

3

DRAW MORE GUIDES TO DEFINE THE MONKEY'S BODY, LIMBS AND TAIL. ADD ROUGH SHAPES FOR HIS FACIAL FEATURES.

4

ERASE ALL THE CONSTRUCTION LINES, LEAVING THE OUTLINE OF YOUR MONKEY. REFINE THE FACIAL DETAILS, AND DRAW IN THE FINGERS AND TOES.

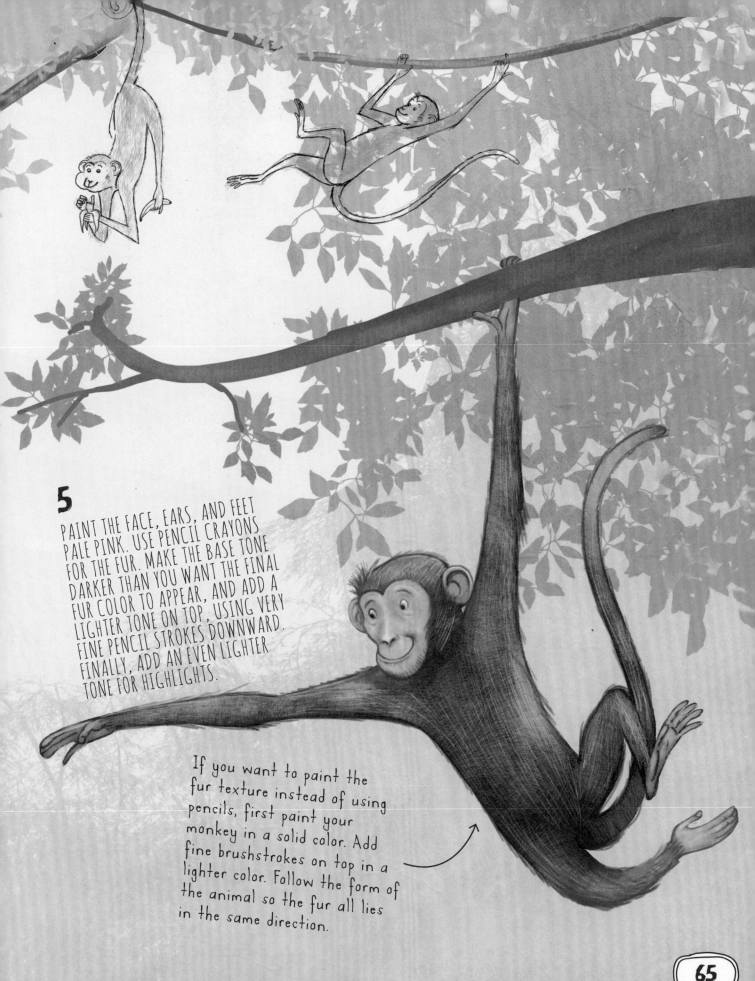

5

PAINT THE FACE, EARS, AND FEET PALE PINK. USE PENCIL CRAYONS FOR THE FUR. MAKE THE BASE TONE DARKER THAN YOU WANT THE FINAL FUR COLOR TO APPEAR, AND ADD A LIGHTER TONE ON TOP, USING VERY FINE PENCIL STROKES DOWNWARD. FINALLY, ADD AN EVEN LIGHTER TONE FOR HIGHLIGHTS.

If you want to paint the fur texture instead of using pencils, first paint your monkey in a solid color. Add fine brushstrokes on top in a lighter color. Follow the form of the animal so the fur all lies in the same direction.

65

SPEECH BUBBLES

START BY PRACTICING SOME COMMON SPEECH BUBBLE SHAPES, SUCH AS OVALS AND RECTANGLES.

ROUND BUBBLES

1 Draw a simple oval shape. It doesn't matter if it's a little wobbly.

2 Add a curved triangular shape to the outer edge, pointing toward the person who is speaking.

3 To create a 3-D effect, draw an extra outline that mimics part of the bubble. Shade in the gap created.

RECTANGULAR BUBBLES

1 Sketch a simple rectangular shape with rounded corners.

2 Add the curved triangular shape. It can be quite long if you want, like a dog's tail.

3 The 3-D effect is better if you make some areas a bit darker, as if in shadow.

NOW TRY THESE
Practice drawing 3-D versions of oval and rectangular bubbles in different positions.

Depending on the space you have, speech bubbles can be fat or thin.

Vertical shading strokes help sell the 3-D effect. The lines are similar to the edges of a coin.

Longer tails are useful when the bubble is far away from the speaker.

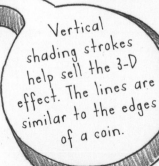

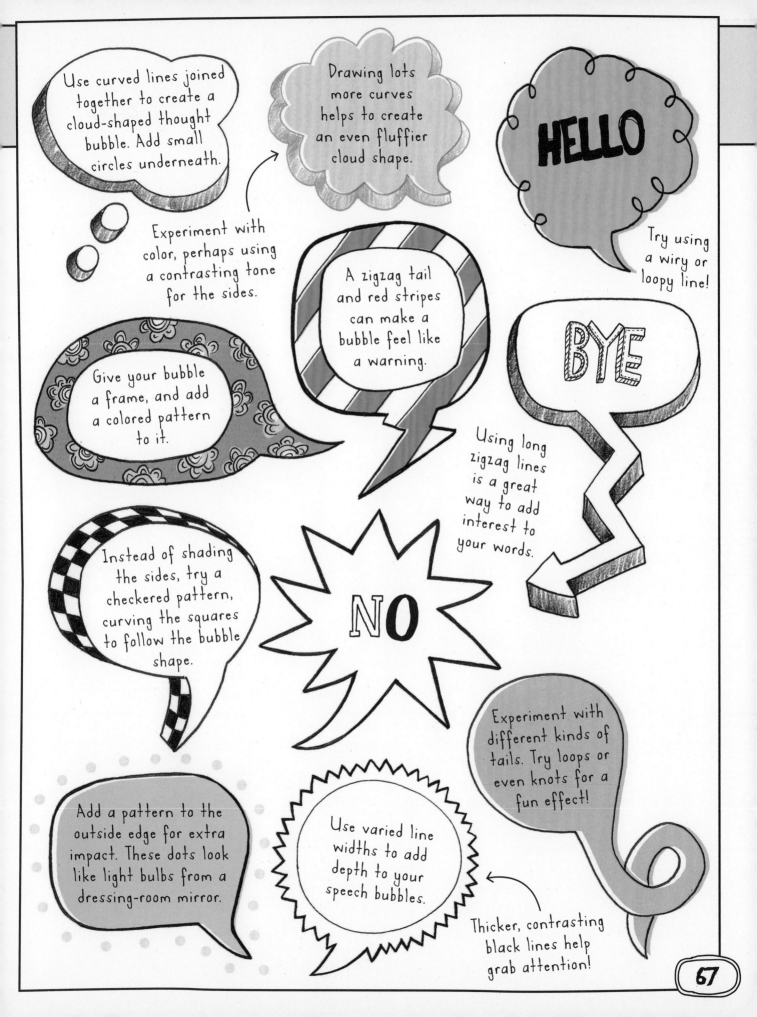

Skateboards

THE BASIC SHAPE OF A SKATEBOARD IS VERY EASY TO DRAW. THE FUN PART IS COMING UP WITH AN EXCITING AND ORIGINAL PATTERN!

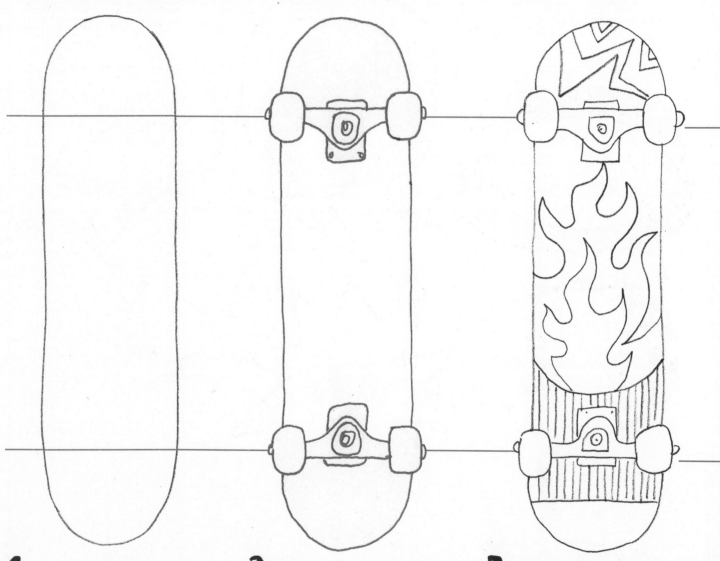

1

DRAW A LARGE RECTANGULAR SHAPE WITH TWO ROUNDED ENDS. SKETCH IN TWO GUIDELINES. THIS WILL HELP YOU ADD THE WHEELS TO THE BOTTOM OF THE SKATEBOARD.

2

SKETCH IN THE SIMPLE SHAPES OF THE SKATEBOARD'S WHEELS AND AXLES, USING THE LINES TO HELP. MAKE SURE THEY ARE THE SAME DISTANCE APART AT EACH END.

3

DRAW THE PATTERN FOR YOUR SKATEBOARD. DIVIDING THE DESIGN INTO THREE PARTS WILL HELP. WHEN YOU ARE HAPPY WITH IT, GO OVER THE PENCIL LINES IN INK.

BOARD DESIGNS

Use your imagination to come up with original designs for the bottom of your board. Color in the skateboards brightly to make the patterns look striking!

Make the board appear 3-D using perspective, like this angle.

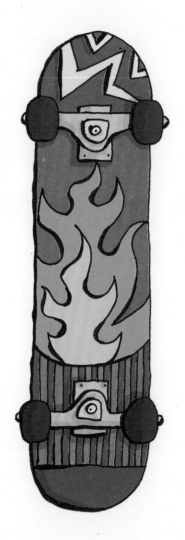

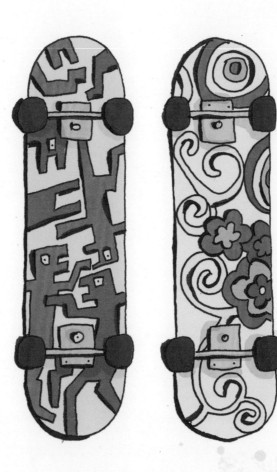

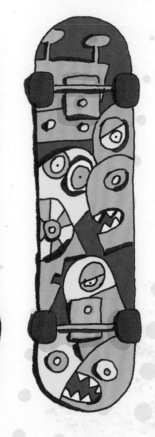

4

USE PAINTS TO COLOR IN YOUR SKATEBOARD. GIVE DEPTH TO THE DESIGN WITH A SLIGHTLY HEAVIER LINE USING A FINE BRUSH AND INK AROUND PARTS OF THE PATTERN.

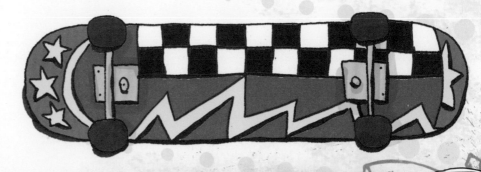

DIVER

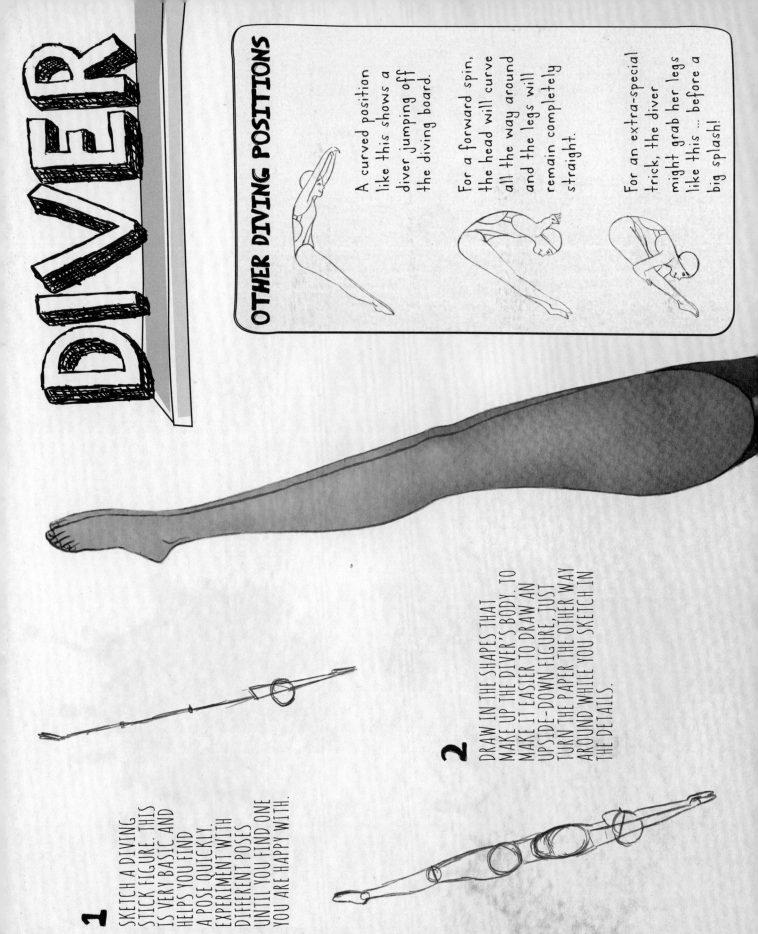

OTHER DIVING POSITIONS

A curved position like this shows a diver jumping off the diving board.

For a forward spin, the head will curve all the way around and the legs will remain completely straight.

For an extra-special trick, the diver might grab her legs like this ... before a big splash!

1

SKETCH A DIVING STICK FIGURE. THIS IS VERY BASIC AND HELPS YOU FIND A POSE QUICKLY. EXPERIMENT WITH DIFFERENT POSES UNTIL YOU FIND ONE YOU ARE HAPPY WITH.

2

DRAW IN THE SHAPES THAT MAKE UP THE DIVER'S BODY. TO MAKE IT EASIER TO DRAW AN UPSIDE-DOWN FIGURE, JUST TURN THE PAPER THE OTHER WAY AROUND WHILE YOU SKETCH IN THE DETAILS.

5

CHOOSE STRIKING COLORS FOR YOUR DIVER'S SWIMSUIT. START WITH A FLAT, DARK COLOR AND THEN BUILD UP THE PICTURE WITH LIGHTER COLORS. USE A SOFT BRUSH TO PAINT THE SKIN.

Paint splashes around the diver hitting the water. Move your hand quickly and freely with a wet, watered-down brush.

3

SKETCH THE SWIMSUIT AND FACE, AND GO AROUND THE OUTLINE CAREFULLY. ERASE ANY PENCIL GUIDELINES.

Use a big wet brush for the water. Mask off the water line for a nice crisp edge for the diver to jump into.

4

FILL IN THE FINAL PARTS OF THE LINE DRAWING. ADD SHADING TO THE SWIMSUIT AND SWIM CAP.

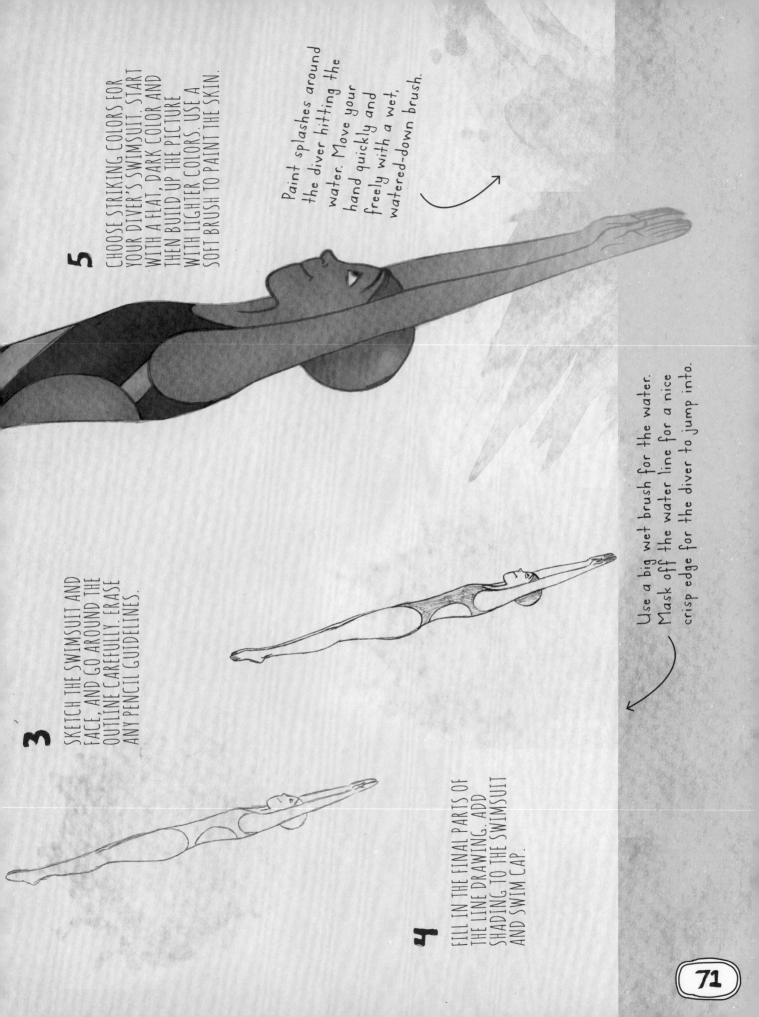

BULLET TRAIN

vanishing point

perspective line

perspective line

1

FOR THIS DRAWING YOU'LL BE USING PERSPECTIVE TO ADD DEPTH AND REALISM TO YOUR BULLET TRAIN. DRAW TWO PERSPECTIVE LINES COMING TOGETHER TO ESTABLISH THE VANISHING POINT OF THE PICTURE. DRAW A LARGE OVAL AT THE OTHER END.

Add a couple more perspective lines to help build your drawing.

2

DRAW TWO MORE OVALS TO BUILD UP THE SHAPE OF THE DRIVER'S WINDOW AND THE BULLET TRAIN'S NOSE. THESE SHAPES NEED TO BE BIG, SINCE THIS PART OF THE TRAIN IS IN THE FOREGROUND.

Adding a simple curved guideline to the train's nose will help it to look more 3-D.

3

ADD A SLIGHT CURVE TO THE THREE LOWER LINES, AS IF THE TRAIN IS TRAVELING ALONG A BENDED TRACK. SKETCH SOME GUIDELINES FOR THE POSITIONS OF THE DOORS AND WINDOWS, THEN WORK UP THE FENDER AND NOSE DETAIL, ADDING AN OVAL FOR THE DRIVER'S HEAD.

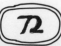

To make your train appear sleeker and more aerodynamic, alter the top perspective line to give it more of a curved shape.

4

DRAW MORE OVALS FOR THE PASSENGERS' HEADS. ADD MORE DECORATIVE DETAIL TO THE TRAIN'S EXTERIOR, AND SKETCH MORE LINES ON THE LIGHTS AND FENDER. CONTINUE THE LOWER GUIDELINES TO HELP YOU DRAW IN A SIMPLE TRACK.

Don't worry if your final line work is a little wobbly. It's a feeling of movement you want to get across, rather than an impression of technical perfection!

5

COLOR YOUR TRAIN, PAYING SPECIAL ATTENTION TO LIGHT AND SHADE. HERE, A LIGHTER FRONT SECTION REINFORCES THE SENSE OF PERSPECTIVE, MAKING THE TRAIN APPEAR TO COME OUT OF THE PAGE TOWARD US.

PEACOCK

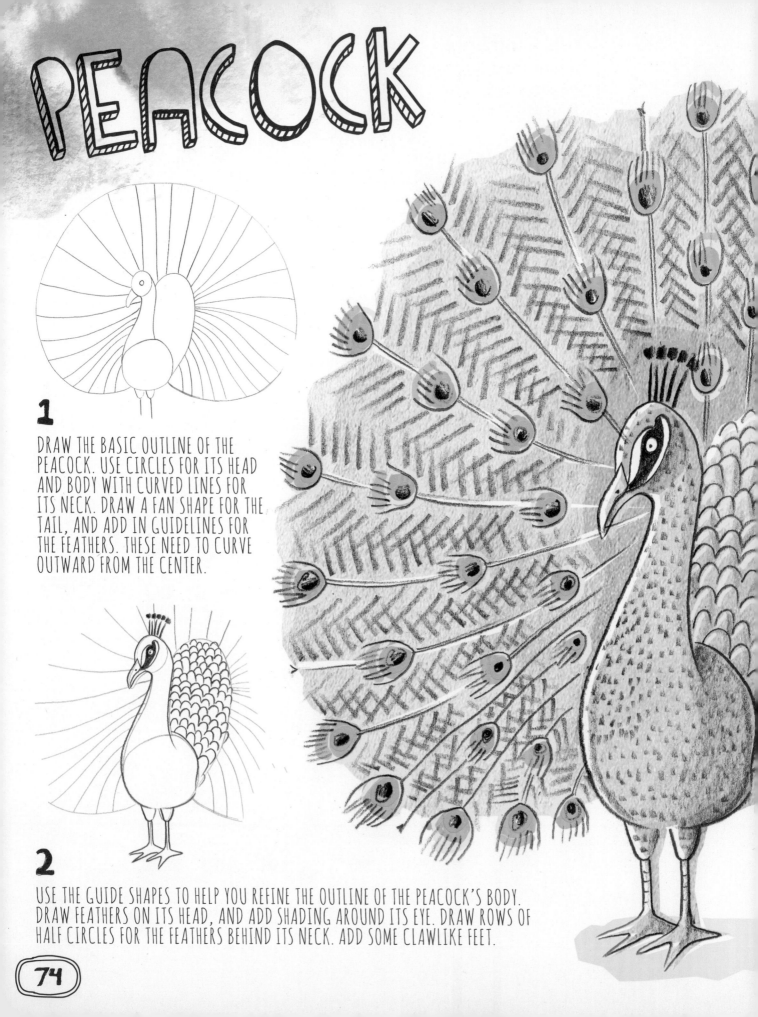

1

DRAW THE BASIC OUTLINE OF THE
PEACOCK. USE CIRCLES FOR ITS HEAD
AND BODY WITH CURVED LINES FOR
ITS NECK. DRAW A FAN SHAPE FOR THE
TAIL, AND ADD IN GUIDELINES FOR
THE FEATHERS. THESE NEED TO CURVE
OUTWARD FROM THE CENTER.

2

USE THE GUIDE SHAPES TO HELP YOU REFINE THE OUTLINE OF THE PEACOCK'S BODY.
DRAW FEATHERS ON ITS HEAD, AND ADD SHADING AROUND ITS EYE. DRAW ROWS OF
HALF CIRCLES FOR THE FEATHERS BEHIND ITS NECK. ADD SOME CLAWLIKE FEET.

To create a feathered effect, use quick flicks of your pencil, easing off the pressure as you make each stroke.

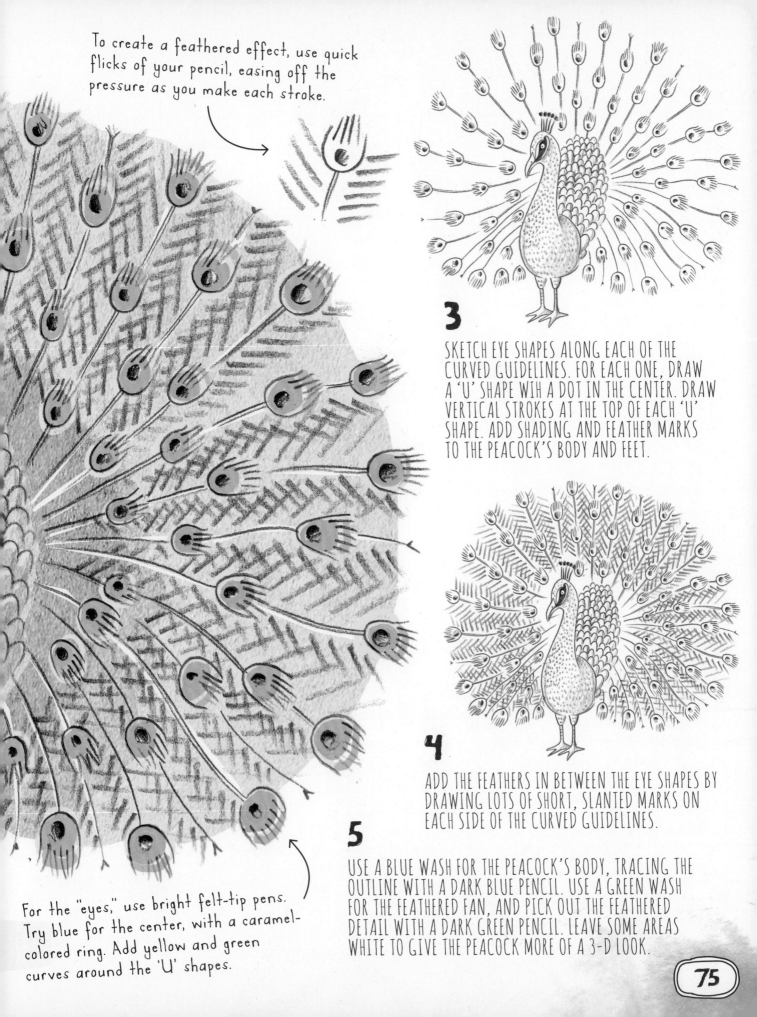

3

SKETCH EYE SHAPES ALONG EACH OF THE CURVED GUIDELINES. FOR EACH ONE, DRAW A 'U' SHAPE WIH A DOT IN THE CENTER. DRAW VERTICAL STROKES AT THE TOP OF EACH 'U' SHAPE. ADD SHADING AND FEATHER MARKS TO THE PEACOCK'S BODY AND FEET.

4

ADD THE FEATHERS IN BETWEEN THE EYE SHAPES BY DRAWING LOTS OF SHORT, SLANTED MARKS ON EACH SIDE OF THE CURVED GUIDELINES.

5

USE A BLUE WASH FOR THE PEACOCK'S BODY, TRACING THE OUTLINE WITH A DARK BLUE PENCIL. USE A GREEN WASH FOR THE FEATHERED FAN, AND PICK OUT THE FEATHERED DETAIL WITH A DARK GREEN PENCIL. LEAVE SOME AREAS WHITE TO GIVE THE PEACOCK MORE OF A 3-D LOOK.

For the "eyes," use bright felt-tip pens. Try blue for the center, with a caramel-colored ring. Add yellow and green curves around the 'U' shapes.

The Eiffel Tower was completed in 1889 and is the tallest building in Paris, France. It is also pretty easy to draw!

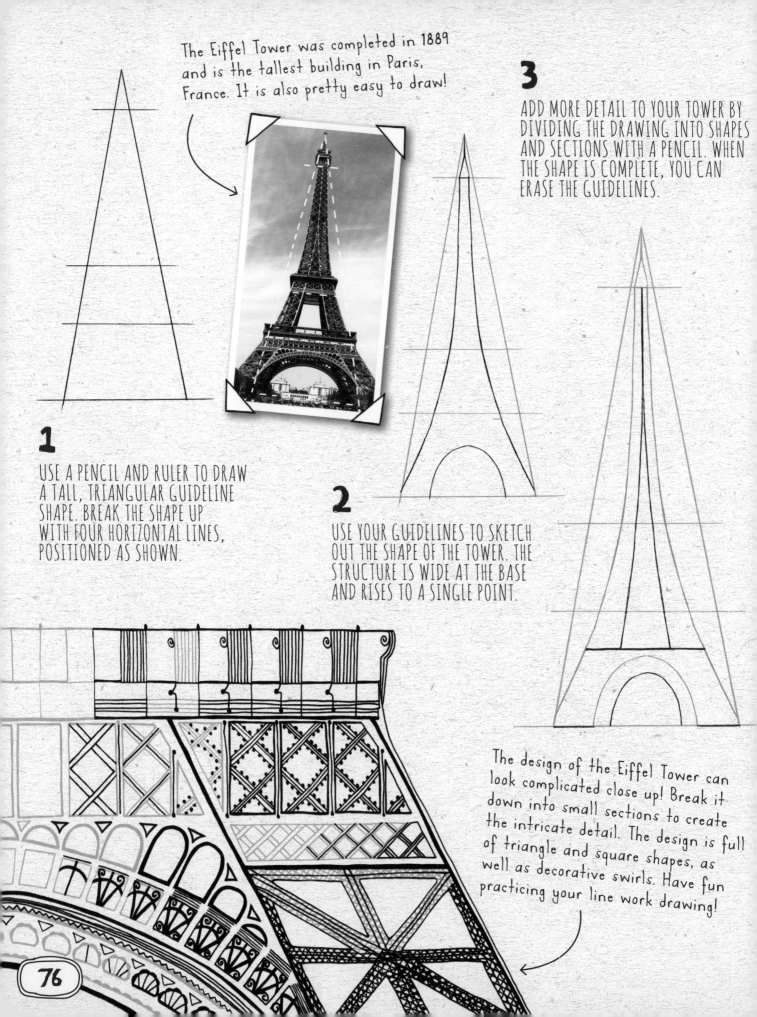

3

ADD MORE DETAIL TO YOUR TOWER BY DIVIDING THE DRAWING INTO SHAPES AND SECTIONS WITH A PENCIL. WHEN THE SHAPE IS COMPLETE, YOU CAN ERASE THE GUIDELINES.

1

USE A PENCIL AND RULER TO DRAW A TALL, TRIANGULAR GUIDELINE SHAPE. BREAK THE SHAPE UP WITH FOUR HORIZONTAL LINES, POSITIONED AS SHOWN.

2

USE YOUR GUIDELINES TO SKETCH OUT THE SHAPE OF THE TOWER. THE STRUCTURE IS WIDE AT THE BASE AND RISES TO A SINGLE POINT.

The design of the Eiffel Tower can look complicated close up! Break it down into small sections to create the intricate detail. The design is full of triangle and square shapes, as well as decorative swirls. Have fun practicing your line work drawing!

4

USE A FINE-POINT INK PEN AND A RULER TO BREAK THE DRAWING INTO EVEN SMALLER SHAPES, LIKE THIS. A RULER WILL HELP MAKE SURE THE LINES ARE NEAT AND AT THE SAME LEVEL.

When your Eiffel Tower is finished, give your picture a wow-factor background. Watercolor paints or inks are good for this. Using a large brush loaded with water, wet the paper. Add on the inks or paint, and watch the colors bleed together.

5

USING A FINE-POINT WATERPROOF PEN, ADD LOTS OF DECORATIVE DETAIL TO FINISH THE DESIGN OF THE TOWER. DRAW IN SOME SILHOUETTED PEOPLE AT THE BOTTOM TO GIVE AN IDEA OF HOW IMPRESSIVELY TALL THE TOWER IS.

EIFFEL TOWER

HAIRSTYLES

LEARN HOW TO DRAW A VARIETY OF HAIRSTYLES TO USE ON YOUR PORTRAITS. EXPERIMENT WITH COLOR AND TEXTURE!

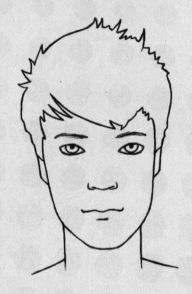

Think about the direction of the hair. Use long, confident strokes for someone who has longer hair, like this.

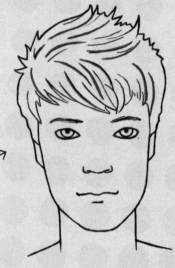

1

FOR A BASIC BOY'S HAIRSTYLE, START BY THINKING HOW THE HAIR WILL FALL ON THE FACE. DRAW THE BASIC OUTLINE ON THE TOP OF THE HEAD, LIKE THIS.

2

SKETCH IN THE HAIR DETAIL. MAKE SURE LINES ARE CLOSE TOGETHER, AND VARY THE LIGHTNESS AND DARKNESS TO SHOW SHADING, USING DIFFERENT PENCILS TO ACHIEVE THIS VARIATION.

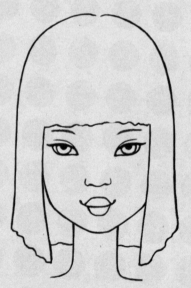

For longer hair, make sure that the strokes of hair are of similar length. Add a little shape to them to show movement.

1

FOR A BASIC GIRL'S HAIRSTYLE, AGAIN START WITH A ROUGH OUTLINE FOR THE SHAPE OF THE GIRL'S HAIR ON A SIMPLE FACE, LIKE THIS.

2

SKETCH IN THE HAIR WITH DOWNWARD PENCIL STROKES. THINK ABOUT THE SHADOWS AND HIGHLIGHTS.

NOW TRY THESE COOL HAIRSTYLES!

WAVY

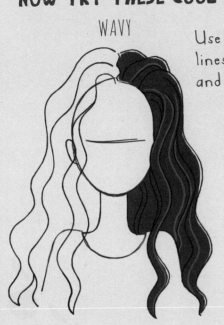

Use flowing lines for curls and waves.

CURLY

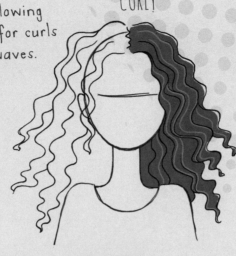

For tight curls, use lots of little scribbled circles next to each other.

AFRO

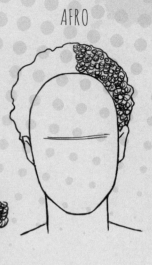

LONG BRAIDED

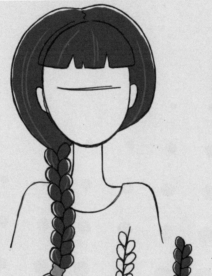

BEEHIVE

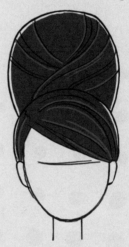

This style is basically a whole other head shape on top of the girl's head!

RINGLETS

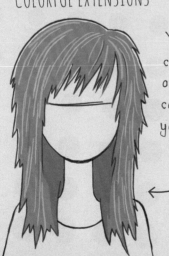

The ringlet is a series of spiral shapes, like this.

For a braid, draw a line with leaf shapes coming off it.

Try leaving out the bangs and adding a headband or tiara. Use your pencil lines to show the direction of the updo.

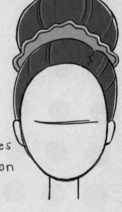

COLORFUL EXTENSIONS

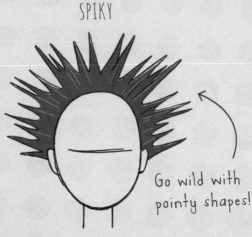

You can choose loads of different colors for your hairstyle!

SPIKY

Go wild with pointy shapes!

ASYMMETRICAL

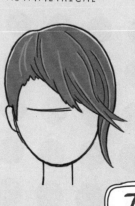

AERIAL DISPLAY

1 DRAW AN ELONGATED OVAL SHAPE FOR THE MAIN BODY OF THE PLANE WITH A PENCIL. ADD TWO SMALL WING SHAPES AT ONE END.

It is always easier to draw a light outline to start with.

2 DRAW IN TWO LARGE WINGS. THEY SHOULD BE COMPLETELY SYMMETRICAL. SKETCH IN FOUR ENGINES ONTO THE WINGS, AND ADD A BIT OF DETAIL TO THE SMALL BOTTOM WINGS.

It's important that the features are the same on both sides.

3 ADD A TARGET DESIGN TO THE WINGS. THIS GIVES SOME INTEREST TO THE PLANE. AGAIN, THESE SHOULD BE SYMMETRICAL. ADD WIGGLY LINES AT THE BOTTOM FOR THE PLANE'S VAPOR TRAIL.

The trail should look soft and fluffy, so use soft, light strokes.

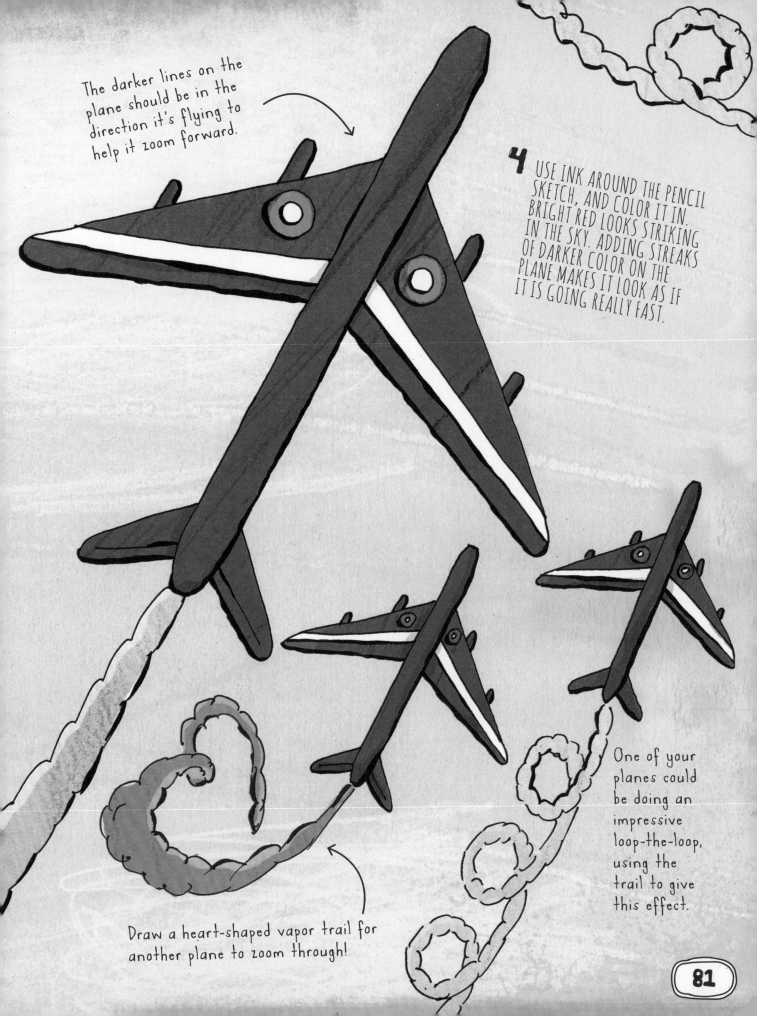

The darker lines on the plane should be in the direction it's flying to help it zoom forward.

4 USE INK AROUND THE PENCIL SKETCH, AND COLOR IT IN. BRIGHT RED LOOKS STRIKING IN THE SKY. ADDING STREAKS OF DARKER COLOR ON THE PLANE MAKES IT LOOK AS IF IT IS GOING REALLY FAST.

One of your planes could be doing an impressive loop-the-loop, using the trail to give this effect.

Draw a heart-shaped vapor trail for another plane to zoom through!

DANCING DOG

3
FOLLOW THE OUTLINE OF THE CHIN, AND DRAW A VERY BIG SMILE. ADD THE EYEBALLS, LEAVING WHITE DOTS TO MAKE THE EYES LOOK LIVELY. WORK UP THE EARS AND FEET.

2
ADD PERKY EARS, EYES, AND A TAIL. DRAW LIGHTLY OVER YOUR GUIDELINES TO BEGIN TO SMOOTH OUT THE SHAPES.

1
DRAW SIMPLE SHAPES TO USE AS GUIDELINES. USE A CIRCLE SHAPE FOR THE HEAD, A BEAN SHAPE FOR THE BODY, AND RECTANGLES FOR THE LEGS AND SNOUT.

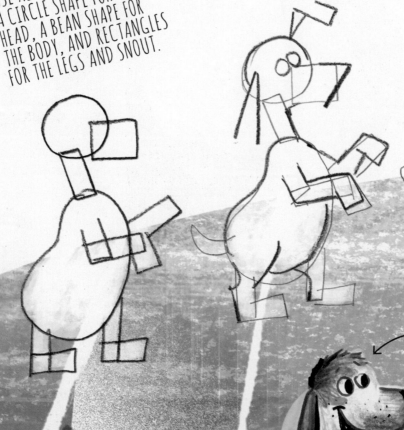

Try this goofy expression for your dancing dog.

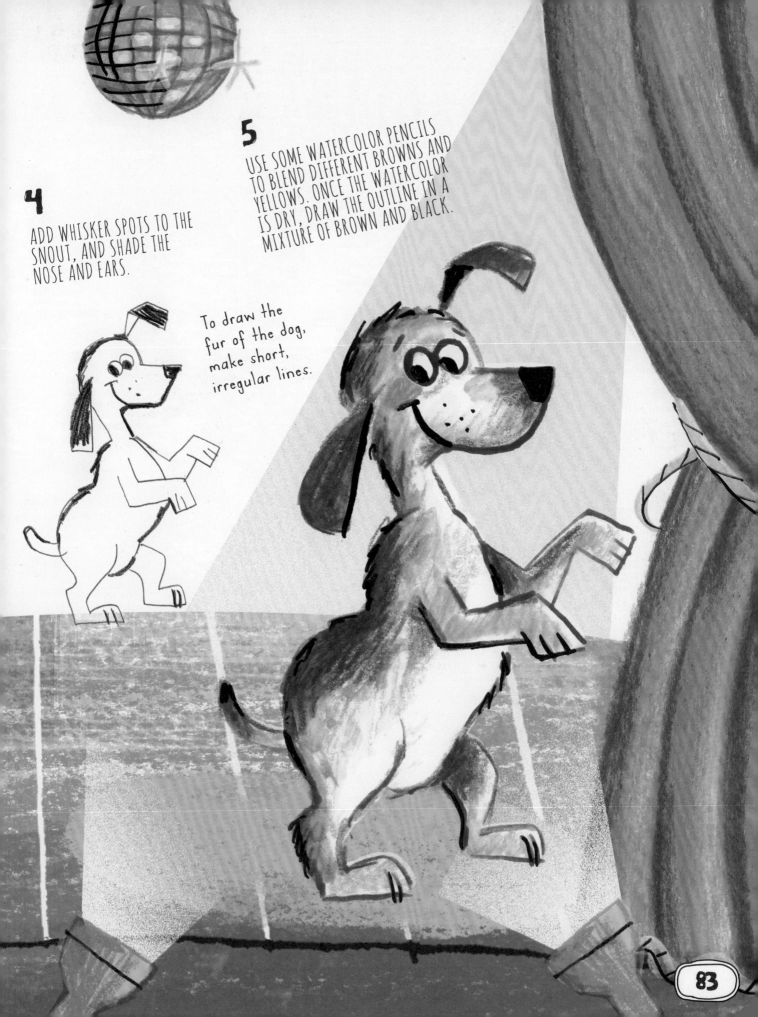

4

ADD WHISKER SPOTS TO THE SNOUT, AND SHADE THE NOSE AND EARS.

5

USE SOME WATERCOLOR PENCILS TO BLEND DIFFERENT BROWNS AND YELLOWS. ONCE THE WATERCOLOR IS DRY, DRAW THE OUTLINE IN A MIXTURE OF BROWN AND BLACK.

To draw the fur of the dog, make short, irregular lines.

SNOWBOARDER

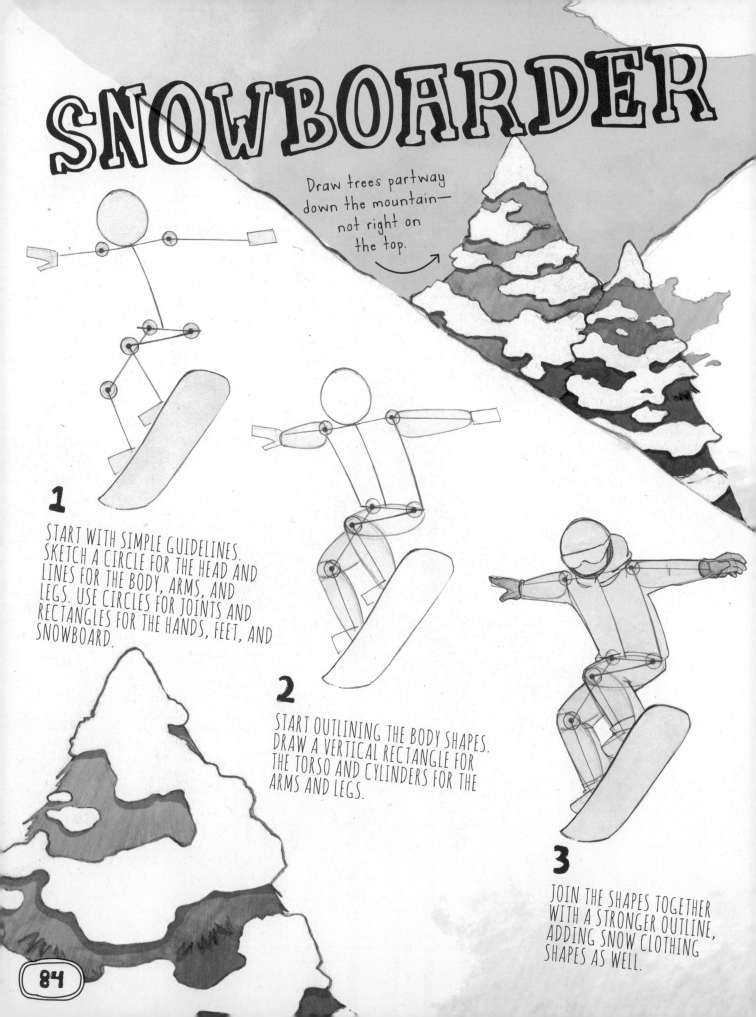

Draw trees partway down the mountain— not right on the top.

1

START WITH SIMPLE GUIDELINES. SKETCH A CIRCLE FOR THE HEAD AND LINES FOR THE BODY, ARMS, AND LEGS. USE CIRCLES FOR JOINTS AND RECTANGLES FOR THE HANDS, FEET, AND SNOWBOARD.

2

START OUTLINING THE BODY SHAPES. DRAW A VERTICAL RECTANGLE FOR THE TORSO AND CYLINDERS FOR THE ARMS AND LEGS.

3

JOIN THE SHAPES TOGETHER WITH A STRONGER OUTLINE, ADDING SNOW CLOTHING SHAPES AS WELL.

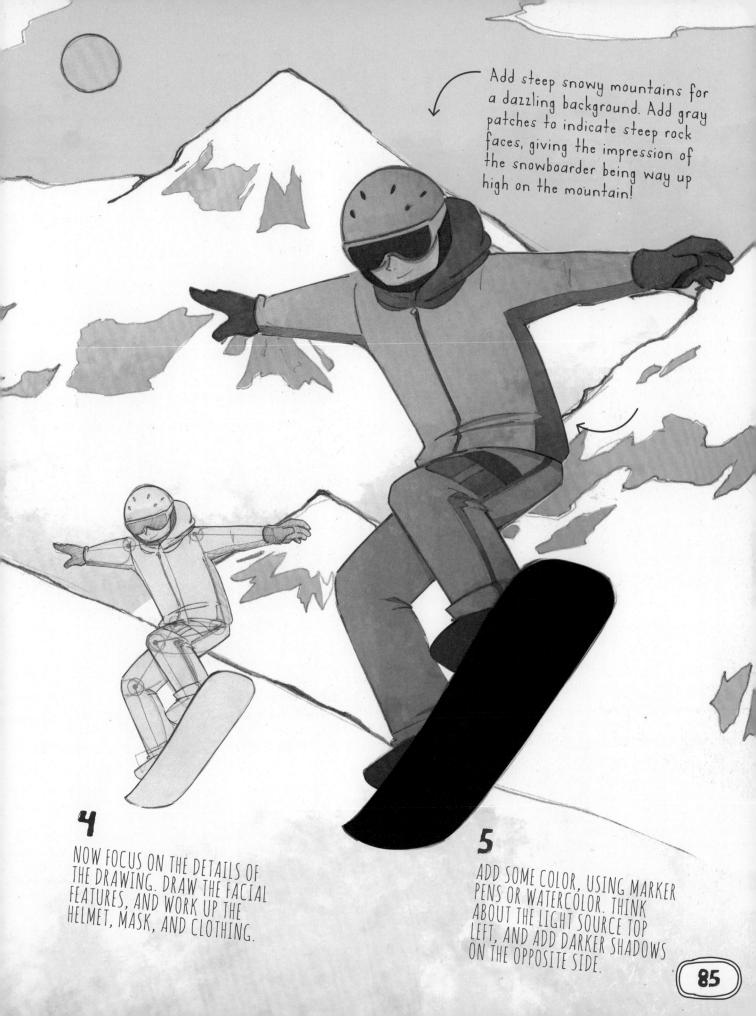

Add steep snowy mountains for a dazzling background. Add gray patches to indicate steep rock faces, giving the impression of the snowboarder being way up high on the mountain!

4

NOW FOCUS ON THE DETAILS OF THE DRAWING. DRAW THE FACIAL FEATURES, AND WORK UP THE HELMET, MASK, AND CLOTHING.

5

ADD SOME COLOR, USING MARKER PENS OR WATERCOLOR. THINK ABOUT THE LIGHT SOURCE TOP LEFT, AND ADD DARKER SHADOWS ON THE OPPOSITE SIDE.

FANTASY MAP

LEARN HOW TO DRAW THE DIFFERENT PARTS OF A FANTASY MAP, THEN PUT THEM ALL TOGETHER TO CREATE YOUR OWN DESIGN!

1

DRAW A SIMPLE COASTLINE FOR YOUR MAP. EXPERIMENT WITH DIFFERENT SHAPES—PERHAPS IT COULD RESEMBLE THE HEAD OF A DRAGON OR SOME OTHER MYTHICAL BEAST. SKETCH WAVY LINES AROUND THE OUTLINE TO REPRESENT THE SEA.

2

DRAW THE SHAPE OF A MOUNTAIN RANGE. FOR ROUNDED HILLS, ADD SHADING USING STROKES THAT FLOW IN ONE DIRECTION. FOR JAGGED PEAKS, DRAW A SHARP OUTLINE, ADDING STROKES THAT CUT INTO EACH OTHER AT DIFFERENT ANGLES.

Varying the angles helps emphasize the jagged effect.

3

SKETCH A CASTLE, BUILDING IT UP FROM DIFFERENT SHAPES SUCH AS TRIANGLES AND RECTANGLES. ADD FLAGPOLES AND SKETCH WAVY LINES FOR FLAGS FLAPPING IN THE BREEZE.

Use small, random pencil strokes to suggest brick and tile textures.

4

TO DRAW A TREE, SKETCH A ROUGH CLOUD SHAPE WITH A TRUNK ATTACHED, ADDING SOME DIAGONAL LINES BELOW FOR SHADE. TO SKETCH A CLUSTER OF TREES, DRAW THE CLOUD SHAPES BUNCHED TOGETHER, ADDING TRUNKS TO THE NEAREST ONES.

Use short, curved strokes to give your trees some texture.

5

BRIDGES, RIVERS, AND STREAMS CAN BE DRAWN VERY SIMPLY. DRAW TWO CURVED LINES FOR A BRIDGE, WITH MORE CURVES UNDERNEATH FOR THE RIVER. ADD MORE LINES TO SUGGEST RUNNING WATER.

6

USE LITTLE GROUPS OF HOUSES TO INDICATE THE LOCATION OF A TOWN. DRAW AN OUTLINE FIRST, THEN ADD SIMPLE, OVERLAPPING ROOF AND BUILDING SHAPES, WITH DOORS AND WINDOWS.

Add some strokes to suggest roof tiles.

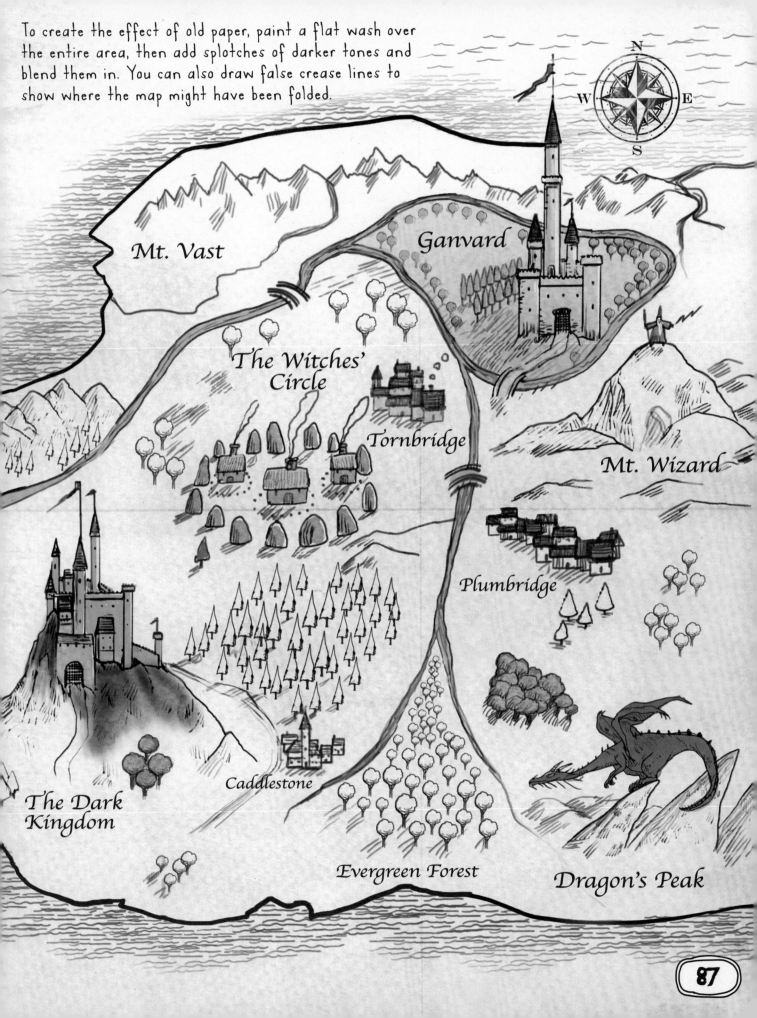

To create the effect of old paper, paint a flat wash over the entire area, then add splotches of darker tones and blend them in. You can also draw false crease lines to show where the map might have been folded.

Mt. Vast

Ganvard

The Witches' Circle

Tornbridge

Mt. Wizard

Plumbridge

The Dark Kingdom

Caddlestone

Evergreen Forest

Dragon's Peak

Sneakers

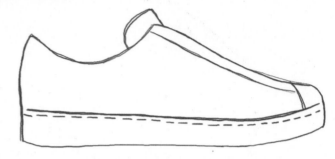

1 USE CURVED LINES TO DRAW THE SIMPLE SHAPE OF A SNEAKER VIEWED SIDE-ON. ADD A LIGHTLY CURVED HORIZONTAL LINE TO CREATE THE SHAPE OF THE SHOE'S SOLE.

2 DRAW THE SHAPE OF THE SHOE'S TONGUE. SKETCH A PARALLEL LINE SLOPING DOWN TOWARD THE FRONT, WITH ANOTHER CURVE SEPARATING THE TOE AREA. ADD A DOTTED HORIZONTAL LINE AT THE BOTTOM.

Patterns

Use contrasting colors to create punchy patterns for your sneakers. Try drawing groups of circles, and paint some of them in light colors against a dark background. Or try a simple overlapping rectangular design.

Angles

Try sketching a shoe at different angles. It's an effective way to understand perspective and will help improve your drawing skills.

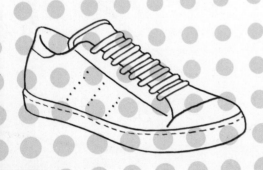
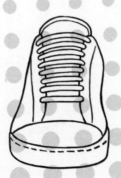
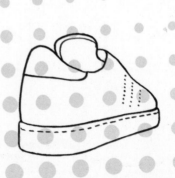
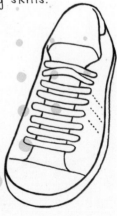

Choose a color for the shoelaces that contrasts with the main color scheme. Yellow works well here against the various shades of blue.

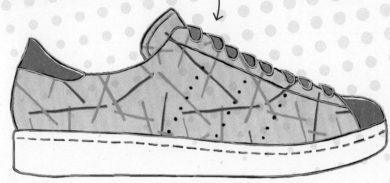

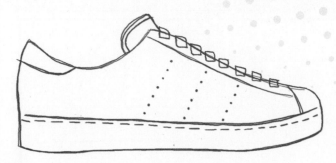

3 ADD SHOELACES BY DRAWING EIGHT SMALL SQUARES ALONG THE TOP OF THE SHOE, STOPPING SHORT OF THE TOE AREA. ADD STITCHING DETAIL BY DRAWING THREE SLANTED, DOTTED LINES.

4 ADD COLORS AND FUN PATTERNS. TO CREATE THIS PATTERN, PAINT THE SHOE WITH A LIGHT BLUE WASH. ADD LOTS OF ANGLED LINES IN CONTRASTING TONES. PICK OUT THE TOE AND HEEL AREAS IN A DARKER COLOR.

Try a simple gingham print by drawing lots of crisscrossing lines to make squares.
Use alternating tones of blue, interspersed with white squares, as shown.
Or try a smaller circular pattern. This one uses rows of little circles on top of a light green wash.

Shapes

Use your imagination to come up with fun designs that build on the basic sneaker shape. As a starting point, think about how you can radically alter one part of the shoe at a time. These designs should inspire you!

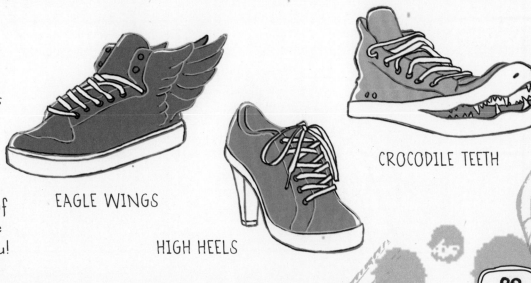

EAGLE WINGS

HIGH HEELS

CROCODILE TEETH

1 CARS ARE SYMMETRICAL, SO DRAW A VERTICAL GUILDELINE, AND SKETCH THE BASIC SHAPE OF A CAR ON ONE HALF. KEEP IT SIMPLE SO THAT YOU CAN COPY IT AS A MIRROR IMAGE ONTO THE OTHER HALF.

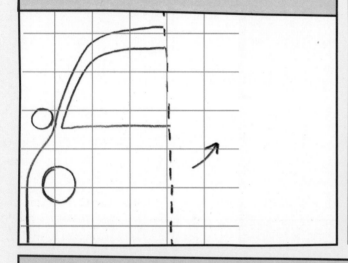

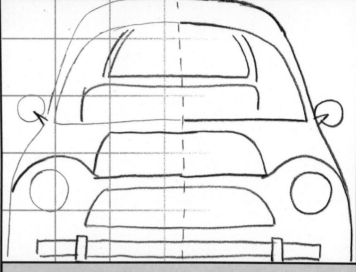

2 ADD SOME DETAILS SUCH AS SEATS AND A HOOD, FOLLOWING THE SHAPE OF THE CAR. ADD CIRCLES FOR HEADLIGHTS AND SIDE MIRRORS.

3 TO ADD A SECRET CAMERA, DRAW A GRID, LIKE THE ONE BELOW, WHERE ALL THE LINES LEAD TOWARD A VANISHING POINT. USE THE GRID TO SKETCH IN THE CAMERA. THE PERSPECTIVE WILL HELP THE CAMERA LOOK AS IF IT'S CLOSE UP FRONT.

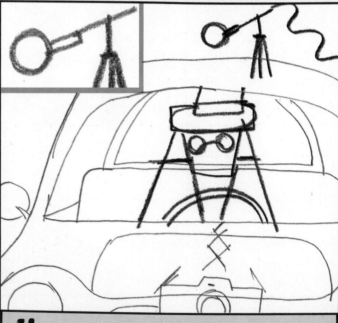

4 ADD A USEFUL MICROPHONE ON A TRIPOD TO THE ROOF OF THE CAR. THEN START DRAWING THE SHAPE OF THE SECRET AGENT AND STEERING WHEEL USING BASIC SHAPES.

5 TO CREATE A CITY SCENE BEHIND THE CAR, DRAW SIMPLE RECTANGLES IN THE BACKGROUND. VARY THE HEIGHT AND WIDTH OF THE BUILDINGS, AND USE GRIDS TO CREATE SLEEK CITY WINDOWS. DRAW VERTICAL LINES TO BUILD UP THE GRILLE ON THE FRONT OF THE CAR.

6 FINALLY, ADD COLOR AND EXTRA DETAIL, SUCH AS CROSSHATCH SHADING, ON THE SEATS. USE WATERCOLOR PENCILS IN COOL COLORS, THEN FINISH THE DRAWING WITH BLACK INK, ESPECIALLY FOR THE BUILDINGS IN THE BACKGROUND. TRY INVENTING MORE GADGETS FOR THE SPY CAR!

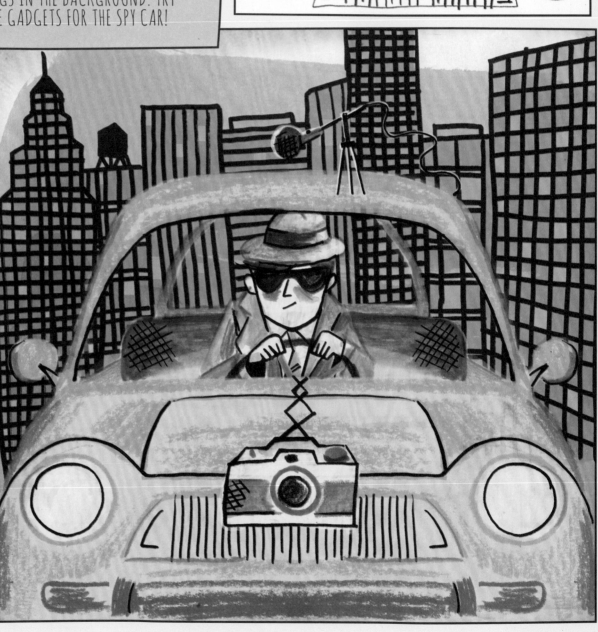

Block in some of the windows with yellow to look as though the lights are turned on.

Make your spy look mysterious with a hat, shades, and turned-up collar.

1 SKETCH SOME STRAIGHT LINES TO PLAN THE ANGLE OF YOUR ROCK STAR'S POSE: USE SLIGHTLY SKEWED HORIZONTAL LINES TO MAKE THE ANGLES OF THE SHOULDERS AND HIPS. ADD A NEAR-VERTICAL LINE RUNNING THROUGH THEM FOR THE POSITION OF THE HEAD AND TORSO.

Keep the initial outline of your figure simple. If it helps, imagine you're drawing around a body at a crime scene!

2 USING A 2H PENCIL, SKETCH THE OUTLINE OF YOUR ROCK STAR, CONCENTRATING ON GETTING HIS BODY SHAPES AND PROPORTIONS RIGHT. USE THE ANGLED GUIDELINES TO HELP YOU DRAW A DYNAMIC POSE—IN THIS CASE, THE FIGURE'S FEET ARE APART AND HE'S LEANING FORWARD A LITTLE.

Think about where your light source is coming from, and add shading lines accordingly.

3 DRAW THE SHAPE OF THE ROCK STAR'S CAP AND HAIR. ADD BASIC FACIAL FEATURES. SKETCH THE SHAPE OF THE CLOTHES, SHOES, AND STRAP, AND FIRM UP THE OUTLINE OF THE GUITAR. DRAW THE ROCK STAR'S FINGERS RESTING ON THE GUITAR'S NECK. ADD A FEW CREASES TO THE CLOTHES.

4 USING A 2B PENCIL OR HEAVIER, WORK UP THE DETAIL. REFINE THE FACIAL FEATURES, THEN ADD FRETS AND EXTRA PEGS TO THE GUITAR. DOUBLE UP THE GUITAR'S OUTLINE IN A FEW PLACES TO MAKE IT LOOK MORE 3-D. ADD SHADING TO THE ROCK STAR'S CLOTHES, AND DRAW LINES WHERE THE MATERIAL IS CREASED.

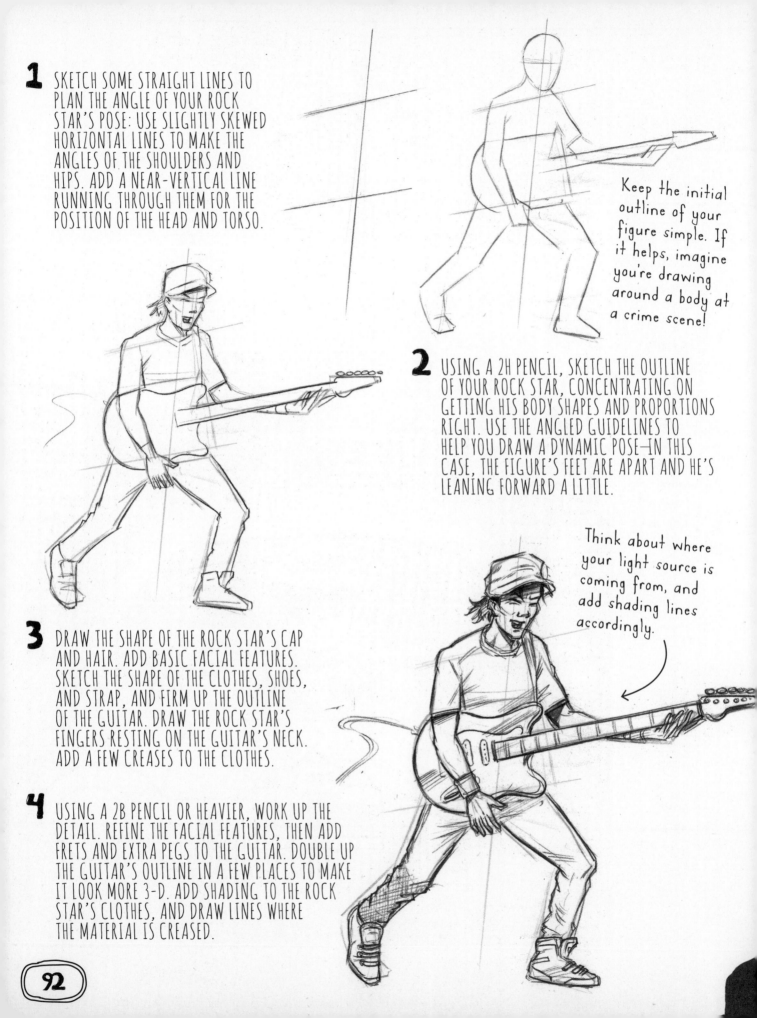

ROCK STAR!

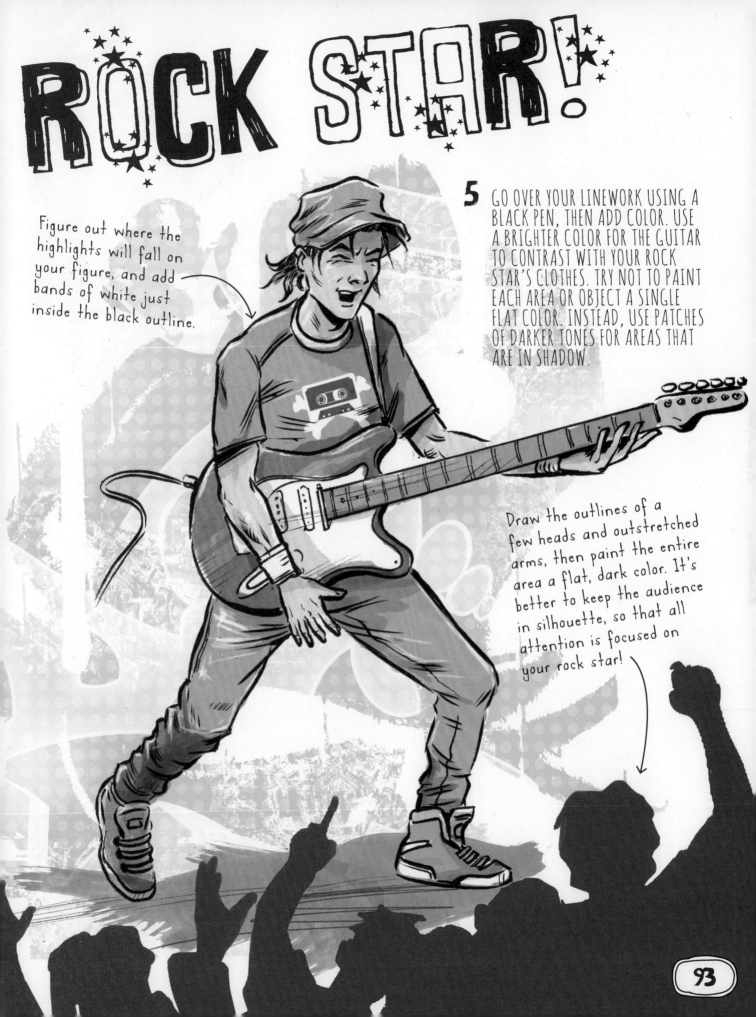

Figure out where the highlights will fall on your figure, and add bands of white just inside the black outline.

5 GO OVER YOUR LINEWORK USING A BLACK PEN, THEN ADD COLOR. USE A BRIGHTER COLOR FOR THE GUITAR TO CONTRAST WITH YOUR ROCK STAR'S CLOTHES. TRY NOT TO PAINT EACH AREA OR OBJECT A SINGLE FLAT COLOR. INSTEAD, USE PATCHES OF DARKER TONES FOR AREAS THAT ARE IN SHADOW.

Draw the outlines of a few heads and outstretched arms, then paint the entire area a flat, dark color. It's better to keep the audience in silhouette, so that all attention is focused on your rock star!

BELTS

DESIGN A COOL FASHION BELT! SKETCH BASIC SHAPES, THEN BUILD UP THE LOOK WITH COLOR. AFTER TRYING THESE IDEAS, USE YOUR IMAGINATION TO COME UP WITH YOUR OWN DESIGNS!

Draw two long parallel lines for the belt with a ruler, then add a series of lines across the width for the keys. The buckle is made of two oval shapes.

Draw five long parallel lines with about 1/2 inch between each of them. Then draw a series of lines up and down it, also 1/2 inch apart, for the check pattern. Here, the buckle is made of two rectangles.

Draw two parallel lines. Inside these lines, draw a zigzig pattern made up of triangle shapes, like this.

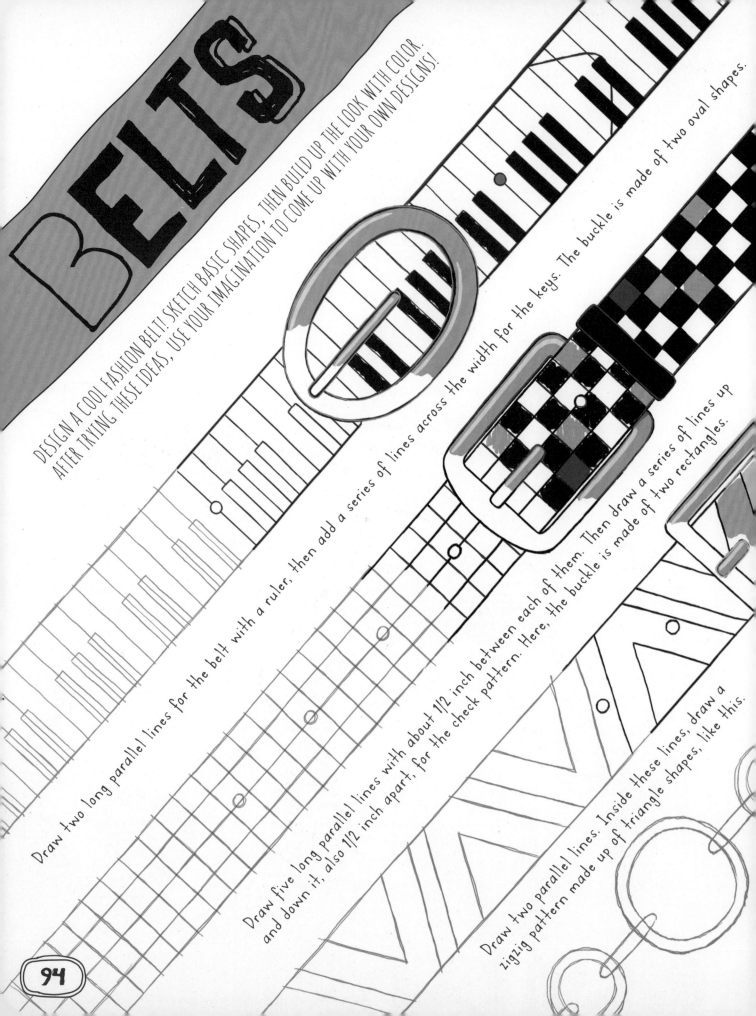

The buckle is made of two squares.

Link each loop with an oblong shape.

Draw double circles, varying between small and large along the belt.

Draw two parallel lines to the belt.

Sketch the butterfly body first, then draw the wings on each side. Draw two parallel lines
coming off each side of the butterfly, then add a pretty pattern to the belt.

Draw two light parallel lines to
use as guidelines for your belt.
Sketch parallel waves inside these
guidelines. Erase any overlapping
lines before adding color.

SUPERHERO

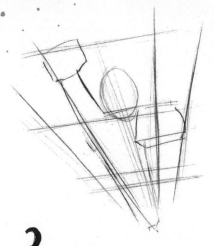

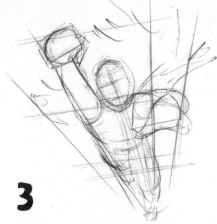

1

USING A HARDER PENCIL SUCH AS A 2H, LIGHTLY SKETCH SOME PERSPECTIVE LINES TO CREATE THE IMPRESSION OF THE SUPERHERO COMING TOWARD US. ADD AN OVAL FOR HIS HEAD.

2

LOOSELY BLOCK OUT THE SHAPE AND PROPORTIONS OF THE FIGURE, USING YOUR GUIDES CAREFULLY. THE HANDS ARE THE CLOSEST THINGS TO US, SO THEY NEED TO LOOK QUITE BIG.

3

ROUGHLY SKETCH THE SHAPE OF THE BODY AND CAPE. THE FEET ARE A LONG WAY FROM US SO WILL BE A LOT SMALLER THAN YOU MIGHT THINK. IT'S IMPORTANT TO GET THE PERSPECTIVE RIGHT AT THIS STAGE, SINCE IT'S TRICKY TO ALTER LATER.

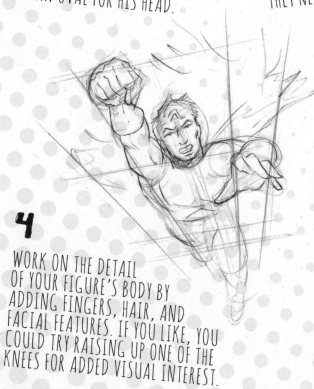

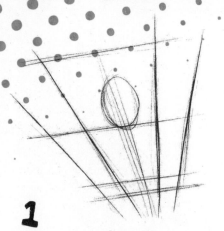

4

WORK ON THE DETAIL OF YOUR FIGURE'S BODY BY ADDING FINGERS, HAIR, AND FACIAL FEATURES. IF YOU LIKE, YOU COULD TRY RAISING UP ONE OF THE KNEES FOR ADDED VISUAL INTEREST.

5

WORK ON THE TOP HALF OF THE FIGURE, ADDING DETAIL TO THE COSTUME. GIVE MORE DEFINITION TO THE MUSCLES AND LEGS. CHOOSE WHERE THE LIGHT SOURCE IS COMING FROM (TOP RIGHT IN THIS SKETCH), AND ROUGHLY SHADE SOME OF THE SHADOWY AREAS, SUCH AS JUST BELOW THE NECK AND HANDS.

If you find it difficult getting the hands exactly right, try placing a camera in a high spot and set the self-timer. Then strike a typical superhero pose, and use your pic as reference!

6

USING A DARKER PENCIL SUCH AS A 4B, WORK ON THE FINER DETAIL AND THE SHADOWED AREAS. ADD SOME MOVEMENT LINES TO GIVE A SENSE OF SPEED.

Don't be afraid to shade large black areas where necessary. They will add visual impact to your superhero and help to bring out his impressive muscle tone!

7

COLOR YOUR FIGURE IN BOLD COLORS, USING INKS OR WATERCOLORS. USE LIGHTER TONES FOR THE AREAS WHERE THE LIGHT IS HITTING THE FIGURE AND DARKER HUES FOR THE PARTS THAT ARE IN SHADOW.

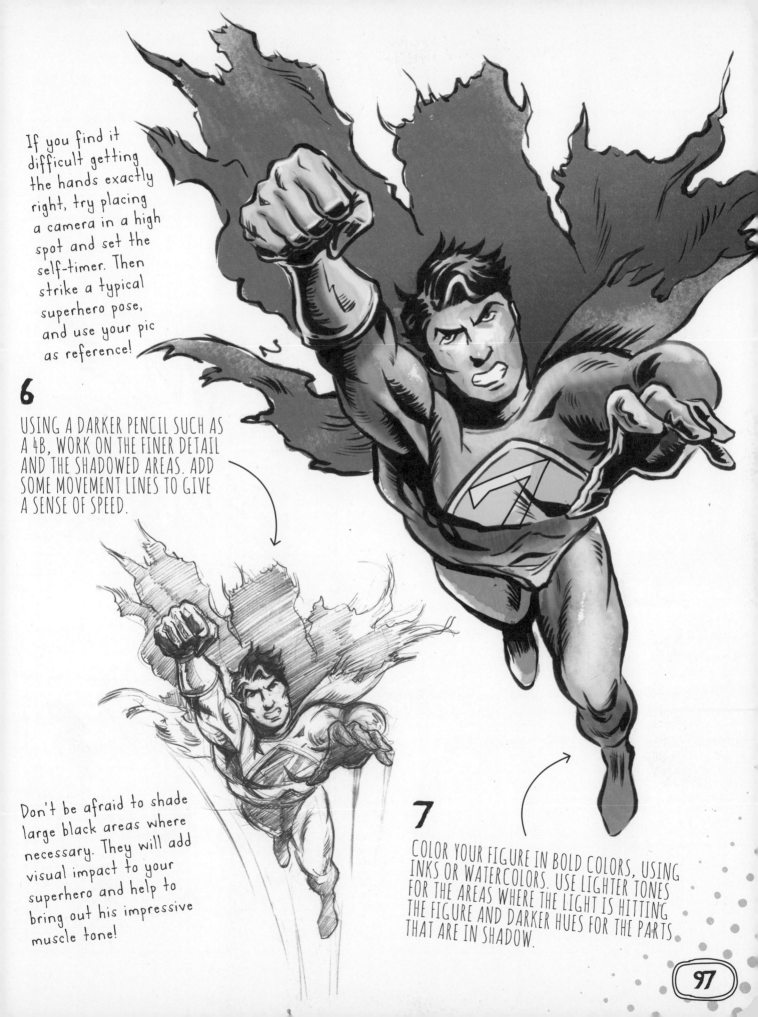

CARTOON EXPLOSIONS

LIVEN UP YOUR DRAWINGS BY ADDING SOME NOISE! LEARN HOW TO DRAW COOL CARTOON EXPLOSIONS THAT LOOK THE WAY THEY SOUND.

BANG

1 USING A PENCIL, DRAW A STARBURST SHAPE, LIKE THIS. MAKE THE POINTS REALLY SPIKY AS YOU DRAW IN AND OUT.

2 DRAW THE LETTERS OF YOUR SOUND WORD, ZIGZAG FLASHES, AND MOVEMENT LINES. GO OVER THE LINES IN HEAVY BLACK INK.

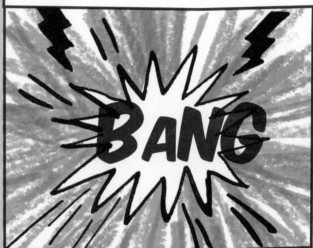

KA-BOOM

1 THIS CLOUD BURST SUGGESTS A SMOKY EXPLOSION. SKETCH THE SHAPE IN PENCIL FIRST TO BE SURE YOU ARE HAPPY WITH IT.

2 ADD LETTERING, THEN COLOR THE BACKGROUND. OUTLINE THE CLOUD SHAPE WITH INK, VARYING THE LINE THICKNESS.

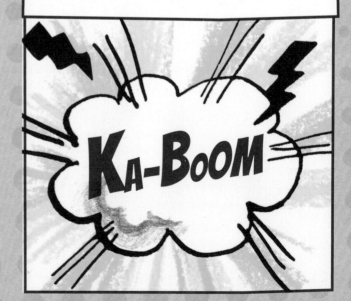

POW

1 THIS SHAPE IS GOOD TO SHOW IMPACT. DRAW A SERIES OF INWARD-SWEEPING CURVES WITH SPIKY POINTS.

2 ADD A WORD, SOME CLOUD BURSTS, MOVEMENT LINES, AND STARS. COLOR WITH LINES COMING FROM THE CENTER AND THEN INK OVER THE PENCIL LINES.

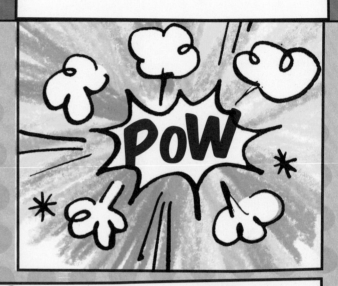

Use cloud shapes together with motion lines to make up smoke rings that show something moving fast.

BLAST

1 DRAW THIS CLOUD SHAPE WITHOUT TAKING YOUR PENCIL OFF THE PAPER. THE SPIRAL OUTLINE SUGGESTS CHAOS!

2 ADD THE WORD AND MOVEMENT LINES BEFORE COLORING THE BACKGROUND AND INKING OVER THE PENCIL LINES.

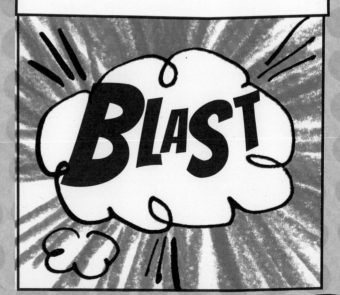

SPACE ROCKET

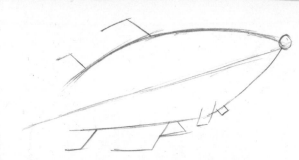

1 START WITH THE BASIC SHAPES OF THE ROCKET BODY AND THE LARGE OUTER FINS. THINK OF THE ROCKET AS A FOOTBALL SHAPE. DRAW A GUIDELINE ALONG THE CENTER TO HELP YOU.

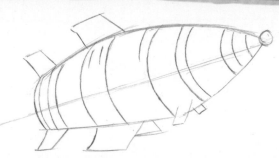

2 NOW DRAW A NUMBER OF LINES THAT FOLLOW THE CURVE OF THE ROCKET'S BODY, AND DIVIDE IT INTO SECTIONS. THESE WILL BE THE PANELS AND HELP WITH POSITIONING OTHER ELEMENTS.

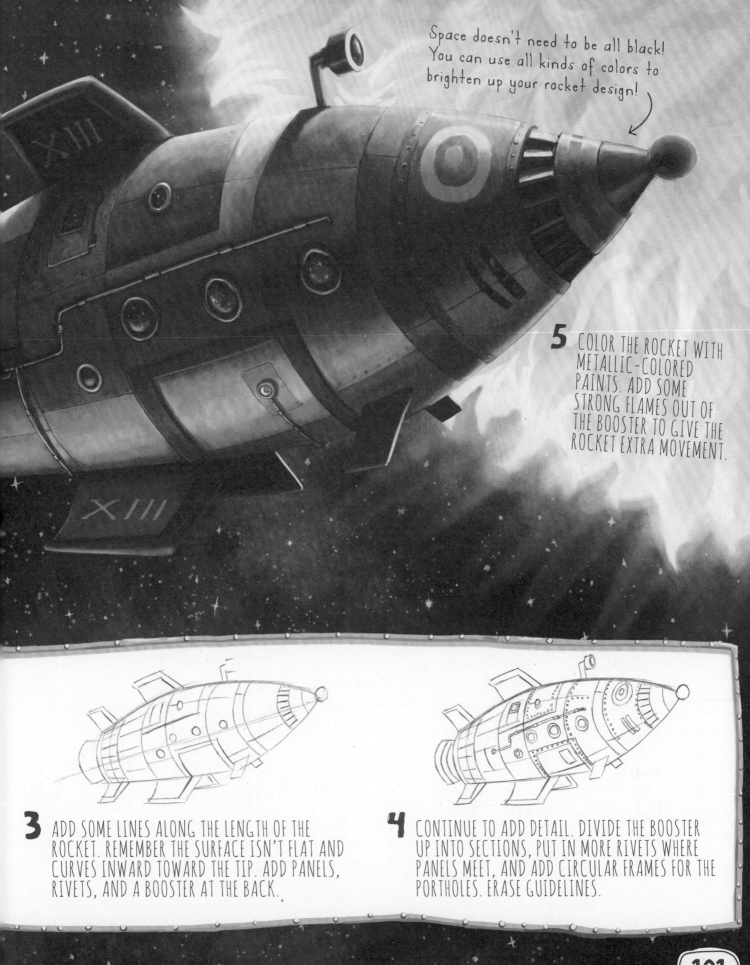

Space doesn't need to be all black! You can use all kinds of colors to brighten up your rocket design!

5 COLOR THE ROCKET WITH METALLIC-COLORED PAINTS. ADD SOME STRONG FLAMES OUT OF THE BOOSTER TO GIVE THE ROCKET EXTRA MOVEMENT.

3 ADD SOME LINES ALONG THE LENGTH OF THE ROCKET. REMEMBER THE SURFACE ISN'T FLAT AND CURVES INWARD TOWARD THE TIP. ADD PANELS, RIVETS, AND A BOOSTER AT THE BACK.

4 CONTINUE TO ADD DETAIL. DIVIDE THE BOOSTER UP INTO SECTIONS, PUT IN MORE RIVETS WHERE PANELS MEET, AND ADD CIRCULAR FRAMES FOR THE PORTHOLES. ERASE GUIDELINES.

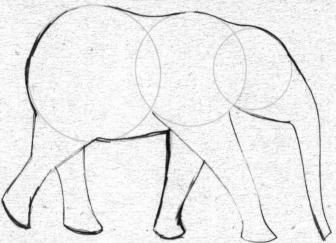

1 DRAW THREE OVERLAPPING CIRCLES. USE A SMALL ONE TO FORM THE SHAPE OF THE HEAD, A MEDIUM ONE FOR THE FRONT OF THE BODY, AND A LARGE ONE FOR THE BACK PART OF THE ELEPHANT.

2 JOIN THE EDGES OF THE CIRCLES TO SKETCH THE OUTLINE OF THE ELEPHANT. DRAW IN LEGS, MAKING THE SHAPES NARROWER TOWARD THE BOTTOM AND ADDING FEET. SKETCH LONG CURVES FOR A TRUNK.

ELEPHANT

5 DRAW A RECTANGULAR BLANKET WITH CURVED EDGING. SKETCH MORE CURVES FOR THE HAT AND TRUNK DECORATION. USE SWIRLS AND LEAF SHAPES TO MAKE THE HEADDRESS. ADD DETAIL TO THE TUSK, TAIL, AND FEET, TOO.

6 DRAW THE BASIC SHAPE OF THE CANOPY. SKETCH DIFFERENT-SIZED FLOWER SHAPES ON THE BLANKET, DOUBLING UP YOUR LINE WORK FOR SOME OF THEM. ADD MORE DECORATION TO THE ELEPHANT'S HEAD.

Try not to add too much detail to an area all at the same time. Instead, gradually build up the detail across the whole drawing.

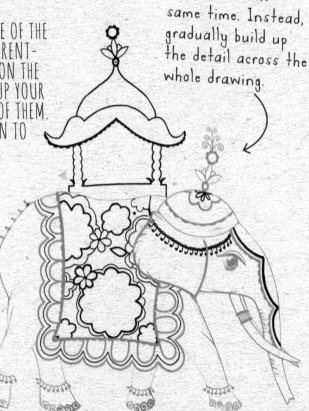

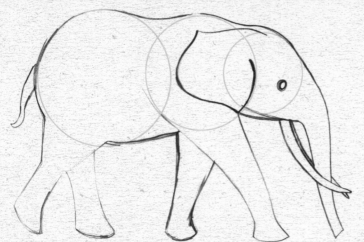

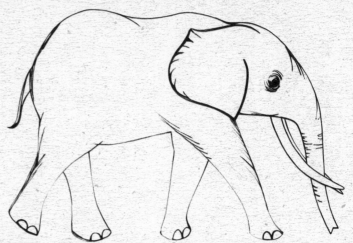

3 DRAW THE SHAPE OF THE EAR, AND ADD A CIRCLE FOR THE EYE. USE SIMPLE CURVES FOR TWO TUSKS AND WAVY LINES FOR THE ELEPHANT'S TAIL.

4 ADD DETAIL TO YOUR ELEPHANT TO GIVE IT CHARACTER. SHOW FOLDS IN ITS SKIN BY DRAWING FINE LINES ON THE LEGS, TRUNK, AND EAR. ADD MORE DETAIL TO ITS EYE, AND GIVE IT SOME TOENAILS!

7 GO OVER YOUR LINE WORK IN PEN AND INK, THEN ADD THE FINE DETAILS. DRAW FLORAL PATTERNS ON THE CANOPY, AND BUILD UP THE BLANKET DETAILS. DRAW SIMPLE LEAF PATTERNS ON THE HAT AND LEGS.

8 USE A WARM GRAY TO PAINT THE ELEPHANT'S BODY, SUCH AS GRAY WITH A LITTLE RED MIXED IN. CHOOSE BRIGHT COLORS FOR THE DECORATIVE ELEMENTS TO MAKE THEM REALLY STAND OUT FROM THE ELEPHANT'S SKIN.

Adding more water to your paints will help give a washlike effect.

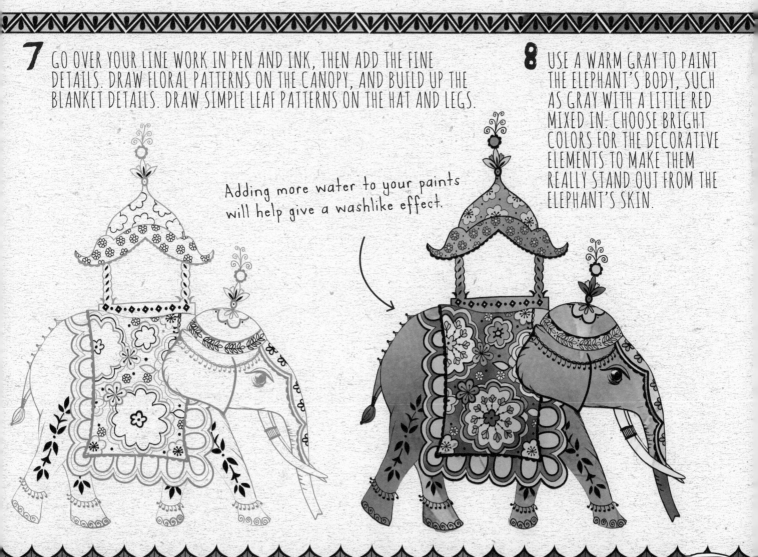

STREET ART

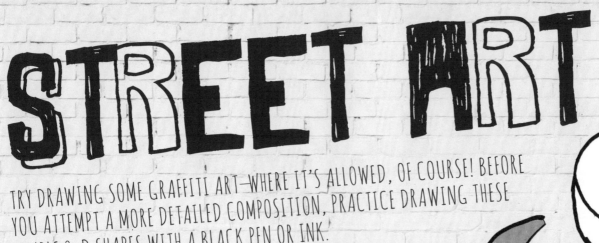

TRY DRAWING SOME GRAFFITI ART—WHERE IT'S ALLOWED, OF COURSE! BEFORE YOU ATTEMPT A MORE DETAILED COMPOSITION, PRACTICE DRAWING THESE SIMPLE 3-D SHAPES WITH A BLACK PEN OR INK.

Draw a star shape, and add some lines coming away from three of the points, as shown. Create a 3-D effect by making the star a lighter color than its tail.

Draw a simple arrow, and make it look 3-D by adding lines underneath that follow the same basic shape.

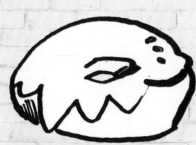

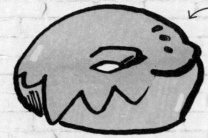

A doughnut is basically an oval shape. Draw a hole in the middle, and add some messy frosting and perhaps a few sprinkles.

The popsicle is simply a rectangular shape curved at the top. Draw a line below to achieve the 3-D effect, and add a stick and a little shading.

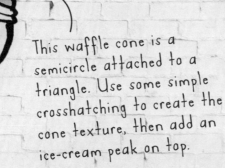

This waffle cone is a semicircle attached to a triangle. Use some simple crosshatching to create the cone texture, then add an ice-cream peak on top.

COMBINE LOTS OF STARS AND ARROWS INTO ONE COMPOSITION. DRAW THEM IN DIFFERENT SIZES AND USE A VARIETY OF COLORS. MAKE THEM FACE DIFFERENT DIRECTIONS TO ADD VISUAL INTEREST AND A SENSE OF MOVEMENT.

Vary the thickness of the outlines, and try adding some circular shapes to break up all the straight lines.

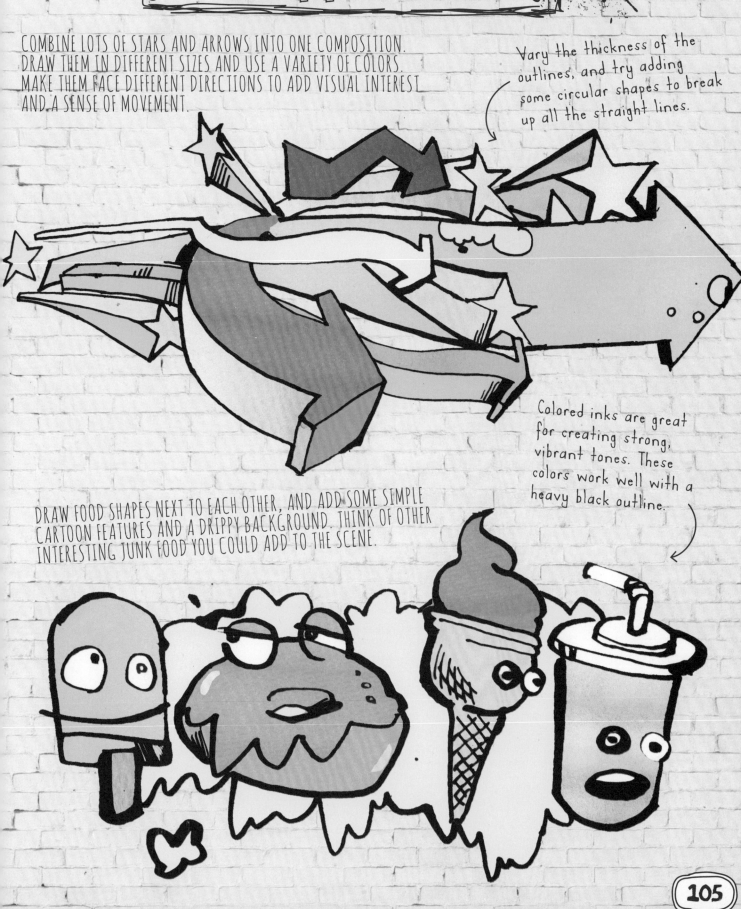

Colored inks are great for creating strong, vibrant tones. These colors work well with a heavy black outline.

DRAW FOOD SHAPES NEXT TO EACH OTHER, AND ADD SOME SIMPLE CARTOON FEATURES AND A DRIPPY BACKGROUND. THINK OF OTHER INTERESTING JUNK FOOD YOU COULD ADD TO THE SCENE.

SKATEBOARDER

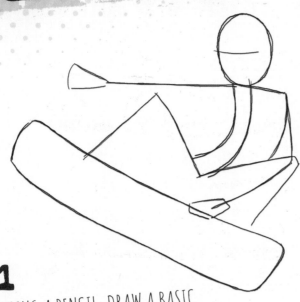

1

USING A PENCIL, DRAW A BASIC RECTANGULAR SHAPE FOR THE SKATEBOARD. SKETCH A ROUGH CIRCLE FOR THE BOY'S HEAD AND GUIDELINES FOR HIS BODY, ARMS, HANDS, AND LEGS.

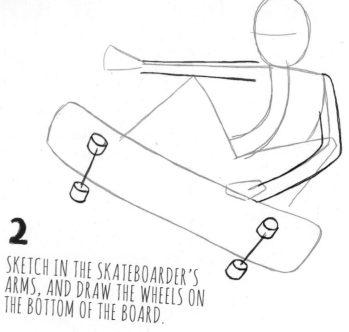

2

SKETCH IN THE SKATEBOARDER'S ARMS, AND DRAW THE WHEELS ON THE BOTTOM OF THE BOARD.

The helmet should sit slightly above the top of the skateboarder's head.

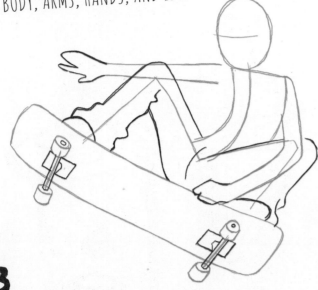

3

ADD MORE DETAIL TO THE BOARD'S WHEELS, AND GIVE YOUR FIGURE SOME ROUGH HANDS AND JEANS. DRAW TWO CURVED LINES FOR HIS SHOES.

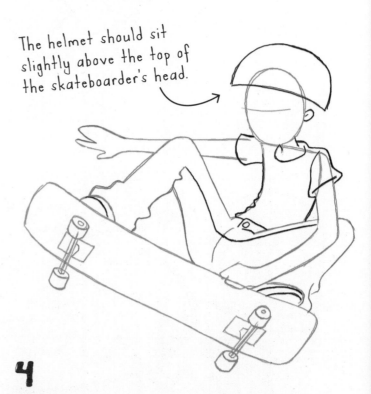

4

DRAW A HALF CIRCLE ABOVE THE HEAD FOR THE SKATEBOARDER'S HELMET. SKETCH IN GUIDELINES FOR HIS T-SHIRT, BELT, AND SHOES.

Make sure the boy is holding onto the board tightly!

Change the pose of the character by drawing both arms in the air!

5

FINISH THE SKETCH BY ADDING GLOVES AND FINGERS TO THE HANDS. SKETCH IN THE BOY'S EYES, NOSE, AND MOUTH. GIVE HIM HAIR, TOO. FINALIZE THE DETAILS ON THE HELMET AND BOARD.

Use shading and lines within your color for depth and movement.

6

ADD FINAL DETAILS TO YOUR DRAWING THEN ERASE ANY STRAY LINES FROM THE ORIGINAL SKETCH. ADD COLOR! USE DIFFERENT SHADES OF THE SAME COLOR ON THE CLOTHES TO GIVE THE PICTURE SOME DEPTH.

Give your board an exciting design underneath, like these bright flames. See pages 68 and 69 for some more ideas.

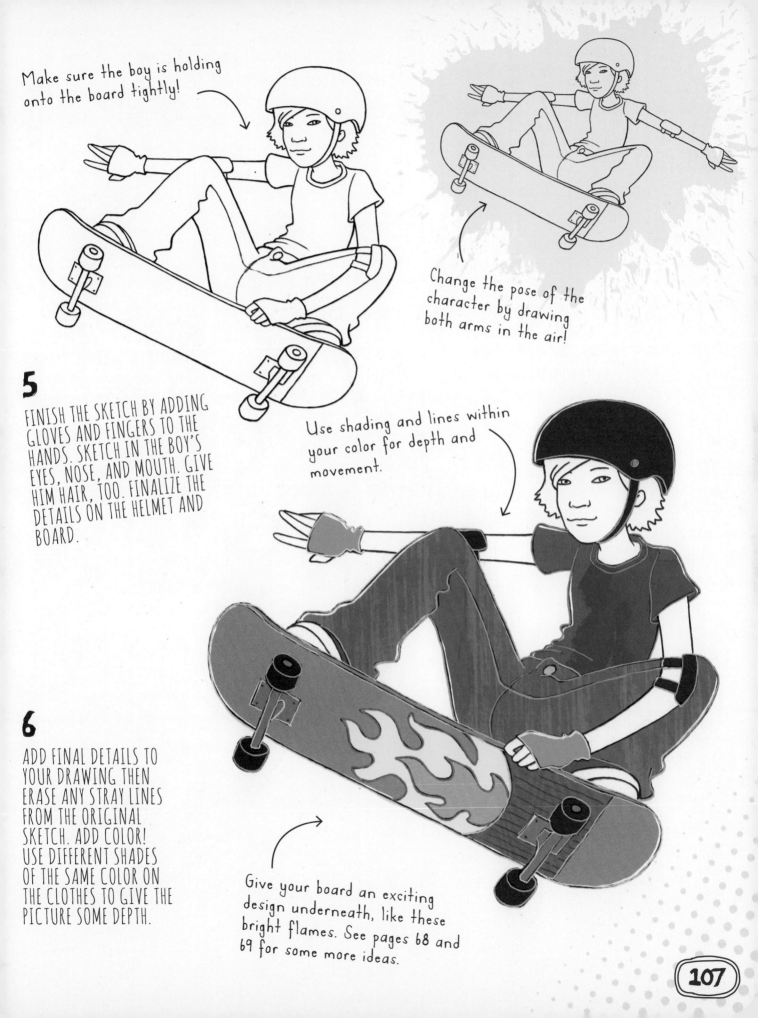

PIZZA

FEELING HUNGRY? DISCOVER HOW EASY IT IS TO
DRAW YOUR OWN PIZZA WITH SIMPLE SHAPES!

Draw a large circle. It helps if you
use a compass to give you a center
point. Draw four lines through the
center of the pizza, like this, to
divide it into eight slices.

TOPPINGS

ADDING SLIGHTLY BROADER INK LINES GIVES
YOUR PIZZA ILLUSTRATION MORE DEPTH.

TOMATO

SALAMI

OLIVES

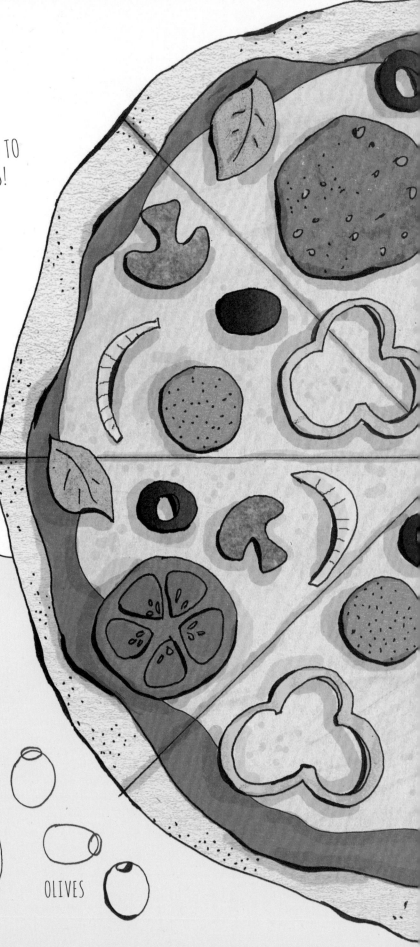

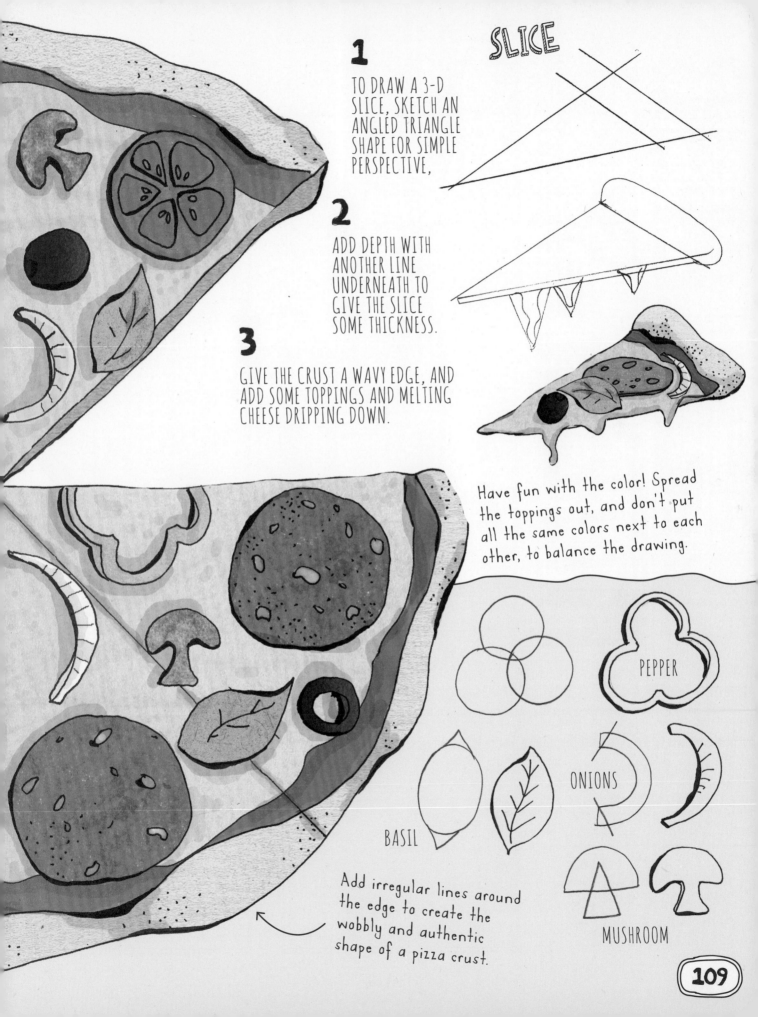

SLICE

1

TO DRAW A 3-D SLICE, SKETCH AN ANGLED TRIANGLE SHAPE FOR SIMPLE PERSPECTIVE,

2

ADD DEPTH WITH ANOTHER LINE UNDERNEATH TO GIVE THE SLICE SOME THICKNESS.

3

GIVE THE CRUST A WAVY EDGE, AND ADD SOME TOPPINGS AND MELTING CHEESE DRIPPING DOWN.

Have fun with the color! Spread the toppings out, and don't put all the same colors next to each other, to balance the drawing.

Add irregular lines around the edge to create the wobbly and authentic shape of a pizza crust.

PEPPER

ONIONS

BASIL

MUSHROOM

GEOMETRIC PATTERNS

CREATE PATTERNS USING BASIC GEOMETRIC SHAPES. START WITH SIMPLE REPEATING SHAPES, AND BUILD UP TO SOMETHING MORE COMPLEX. TRY OVERLAPPING SHAPES OR USING MIRROR IMAGES.

Circles

Hearts

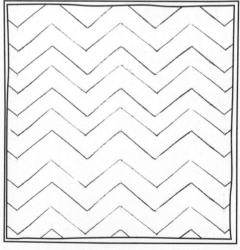

Zigzag

ADD REPEATED CIRCLES AROUND LOTS OF DIFFERENT-SIZED CIRCLES. COLOR EACH RING, OVERLAPPING FOR EFFECT.

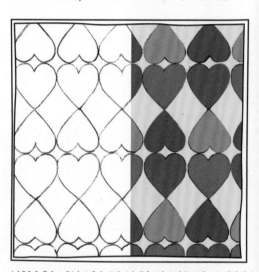

MIRROR-IMAGE HEARTS MAKE UP A COOL PATTERN. COLOR THE GAPS IN BETWEEN TO EMPHASIZE THE DIAMOND SHAPE.

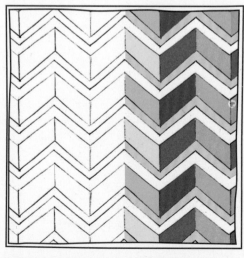

DIVIDE ZIGZAGS BY COLORING ONE SIDE LIGHT AND ONE DARK.

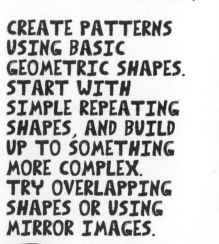

FIGURE OUT SOME FANCY PATTERNS ON PAPER, THEN APPLY THE BEST ONES TO YOUR FAVORITE SNEAKERS, CLOTHES, OR PENCIL CASE USING FABRIC PENS.

Ovals

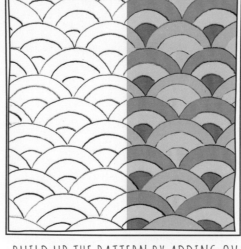

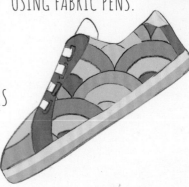

BUILD UP THE PATTERN BY ADDING OVALS INSIDE OVALS. START AT THE BOTTOM AND WORK YOUR WAY TO THE TOP.

Diamonds

BUILD UP A DIAMOND PATTERN WITH CRISSCROSS DOTTED LINES INSIDE SOLID ONES TO ADD TEXTURE.

Wavy

TRY VARIATIONS OF WAVY LINES WHERE GAPS ARE WIDER OR THINNER.

T. REX

2

ADD BASIC SHAPES FOR THE NECK, EYE, ARMS, LEGS, AND THE TIP OF THE TAIL. USE THE SHAPES FROM STEP ONE TO HELP YOU PLOT WHERE EACH PART NEEDS TO BE DRAWN.

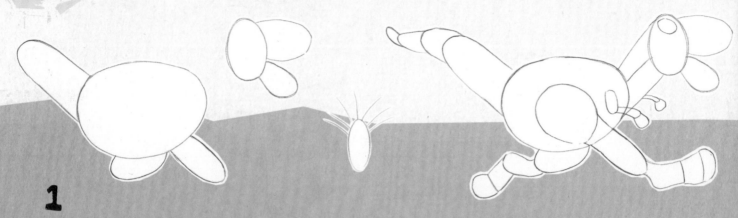

1

DRAW THE BASIC SHAPE OF THE T. REX WITH A PENCIL. THE DINOSAUR IS MADE UP OF CIRCULAR AND OBLONG SHAPES, AS SHOWN.

Gently rub a pencil over the areas you want to shade to create different skin tones and shadow.

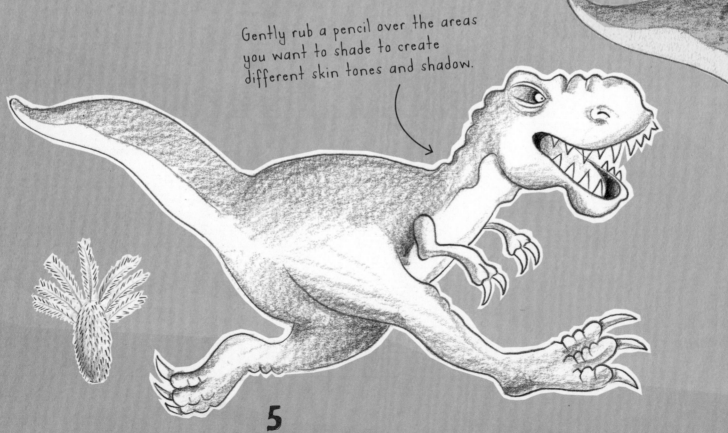

5

ADD SHADING TO YOUR DINO. LEAVE CERTAIN AREAS WHITE TO HELP TO SHOW THE DIFFERENT SKIN TONES.

3

SKETCH IN THE OUTLINE OF THE DINO'S BODY.
IT HAS SMALL RIDGES ON THE NOSE, NECK,
LEGS, AND TOES. SKETCH THE OUTLINE WITH
A FAINT LINE TO BEGIN WITH, THEN GO OVER
WITH A HEAVIER, MORE CONFIDENT LINE.

4

DRAW IN THE OTHER FEATURES OF THE
DANGEROUS BEAST. GIVE IT A BIG EYE
AND SOME NOSTRILS. TO MAKE IT LOOK
EXTRA SCARY, MAKE SURE IT HAS REALLY
RAZOR-SHARP TEETH AND CLAWS!

6

FINISH WITH SOME COLOR. ADD LOADS OF DIFFERENT
MARKS USING TRIANGLE SHAPES AND DOTS TO CREATE
A PATTERN FOR THE SKIN. LEAVE THE TEETH WHITE, AND
GIVE YOUR T. REX A BIG RED TONGUE.

Don't forget a
beady yellow eye
and shadows on
those sharp claws!

Drawing in small movement
lines will make the dinosaur
look as if it is running fast!

MOTORCYCLE STUNT RIDER

2

BEGIN JOINING THE DIFFERENT SHAPES TOGETHER. ADD MUDGUARDS, A SEAT, CHAIN, AND FRAME TO BUILD UP THE MOTORCYCLE. ADD HANDS AND FEET TO THE RIDER.

1

SKETCH SIMPLE SHAPES AS GUIDES. USE CIRCLES FOR THE HEAD, WHEELS, AND MOTOR, AND RECTANGLES FOR THE BODY, LEGS, ARMS, AND MOTORCYCLE.

3

START ADDING SOME DETAIL. DRAW THE HELMET, AND ADD RIMS TO THE OUTSIDES OF THE WHEELS AND AXLES IN THE CENTERS OF THE WHEELS.

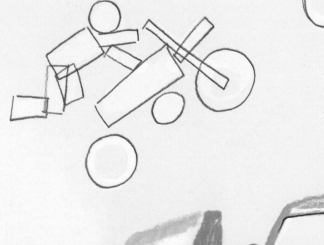

Look for pictures of motorcycles in magazines for inspiration and to understand the shape. Each make of stunt motorcycle will have different details.

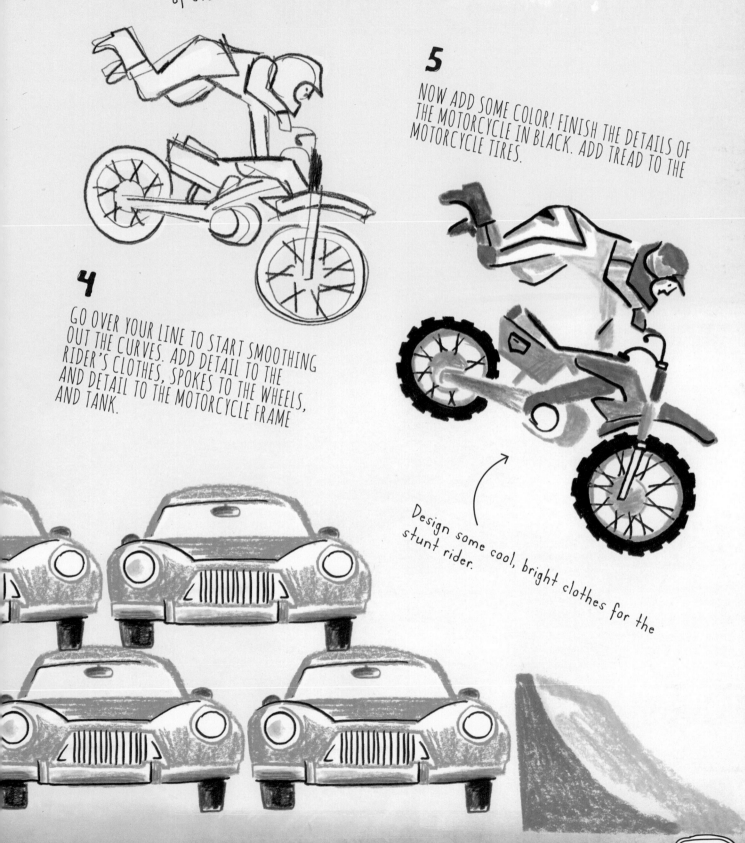

5

NOW ADD SOME COLOR! FINISH THE DETAILS OF THE MOTORCYCLE IN BLACK. ADD TREAD TO THE MOTORCYCLE TIRES.

4

GO OVER YOUR LINE TO START SMOOTHING OUT THE CURVES. ADD DETAIL TO THE RIDER'S CLOTHES, SPOKES TO THE WHEELS, AND DETAIL TO THE MOTORCYCLE FRAME AND TANK.

Design some cool, bright clothes for the stunt rider.

WILD HATS

1

START WITH A FLATTENED OVAL TO FORM THE BRIM OF THE HAT. IF YOU ARE ADDING IT TO A CHARACTER, THINK OF THE ANGLE YOU WANT THE BRIM ON THE HEAD.

2

ADD AN ALMOST HALF CIRCLE FOR THE DOME OF THE HAT. ADD A LINE FOLLOWING THE CURVE OF THE BRIM TO MAKE A HATBAND. THIS WILL BE THE RIBBON WHERE THE HAT DECORATIONS WILL BE FIXED.

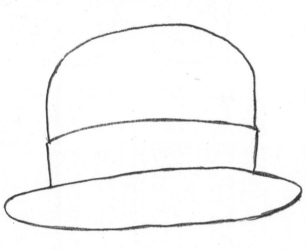

Remember to check the proportions of the dome against the head, so that it looks as though it fits comfortably.

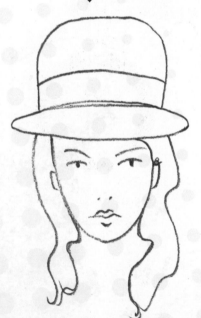

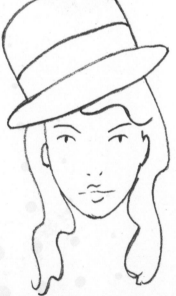

3

TO CREATE A FEATHER, DRAW A CURVED OVAL WITH POINTED ENDS. ADD THE CENTER LINE, THEN SMALL LINES TO BUILD UP THE TEXTURE.

A rounded dome like this makes a hat called a bowler hat.

4

ADD COLOR USING A VARIETY OF MATERIALS TO BUILD UP TEXTURE AND INTEREST. FOR EXAMPLE, FIRST APPLY A WATERCOLOR WASH, THEN ADD SOME LOOSER PENCIL LINES, WITH SOFT PASTEL OR CHARCOAL OVER THE TOP.

5

FINALLY, APPLY AN INK OUTLINE WITH A BRUSH. EXPERIMENT WITH THICK AND THIN LINES FOR SOME OF THE FEATHERY TRIMMINGS. ADD A SOFT SHADOW BELOW THE BRIM WITH PENCILS OR PAINT.

Add the feather to the hatband like this.

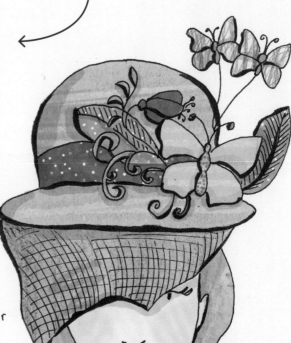

Draw a shaped grid like this to create a net veil that adds mystery to your character.

EXPERIMENT WITH THE SHAPES OF THE DOME AND THE SIZE OF THE BRIM. TRY OUT FEATHERS, FLOWERS, INSECTS, EVEN FOOD—GO WILD!

FANCY TOP HAT

PIANO BOWLER HAT

CUPCAKE HAT

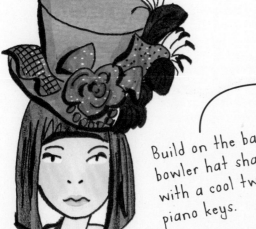

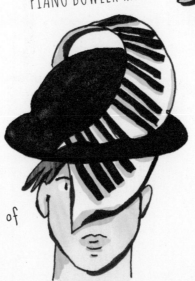

Build on the basic bowler hat shape with a cool twist of piano keys.

117

HAUNTED HOUSE

1 BREAK DOWN THE DRAWING INTO SMALLER PIECES. FIRST, DRAW A SET OF UNEVEN RECTANGLES FOR THE TWO FLOORS OF THE HOUSE, AND TWO ROOFS.

2 SKETCH THE PARTS OF THE HOUSE THAT JUT OUT, AND THE FRONT DOOR. USE A MIXTURE OF TRIANGULAR AND ROUNDED, UNEVEN SHAPES.

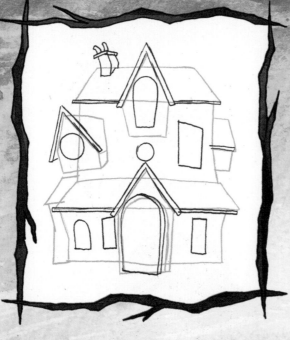

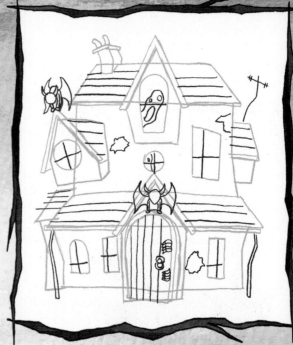

3 ADD THE WINDOWS. USE DIFFERENT-SHAPED ONES TO MAKE THE HOUSE LOOK RICKETY AND CREEPY. USE CIRCLES AND RECTANGULAR SHAPES. ADD DETAIL TO THE CHIMNEY, DOOR, AND ROOF.

4 SKETCH IN LINES FOR THE TILES ON THE ROOFS, GARGOYLES TO MAKE THE HOUSE LOOK EXTRA SCARY, SOME GHOSTS, AND A SET OF CREEPY HANDS.

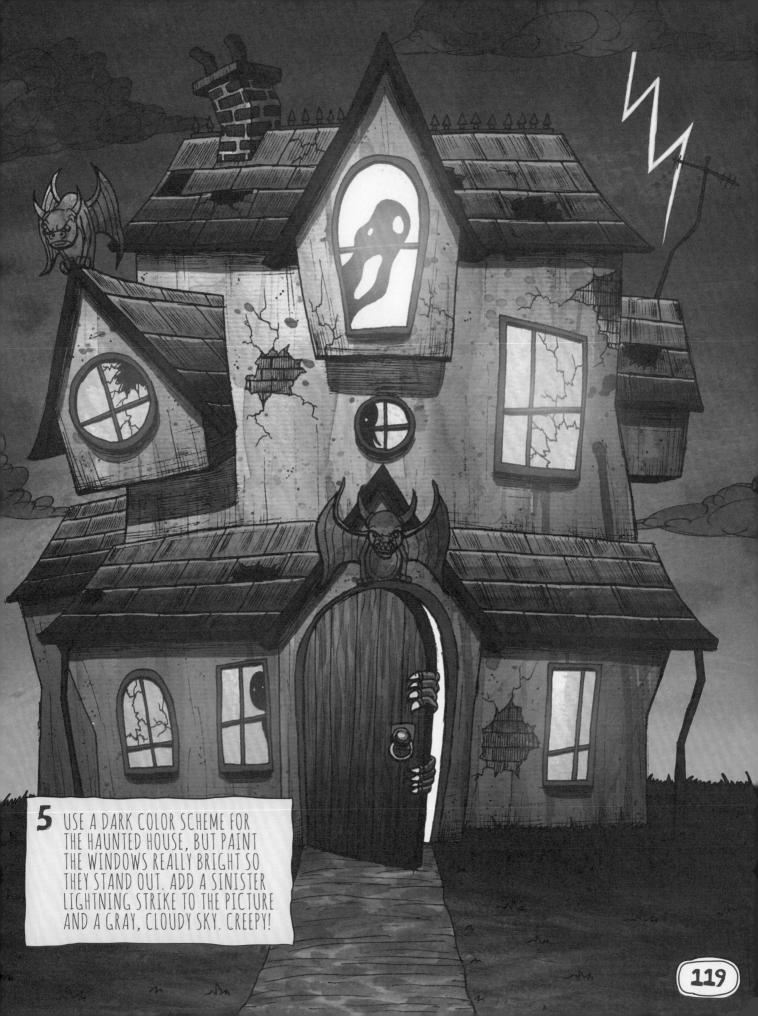

5 USE A DARK COLOR SCHEME FOR THE HAUNTED HOUSE, BUT PAINT THE WINDOWS REALLY BRIGHT SO THEY STAND OUT. ADD A SINISTER LIGHTNING STRIKE TO THE PICTURE AND A GRAY, CLOUDY SKY. CREEPY!

119

MANGA GIRL

1
FIND A PHOTO OF A CUTE, COOL GIRL FOR INSPIRATION. USE A HARD PENCIL TO DRAW SOME GUIDELINES TO GET THE FEEL OF THE POSE.

2
SKETCH THE SHAPE OF THE FIGURE. MAKE HER HEAD BIG AND EMPHASIZE THE HAIR. THE LEGS AND FEET CAN BE QUITE DELICATE TO MAKE HER MORE DOLL-LIKE.

3
START DRAWING THE HANDS AND FACE. THE EYES SHOULD BE BIG AND STAND OUT. SKETCH THE OUTLINE FOR THE CLOTHES. ADD JEWELRY FOR EXTRA INTEREST.

 EYES Manga eyes are lots of fun to draw, so go crazy! Work in light spots to make the pupils shine. Try adding big eyelashes, too!

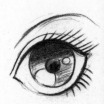

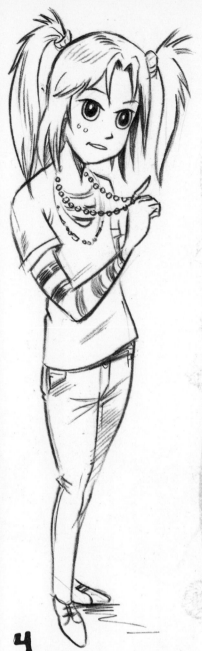

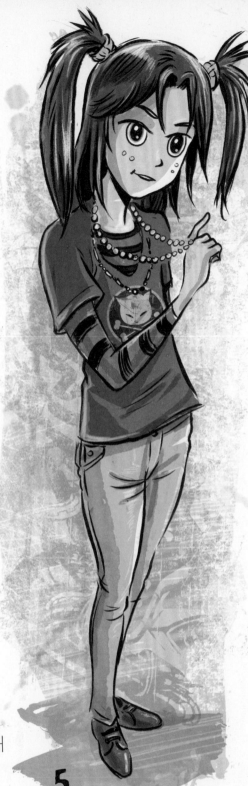

HAIRSTYLES

Manga hairstyles are wild, so don't hold back! Try the hairstyles below, or experiment with some creations of your own.

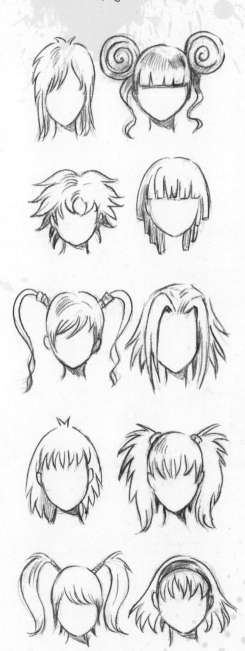

4

USE A SOFT PENCIL TO WORK UP THE DETAIL AND SHADOWS. YOU DON'T NEED MUCH DETAIL FOR THE NOSE AND MOUTH WITH MANGA DRAWINGS. ADD SOME FRECKLES AND HAIR TEXTURE.

5

ACID GREENS AND ELECTRIC PINKS ARE GREAT VIBRANT COLORS TO BRING YOUR MANGA CHARACTER TO LIFE. USE A DARKER TONE TO CREATE THE SHADOWS THAT WILL GIVE THE FIGURE DIMENSION.

URBAN BRIDGE

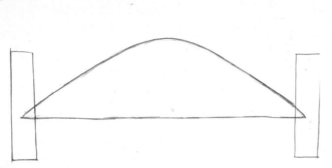

1 DRAW A WIDE TRIANGLE SHAPE WITH THE TOP POINT ROUNDED OFF. ADD AN OVERLAPPING RECTANGLE SHAPE AT BOTH ENDS.

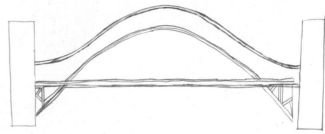

2 DRAW MORE CURVES ABOVE AND BELOW YOUR GUIDE ARCH. LEVEL OFF THE TOP CURVE ENDS. ADD MORE HORIZONTAL LINES ALONG THE BOTTOM OF THE TRIANGLE FOR THE ROAD, AND ADD SETS OF DIAGONAL LINES FOR THE FRAMEWORK BELOW. ERASE ANY UNWANTED GUIDELINES.

Use dark lines and shadows to make some elements of your drawing fade into the background. Here, the blackened bars help the red ones in the foreground to stand out.

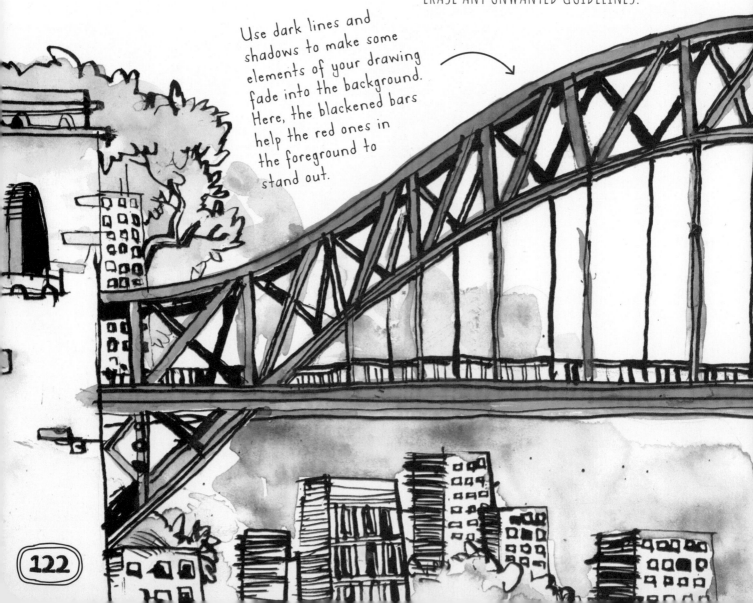

3 DRAW A SEQUENCE OF CRISSCROSSING BARS TO FILL THE GAP BETWEEN THE TWO CURVED SHAPES. ADD A LITTLE SHADING HERE AND THERE TO CREATE A 3-D EFFECT.

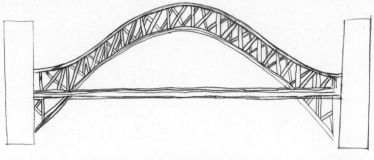

4 TURN THE RECTANGLES INTO BUILDINGS BY ADDING WINDOWS AND STONEWORK DETAIL. SKETCH ROUGH OUTLINES OF A COUPLE OF TREES BEHIND. ADD SOME APARTMENT BUILDINGS BELOW BY DRAWING A FEW VERTICAL RECTANGLES. THEN ADD ROUGH SQUARE SHAPES FOR WINDOWS.

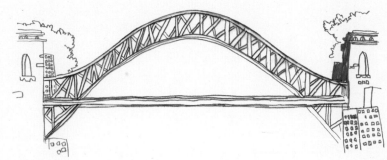

Draw a few leaves here and there, then paint a yellowy-green wash. Draw some jaggedy, inky lines for leafless branches.

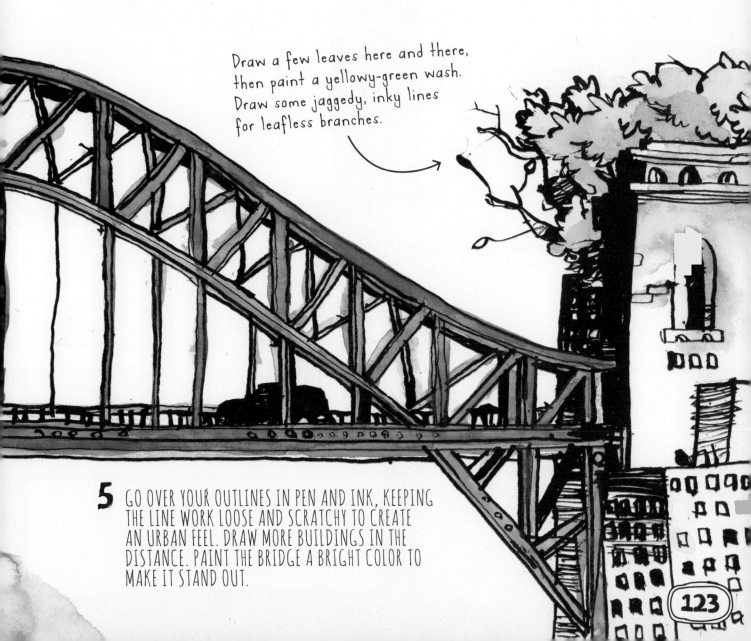

5 GO OVER YOUR OUTLINES IN PEN AND INK, KEEPING THE LINE WORK LOOSE AND SCRATCHY TO CREATE AN URBAN FEEL. DRAW MORE BUILDINGS IN THE DISTANCE. PAINT THE BRIDGE A BRIGHT COLOR TO MAKE IT STAND OUT.

CARTOON WILD ANIMALS

CARTOON ANIMALS ARE EASIER TO DRAW THAN YOU THINK! CHECK OUT THESE SUGGESTIONS, THEN GO WILD WITH YOUR PENCIL AND PAINTS.

NOSES

DIFFERENT ANIMALS HAVE DIFFERENT NOSE SHAPES—TRIANGLES, TRUNKS, OR EVEN JUST TWO DOTS FOR NOSTRILS, LIKE ON A HIPPO.

EARS

WHETHER THEY'RE ROUND AND FUZZY OR WIDE AND FLAPPY, ALWAYS LOOK AT HOW HIGH ON THE HEAD THE EARS SHOULD BE.

FEET

WHAT KIND OF FEET DOES YOUR CARTOON ANIMAL NEED? TRY THESE SIMPLE SHAPES. DON'T FORGET TO ADD MARKS FOR TOES!

EYES

START WITH CIRCLES, THEN ADD STRAIGHT EYELID LINES TO GIVE YOUR CARTOONS DIFFERENT EXPRESSIONS. USE LITTLE SEMICIRCLES TO ADD GLINTS TO THE EYES, TOO.

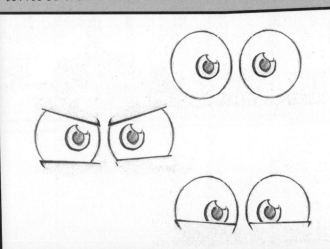

Find some pictures for inspiration, and look at what features are unique to that animal. Then exaggerate them!

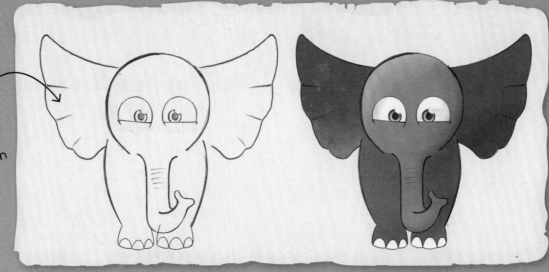

Use jagged lines to show a furry beard, and light lines inside for the fur texture.

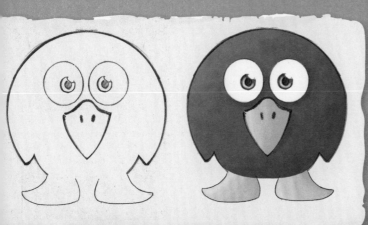

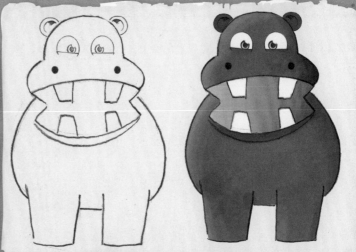

JETPACK

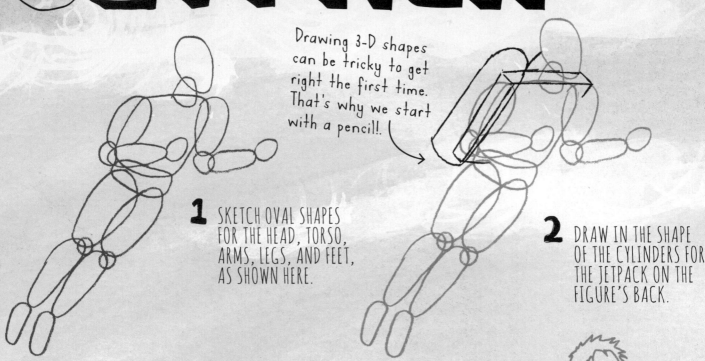

Drawing 3-D shapes can be tricky to get right the first time. That's why we start with a pencil!.

1 SKETCH OVAL SHAPES FOR THE HEAD, TORSO, ARMS, LEGS, AND FEET, AS SHOWN HERE.

2 DRAW IN THE SHAPE OF THE CYLINDERS FOR THE JETPACK ON THE FIGURE'S BACK.

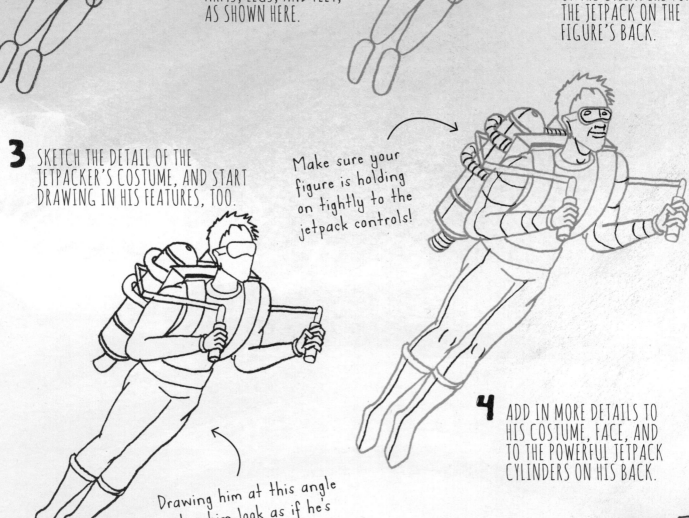

3 SKETCH THE DETAIL OF THE JETPACKER'S COSTUME, AND START DRAWING IN HIS FEATURES, TOO.

Make sure your figure is holding on tightly to the jetpack controls!

Drawing him at this angle makes him look as if he's zooming up into the air.

4 ADD IN MORE DETAILS TO HIS COSTUME, FACE, AND TO THE POWERFUL JETPACK CYLINDERS ON HIS BACK.

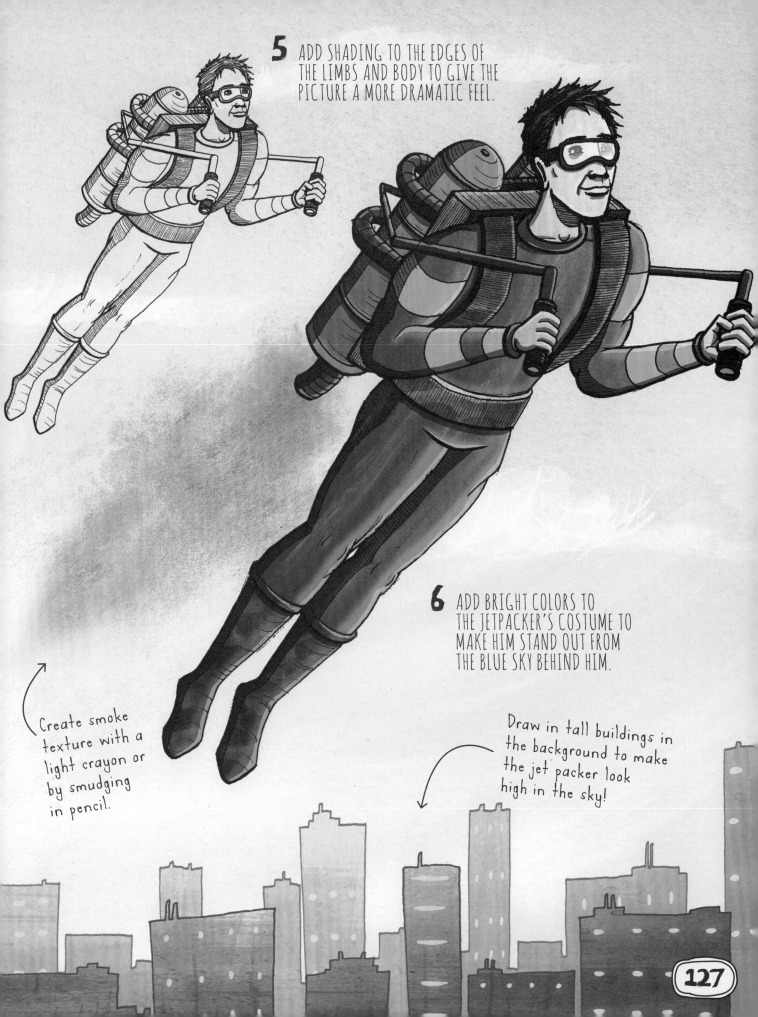

5 ADD SHADING TO THE EDGES OF THE LIMBS AND BODY TO GIVE THE PICTURE A MORE DRAMATIC FEEL.

6 ADD BRIGHT COLORS TO THE JETPACKER'S COSTUME TO MAKE HIM STAND OUT FROM THE BLUE SKY BEHIND HIM.

Create smoke texture with a light crayon or by smudging in pencil.

Draw in tall buildings in the background to make the jet packer look high in the sky!

MONSTER PLANT

1

DRAW A SQUARE POT WITH AN OVAL AT THE TOP. FOLLOW THE CURVE OF THE OVAL TO GIVE YOUR POT DEPTH.

2

LIGHTLY DRAW THREE CURVING GUIDELINES COMING FROM THE POT. DRAW PARALLEL LINES ON EITHER SIDE OF THE GUIDELINES TO MAKE THE PLANT STALKS. USE OVALS OR CIRCLES AT THE END OF EACH STALK TO MAKE MONSTER-HEAD SHAPES.

Add a caterpillar crawling up the stalk, using a line of circles stuck together.

3

DRAW ROOTS BURSTING OUT OF CRACKS IN THE POT. THE ROOTS SHOULD BECOME THINNER, ENDING IN A SHARP POINT.

Use a leaf shape to draw stalks winding around like tentacles.

128

4

DRAW FANGS AND GROSS
LIQUID DRIBBLING OUT OF THE
MOUTH. ADD SOME BULGING
EYEBALLS OR EYES.

Add a random eyeball to
the stem, like a plant bud.

Add some leaves with rough
circles to make it look like
the leaves have been eaten.

5

FINISH THE PLANT WITH
WATERCOLOR PENCILS. BLEND
YELLOWS AND GREENS TOGETHER.
MAKE THE STALKS DARKER AT THE
EDGES TO CREATE THE EFFECT OF
A CYLINDER. THEN USE BLACK
TO GIVE THE MONSTER PLANT A
HEAVY OUTLINE.

Add sharp triangular thorns.

Draw a juicy black fly
for the monster plant's
slurping tongue to catch.

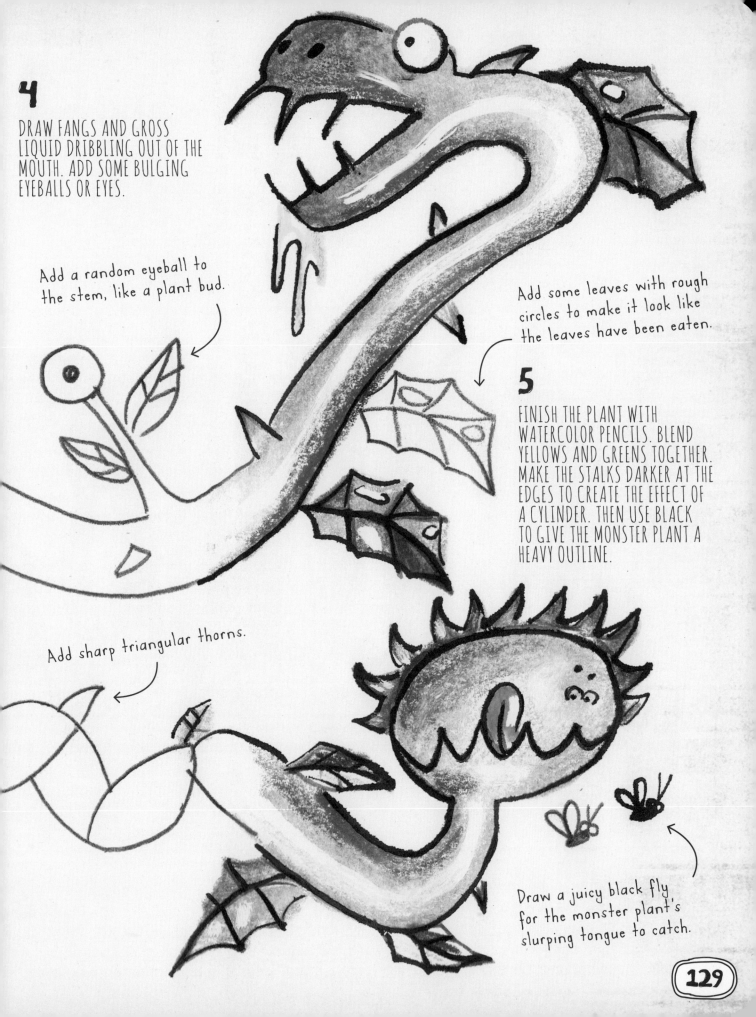

WORLD'S TALLEST HAMBURGER

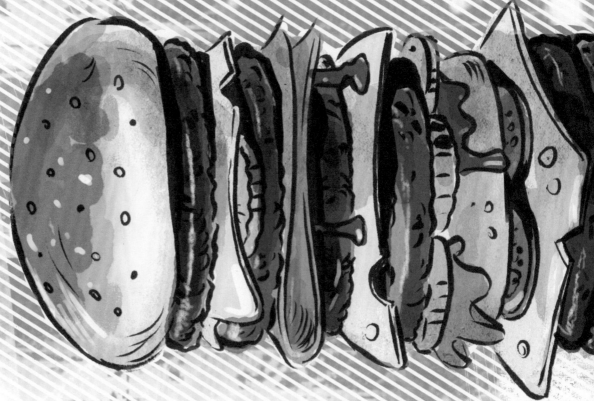

1

USING A 2H PENCIL, DRAW THE ROUGH OUTLINE OF YOUR HUGE, MULTILAYERED HAMBURGER! MAKE THE SHAPE SLIGHTLY NARROWER IN THE MIDDLE TO GIVE YOUR FINAL DRAWING ADDED VISUAL INTEREST. USE ROUGH ELLIPSES AND CURVED SHAPES FOR THE LAYERS OF BREAD.

3

USING A SOFTER PENCIL SUCH AS A 2B, GIVE YOUR FILLINGS MORE DETAIL, AND DOUBLE UP ON THE OUTLINES IN PLACES TO MAKE THE FILLINGS LOOK 3-D. DECIDE WHERE THE LIGHT IS COMING FROM, AND ADD SHADING LINES FOR THE AREAS THAT ARE IN SHADOW.

To create a sense of movement in your picture, vary the thickness of your line work, and keep the coloring loose. It doesn't matter if some areas of color accidentally cross over a line!

4

GO OVER YOUR LINEWORK WITH A BLACK PEN. A THICK, HEAVY OUTLINE WILL CREATE MORE OF A GRAPHIC-NOVEL EFFECT. COLOR YOUR DRAWING, USING DARKER TONES FOR THE SHADED AREAS, WITH ADDED WHITE BANDS FOR THE HIGHLIGHTS.

2

ADD LAYERS OF FILLING! USE WAVY LINES FOR LETTUCE LEAVES AND STRAIGHTER EDGES FOR CHEESE SLICES. USE ROUND SHAPES FOR SLICES OF TOMATO, ONION, AND PICKLES. EXAGGERATE THE SIZES OF THE DIFFERENT FILLINGS, AND HAVE THEM HANG OVER THE SIDES SO THEY'RE CLEARLY VISIBLE.

Circular Patterns

MAKE USE OF THE EASY-TO-DRAW CIRCLE SHAPE TO COME UP WITH PATTERNS THAT LOOK MORE COMPLICATED THAN THEY ARE! USE THEM TO DECORATE YOUR THINGS OR DRAWINGS.

One simple circular pattern option is to draw lots of circles inside each other. Use thick and thin lines for the rings.

For a color option, choose different tints for each ring of the pattern. Try colors that work well together until you find combinations that you like.

Or try drawing tiny circles around your center circle. Experiment with outlines and solids, or circles of different sizes. Add color or not!

MAKE A COMBINATION PATTERN BY DRAWING YOUR PATTERNS ONE ON TOP OF THE OTHER, VARYING THE THIN AND THICK LINES.

MIX THE TWO DIFFERENT-COLORED CIRCLES PATTERNS THAT YOU HAVE CREATED TO MAKE A LARGER, DYNAMIC COLORED PATTERN.

MAKE A PATTERN BY MIXING UP THE OUTLINE SHAPES AND SOLID COLOR SHAPES. THEY DON'T ALL HAVE TO BE THE SAME SIZE.

RADIAL

WITH A PENCIL, DRAW TWO BASIC CIRCLES INSIDE EACH OTHER. ADD LEAF SHAPES OR TEAR DROPS AROUND THE OUTSIDE, THEN ADD COLOR!

GEOMETRIC

DRAW AN INNER CIRCLE, THEN AN OUTER CIRCLE. DIVIDE THE CIRCLE IN HALF, THEN QUARTERS, THEN AGAIN TO END UP WITH 12 SECTIONS LIKE A CLOCK. DRAW A ZIGZAG LINE IN EACH CIRCLE. EXPERIMENT WITH COLORS.

ORNAMENTAL

DRAW A CIRCLE AND DIVIDE IT INTO SIX. ADD SOME LEAF SHAPES ON THE DIVIDING LINES. EXPERIMENT WITH OTHER SHAPES USING THE DIVIDING LINES AS GUIDES TO MAKE UP A UNIQUE PATTERN.

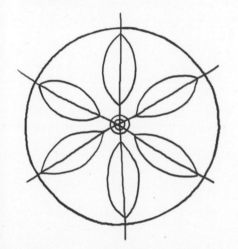 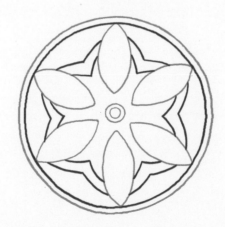 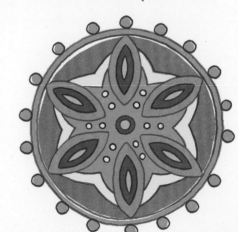

ZOMBIE

1

USE A PENCIL TO DRAW A SIMPLE STICK FIGURE. SKETCH THE BASIC SHAPE OF ONE HAND REACHING OUT.

2

SKETCH IN THE SHAPE OF THE ZOMBIE BODY, BIT BY BIT.

3

ADD DETAIL TO THE ZOMBIE'S FACE, BODY, AND CLOTHING. GIVE HIM AN UNNATURAL POSE.

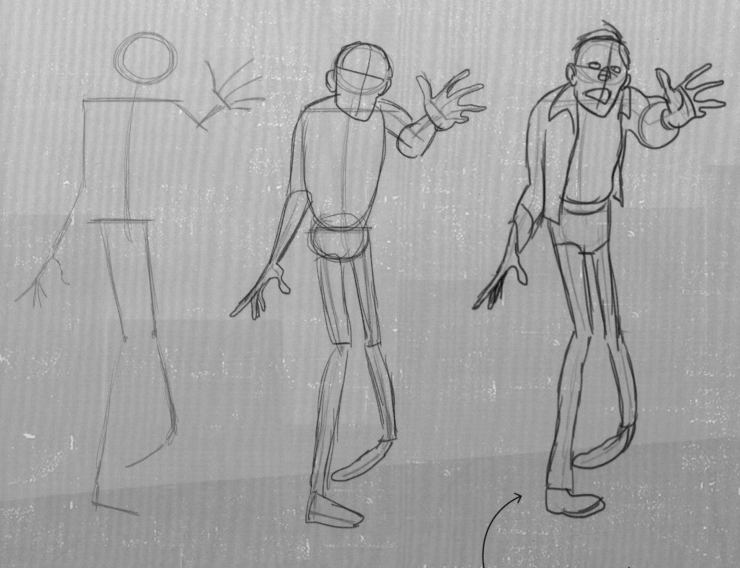

As your sketch takes shape, use darker lines to create the outline you'll go with for your monstrous figure.

4

DRAW IN MORE ZOMBIE DETAIL. GIVE HIM BIG, DARK SHADOWS AROUND HIS EYES, HORRIBLE SKIN, AND RIPS IN HIS SHABBY CLOTHING.

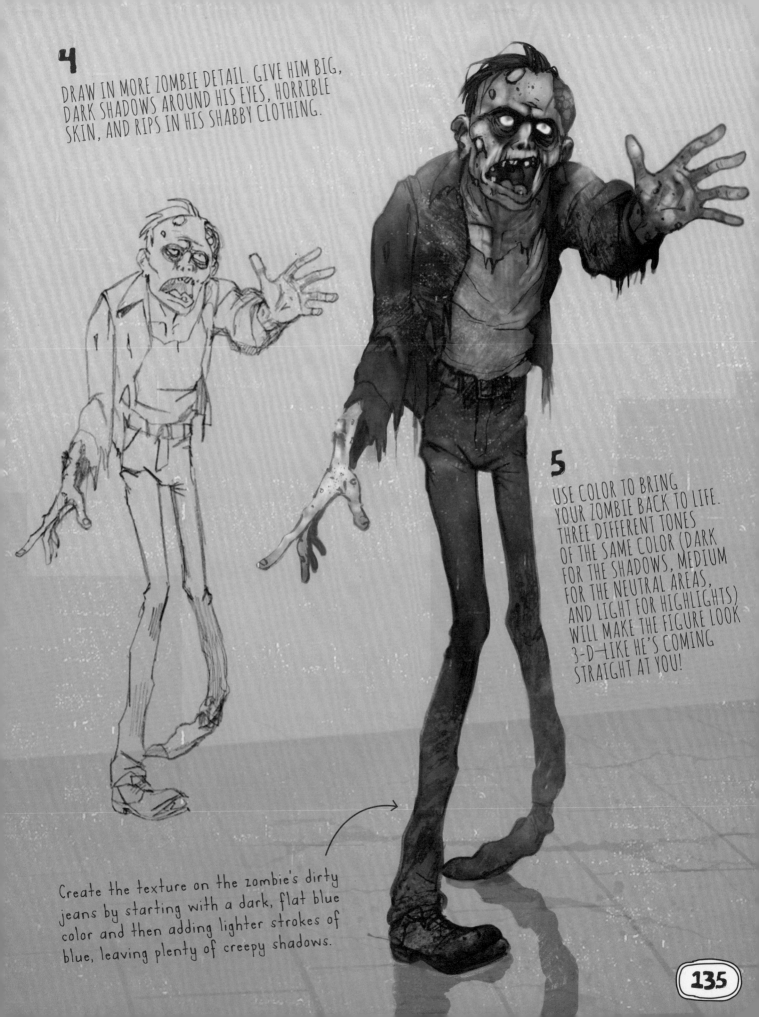

5

USE COLOR TO BRING YOUR ZOMBIE BACK TO LIFE. THREE DIFFERENT TONES OF THE SAME COLOR (DARK FOR THE SHADOWS, MEDIUM FOR THE NEUTRAL AREAS, AND LIGHT FOR HIGHLIGHTS) WILL MAKE THE FIGURE LOOK 3-D—LIKE HE'S COMING STRAIGHT AT YOU!

Create the texture on the zombie's dirty jeans by starting with a dark, flat blue color and then adding lighter strokes of blue, leaving plenty of creepy shadows.

CANDY MACHINE

DRAW A COMPLICATED-LOOKING, GADGETY, MAGICAL CANDY MACHINE BY BREAKING IT DOWN INTO DIFFERENT PARTS.

1 USE A PENCIL TO CREATE A SIMPLE CYLINDER SHAPE. DRAW A SMALL CIRCLE FOR A PRESSURE GAUGE. LINES FOLLOWING THE FORM OF THE CYLINDER BASE WILL GIVE THE EFFECT OF METAL PANELING ON YOUR MACHINE.

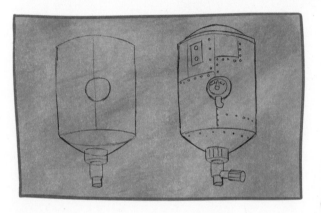

Add containers and levers to make the machine look more complex!

2 DRAW LIQUID SPILLING OUT OF A FAUCET USING LOOSE WOBBLY LINES. ADD CIRCLES AROUND THE LIQUID TO GIVE THE IMPRESSION THAT IT'S BUBBLING AND SPLASHING. SHADE THE FUNNEL FOR A 3-D LOOK.

For the control panel, split the front face of the box into smaller squares and rectangles, and draw lots of even smaller button shapes onto them.

3 SKETCH ANOTHER CYLINDER SHAPE UNDER THE MACHINE'S FUNNEL.

To draw a valve, start with a cylinder then draw another, thinner cylinder sticking out from it. Draw a big circle on top of it.

Draw a cross at the center of the circle to help you position the arms of the valve that join the outer ring.

5 TO DRAW A SIMPLE CONVEYOR BELT, START WITH A SMALL CIRCLE SHAPE AT BOTH THE START AND THE END OF WHERE YOU WANT YOUR CONVEYOR BELT TO BE, THEN JOIN THEM WITH A PAIR OF STRAIGHT LINES.

What candies will your machine produce? Here are some ideas!

4 PIPES ARE MADE OF REPEATED SHAPES. YOU CAN DRAW COMPLICATED PIPE DESIGNS BY DRAWING ONE SEGMENT AT A TIME AND REPEATING THEM END TO END. DRAW THE BASIC SHAPES FIRST, AND THEN DROP IN THE DETAIL.

6 DRAW A PARALLEL HORIZONTAL LINE ON TOP, THEN JOIN THE TWO SETS OF LINES WITH SHORT HORIZONTAL LINES TO CREATE A 3-D BELT SHAPE. NOW DRAW IN THE REST OF THE CIRCLES ALONG THE LENGTH OF THE SHAPE.

A simple jar can be drawn by starting with a cylinder shape and filling it up with different-shaped candies.

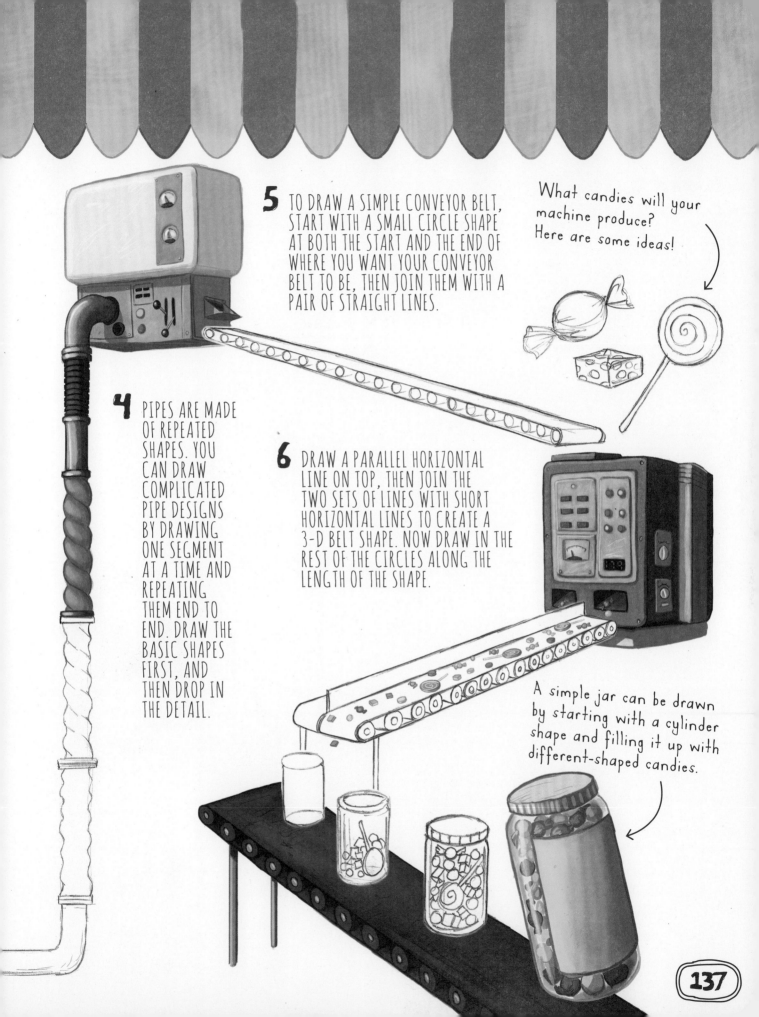

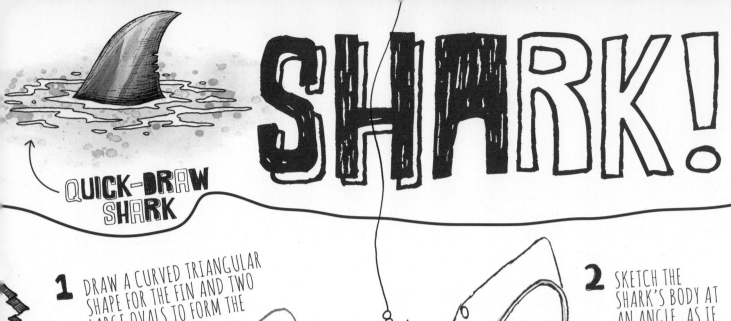

SHARK!

QUICK-DRAW SHARK

1 DRAW A CURVED TRIANGULAR SHAPE FOR THE FIN AND TWO LARGE OVALS TO FORM THE SHARK'S MOUTH.

Draw the two ovals overlapping each other.

2 SKETCH THE SHARK'S BODY AT AN ANGLE, AS IF IT'S JUMPING OUT OF THE WATER. DRAW CURVED SHAPES FOR THE MOUTH AND TONGUE, THEN ADD AN EYE.

This shading technique uses lots of curved and straight lines. Draw them closer together for the darker areas, such as the inside of the shark's mouth.

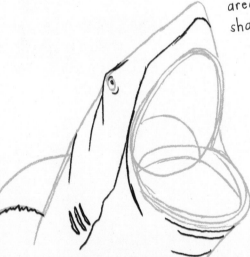

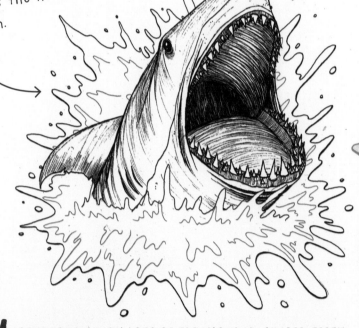

3 DRAW MORE LINES AND CURVES ON THE SHARK'S BODY TO MAKE IT LOOK MORE 3-D. ADD IN EXTRA LINES AROUND THE EYES AND MOUTH.

4 GIVE YOUR SHARK LOTS OF TRIANGULAR-SHAPED TEETH. ADD SHADING TO EMPHASIZE THE CURVED SHAPE OF THE BODY, WITH HEAVIER SHADING FOR THE INSIDE OF THE MOUTH. DRAW A BIG WATER SPLASH WITH WAVY LINES.

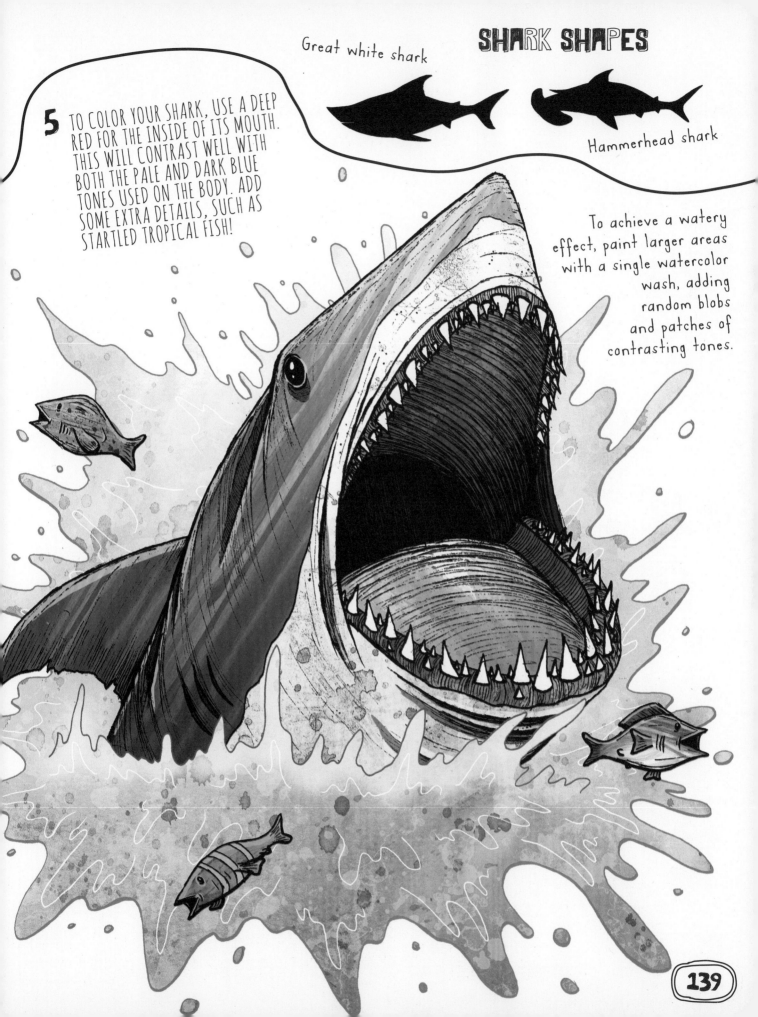

Great white shark

Hammerhead shark

5 TO COLOR YOUR SHARK, USE A DEEP RED FOR THE INSIDE OF ITS MOUTH. THIS WILL CONTRAST WELL WITH BOTH THE PALE AND DARK BLUE TONES USED ON THE BODY. ADD SOME EXTRA DETAILS, SUCH AS STARTLED TROPICAL FISH!

To achieve a watery effect, paint larger areas with a single watercolor wash, adding random blobs and patches of contrasting tones.

SKYSCRAPERS

1

USING A PENCIL, DRAW A SERIES OF BLOCKS IN A ROW TO FORM A SKYLINE.

2

ADD EXTRA SHAPES TO YOUR BLOCKS TO MAKE THE BUILDINGS MORE INTERESTING.

Will you base your skyscrapers on real buildings, make up imaginary ones, or do a mixture of both?

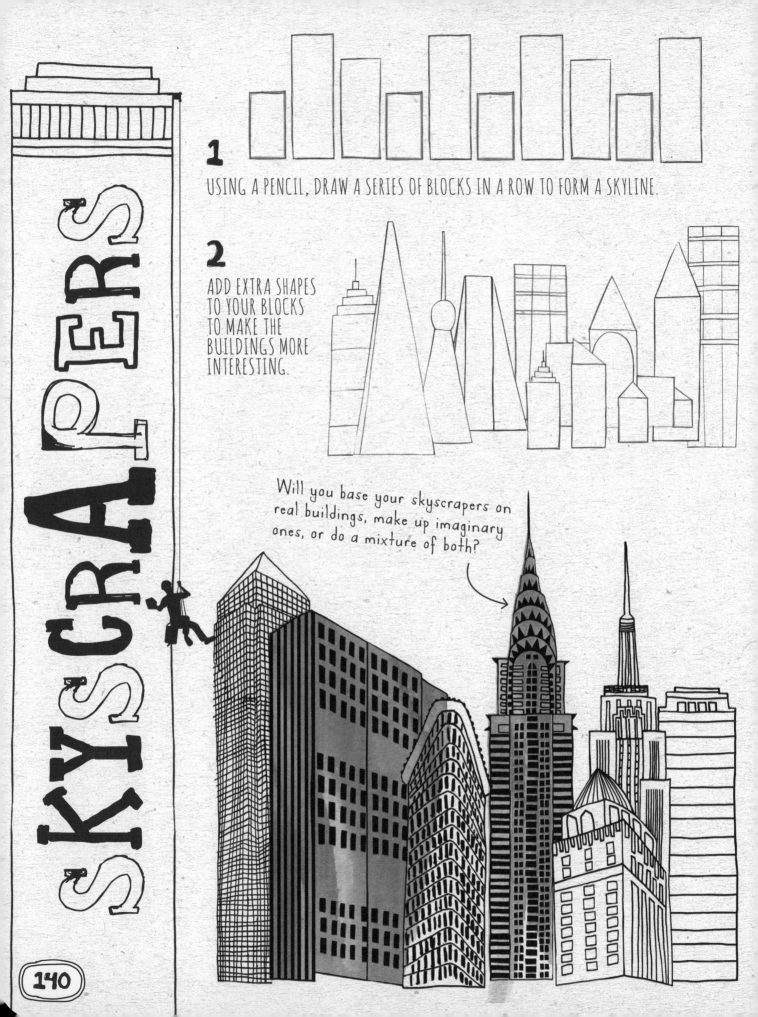

3

ADD SOME GUIDELINES
TO HELP YOU DRAW DETAILS
SUCH AS WINDOWS AND
ORNATE DECORATION.

4

USING A FINE-LINE PEN,
DRAW OVER YOUR PENCIL
LINES, AND FILL IN THE
DETAILS OF THE BUILDINGS.
ERASE THE PENCIL LINES
WHEN YOU HAVE FINISHED.

5

ADD A WASH OF COLOR OVER YOUR
BUILDINGS USING WATERCOLOR PAINTS.

Gather some inspiration from
pictures of real buildings.

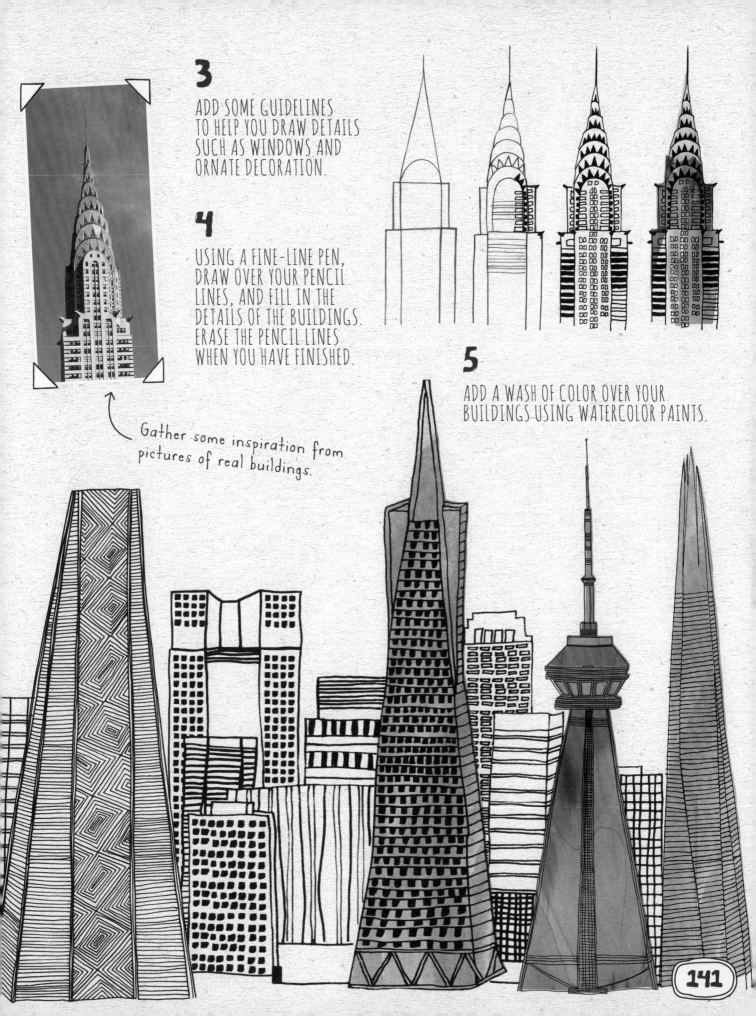

BASKETBALL PLAYER

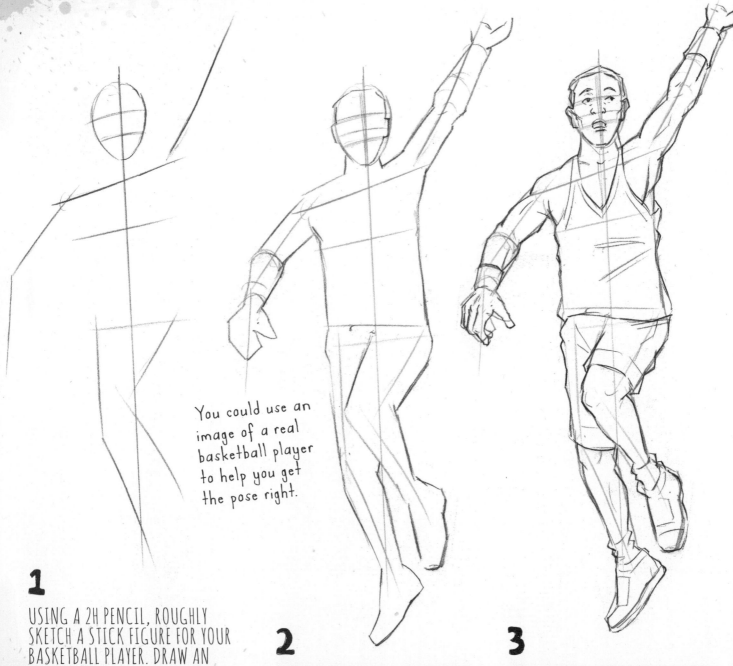

You could use an image of a real basketball player to help you get the pose right.

1

USING A 2H PENCIL, ROUGHLY SKETCH A STICK FIGURE FOR YOUR BASKETBALL PLAYER. DRAW AN ARM POINTING IN THE AIR, AND MAKE ONE LEG MORE BENT THAN THE OTHER FOR A JUMPING POSE. EVEN AT THIS INITIAL STAGE, TRY AND DRAW A FIGURE THAT LOOKS LIKE IT'S IN MOTION.

2

SKETCH THE BASIC OUTLINE AND PROPORTIONS OF YOUR FIGURE, USING THE STICK LINES AS A GUIDE. NOTICE HOW THE MUSCLES BULGE OUT MORE ON THE LEG THAT'S BENT.

3

WORK ON THE BODY PARTS, USING CURVED LINES FOR THE MUSCLE SHAPES. ADD THE FINGERS, HAIR, AND FACIAL FEATURES. DRAW IN CLOTHING, THINKING ABOUT HOW THE POSE WILL AFFECT THE WAY THE CLOTHES HANG.

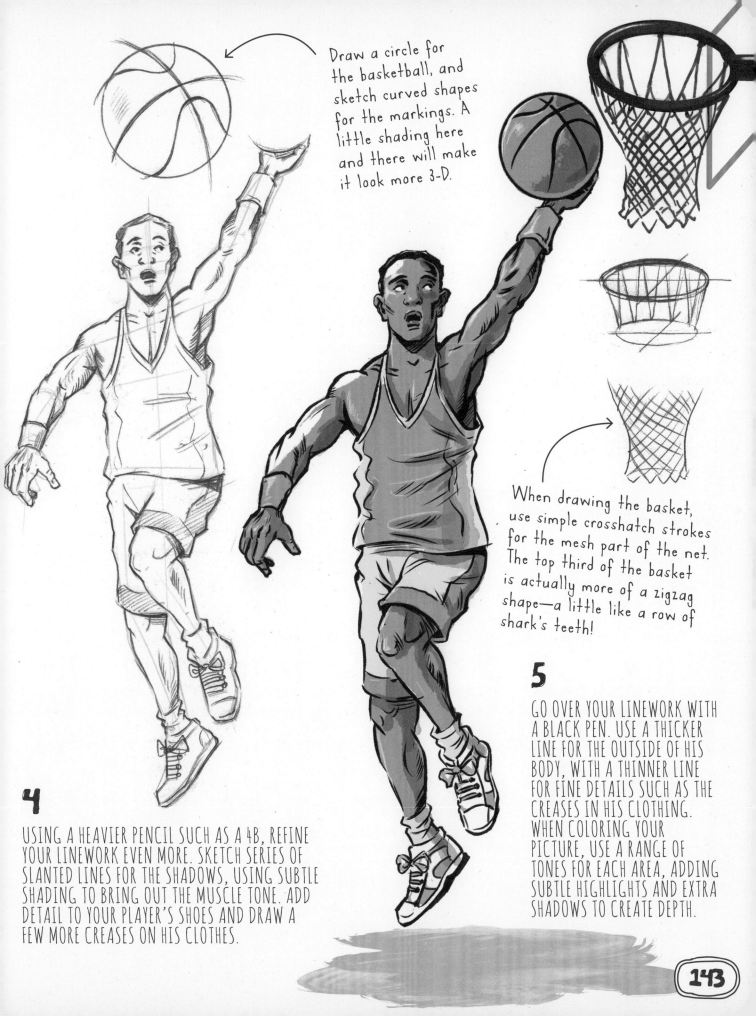

Draw a circle for the basketball, and sketch curved shapes for the markings. A little shading here and there will make it look more 3-D.

When drawing the basket, use simple crosshatch strokes for the mesh part of the net. The top third of the basket is actually more of a zigzag shape—a little like a row of shark's teeth!

5

GO OVER YOUR LINEWORK WITH A BLACK PEN. USE A THICKER LINE FOR THE OUTSIDE OF HIS BODY, WITH A THINNER LINE FOR FINE DETAILS SUCH AS THE CREASES IN HIS CLOTHING. WHEN COLORING YOUR PICTURE, USE A RANGE OF TONES FOR EACH AREA, ADDING SUBTLE HIGHLIGHTS AND EXTRA SHADOWS TO CREATE DEPTH.

4

USING A HEAVIER PENCIL SUCH AS A 4B, REFINE YOUR LINEWORK EVEN MORE. SKETCH SERIES OF SLANTED LINES FOR THE SHADOWS, USING SUBTLE SHADING TO BRING OUT THE MUSCLE TONE. ADD DETAIL TO YOUR PLAYER'S SHOES AND DRAW A FEW MORE CREASES ON HIS CLOTHES.

VOLCANO

1 DRAW A PYRAMID SHAPE (WITH THE TOP CUT OFF) IN PENCIL. USE INK TO DRAW JAGGED LINES TO GIVE THE VOLCANO TEXTURE.

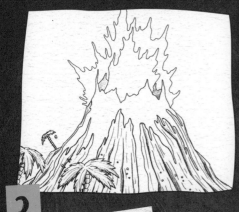

2 USING INK, DRAW THICK LINES ON THE VOLCANO SIDES. ADD TREES, ROCKS, FLEEING DINOS, AND LAVA.

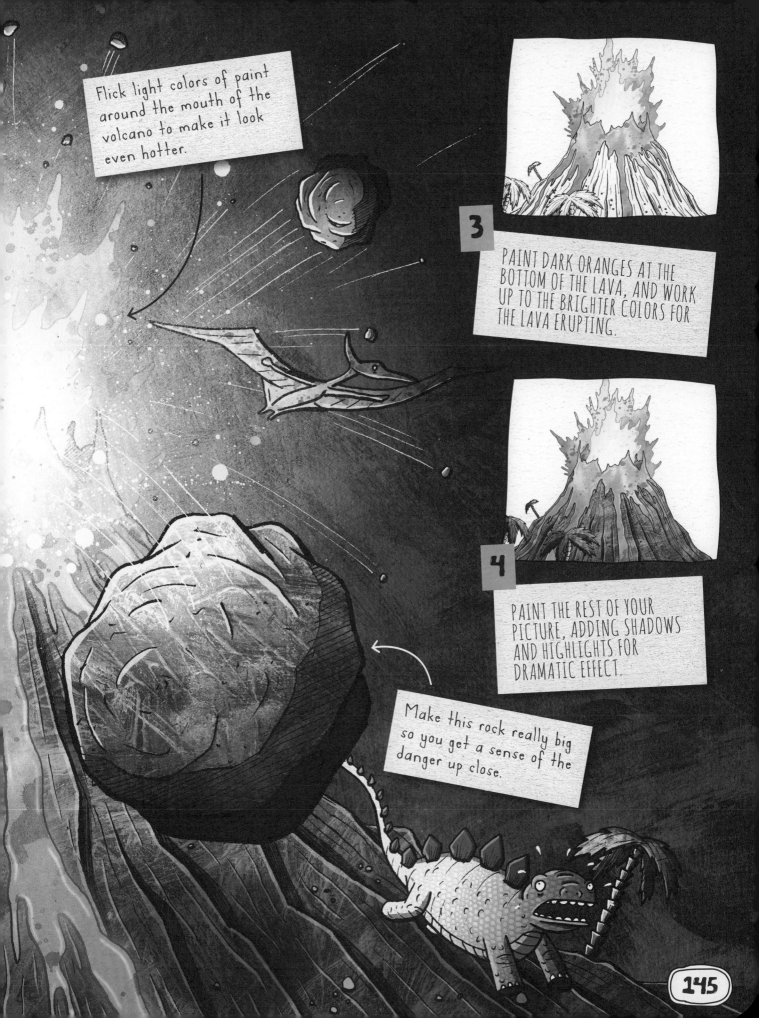

WEIRD BEARDS

BEARDS ARE SIMPLE TO DRAW, BUT YOU CAN HAVE PLENTY OF FUN INVENTING ALL KINDS OF STRANGE STYLES.

1 DRAW A CURVED SHAPE FOR THE TOP OF THE HEAD, AND ADD AN EAR TO EACH SIDE. SKETCH A SIMPLE OUTLINE OF A BEARD WITH AN ADJOINING MUSTACHE.

2 FOR AN EASY WAY OF DRAWING HAIR, SIMPLY FILL THE BEARD AREA WITH LOTS OF VERTICAL, WAVY LINES. USE SHORTER LINES TO FILL IN THE MUSTACHE AREA.

Drawing the lines closer together will make your beard look darker.

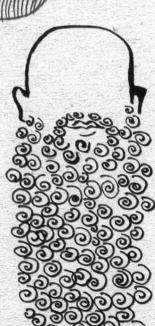

TO GET THE EFFECT OF A DENSE, WAVY BEARD, DRAW LOTS OF REPEATED CURVES IN LONG, WINDING ROWS.

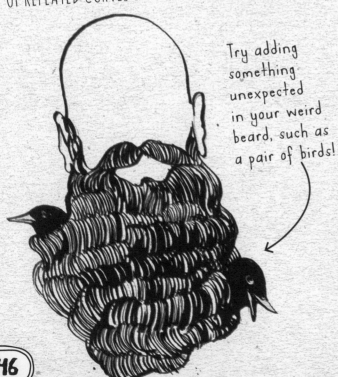

Try adding something unexpected in your weird beard, such as a pair of birds!

DRAW LOTS OF LITTLE SPIRALS FOR A LONG, CURLY BEARD.

You could experiment with other simple doodles and try using them for different beard textures.

146

TRY DRAWING SOME OF THESE WEIRD BEARDS, OR INVENT YOUR OWN!

BEARD GALLERY

PENCIL STROKES

DRAW SHORT, SIMPLE LINES FANNING OUTWARD TO EACH SIDE TO CREATE A BUSHY BEARD.

TWISTS AND CURLS

TRY DRAWING A BEARD THAT LOOKS MORE LIKE A BIG, CURLY MUSTACHE. ADD WAVY LINES FOR TEXTURE.

LONG

ALTHOUGH A BRAIDED BEARD LOOKS COMPLICATED, IT'S JUST A SUCCESSION OF SIMPLE SHAPES, WITH ADDED LINES FOR TEXTURE.

THE WAVE

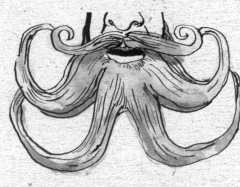

THE BRUSH

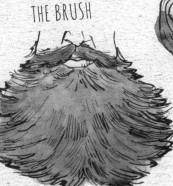

LONG BRAID

When coloring, use different color tones to add depth.

THE MAD MAJOR

THE CHECKS

Draw lots of linked curved shapes like this:

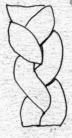

THE RINGMASTER

THE OCTOPUS

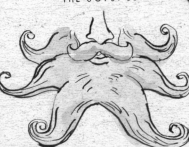

Then fill them in.

This builds on the Mad Major style, but the curls are tighter, like waxed loops!

SPEEDBOAT

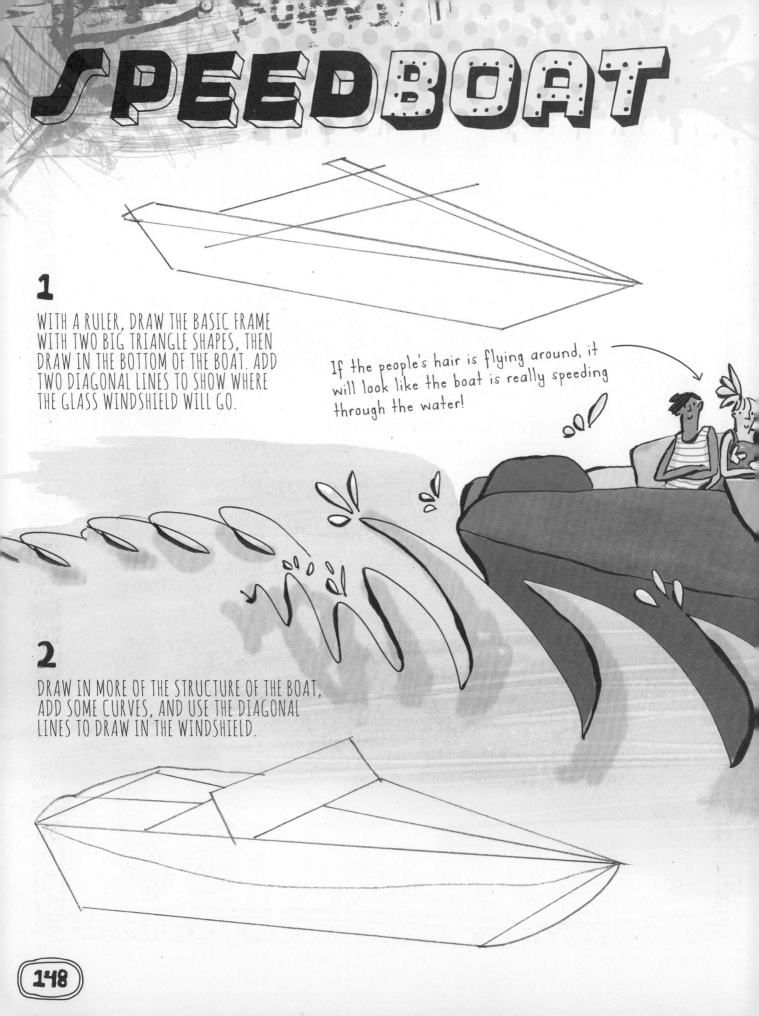

1

WITH A RULER, DRAW THE BASIC FRAME WITH TWO BIG TRIANGLE SHAPES, THEN DRAW IN THE BOTTOM OF THE BOAT. ADD TWO DIAGONAL LINES TO SHOW WHERE THE GLASS WINDSHIELD WILL GO.

If the people's hair is flying around, it will look like the boat is really speeding through the water!

2

DRAW IN MORE OF THE STRUCTURE OF THE BOAT, ADD SOME CURVES, AND USE THE DIAGONAL LINES TO DRAW IN THE WINDSHIELD.

3

ERASE THE LINES YOU DON'T NEED, AND ADD SOME CURVES AND DETAILS. ROUGHLY SKETCH IN WHERE THE PEOPLE WILL SIT IN THE SPEEDBOAT, A STEERING WHEEL, AND MOTOR.

4

DRAW IN SOME SPIKY WAVES. THESE ARE SUPPOSED TO LOOK LOOSE AND SPLASHY, SO DON'T WORRY ABOUT BEING TOO PRECISE. ADD IN THE PEOPLE'S FEATURES AND A REFLECTION LINE ON THE WINDSHIELD.

5

FINISH BY COLORING THE PICTURE. BE PRECISE WITH THE COLOR OF THE BOAT AND LOOSE WHEN COLORING THE WAVES.

Add little splash marks loosely colored in to really give the sense of the boat's speed!

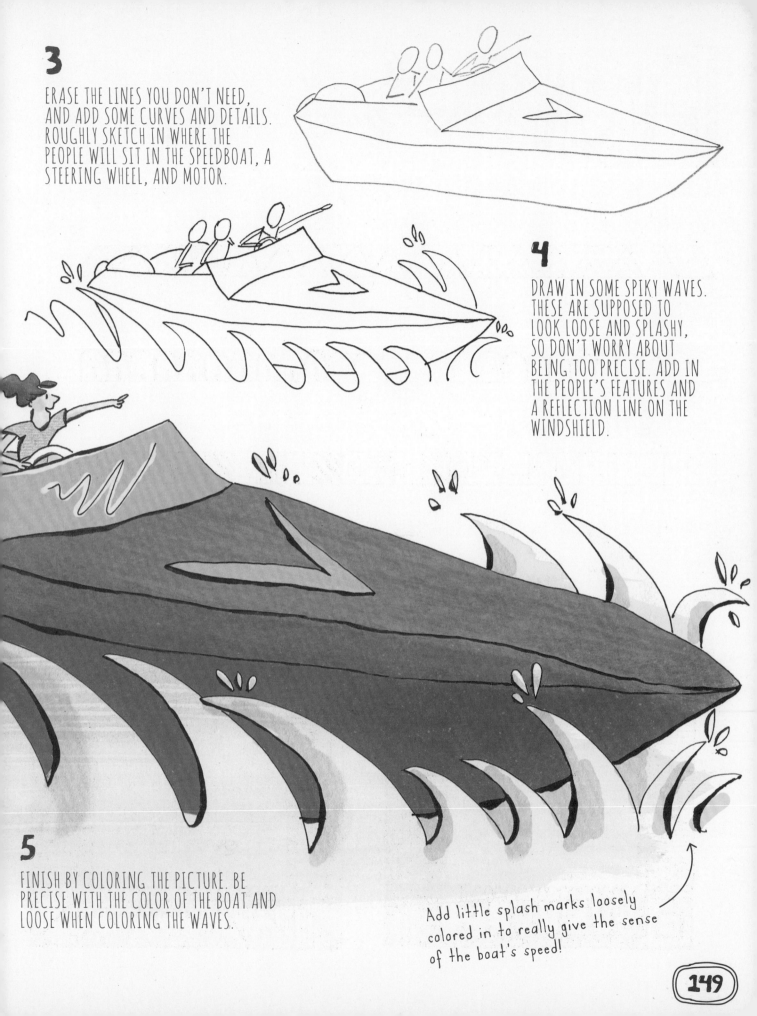

Frames

TRY DRAWING FRAMES FOR YOUR PICTURES USING SIMPLE SHAPES TO BUILD UP PATTERNS.

FOR A ZIGZAG PATTERN, DRAW TWO LONG PARALLEL LINES, THEN DRAW ZIGZAG LINES BETWEEN THEM. BUILD UP A COMPLEX PATTERN BY ADDING DETAIL AND SHADING LINES IN THE TRIANGLES YOU'VE CREATED.

THIS PATTERN IS SIMILAR TO THE ONE ABOVE, BUT THIS TIME, USE CONSECUTIVE CURVES AND REMOVE THE TOP LINE TO GIVE A DIFFERENT, ROUNDED STYLE. ADD DETAIL INSIDE THE CURVES FOR SOPHISTICATION.

FOR ANOTHER INTERESTING PATTERN, DIVIDE THE SPACE BETWEEN THE PARALLEL LINES INTO SMALL SQUARES. TRY DIFFERENT PATTERNS IN EACH ONE, OR REPEAT SOME OF THE DESIGNS TO BUILD UP A BIGGER PATTERN.

The top and bottom panels of a frame could share the same pattern. Add variety by drawing a different pattern for the two side panels. Try mixing soft curves and sharp zigzags for this striking frame.

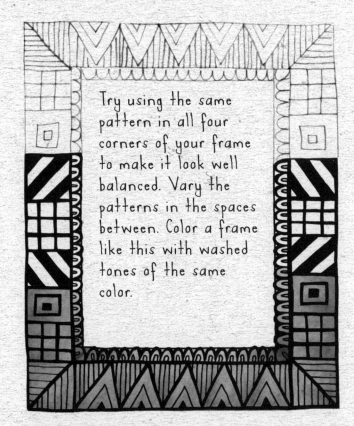

Try using the same pattern in all four corners of your frame to make it look well balanced. Vary the patterns in the spaces between. Color a frame like this with washed tones of the same color.

Round

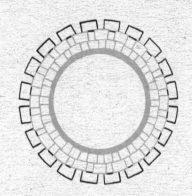

Start by drawing a thick circle. Add squares around the outside, leaving spaces in between. On the next layer, add squares, building on the spaces in the first layer. Do the same for the third layer. Mix different tones of watercolor paints to color the squares, leaving white space in between.

Oval

Draw an oval shape with a larger oval around the outside. Draw lines close together inside. Add larger ovals, and divide them up into equal sections, as shown. Add curves around the outside of the frame, looping from line to line. Color with watercolor paints and varying tones.

Star

To make a star-shaped frame, draw two interlocking triangles, one on top of the other. Add larger stars around the outside. In light pencil, draw curves around the outside. Paint the frame. When it's dry, ink over the lines varying the thickness to make it interesting. Add pretty detail!

CARICATURES

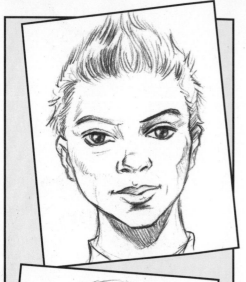

THIS BOY HAS SPIKY HAIR AND A FIRM JAWLINE AND CHEEKBONES. LET'S EXAGGERATE THESE! START WITH SOME GUIDELINES FOR THE EYES AND NOSE, THEN USE A LIGHT PENCIL TO SKETCH IN THE BASIC HEAD SHAPE AND FEATURES.

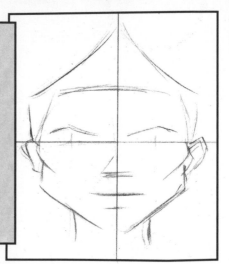

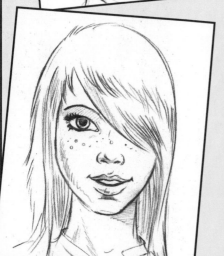

1

THIS GIRL'S HAIR SWEEPS OVER ONE EYE, MAKING THE OTHER EYE LOOK HUGE. SHE ALSO HAS FRECKLES AND AN OVAL FACE. USING GUIDELINES, LIGHTLY SKETCH AN EXAGGERATED OVAL HEAD SHAPE AND HAIR.

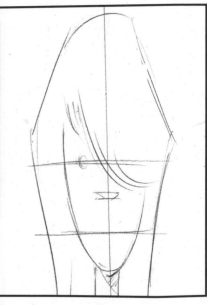

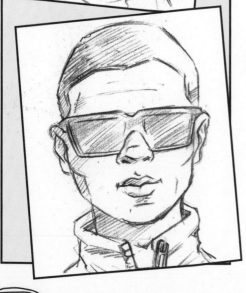

1

THIS GUY'S KEY FEATURES ARE HIS GLASSES AND HEAD SHAPE. THE GLASSES DIVIDE HIS HEAD IN TWO, EMPHASIZING HIS FOREHEAD AND EARS. MAP SOME GUIDELINES, AND SKETCH IN THE MAIN SHAPES.

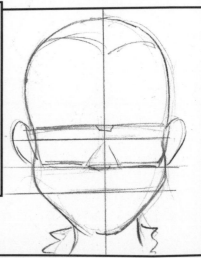

A CARICATURE IS A PICTURE THAT EXAGGERATES CERTAIN FEATURES FOR COMICAL EFFECT. START WITH A PHOTO OR SKETCH OF A PERSON, THEN EXAGGERATE THE FEATURES THAT STAND OUT—MAYBE A DISTINCTIVE NOSE OR WACKY HAIRSTYLE!

2 USE A SOFTER PENCIL TO START ADDING IN SOME OF THE DETAIL. LOOK AT THE SHAPE OF THE EYES, NOSE, AND MOUTH, AND SLIGHTLY EXAGGERATE THEM.

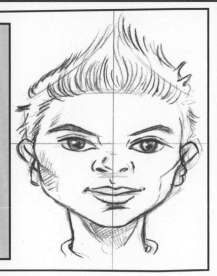

3 KEEP REFERRING BACK TO THE PHOTO. USE COLOR TO BRING THE CARICATURE TO LIFE!

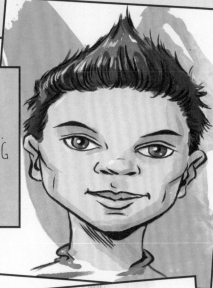

2 MAKE HER EYE SHAPE SLIGHTLY BIGGER, SEPARATE THE EYELASHES AND SKETCH IN FRECKLES. YOU CAN MAKE THE HAIR MORE SHAGGY TO EMPHASIZE THE STRAIGHT STYLE.

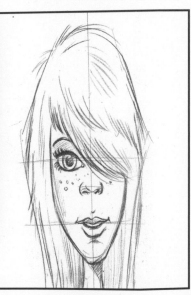

3 YOU ARE PLAYING UP THE HAIR, SO MAKE IT COLORFUL, WITH A DRAMATIC STREAK. ADD COLOR TO THE FACE TOO.

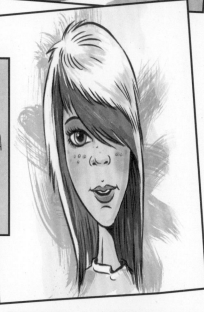

2 ADD DETAIL TO THE FACE, AND SHADE IN THE DARKER AREAS, EMPHASIZING HIS FOREHEAD. LEAVE WHITE HIGHLIGHTS, PARTICULARLY ON THE GLASSES.

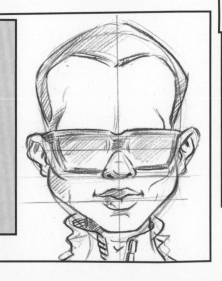

3 BRING OUT THE CARICATURE, WITH COLOR, USING GRAYS, BLACKS, BLUES, AND WHITE HIGHLIGHTS.

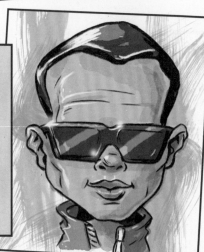

CROCODILE

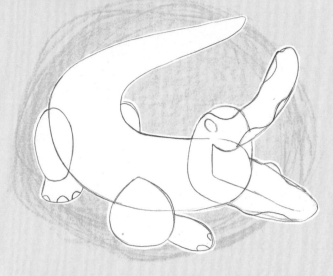

1 SKETCH THE BASIC SHAPE OF THE CROCODILE'S BODY WITH A LIGHT, SHARP PENCIL. ADD ROUGH CIRCLE SHAPES FOR THE THREE LEGS YOU'LL SEE.

2 DRAW AN OVAL SHAPE FOR THE HEAD BEFORE ADDING IN THE OPEN MOUTH. SKETCH IN THE ROUGH DETAIL OF THE MOUTH, AND ADD SOME FEET FOR THE BEGINNING OF THE CLAWS.

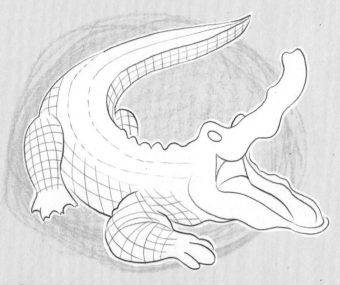

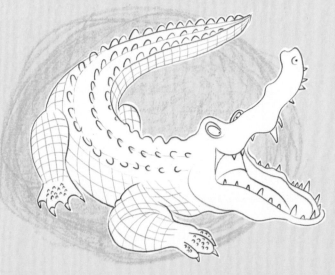

3 SKETCH THE OUTLINE OF THE CROCODILE. DRAW TWO LINES RUNNING PARALLEL ALONG HIS BACK. USING A GRID SYSTEM, DRAW A GUIDE FOR THE SCALES ON THE LIMBS AND BODY.

4 ADD THE EYES, CLAWS, TEETH, AND BACK SCALES, MAKING SURE THE SCALES FOLLOW THE CONTOUR OF THE BODY. MARK SMALL CURVES FOR SCALES ON THE FEET AND BACK.

5 USING THE GRID AGAIN, ROUND OFF THE SQUARES, AND FILL IN THE GAPS WITH SHADES OF PENCIL. TO CREATE A SOFT, EVEN TONE, ANGLE YOUR PENCIL AND USE GENTLE SWEEPING MARKS. PUSH HARDER FOR HEAVIER TONES.

Applying shading to the crocodile's body gives a fantastic feeling of scaly texture across the whole picture.

6 FINISH YOUR DRAWING WITH COLOR. ADD TONES OF GREEN AND SKIN MARKS ACROSS THE BODY WITH SMALL CIRCLES AND DOTS.

Draw in a suitably swampy background for your croc.

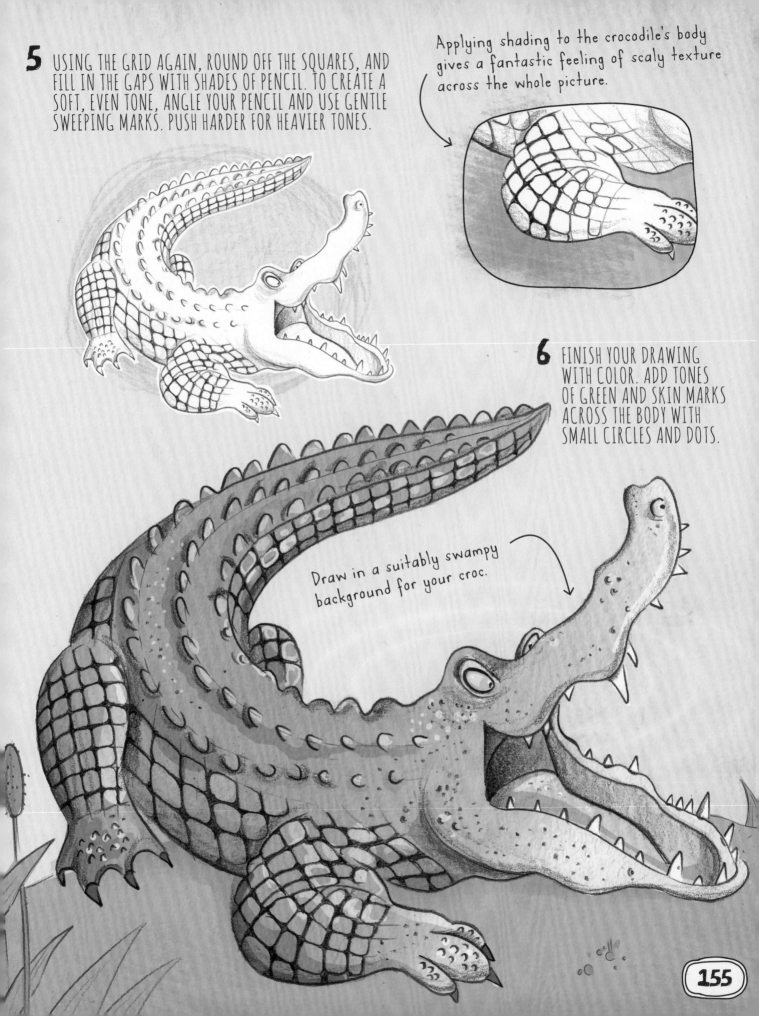

tOrnAdo

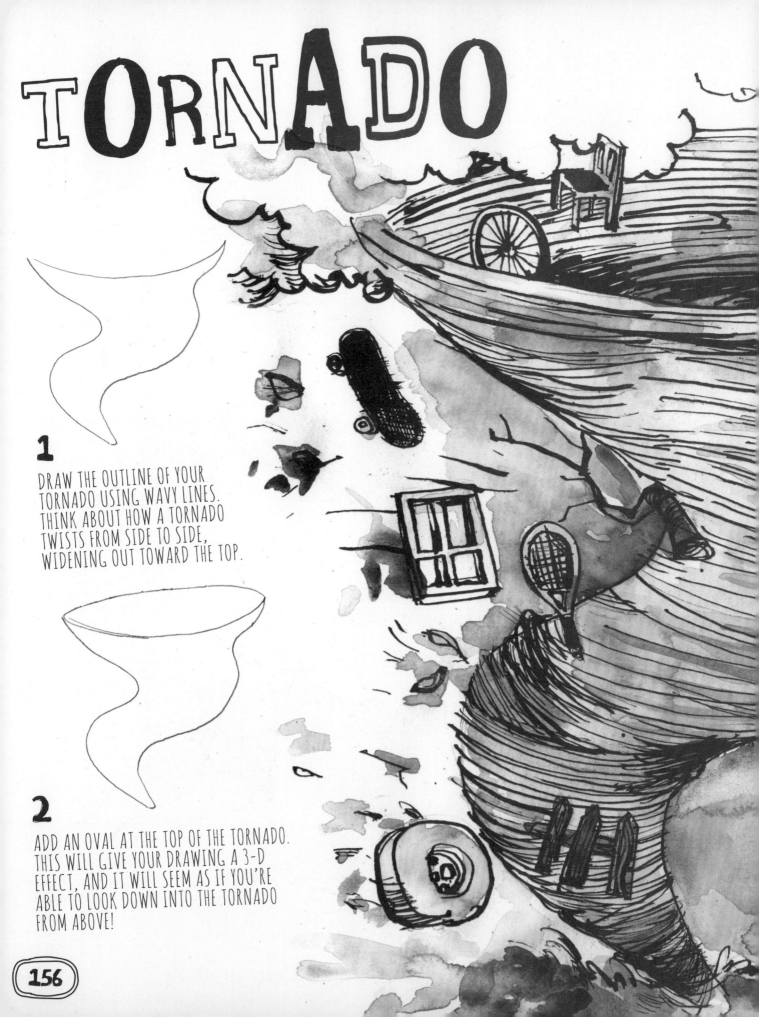

1

DRAW THE OUTLINE OF YOUR TORNADO USING WAVY LINES. THINK ABOUT HOW A TORNADO TWISTS FROM SIDE TO SIDE, WIDENING OUT TOWARD THE TOP.

2

ADD AN OVAL AT THE TOP OF THE TORNADO. THIS WILL GIVE YOUR DRAWING A 3-D EFFECT, AND IT WILL SEEM AS IF YOU'RE ABLE TO LOOK DOWN INTO THE TORNADO FROM ABOVE!

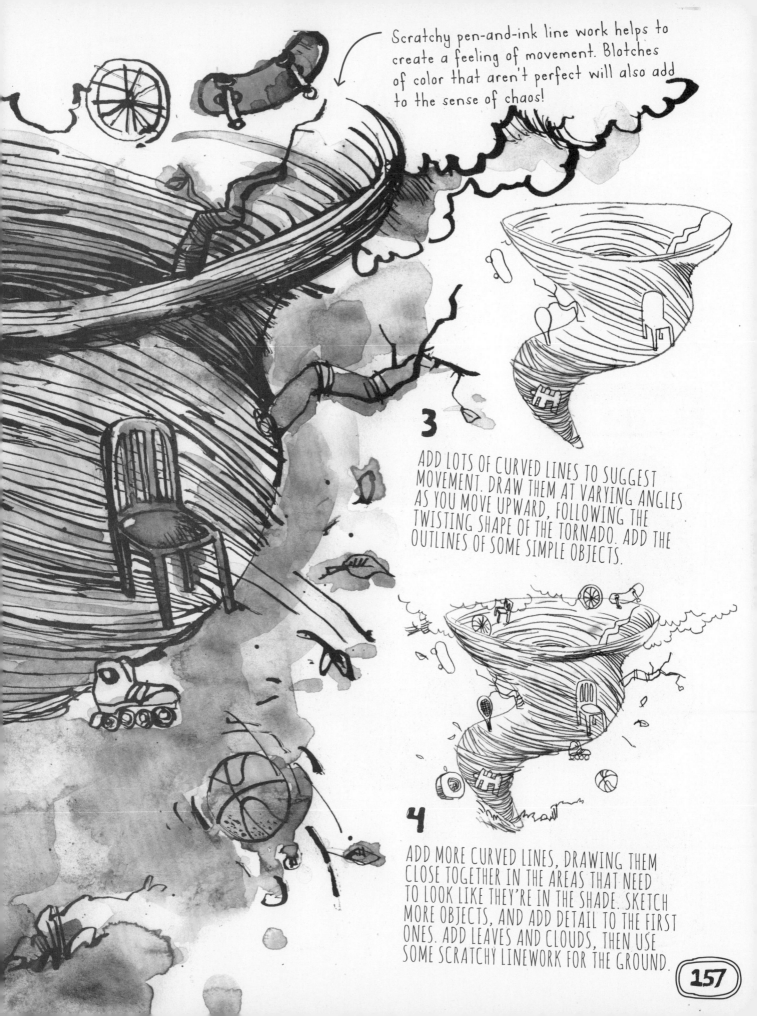

Scratchy pen-and-ink line work helps to create a feeling of movement. Blotches of color that aren't perfect will also add to the sense of chaos!

3

ADD LOTS OF CURVED LINES TO SUGGEST MOVEMENT. DRAW THEM AT VARYING ANGLES AS YOU MOVE UPWARD, FOLLOWING THE TWISTING SHAPE OF THE TORNADO. ADD THE OUTLINES OF SOME SIMPLE OBJECTS.

4

ADD MORE CURVED LINES, DRAWING THEM CLOSE TOGETHER IN THE AREAS THAT NEED TO LOOK LIKE THEY'RE IN THE SHADE. SKETCH MORE OBJECTS, AND ADD DETAIL TO THE FIRST ONES. ADD LEAVES AND CLOUDS, THEN USE SOME SCRATCHY LINEWORK FOR THE GROUND.

157

MONSTER

PIECE TOGETHER DIFFERENT IMAGINATIVE BODY PARTS TO CREATE A MOB OF MASHED-UP MONSTERS!

1

START WITH THE MONSTER'S BODY. USE A SIMPLE CIRCLE, BENDING THE LINES A LITTLE, THEN ADD MONSTER DETAIL ON TOP, SUCH AS SPIKES OR STRIPES.

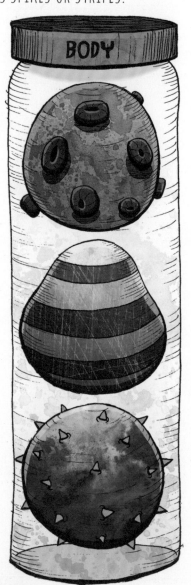

2

FOR THE LEGS, TRY TENTACLES, LEGS WITH WEBBED FEET LIKE A BIRD, BIG HAIRY ONES WITH GIANT CLAWS, OR ANYTHING ELSE YOU CAN THINK OF. GO WILD!

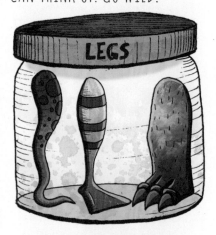

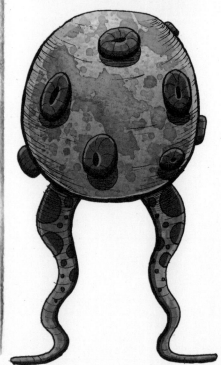

3

SIMILARLY FOR THE HANDS, THERE ARE SO MANY POSSIBILITIES! TRY SIMPLE CLAWS, A BIG HAIRY HAND WITH SHARP NAILS, OR EVEN A CLAW LIKE A SEA CREATURE.

Attach the hands directly to the body, or draw long wavy lines for arms.

MASH-UP

4

FOR INTEREST, GIVE YOUR MONSTER SOMETHING OTHER THAN TWO EYES— TRY ONE LARGE ONE IN THE MIDDLE OF THE HEAD, PUT A FEW ON LITTLE STALKS, OR DRAW ON LOADS!

Draw a head with a similar texture to the body, so that it looks connected.

5

THE MOUTH SHOULD BE QUITE BIG TO MAKE THE MONSTER LOOK SCARY. AND DON'T FORGET THE TEETH! THE SHARPER THE TEETH, THE SCARIER THE MONSTER!

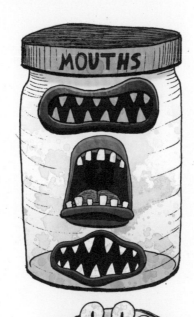

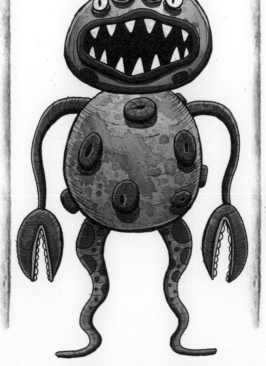

6

ADD MASSIVE HORNS COMING OUT OF THE SIDE OF THE MONSTER'S HEAD OR MAYBE SMALLER ONES ON THE FRONT. DON'T FORGET, YOU DON'T HAVE TO STOP AT JUST TWO!

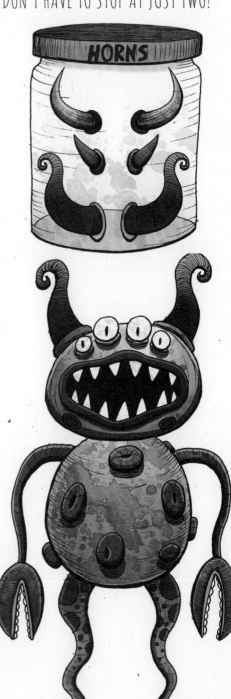

FERRIS WHEEL

1

DRAW TWO OVAL SHAPES TO FORM THE MAIN STRUCTURE OF THE WHEEL. THIS DRAWING USES PERSPECTIVE, SO THE WHEEL WILL LOOK ELLIPTICAL RATHER THAN PERFECTLY ROUND.

2

DRAW TWO PARALLEL GUIDELINES THROUGH THE CENTER OF THE WHEEL. USE THEM TO POSITION TWO MORE ELLIPSES. THEN DRAW PERSPECTIVE LINES RADIATING OUT FROM THE LARGER ELLIPSE.

These parallel guidelines will also help form the central pivot of the Ferris wheel.

3

DRAW A TALL, A-SHAPED BASE IN FRONT OF THE WHEEL, WITH ANOTHER BEHIND IT. ADD A HORIZONTAL CROSSBAR.

Don't worry about wobbly lines or other imperfections. They'll add to the feeling of movement!

4

LIGHTLY SKETCH SPOKES RADIATING OUT FROM THE SMALLER ELLIPSE. ADD A CURVE TO THE LARGER ELLIPSE TO MAKE IT LOOK 3-D. THEN USE SIMPLE ELLIPSES TO FORM THE SHAPES OF THE BASKETS AND PASSENGERS.

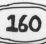

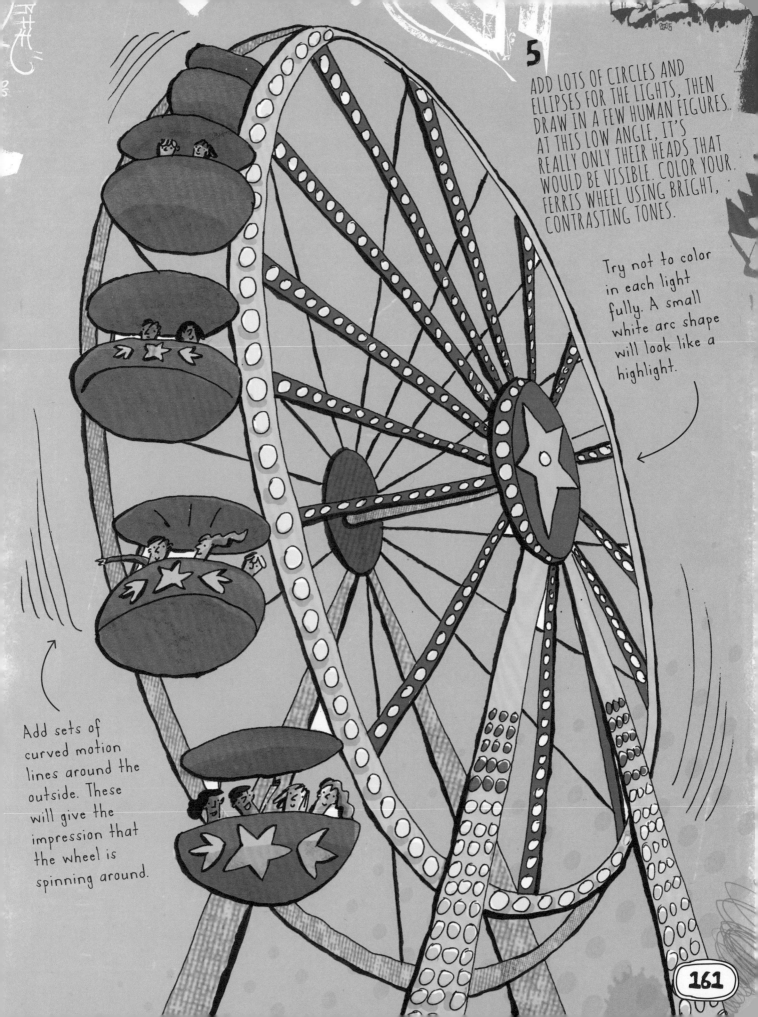

5

ADD LOTS OF CIRCLES AND ELLIPSES FOR THE LIGHTS, THEN DRAW IN A FEW HUMAN FIGURES. AT THIS LOW ANGLE, IT'S REALLY ONLY THEIR HEADS THAT WOULD BE VISIBLE. COLOR YOUR FERRIS WHEEL USING BRIGHT, CONTRASTING TONES.

Try not to color in each light fully. A small white arc shape will look like a highlight.

Add sets of curved motion lines around the outside. These will give the impression that the wheel is spinning around.

SCAREDY-CAT

1 DRAW AN EGG-SHAPED BODY, CONTINUING THE TOP CURVE TO FORM THE CAT'S REAR LEG. ADD SIMPLE SHAPES FOR THE FRONT LEGS AND TAIL. DRAW A CIRCLE FOR THE MOUTH AND A RECTANGLE FOR THE HEAD.

For a more subtle fur texture, apply pressure at the start of each pencil stroke, easing off as your pencil flicks sharply upward.

2 DRAW ROUGH TRIANGULAR SHAPES FOR THE CAT'S CHEEKS AND WHISKERS, AND CIRCLES FOR ITS FEET, TOES, AND EYES. USE THE CURVED LINE RUNNING THROUGH THE FACE TO HELP YOU POSITION AN OPEN MOUTH.

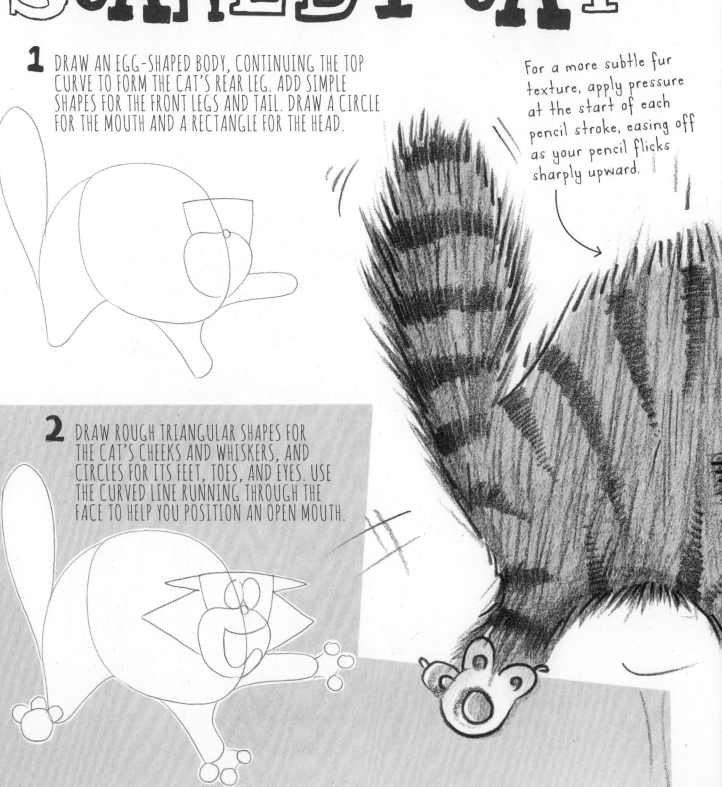

3 WORK ON THE FACIAL DETAILS, ADDING TEETH, WHISKERS, AND A TONGUE. DRAW IN THE TOES AND CLAWS. THEN SKETCH LOTS OF PARALLEL LINES ALONG THE OUTLINE OF THE CAT'S BODY TO SUGGEST FUR STANDING ON END!

Small details will help make your scaredy cat look even more afraid. Draw large ovals for its wide eyes, adding raised eyebrows just above the head. Make the mouth wide open, and use zigzags for the whiskers.

4 DRAW IN THE BODY FUR BY USING SWEEPING PENCIL STROKES IN AN UPWARD DIRECTION. USE SMALLER STROKES TO ADD SOME STRIPES.

5 NOW USE CONTRASTING COLORED PENCILS TO COLOR. THIS PICTURE USES GREEN AND BROWN TONES, WITH CERTAIN AREAS LEFT WHITE, SUCH AS THE EYES AND HIGHLIGHTS ON THE MOUTH AND PAWS. ADD MOVEMENT LINES TO ADD TO THE "SCAREDY-CAT" EFFECT!

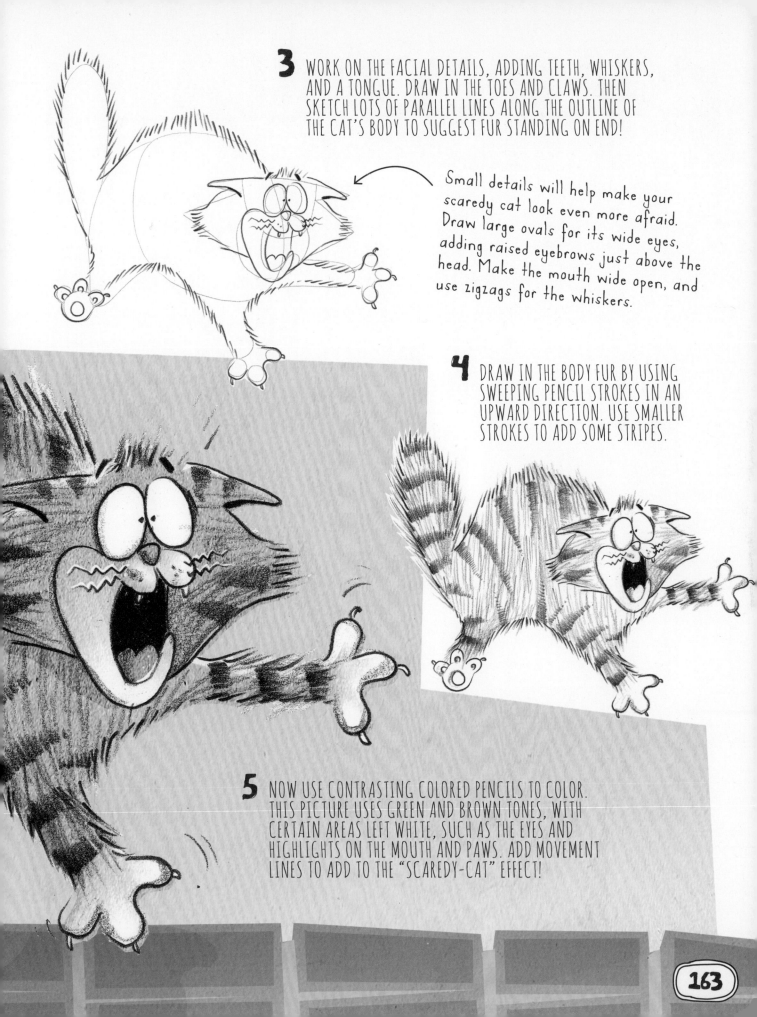

CYBORG

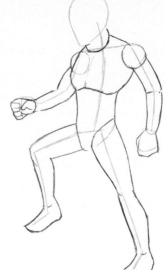

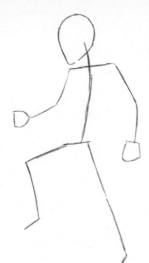

1

DRAW A STICK FIGURE TO SHOW THE BASIC POSE AND PROPORTIONS. SKETCH A SLIGHT CURVE FOR THE BACK AND HORIZONTAL LINES FOR THE HIPS AND SHOULDERS. ADD ARMS AND LEGS AND AN OVAL SHAPE FOR THE HEAD.

2

TO FLESH OUT THE LIMBS, DRAW CYLINDERS AROUND THE STICK LINES, MAKING THE LINES CURVE OUTWARD TO SUGGEST BULGING MUSCLES. ADD IN THE CHEST MUSCLES, PLUS A CIRCLE TO SUGGEST A PUMPED-UP SHOULDER!

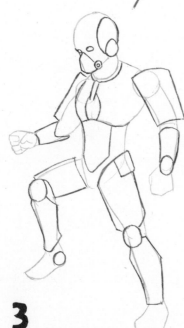

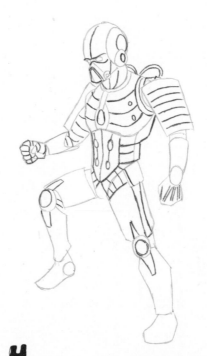

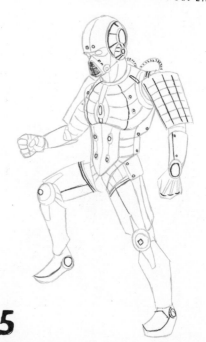

3

ERASE THE STICK LINES. DRAW THE CYBORG'S ARMOR BY SKETCHING SHAPES THAT MIMIC THE BODY PARTS UNDERNEATH, BUT LARGER TO GIVE THE IMPRESSION OF WEIGHT AND THICKNESS. USE CIRCLES FOR THE WRIST, KNEE, AND ANKLE JOINTS.

4

WORK ON THE ARMOR DETAIL. ADD CIRCULAR LIGHTS, AND DRAW CURVED LINES ON THE CHEST AND SHOULDER AREAS. CREATE A SCI-FI FEEL BY ADDING TUBING AND MORE ELABORATE KNEE JOINTS. ADD MORE DETAIL TO THE MASK AND HELMET.

5

REFINE THE DETAIL FURTHER. DRAW RIVETS ON THE ARMOR, LINES ON THE MASK, AND A CRISSCROSS PATTERN ON THE SHOULDER PLATE. ADD LINES TO DIVIDE PARTS OF THE ARMOR INTO SMALLER SECTIONS, SUCH AS THE HELMET AND UPPER LEG AREAS.

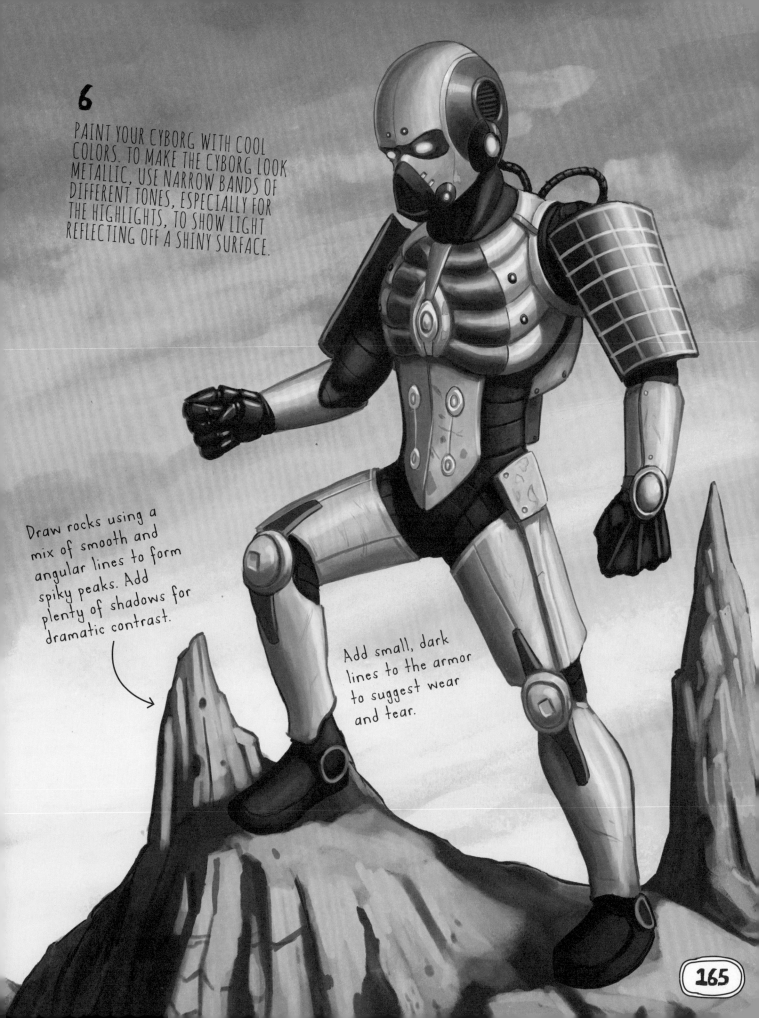

6

PAINT YOUR CYBORG WITH COOL COLORS. TO MAKE THE CYBORG LOOK METALLIC, USE NARROW BANDS OF DIFFERENT TONES, ESPECIALLY FOR THE HIGHLIGHTS, TO SHOW LIGHT REFLECTING OFF A SHINY SURFACE.

Draw rocks using a mix of smooth and angular lines to form spiky peaks. Add plenty of shadows for dramatic contrast.

Add small, dark lines to the armor to suggest wear and tear.

FUNKY CAKE

1 DRAW A SIMPLE, SLIGHTLY CURVED RECTANGLE FOR THE CAKE BASE. ADD THE EDGE OF A PLATE BENEATH.

2 REPEAT THE RECTANGLE SHAPE AS MANY TIMES AS YOU LIKE. IF YOU'RE FEELING HUNGRY AND EXTRA CREATIVE, MAKE IT A REALLY TALL CAKE!

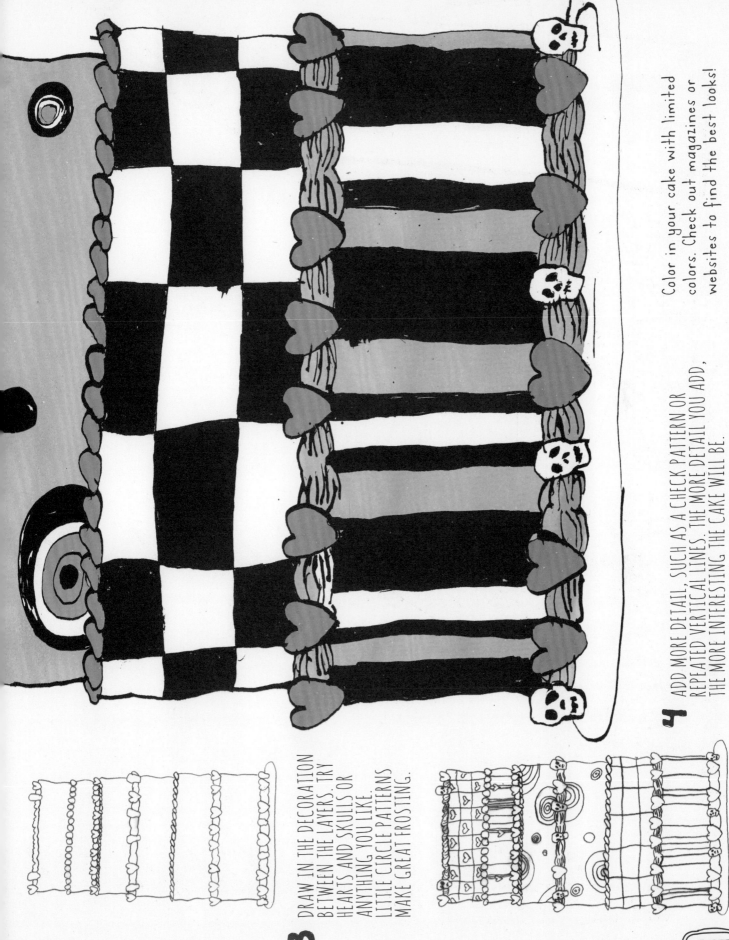

3 DRAW IN THE DECORATION BETWEEN THE LAYERS. TRY HEARTS AND SKULLS OR ANYTHING YOU LIKE. LITTLE CIRCLE PATTERNS MAKE GREAT FROSTING.

4 ADD MORE DETAIL, SUCH AS A CHECK PATTERN OR REPEATED VERTICAL LINES. THE MORE DETAIL YOU ADD, THE MORE INTERESTING THE CAKE WILL BE.

Color in your cake with limited colors. Check out magazines or websites to find the best looks!

167

ROBOT

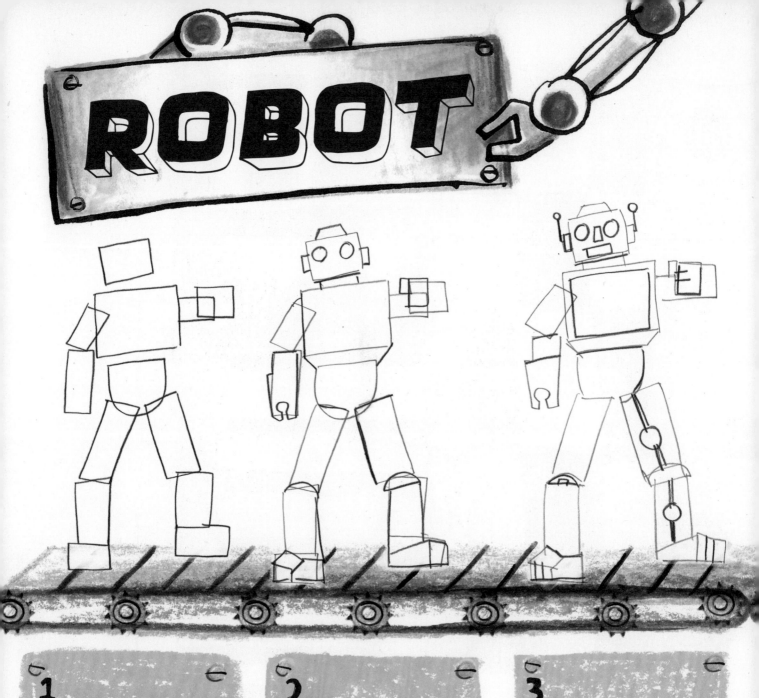

1

USING A LIGHT PENCIL, DRAW SQUARES AND RECTANGLES TO BEGIN THE ROUGH SHAPES OF YOUR ROBOT. INCLUDE A HEAD, BODY, ARMS, LEGS, AND FEET.

2

DRAW THE EYES AND CONNECT THE SQUARES TO MAKE THE ROBOT LOOK MORE SOLID. ADD SHAPES ON THE FEET TO ADD DIMENSION TO THE ROBOT.

3

START ADDING SOME DETAIL. USE SIMPLE SHAPES FOR A FACE, HEADPHONES, AND ANTENNAE. ADD CLAW HANDS TO THE ARMS AND DETAIL TO THE LEGS.

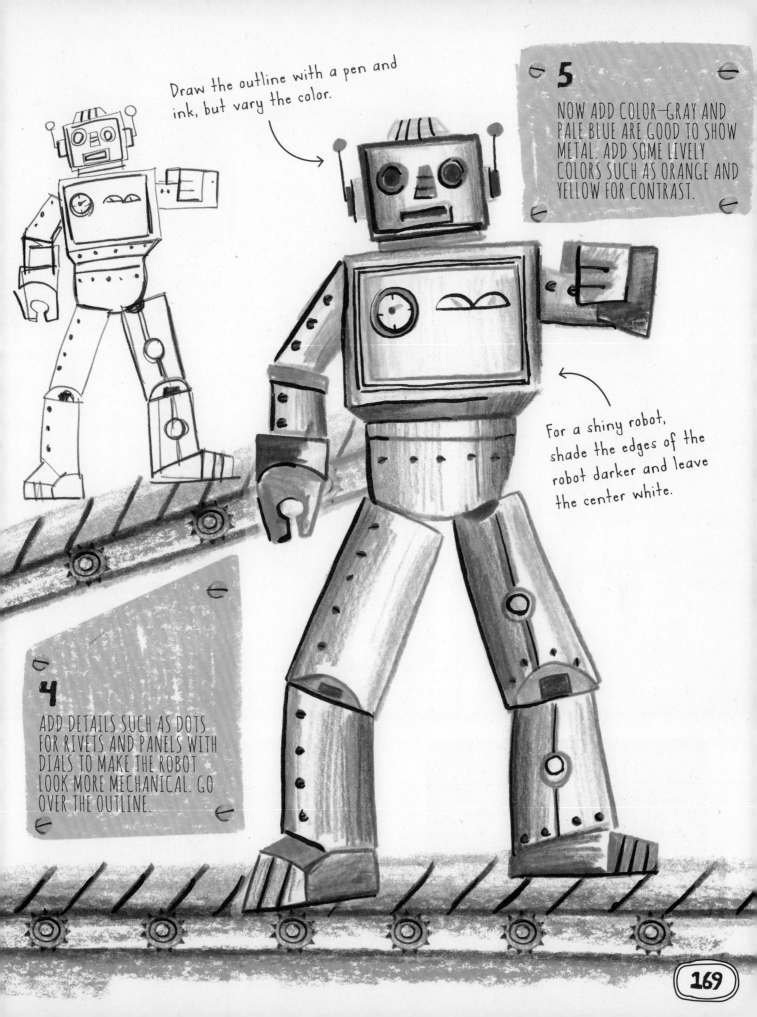

Draw the outline with a pen and ink, but vary the color.

5

NOW ADD COLOR—GRAY AND PALE BLUE ARE GOOD TO SHOW METAL. ADD SOME LIVELY COLORS SUCH AS ORANGE AND YELLOW FOR CONTRAST.

For a shiny robot, shade the edges of the robot darker and leave the center white.

4

ADD DETAILS SUCH AS DOTS FOR RIVETS AND PANELS WITH DIALS TO MAKE THE ROBOT LOOK MORE MECHANICAL. GO OVER THE OUTLINE.

PICTURES IN LIGHTS

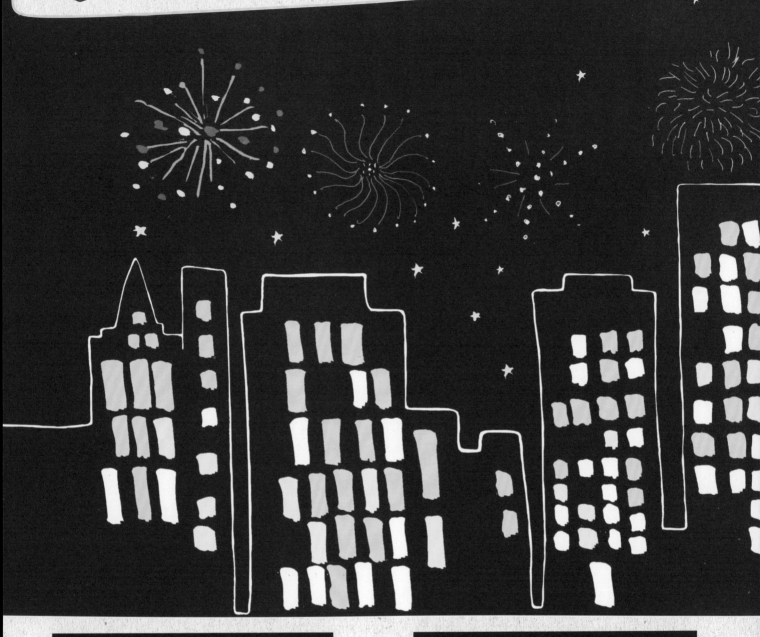

1 DRAW A BASIC CITY SKYLINE OF DIFFERENT-SHAPED BUILDINGS WITH WHITE CHALK OR PAINT ONTO A PIECE OF BLACK CARD STOCK OR PAPER, LIKE THIS.

2 DRAW SMALL WHITE AND YELLOW RECTANGLES TO LIGHT UP ALL THE BUILDINGS, AND MAKE YOUR CITY LOOK BRIGHT AND BUSY.

3 USE LINES, SWIRLS, AND DOTS COMING OUT OF A CENTRAL POINT TO MAKE FIREWORKS. TRY DIFFERENT DESIGNS BEFORE ADDING THEM TO YOUR PICTURE.

4 USE BRIGHT COLORS TO FILL THE NIGHT SKY WITH YOUR FIREWORK DESIGNS. ADD A FEW BRIGHT STARS INTO THE PICTURE, TOO.

CARTOON CUTE ANIMALS

LEARN TO DRAW DIFFERENT FEATURES, THEN HAVE FUN PUTTING THEM TOGETHER TO CREATE YOUR OWN CUTE CARTOON ANIMALS.

TAILS

THINK SHAGGY AND WAGGY OR THIN AND CURLY—TAILS CAN ADD A LOT OF CHARACTER TO YOUR ANIMALS!

NOSES

TRY AN UPSIDE-DOWN TRIANGLE FOR A NOSE AND SIMPLE LINES FOR A MOUTH. USE PENCIL STROKES FLICKING OUTWARD FOR WHISKERS.

EYES

EXPERIMENT WITH DIFFERENT-SHAPED EYELIDS—THE SLANT OF THE LINE CAN MAKE YOUR CHARACTER LOOK MEAN, CROSS, OR SAD. USE A SMALL CIRCLE FOR AN EYE GLINT.

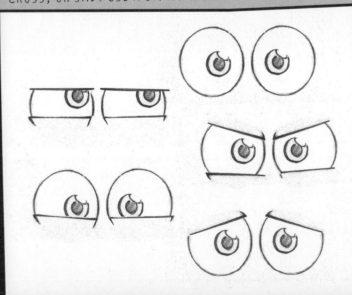

PAWS

HERE ARE SOME SIMPLE SHAPES YOU CAN USE FOR PAWS AND HOOFS. BIG PAWS RELATIVE TO A BODY CAN EMPHASIZE THE CARTOON FEEL.

Add dark colors and shadows to give dimension to the cartoon figures.

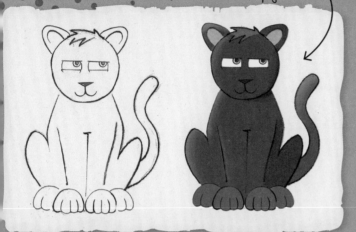

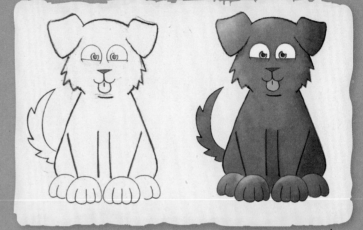

Cartoon characters are just that—cartoons! They don't need to look real, so you can use realistic colors, but try wacky ones, too!

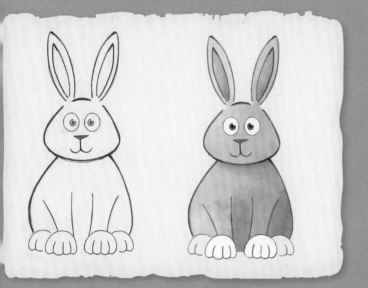

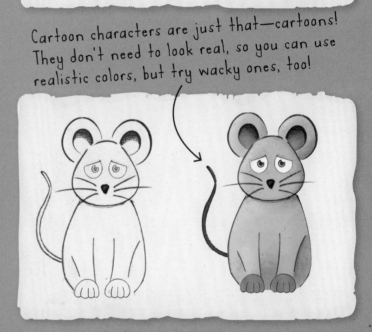

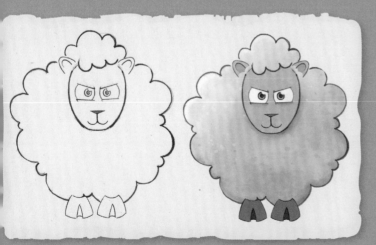

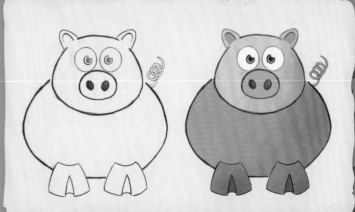

SURFER

1 DRAW A VERTICAL ELLIPSE WITH POINTED ENDS FOR THE SURFBOARD. DRAW STICK LINES FOR THE SURFER'S LIMBS, HIPS, SHOULDERS, AND TORSO. FOR THE CROUCHING POSITION, DRAW THE LEGS BENT AT THE KNEES, WITH THE UPPER BODY LEANING FORWARD SLIGHTLY. ADD A CIRCLE HEAD.

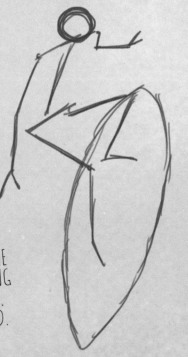

2 FLESH OUT YOUR FIGURE'S BODY PARTS, USING SAUSAGE SHAPES FOR HIS LIMBS. DRAW CIRCLES FOR HIS KNEE JOINTS AND ADD ROUGH SHAPES FOR HIS HANDS.

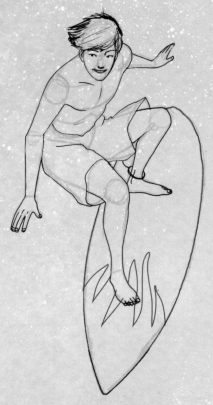

3 SKETCH THE POSITIONS OF THE FACIAL FEATURES, AND ADD AN OUTLINE FOR THE HAIR. DRAW THE SHAPE OF THE BAGGY SURF TRUNKS, THEN ADD FINGERS.

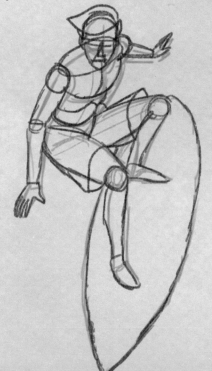

4 REFINE THE SURFER'S BODY AND FACIAL FEATURES, AND DRAW IN THE TEXTURE OF HIS HAIR. ADD A FLAME DESIGN TO THE SURFBOARD USING WOBBLY ZIGZAG LINES. ERASE ANY GUIDELINES.

5 PAINT YOUR SURFER'S SKIN USING A FLAT BROWN COLOR. THEN USE PALER HUES ON TOP TO BRING OUT HIS MUSCLE TONE, WITH BANDS OF WHITE FOR HIGHLIGHTS. GIVE HIM A NECKLACE AND BRACELET, AND PAINT A FLOWERY DESIGN ON HIS SHORTS. COLOR THE FLAMES RED FOR DRAMATIC IMPACT.

Add sea spray by dipping an old toothbrush in white paint. Then run your finger along the bristles to flick tiny dots of paint onto the picture.

Choose a simple but striking color scheme. Here, the red flames contrast well with the green of the surfer's shorts.

Paint the background with a big brush. Use watercolor washes in different shades of blue, starting with a lighter tone first, before merging in slightly darker areas.

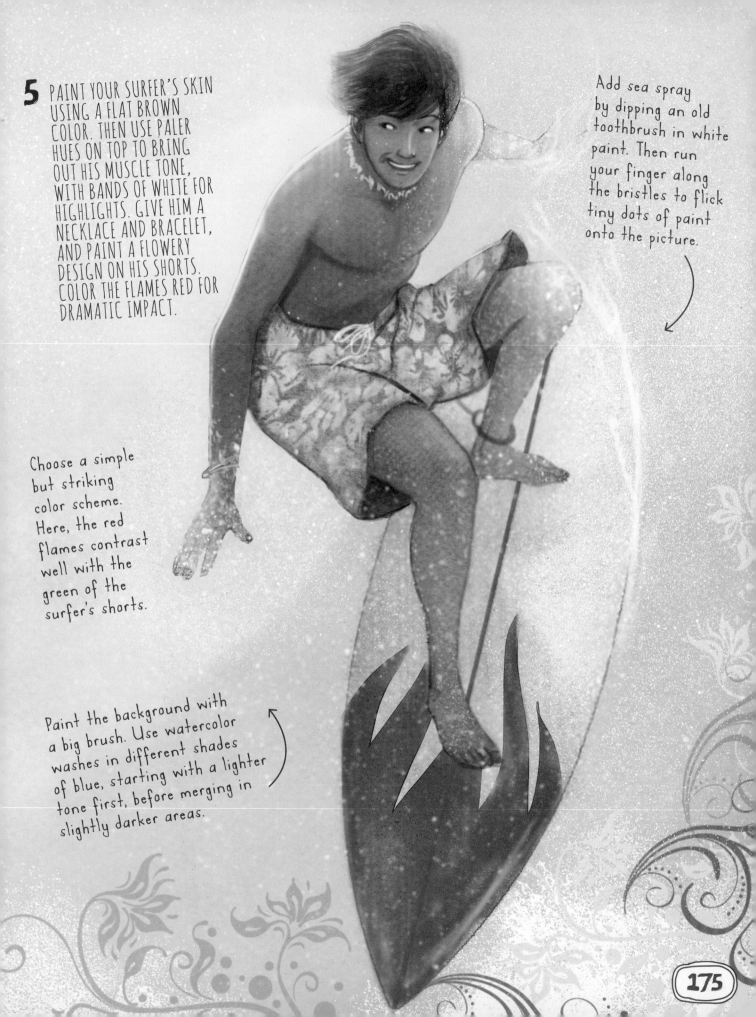

COOL SHADES

TRY SKETCHING A SIMPLE PAIR OF GLASSES, THEN GET CREATIVE AND VARY THESE FOR SOME OF YOUR OWN COOL DESIGNS.

1 SKETCH TWO ROUNDED LENS SHAPES, THEN DRAW AN EXTRA LINE AROUND EACH ONE TO CREATE THE FRAMES. ADD A BRIDGE WHERE THE SHADES SIT ON THE NOSE, PLUS AN EXTRA BAR ABOVE THAT, IF YOU WANT.

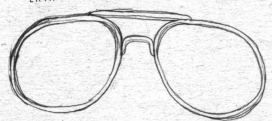

2 DRAW THE ARMS OF YOUR GLASSES. THEY WILL BE PARTIALLY VISIBLE THROUGH THE SHADES, SO, ADD A CROSSHATCH EFFECT ON THE LENSES, LEAVING CERTAIN AREAS WHITE TO GIVE THE EFFECT OF REFLECTIONS ON THE GLASS.

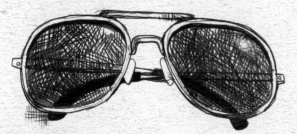

3 TRY DRAWING THE SAME PAIR OF GLASSES FROM A SIDEWAYS PERSPECTIVE WITH THE ARMS STRAIGHTENED OUT, LIKE THIS. THE LENS AND ARM NEAREST TO US WILL NEED TO LOOK SLIGHTLY BIGGER.

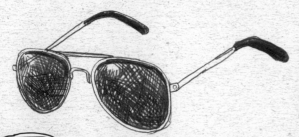

NOW THINK ABOUT HOW YOUR SHADES WILL LOOK ON SOMEONE'S FACE. HOW REFLECTIVE OR TRANSPARENT WILL THEY BE?

You could draw your shades as flat, black circles. Add narrow bands of white for reflections.

When drawing shades in profile, the nearer lens will look more like an ellipse. The other will only be partially visible.

To draw highly reflective glasses, add white, wavy bands on top of a dark base color.

SHADES CAN BE PLAIN OR PATTERNED, AND CAN COME IN ALL KINDS OF SHAPES AND SIZES ...

STANDARD SHAPE

STANDARD FRAMES ARE BASICALLY SQUARES WITH CURVED EDGES. EXPERIMENT WITH DIFFERENT SHAPES, CHOOSING HEAVY BLACK FRAMES, OR EVEN ONES WITH AN UNUSUAL STRIPED EFFECT!

SECRET AGENT

STRIPY

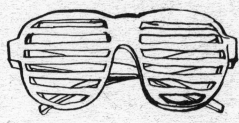

PATTERNED SHADES

A SIMPLE REPEATED MOTIF IS GOOD FOR DECORATING YOUR FRAMES, SUCH AS THESE THIN LINES. YOU COULD ALSO TRY GIVING YOUR FRAMES A MOTTLED PAINT EFFECT.

HALF-PATTERNED FRAMES

PATTERNED LENSES

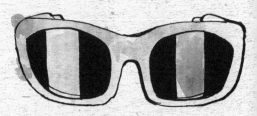

SHAPED FRAMES

PLAY AROUND WITH DIFFERENT SHAPES AND STYLES. FROM POINTY EDGES TO LOVE HEARTS, THEY CAN BE ANY SHAPE YOU LIKE.

DIAMANTÉ BLING

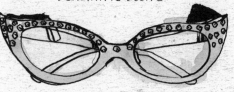

LOVE HEARTS

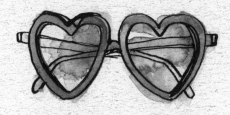

POP IDOL

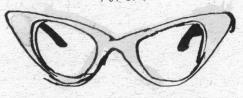

SQUARE

STARS

STATEMENT SHADES

EVEN A BASIC STYLE OF FRAME CAN BE LIVENED UP BY ADDING QUIRKY DETAILS OR A REFLECTIVE PATTERN TO THE LENSES.

WACKY WINDSHIELD WIPERS

SKI CHIC

177

FRANKENSTEIN'S MONSTER

1

DRAW BASIC GUIDE SHAPES FOR THE MONSTER'S HEAD, BODY, LEGS, AND HANDS.

2

USE SAUSAGE SHAPES TO BUILD UP HIS FEET AND LIMBS. ADD THE FINGERS, DRAWING SMALL CIRCLES AT THE END OF EACH ONE.

Draw sausage shapes for the ears and eyebrows, adding round and triangular shapes for the other facial features.

3

POLISH THE OUTLINE OF THE MONSTER, AND DRAW SOME CLOTHES. ADD MORE DETAIL TO THE HANDS AND HEAD.

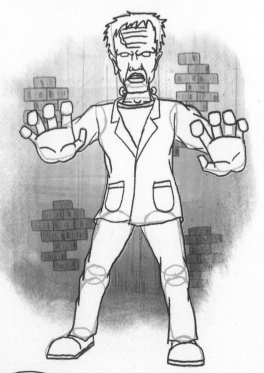

4

SHADE THE PARTS OF YOUR MONSTER THAT ARE IN SHADOW. USE MORE SHADING FOR THE CREASES IN HIS CLOTHES, AND ADD SOME TO HIS FACE TO EMPHASIZE HIS SCARY EYES!

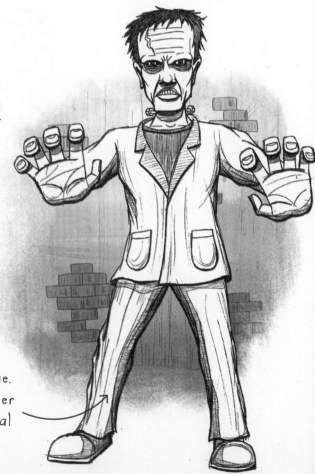

Use a fine point for this shading technique. Make areas look darker with rows of horizontal or vertical lines.

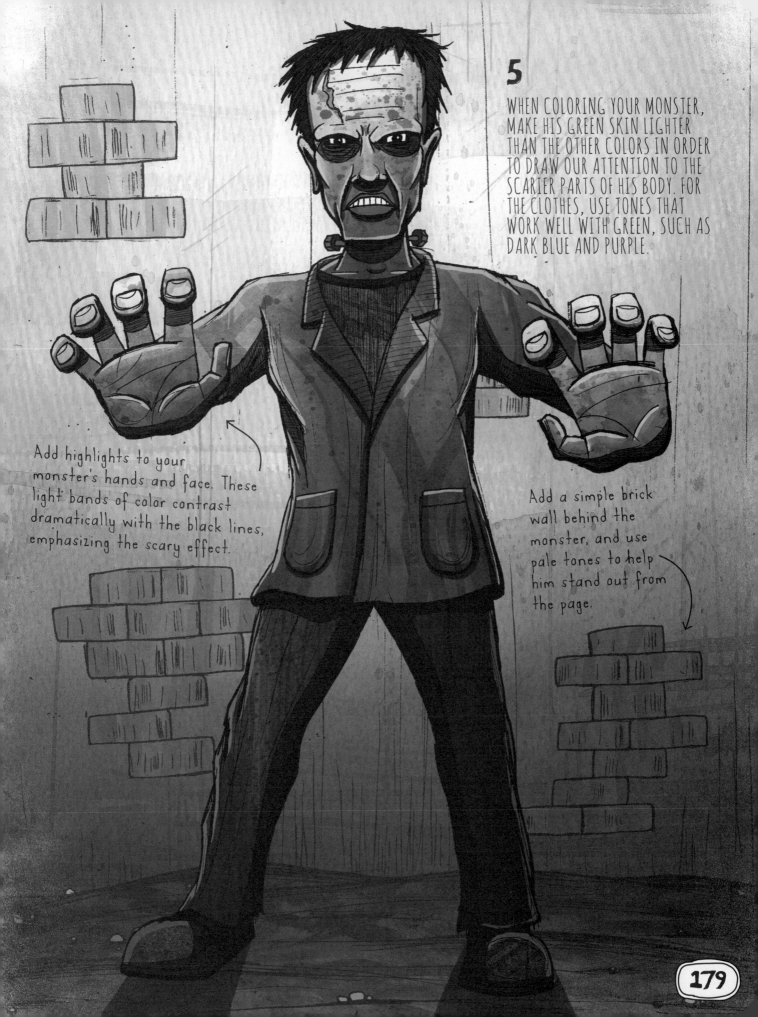

5

WHEN COLORING YOUR MONSTER, MAKE HIS GREEN SKIN LIGHTER THAN THE OTHER COLORS IN ORDER TO DRAW OUR ATTENTION TO THE SCARIER PARTS OF HIS BODY. FOR THE CLOTHES, USE TONES THAT WORK WELL WITH GREEN, SUCH AS DARK BLUE AND PURPLE.

Add highlights to your monster's hands and face. These light bands of color contrast dramatically with the black lines, emphasizing the scary effect.

Add a simple brick wall behind the monster, and use pale tones to help him stand out from the page.

Woodland Animals

1

STARTING WITH A LIGHT PENCIL, DRAW CIRCLES FOR A SQUIRREL'S HEAD, LEG, AND NUT. SKETCH IN EARS, ARMS, LEGS, AND A BUSHY TAIL.

2

ADD THE NOSE, EYE, AND WHISKERS. BUILD THE SHAPE BY SMOOTHING OUT THE CURVES. ERASE ANY GUIDELINES.

3

USE DIFFERENT TONES OF THE SAME COLOR TO SHADE IN THE FUR. THIS WILL CREATE THE EFFECT OF VOLUME. NOTICE WHERE THE FUR IS DARKER OR LIGHTER.

ANIMAL FUR

Use short pencil strokes, mixing different tones of the main color. The direction of the strokes should follow the shape of the animal.

1 DRAW THE FOX'S SHAPE USING CIRCLES AND TRIANGLES. ADD A BEAN SHAPE FOR THE BODY, THEN ADD THE LEGS. NOTICE THE WAY THE BACK LEGS BEND.

1 TO DRAW A DEER, USE CIRCLES FOR THE HEAD AND KNEES, AND RECTANGLES FOR THE NECK, BODY, AND LEGS.

2 USING THE SHAPES AS A GUIDE, SMOOTH AND SOFTEN THE OUTLINE OF THE SHAPE. ADD EARS, NOSE, AN EYE, MOUTH, AND TAIL.

3 ERASE THE GUIDELINES AND ADD SOME COLOR. BLEND DIFFERENT BROWN PENCILS TO CREATE THE FUR, AND ADD STROKES OF WHITE PAINT FOR THE DOTS. USE BLACK INK FOR THE FINAL DETAILS. AND HOOVES.

2 DRAW AROUND YOUR GUIDELINES TO SMOOTH OUT THE FOX SHAPE. ADD DOTS FOR THE EYES AND NOSE. DRAW THE TAIL LIKE THE SHAPE OF A LETTER S.

3 ERASE ANY GUIDELINES, THEN USE COLORED PENCILS TO DRAW THE FUR, FOLLOWING THE DIRECTION OF THE FOX'S SHAPE. ADD THE EYES, NOSE, MOUTH, AND WHISKERS TO GIVE THE FOX PERSONALITY.

Add mushrooms to create a colorful scene. Use a rounded triangle for the cap and a rectangle for the stalk. Draw circles for spots, then color it all in.

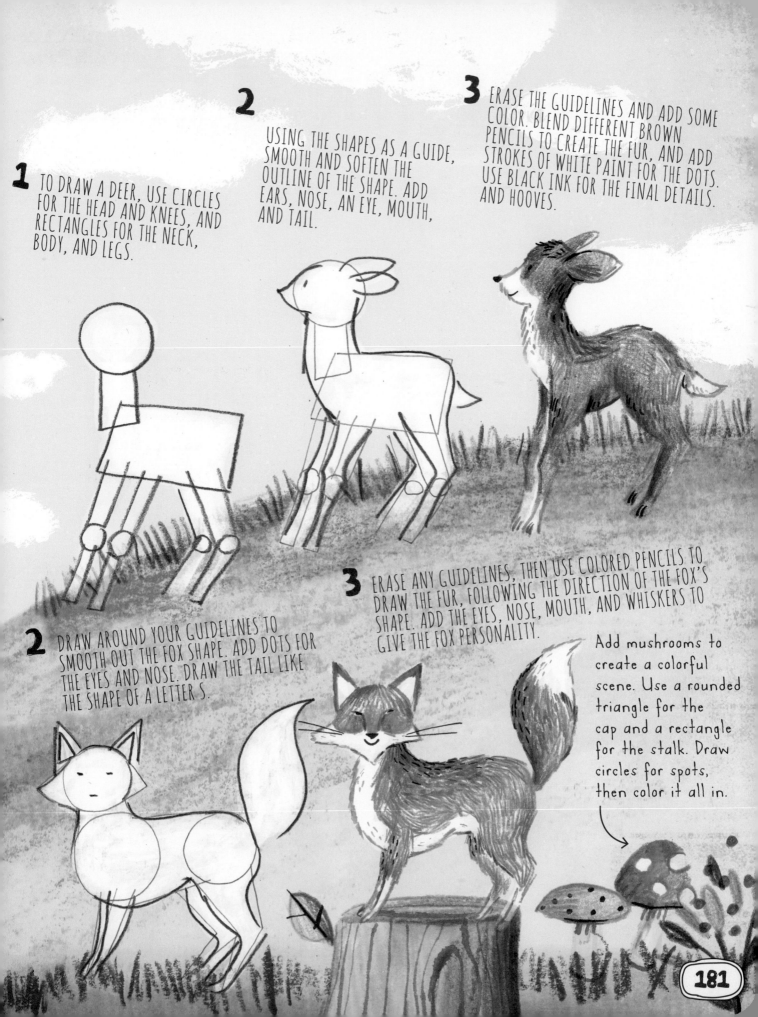

181

MOUNTAIN BIKE

1 DRAW A LARGE CIRCLE FOR THE BACK WHEEL. SKETCH A SIMPLE 'H' SHAPE LEANING BACKWARD NEXT TO IT. THIS FORMS THE BASIC SHAPE OF THE BIKE'S FRAME.

2 DRAW THE FRONT WHEEL BY ADDING ANOTHER CIRCLE THE SAME SIZE AS THE FIRST ONE. SKETCH A SMALLER CIRCLE FOR THE CHAIN WHEEL, THEN ADD A DIAGONAL LINE FROM THE CENTER OF THIS WHEEL TO THE FRONT PART OF THE FRAME.

The two spokes of the 'H' frame need to go through the center of both the front wheel and chain wheel.

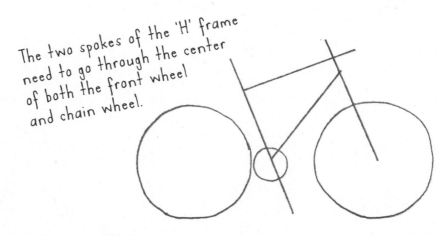

3 ADD SMALL ELLIPSES FOR THE SEAT AND HANDLEBARS, WITH LITTLE RECTANGLES TO MARK THE POSITIONS OF THE PEDAL. SKETCH ANOTHER CIRCLE FOR THE REAR CHAIN WHEEL.

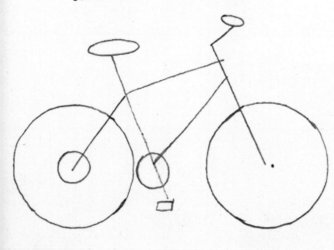

4 FOLLOWING YOUR GUIDES, DRAW TWO PARALLEL LINES FOR EACH PART OF THE BICYCLE FRAME. SKETCH A LARGER CIRCLE AROUND EACH WHEEL SHAPE, AND ADD SMALLER ONES FOR THE GEAR SYSTEM. DRAW SETS OF PARALLEL LINES FOR THE SPOKES.

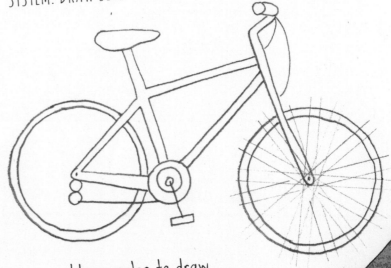

Use a ruler to draw the spokes for a professional-looking bike.

5 ERASE ANY LINES THAT AREN'T NEEDED. REFINE THE SPIKY SHAPE OF THE CHAIN WHEEL, AND ADD OTHER DETAILS, SUCH AS THE WAVY BIKE CHAIN AND BRAKE CABLES AND PADS BETWEEN THE HANDLEBARS AND FRONT WHEEL.

Don't worry if the spoke lines are incomplete. The faintness of the line work suggests that the spokes are very thin.

6 GO OVER YOUR LINE WORK IN PEN AND INK. CHOOSE A BRIGHT COLOR FOR THE FRAMEWORK TO CONTRAST WITH THE DARK TIRES. ADD MARKINGS TO THE FRAME FOR EXTRA VISUAL INTEREST.

Add a simple background in a contrasting tone to make your bike stand out from the page.

Try using a fine paintbrush and black India ink to add shadows and depth to your bike.

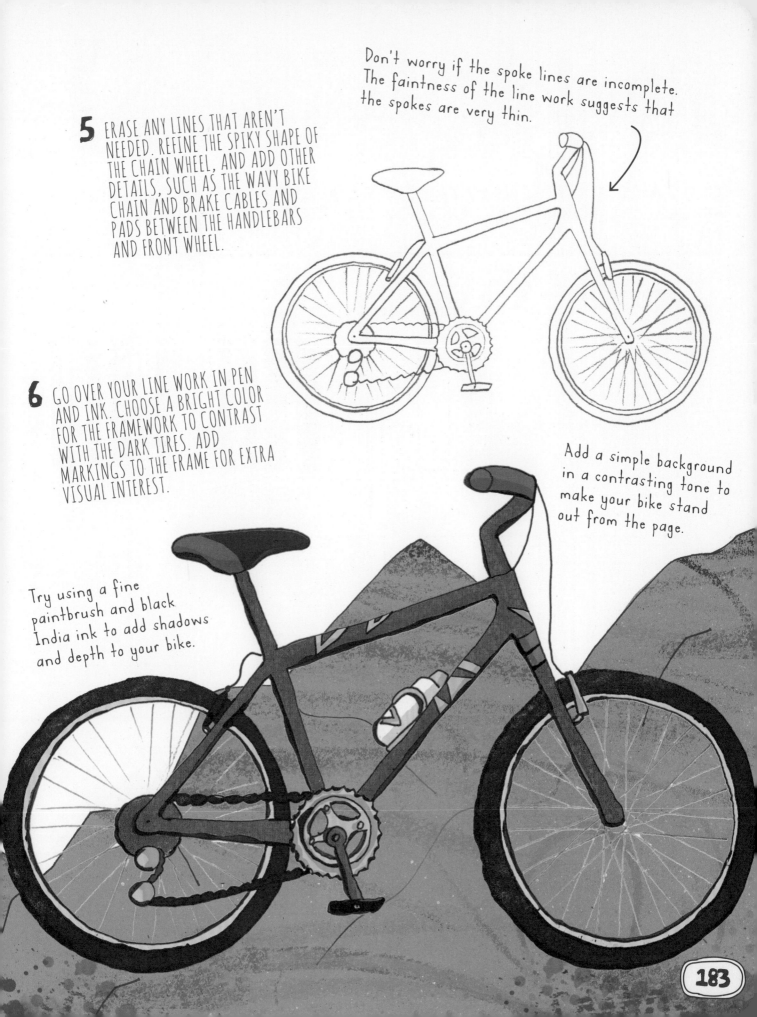

Straight Patterns

IT IS AMAZING HOW MANY PATTERNS YOU CAN INVENT USING THE HUMBLE LINE! DOODLE SOME LINES, AND SEE WHAT YOU COME UP WITH.

Lines and Stripes

SIMPLE HAND-DRAWN VERTICAL LINES CAN MAKE A SURPRISINGLY SOPHISTICATED DESIGN. TRY THIN AND THICK STYLES OF STRIPES AND THEN COMBINE THEM. HAVE A COUPLE OF DIFFERENT-SIZED PENS AND BRUSHES ON HAND TO FIND WHAT WORKS BEST.

Draw pinstripes with a fine pen or brush.

A flat brush will make wide stripes.

The two styles combined look fab!

Use tonal colors of different widths.

Draw contrasting horizontal stripes.

Combine them to make a plaid pattern!

CHANGING THE DIRECTION, WIDTH AND COLOR OF THE LINES ADDS TO THE VARIETY OF PATTERNS YOU CAN ACHIEVE. OVERLAPPING COLORS CAN ADD TO THE PATTERN IN SURPRISING WAYS.

BUILDING UP CRISS-CROSS DIAGONALS IN DIFFERENT LINE WIDTHS CAN LOOK QUITE ORGANIC. TRY COMBINING TWO SIMPLE PATTERNS ON TOP OF EACH OTHER. TRY THIS WITH INK ON ABSORBENT PAPER TO GET A FUZZY EDGE TO THE LINES.

Mix up the width and direction.

Change the corner-to-corner direction.

Lay one pattern on top of the other.

Zigzags

ADD A SPLASH OF ZINGY COLOR TO BLACK AND WHITE TO CREATE A LIVELY ZIGZAG PATTERN.

Dotted lines help keep the zigzags symmetrical.

Experiment with thin and thick zigzags.

Alternate between zigzags in ink and paint.

Use your imagination to combine new patterns you have invented.

Grid Squares

WORKING ON GRAPH PAPER CREATES A REGULAR, MOSAIC EFFECT.

Using two colors, block in the squares to make diamond shapes. Experiment with different variations. Think of the squares you haven't colored as part of the pattern, too. When you have a couple of designs, try combining them.

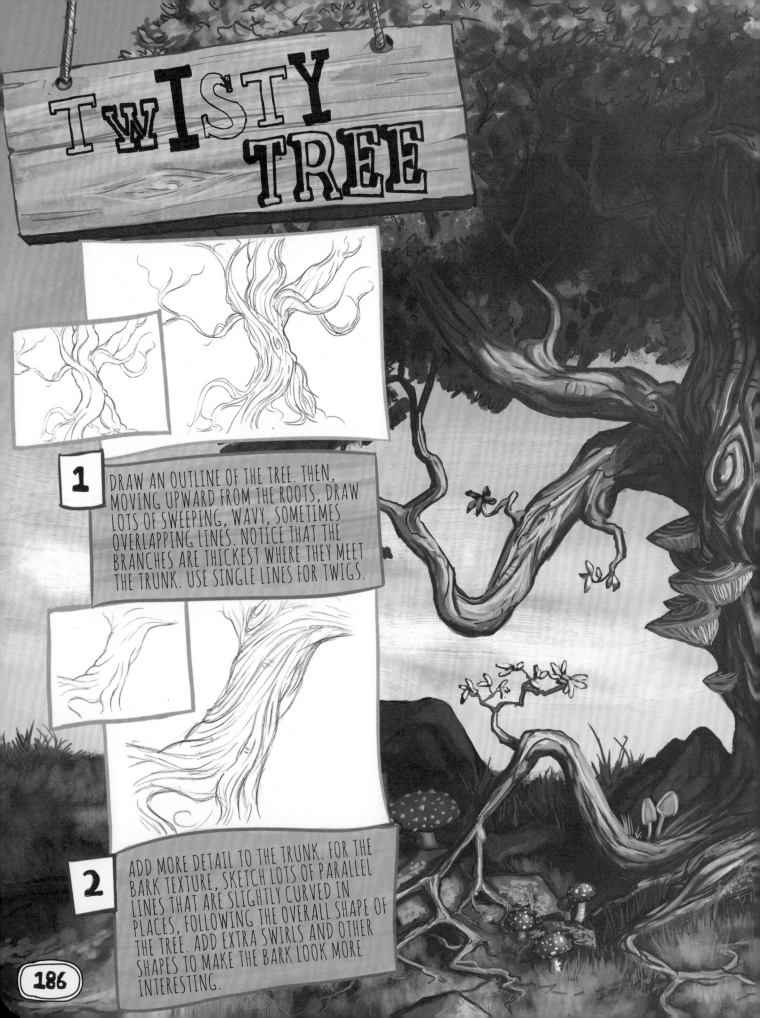

TWISTY TREE

1 DRAW AN OUTLINE OF THE TREE. THEN, MOVING UPWARD FROM THE ROOTS, DRAW LOTS OF SWEEPING, WAVY, SOMETIMES OVERLAPPING LINES. NOTICE THAT THE BRANCHES ARE THICKEST WHERE THEY MEET THE TRUNK. USE SINGLE LINES FOR TWIGS.

2 ADD MORE DETAIL TO THE TRUNK. FOR THE BARK TEXTURE, SKETCH LOTS OF PARALLEL LINES THAT ARE SLIGHTLY CURVED IN PLACES, FOLLOWING THE OVERALL SHAPE OF THE TREE. ADD EXTRA SWIRLS AND OTHER SHAPES TO MAKE THE BARK LOOK MORE INTERESTING.

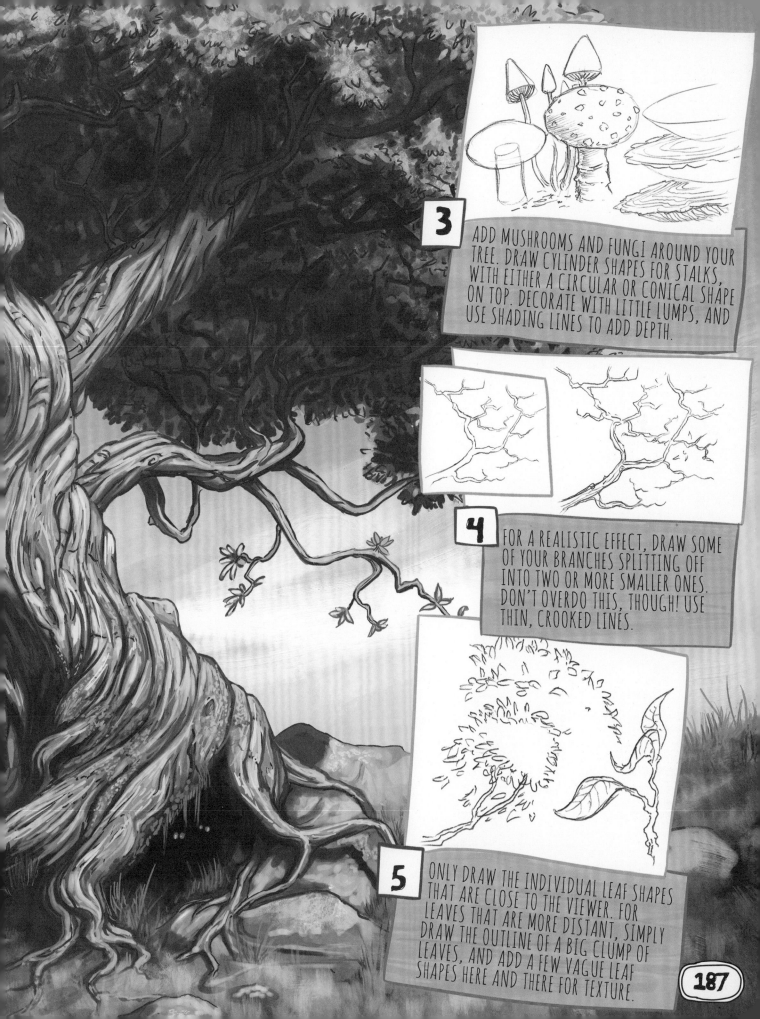

3 ADD MUSHROOMS AND FUNGI AROUND YOUR TREE. DRAW CYLINDER SHAPES FOR STALKS, WITH EITHER A CIRCULAR OR CONICAL SHAPE ON TOP. DECORATE WITH LITTLE LUMPS, AND USE SHADING LINES TO ADD DEPTH.

4 FOR A REALISTIC EFFECT, DRAW SOME OF YOUR BRANCHES SPLITTING OFF INTO TWO OR MORE SMALLER ONES. DON'T OVERDO THIS, THOUGH! USE THIN, CROOKED LINES.

5 ONLY DRAW THE INDIVIDUAL LEAF SHAPES THAT ARE CLOSE TO THE VIEWER. FOR LEAVES THAT ARE MORE DISTANT, SIMPLY DRAW THE OUTLINE OF A BIG CLUMP OF LEAVES, AND ADD A FEW VAGUE LEAF SHAPES HERE AND THERE FOR TEXTURE.

187

THIS IS A VERY JAPANESE STYLE OF DRAWING! SEE PAGES 120 AND 121 FOR A COOL MANGA GIRL.

1

USING A LIGHT PENCIL, LOOSELY SKETCH SOME GUIDELINES TO GET THE FEEL OF THE MANGA BOY'S POSE. ANGLE THE SHOULDERS AND HEAD TO GIVE HIM SOME ATTITUDE.

2

SKETCH THE OUTLINE SHAPE OF THE FIGURE. EXAGGERATE THE FEATURES SLIGHTLY, SO MAKE THE HEAD A LITTLE BIGGER THAN NORMAL. GO OVER YOUR LINES UNTIL YOU'RE HAPPY WITH THE PROPORTIONS.

3

START WORKING ON THE OUTLINE OF THE HANDS, HAIR, AND FACE. ADD THE BASIC OUTLINE FOR THE SWEATSHIRT, JEANS, AND SNEAKERS. THE CLOTHES ARE PART OF THE MANGA CHARACTER.

 EYES

You don't need too much detail for manga facial features. Experiment with line shapes to get the right expression for your character's eyes.

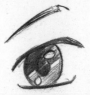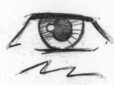

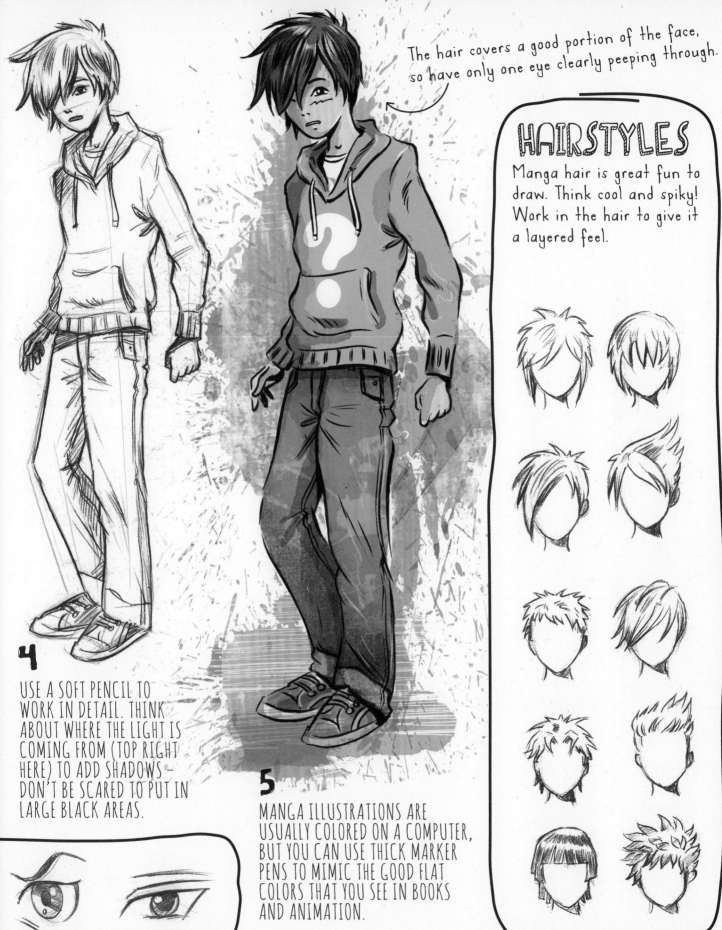

The hair covers a good portion of the face, so have only one eye clearly peeping through.

HAIRSTYLES

Manga hair is great fun to draw. Think cool and spiky! Work in the hair to give it a layered feel.

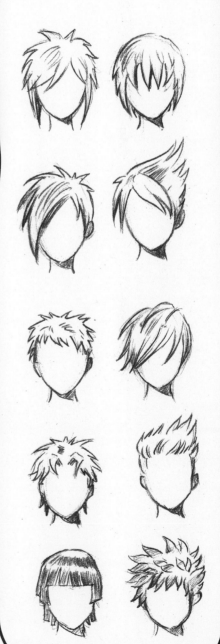

4

USE A SOFT PENCIL TO WORK IN DETAIL. THINK ABOUT WHERE THE LIGHT IS COMING FROM (TOP RIGHT HERE) TO ADD SHADOWS — DON'T BE SCARED TO PUT IN LARGE BLACK AREAS.

5

MANGA ILLUSTRATIONS ARE USUALLY COLORED ON A COMPUTER, BUT YOU CAN USE THICK MARKER PENS TO MIMIC THE GOOD FLAT COLORS THAT YOU SEE IN BOOKS AND ANIMATION.

SUBMARINE

1 DRAW A LARGE OVAL WITH A SLIGHTLY POINTED TIP. ADD A CURVED FIN AT THE BACK AND ANOTHER CURVED SHAPE AT THE FRONT. SKETCH A LONG LINE RUNNING ALONG THE MIDDLE.

2 DRAW EXTRA ROUNDED SHAPES ON THE TOP OF YOUR SUB, ADDING A CURVED FIN ON THE NEAR SIDE. DRAW TWO WINDOWS ON THE SIDE, MAKING ONE ELLIPTICAL TO REINFORCE THE SENSE OF PERSPECTIVE.

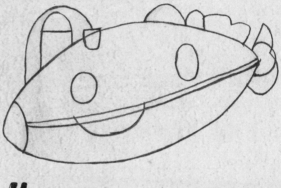

3 ADD THREE RECTANGULAR FUNNELS AT THE REAR, EACH WITH A CONE SHAPE ON TOP. DRAW CURVED LINES FOR THE PROPELLERS. SKETCH THE OUTLINE OF THE BRIDGE WITH A CURVED PERISCOPE ON TOP. ADD MORE CURVED LINES AT THE FRONT.

4 WORK ON THE FINE DETAIL. DRAW EXTRA LINES AND CIRCLES ON THE WINDOW FRAMES, THEN ADD SWIRLS AND COILS TO THE FRONT FOR AN OLD-FASHIONED, DECORATIVE EFFECT. DRAW CURVED, DOTTED LINES ON THE BODY TO SUGGEST IT'S BEEN RIVETED TOGETHER.

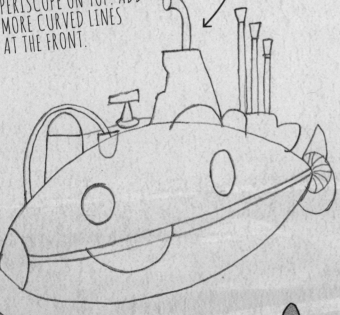

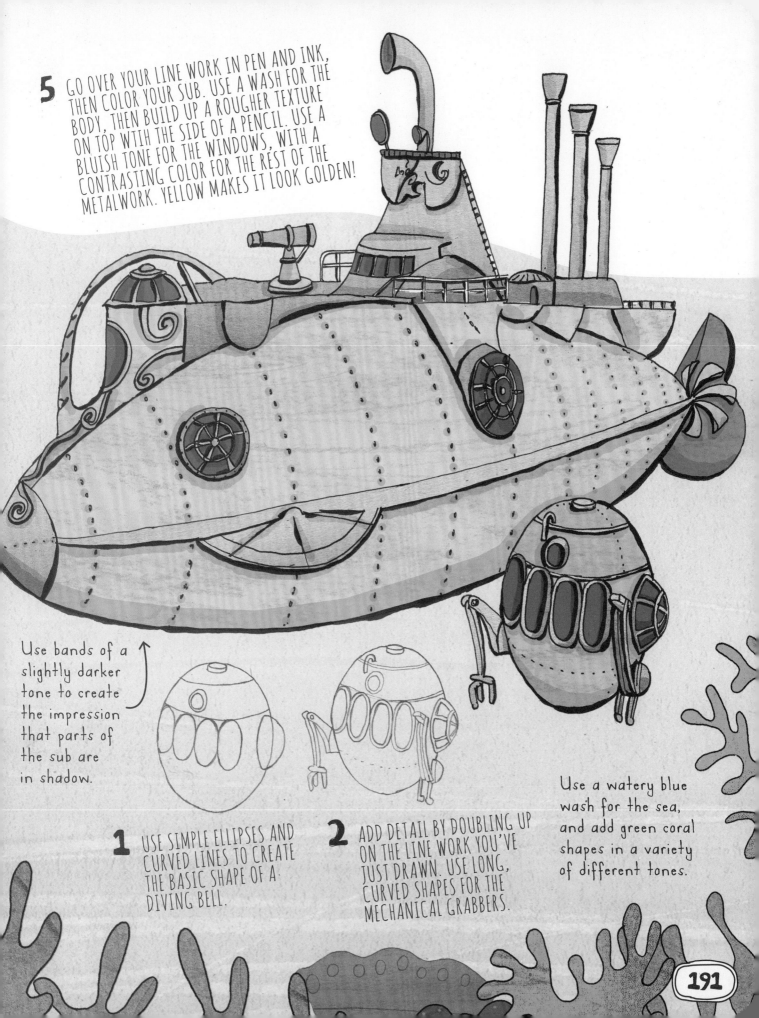

5 GO OVER YOUR LINE WORK IN PEN AND INK, THEN COLOR YOUR SUB. USE A WASH FOR THE BODY, THEN BUILD UP A ROUGHER TEXTURE ON TOP WTIH THE SIDE OF A PENCIL. USE A BLUISH TONE FOR THE WINDOWS, WITH A CONTRASTING COLOR FOR THE REST OF THE METALWORK. YELLOW MAKES IT LOOK GOLDEN!

Use bands of a slightly darker tone to create the impression that parts of the sub are in shadow.

1 USE SIMPLE ELLIPSES AND CURVED LINES TO CREATE THE BASIC SHAPE OF A DIVING BELL.

2 ADD DETAIL BY DOUBLING UP ON THE LINE WORK YOU'VE JUST DRAWN. USE LONG, CURVED SHAPES FOR THE MECHANICAL GRABBERS.

Use a watery blue wash for the sea, and add green coral shapes in a variety of different tones.

TROLL

1 USE A PENCIL TO DRAW THE BASIC SHAPE OF THE TROLL. DON'T ADD DETAIL YET—THE AIM IS TO GET THE PROPORTIONS RIGHT FIRST. DRAW THE HEAD LOW ON THE SHOULDERS, AND GIVE YOUR TROLL A WIDE BODY AND CLUB.

2 WHEN YOU ARE HAPPY WITH THE PROPORTIONS, START ADDING GUIDELINES FOR THE FACE, HAIR, AND CLOTHES.

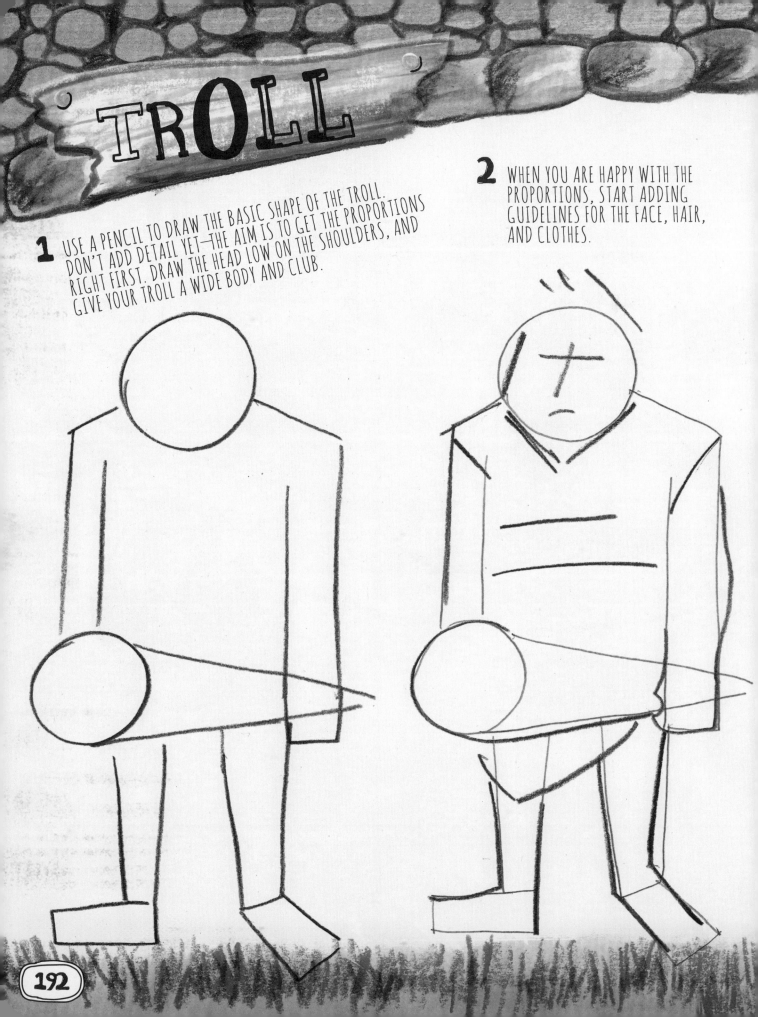

3 NOW BEGIN ADDING DETAIL. DRAW THE HAIRLINE LOW ON THE BROW, HEAVY EYEBROWS, A POINTY NOSE, EARS, A DOWN-TURNED MOUTH. ADD RIPPED EDGES TO THE CLOTHES, AND START FLESHING OUT THE BODY AND CLUB.

4 USE SLUDGY GREEN WATERCOLOR PENCILS AND DRAW YOUR OUTLINE IN BROWN. ADD FINISHING TOUCHES, SUCH AS TUFTS OF HAIR, WITH PEN AND INK.

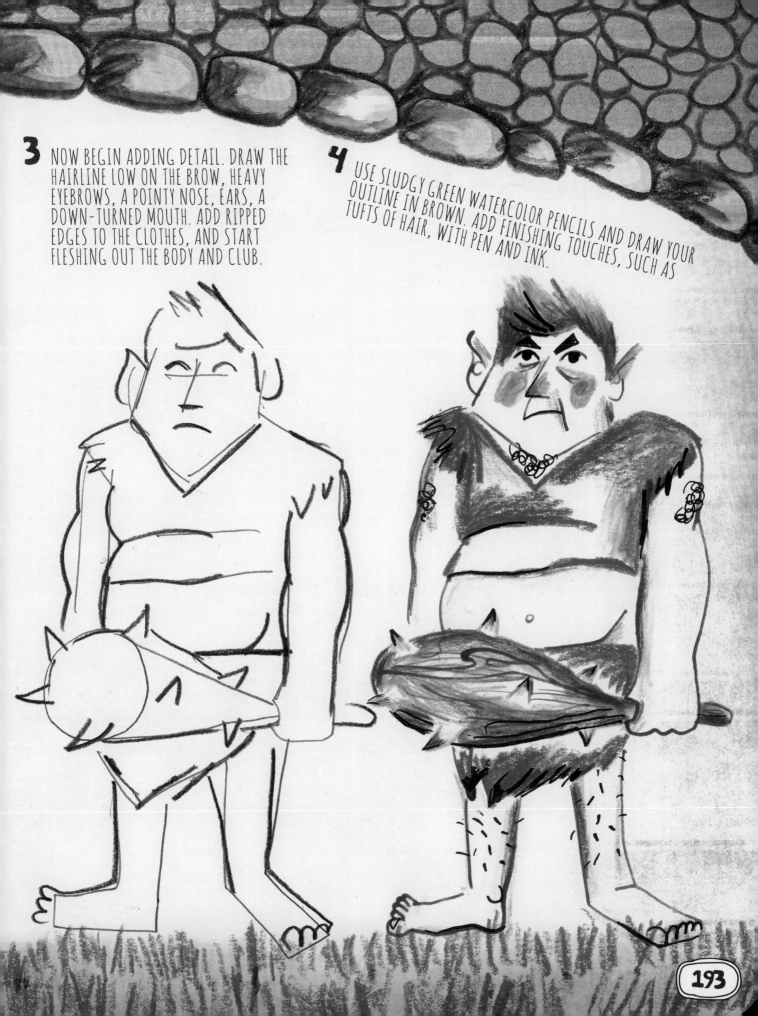

HOCKEY PLAYER

1 LIGHTLY DRAW GUIDELINES FOR THE FIGURE WITH CIRCLES AND LINES. NOTICE HOW THE ARMS ARE MOVING ACROSS THE BODY, MAKING THE FIGURE LOOK DYNAMIC.

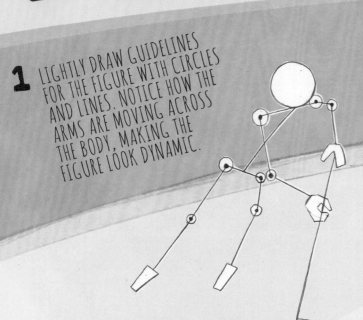

2 CHECK THAT THE PROPORTIONS LOOK CORRECT, THEN START OUTLINING THE BODY SHAPES. IMAGINE THE MUSCLES AROUND THE SKELETON TO HELP YOU CURVE THE ARMS AND LEGS IN THE RIGHT PLACES.

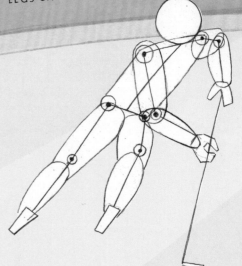

3 NOW START ADDING THE SHAPE OF THE CLOTHING AND EQUIPMENT AROUND YOUR BASIC SHAPES. THINK ABOUT HOW THE HAIR AND CLOTHES WOULD MOVE WITH THE FIGURE.

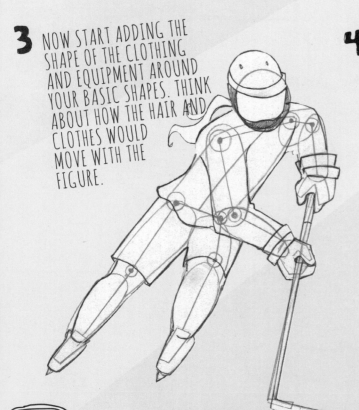

4 WHEN YOU ARE HAPPY WITH YOUR SHAPES AND PROPORTIONS, USE A STRONGER PENCIL LINE TO OUTLINE THE FIGURE. THEN ERASE ANY GUIDELINES THAT ARE NOT NEEDED.

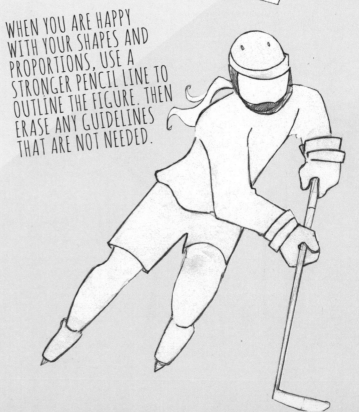

Remember to keep your hand relaxed for a more fluid line. This will help your figure look as though she's moving.

6 FINALLY, ADD SOME COLOR! START WITH THE LIGHTER COLORS AND BUILD UP DARKER COLORS ON TOP. ADD SCRATCHY SQUIGGLES AT THE BOTTOM FOR A COOL ICE FEEL.

5 ADD DETAILS TO THE FACE AND CLOTHING, SUCH AS FABRIC FOLDS, POCKETS, OR TEAM BRANDING. FIND PICTURES IN MAGAZINES FOR INSPIRATION.

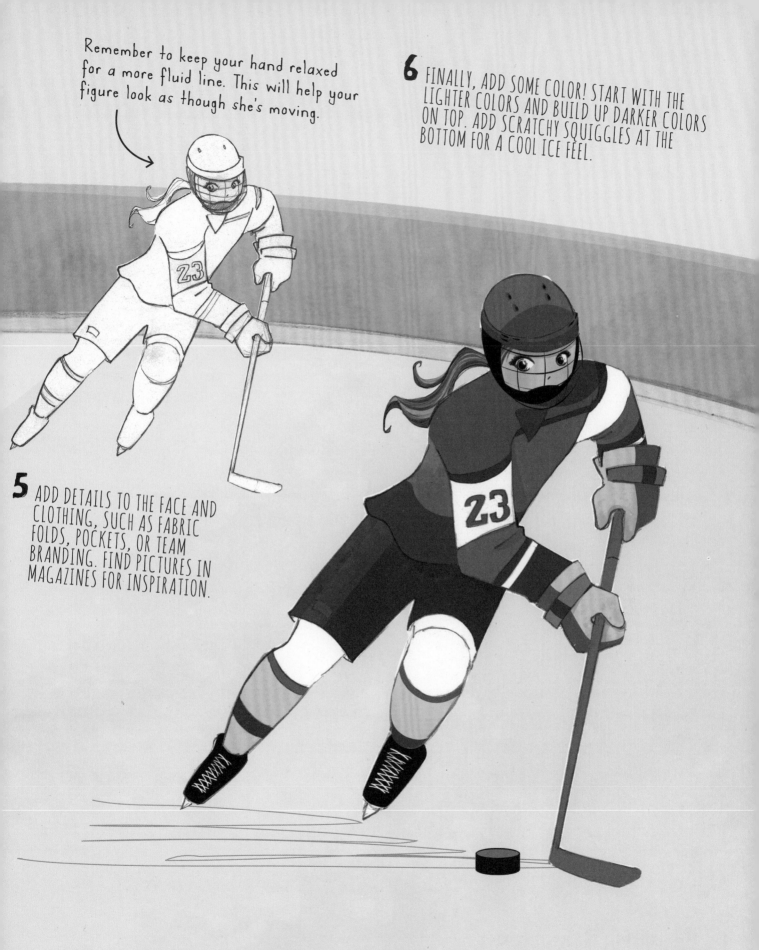

GYROCOPTER

A GYROCOPTER LOOKS SIMILAR TO A HELICOPTER AND WAS INVENTED SO PEOPLE COULD FLY THROUGH THE AIR SAFELY AT A SLOW SPEED. DRAW ONE YOURSELF, AS SLOWLY—OR QUICKLY—AS YOU LIKE!

1

SKETCH OUT THE BASIC SHAPES OF THE GYROCOPTER WITH A PENCIL: USE A RULER TO HELP YOU DRAW A T SHAPE, AND ADD TWO OTHER TRIANGLE SHAPES AT EITHER SIDE, PLUS AN L SHAPE TO CONNECT ONE OF THE TRIANGLES.

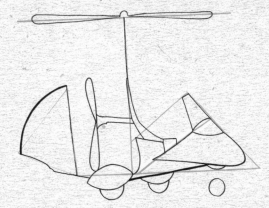

2

DRAW IN THE OTHER DETAILS TO YOUR FLYING MACHINE IN PENCIL. THERE ARE LOTS OF CURVED SHAPES FOR THE WHEELS, WINGS, AND BODY. ADD TWO PROPELLERS AT THE TOP OF THE GYROCOPTER, TOO.

5

DRAW IN BLACK DOTS AROUND THE FLYING MACHINE. THIS IS A QUICK AND EASY WAY TO MAKE THE DRAWING LOOK INCREDIBLY DETAILED AND TECHNICAL.

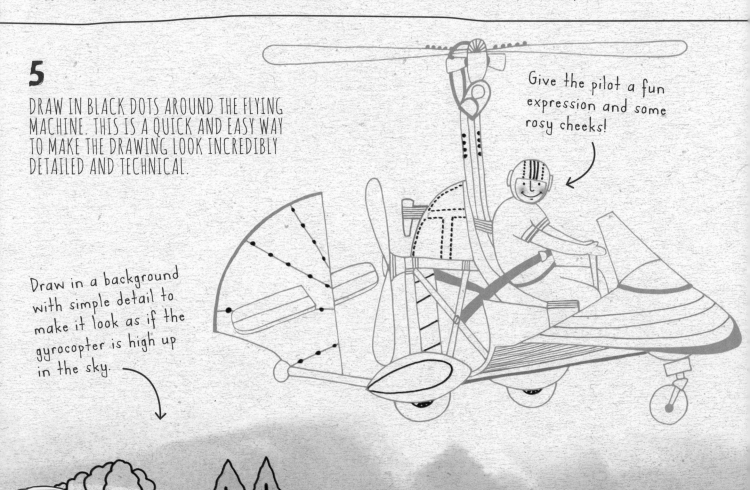

Give the pilot a fun expression and some rosy cheeks!

Draw in a background with simple detail to make it look as if the gyrocopter is high up in the sky.

3

ADD DETAIL TO THE GYROCOPTER TO MAKE IT LOOK REAL.
DRAW IN THE PILOT, THEN DRAW IN THE SAFETY BELT
AND THE MECHANISM THAT RUNS THE TOP PROPELLER.

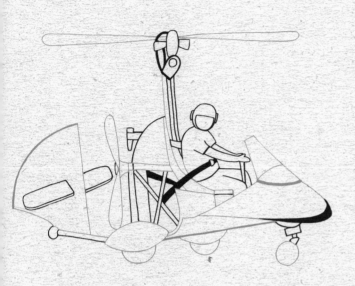

4

ADD MORE DETAIL IN STAGES. BUILD UP THE FINER
TECHNICAL BITS, SUCH AS THE LINES ON THE
WINGS AND THE PARTS AROUND THE PROPELLERS.

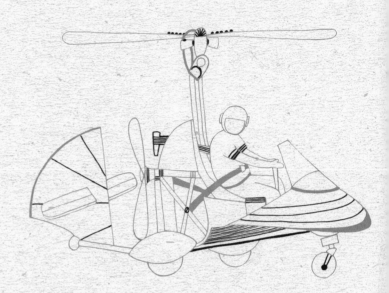

6

USE A FINE-TIP PEN TO
COMPLETE THE DRAWING.
USING DIFFERENT
THICKNESSES OF PEN IS
USEFUL TO ADD VARIETY
TO THE DRAWING. IF YOU
DON'T HAVE DIFFERENT
PENS, JUST USE A THIN
PEN AND GO OVER SOME
LINES A FEW TIMES TO
THICKEN THEM UP.

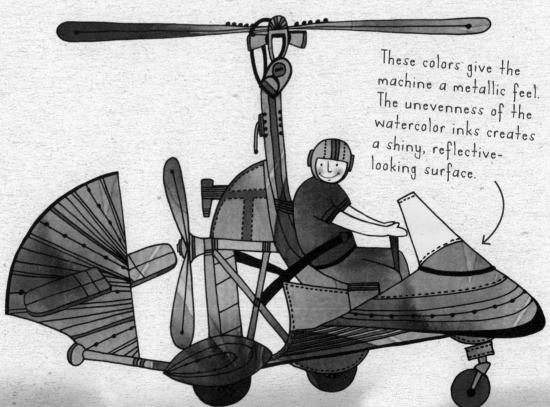

These colors give the
machine a metallic feel.
The unevenness of the
watercolor inks creates
a shiny, reflective-
looking surface.

DrAGON

Try adding a castle to the background. Build up your design by joining basic shapes together, such as boxes, cones, and cylinders.

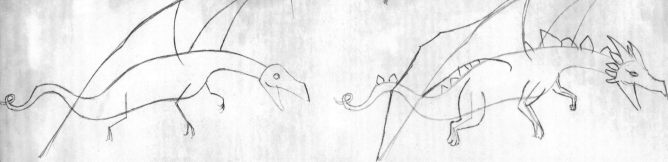

1 DRAW A DRAGON'S SPINE CURVING FROM THE TIP OF A TAIL TO THE BASE OF THE SKULL. DRAW A ROUGH SHAPE FOR THE HEAD AND EYE, THEN ADD ANOTHER LINE TO CREATE THE BODY. ADD ROUGH STICK LINES FOR THE ARMS, LEGS, AND WINGS.

2 FLESH OUT THE DRAGON'S BODY PARTS. REFINE THE HEAD AND DRAW CURVED SHAPES TO CREATE THE ARMS AND LEGS. ADD SOME SPIKES TO THE BACK, AND DRAW HORNS ON THE HEAD. USE SLIGHTLY CURVED LINES FOR THE OUTLINE OF THE NEAR WING.

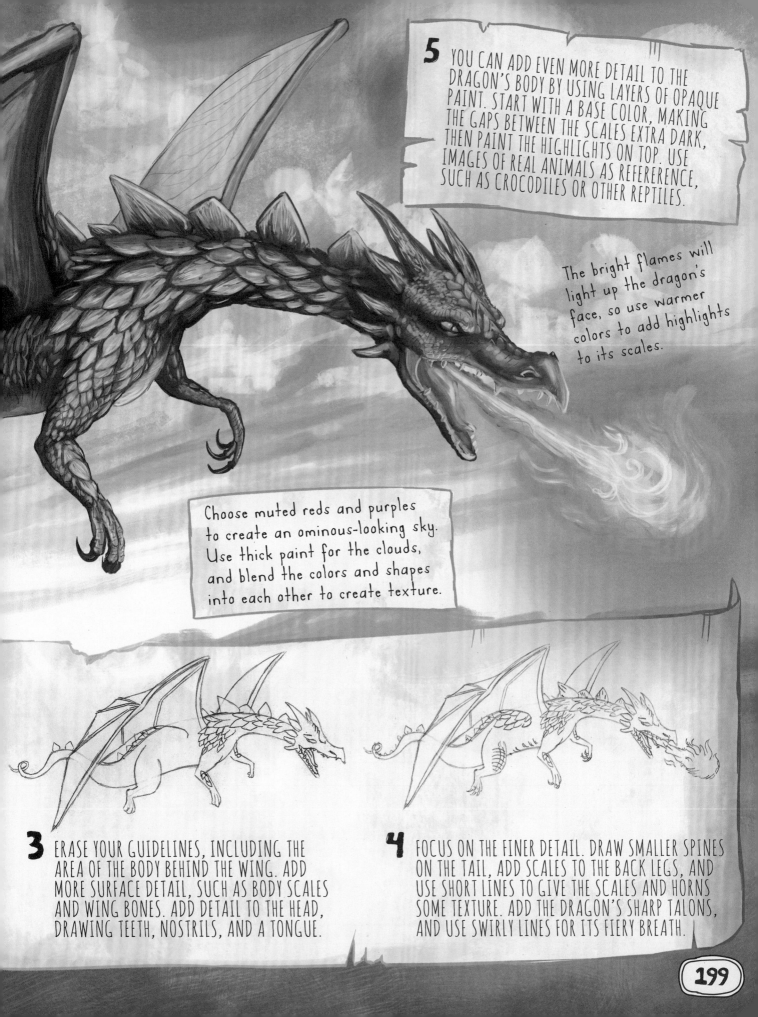

5 YOU CAN ADD EVEN MORE DETAIL TO THE DRAGON'S BODY BY USING LAYERS OF OPAQUE PAINT. START WITH A BASE COLOR, MAKING THE GAPS BETWEEN THE SCALES EXTRA DARK, THEN PAINT THE HIGHLIGHTS ON TOP. USE IMAGES OF REAL ANIMALS AS REFERERENCE, SUCH AS CROCODILES OR OTHER REPTILES.

The bright flames will light up the dragon's face, so use warmer colors to add highlights to its scales.

Choose muted reds and purples to create an ominous-looking sky. Use thick paint for the clouds, and blend the colors and shapes into each other to create texture.

3 ERASE YOUR GUIDELINES, INCLUDING THE AREA OF THE BODY BEHIND THE WING. ADD MORE SURFACE DETAIL, SUCH AS BODY SCALES AND WING BONES. ADD DETAIL TO THE HEAD, DRAWING TEETH, NOSTRILS, AND A TONGUE.

4 FOCUS ON THE FINER DETAIL. DRAW SMALLER SPINES ON THE TAIL, ADD SCALES TO THE BACK LEGS, AND USE SHORT LINES TO GIVE THE SCALES AND HORNS SOME TEXTURE. ADD THE DRAGON'S SHARP TALONS, AND USE SWIRLY LINES FOR ITS FIERY BREATH.

CARTOON

LAUGHING

1

USING CIRCLE SHAPES, DRAW EYES AND AN UPTURNED MOUTH.

2

ADD DETAIL TO THE PUPILS AND MOUTH AND LITTLE LAUGH LINES.

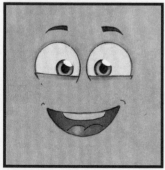

PUZZLED

1

DRAW A SLANTED OVAL MOUTH, ONE EYEBROW UP AND ONE DOWN.

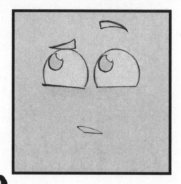

2

FOLLOW THE CURVE OF THE EYEBALL FOR SHADING BELOW THE EYES.

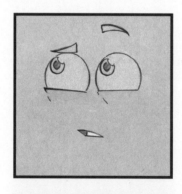

SHOCKED

1

DRAW PUPILS IN THE CENTER AND A DOWNTURNED MOUTH.

2

ADD REALLY HIGH EYEBROWS AND DETAIL TO THE EYES AND MOUTH.

expressions

SMALL CHANGES IN SHAPE CAN MAKE A BIG DIFFERENCE WHEN YOU ARE DRAWING CARTOON EXPRESSIONS. ALL YOU NEED IS CIRCLES, HALF CIRCLES, AND LINES.

ANGRY

1

SLANT THE EYEBROWS DOWN, AND DRAW A DOWNTURNED MOUTH.

2

SKETCH IN TEETH THAT LOOK AS THOUGH THEY ARE CLENCHED.

SURPRISED

1

DRAW CIRCLES FOR EYES AND AN UPTURNED MOUTH.

2

REALLY HIGH, SMALL EYEBROWS INCREASE THE LOOK OF SURPRISE.

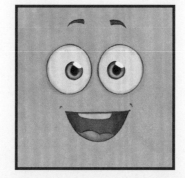

SLEEPY

1

DRAW DROOPY EYELIDS AND A SLANTED OVAL MOUTH.

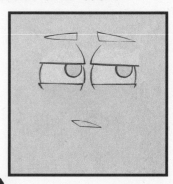

2

USE SHADING ABOVE AND BELOW THE EYES TO ADD TO THE EFFECT.

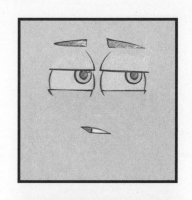

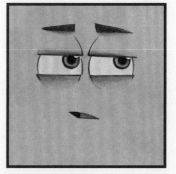

SPACESHIP CONTROLS

CREATE A COMPLICATED-LOOKING, COOL CONTROL COCKPIT BY BUILDING UP BASIC SHAPES.

DIALS

DIALS ARE EASY TO DRAW USING REPEATED CIRCLES. ALWAYS START WTIH TWO LARGE CIRCLES FOR THE OUTSIDE OF THE DIAL AND A SMALL CIRCLE IN THE MIDDLE. THEN ADD DIVISION LINES FOR A GAUGE, NUMBERS, SYMBOLS, HANDS, AND/ OR EXTRA RINGS, DEPENDING ON HOW YOU WANT THE DIAL TO LOOK.

GEAR STICK

START WITH A SMOOTH SQUARE SHAPE AT THE BASE. FROM THERE, DRAW PART OVALS, ONE ON TOP OF THE OTHER, GETTING GRADUALLY SMALLER AS YOU GO UP. FINISH THE STICK WITH A CIRCULAR KNOB AT THE TOP.

SLIDER

TO MAKE UP A PANEL, DRAW TWO RECTANGLES, ONE JUST INSIDE THE OTHER. ADD THREE LONG, VERTICAL RECTANGLES FOR THE SLIDERS. THE SLIDER KNOB IS A CYLINDER SHAPE TURNED ON ITS SIDE. ADD BUTTONS AT THE BOTTOM.

RADIO

USING THE SAME BASIC SHAPES AS THE OTHER COMPONENTS, YOU CAN ADD BUTTONS, LIGHTS, KNOBS, AND DIALS TO A RECTANGULAR PANEL TO CREATE ANYTHING, LIKE THIS RADIO! ADD SHADING TO GIVE THE SIMPLE SHAPES SOME DIMENSION.

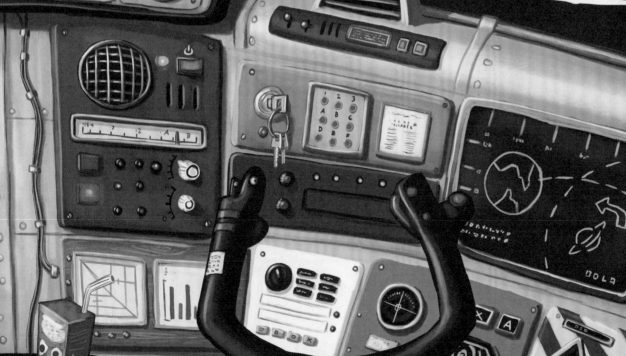

SUPERHEROINE

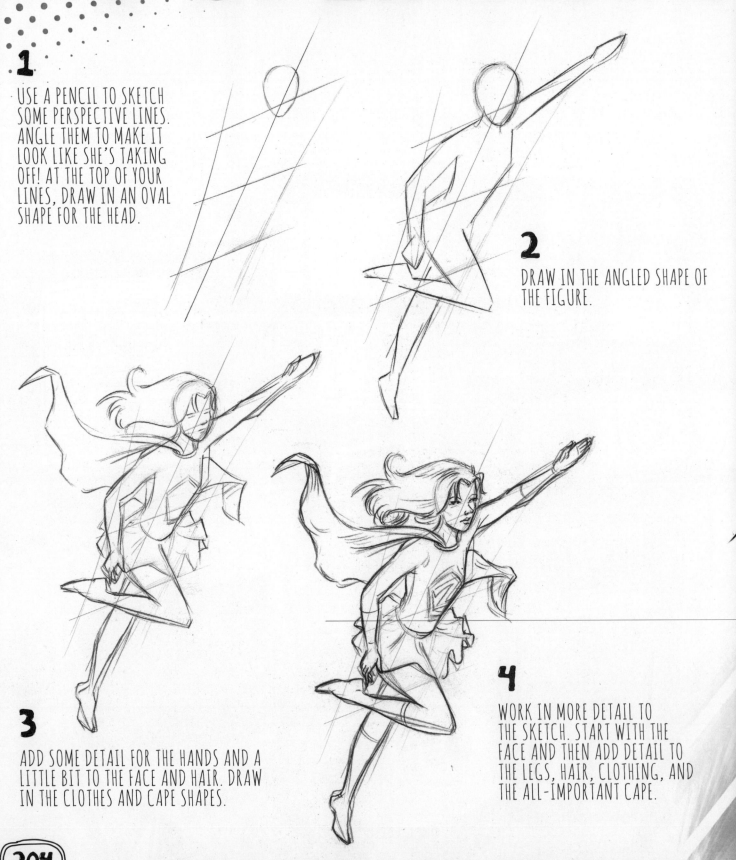

1

USE A PENCIL TO SKETCH SOME PERSPECTIVE LINES. ANGLE THEM TO MAKE IT LOOK LIKE SHE'S TAKING OFF! AT THE TOP OF YOUR LINES, DRAW IN AN OVAL SHAPE FOR THE HEAD.

2

DRAW IN THE ANGLED SHAPE OF THE FIGURE.

3

ADD SOME DETAIL FOR THE HANDS AND A LITTLE BIT TO THE FACE AND HAIR. DRAW IN THE CLOTHES AND CAPE SHAPES.

4

WORK IN MORE DETAIL TO THE SKETCH. START WITH THE FACE AND THEN ADD DETAIL TO THE LEGS, HAIR, CLOTHING, AND THE ALL-IMPORTANT CAPE.

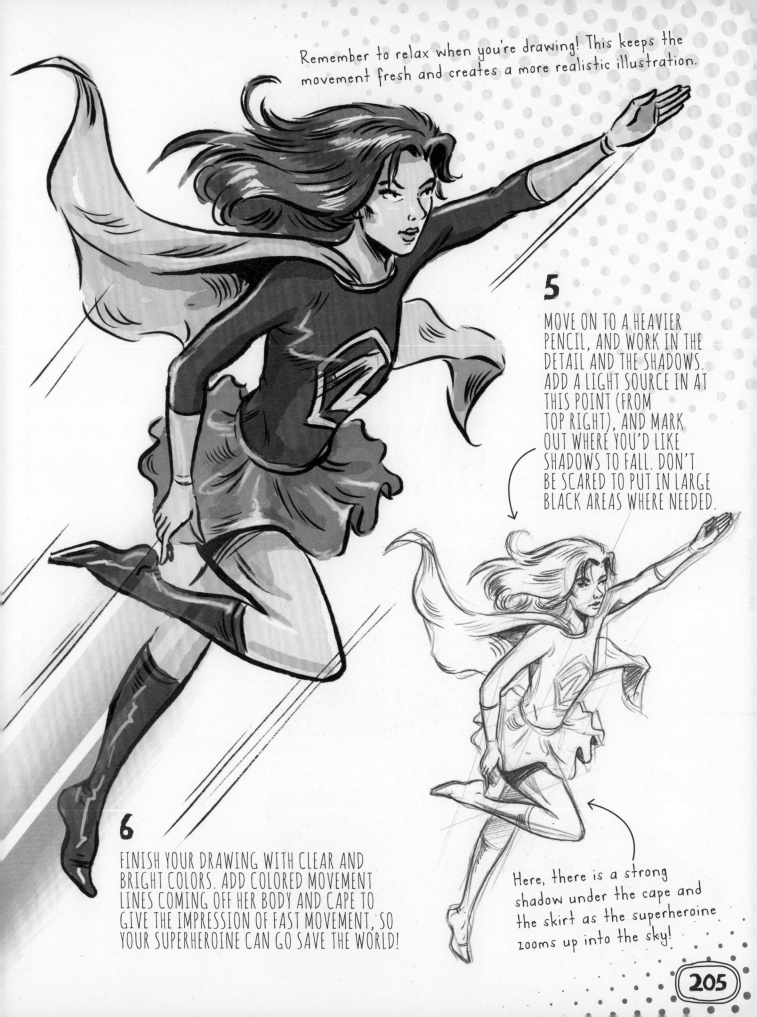

Remember to relax when you're drawing! This keeps the movement fresh and creates a more realistic illustration.

5

MOVE ON TO A HEAVIER PENCIL, AND WORK IN THE DETAIL AND THE SHADOWS. ADD A LIGHT SOURCE IN AT THIS POINT (FROM TOP RIGHT), AND MARK OUT WHERE YOU'D LIKE SHADOWS TO FALL. DON'T BE SCARED TO PUT IN LARGE BLACK AREAS WHERE NEEDED.

6

FINISH YOUR DRAWING WITH CLEAR AND BRIGHT COLORS. ADD COLORED MOVEMENT LINES COMING OFF HER BODY AND CAPE TO GIVE THE IMPRESSION OF FAST MOVEMENT, SO YOUR SUPERHEROINE CAN GO SAVE THE WORLD!

Here, there is a strong shadow under the cape and the skirt as the superheroine zooms up into the sky!

ANIMAL PATTERNS

ANIMAL PATTERNS INSPIRE DESIGNS EVERYWHERE YOU LOOK! THEY'RE USED ON EVERYTHING FROM BOOKS AND BEDDING TO CLOTHING AND ACCESSORIES. USING REFERENCE PHOTOS, LEARN TO DRAW THE BASIC SHAPES FIRST, SUCH AS LEOPARD SPOTS AND ZEBRA STRIPES. EXPERIMENT WITH REALISTIC TONES BUT ALSO PUNCHY FASHION COLORS. THEN TRY TRANSFERRING YOUR FAVORITE PATTERNS TO DRAWINGS OF OTHER OBJECTS.

TIGER

ZEBRA

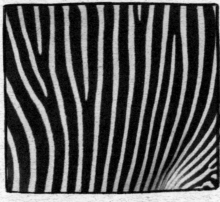

LEOPARD

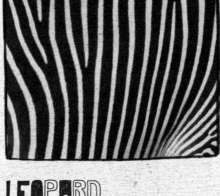

GIRAFFE

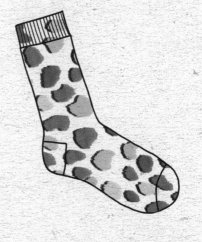

FISHBOWL

DISTORT YOUR PICTURES USING THIS CLEVER TECHNIQUE.

1

START WITH THE NORMAL PICTURE FIRST. FOR A FISH, DRAW AN EGG SHAPE. ADD A CURVE FOR THE FACE, THEN DRAW AN EYE AND MOUTH.

2

SKETCH THE FINS AND TAIL. USE CURVY LINES FOR THE TAIL TO MAKE IT LOOK AS IF THE FISH IS SWISHING AROUND IN THE WATER.

3

ADD LINES TO THE FINS AND TAIL, PLUS SOME SHADING TO THE OUTLINE AND EYE AREA. USE SMALL 'C' SHAPES FOR THE SCALES.

4

USING A RULER, DRAW A RECTANGLE AROUND YOUR FISH. DIVIDE THE SHAPE INTO SMALL SQUARES, MAKING SURE THEY'RE ALL THE SAME SIZE.

5

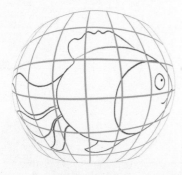

SKETCH A CIRCLE. ADD CURVED HORIZONTAL AND VERTICAL LINES TO GIVE YOU THE SAME NUMBER OF BOXES AS THE ORIGINAL GRID. COMPARE AND COPY CORRESPONDING SQUARES TO HELP YOU DRAW A DISTORTED SHAPE OF THE ORIGINAL.

Use different shades of blue to give the impression of movement in the water. Add curved white shapes to create highlights and to make the bowl look 3-D!

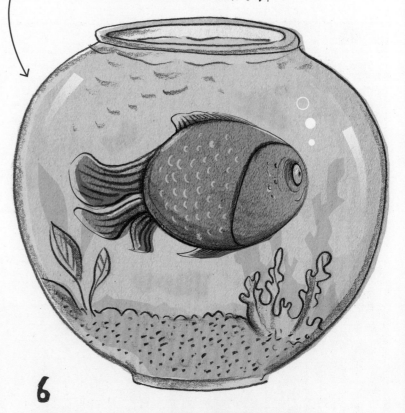

6

ERASE YOUR GUIDELINES, AND DRAW A BOWL, SAND AND PLANTS. THEN COLOR YOUR PICTURE!

CAT LOOKING THROUGH A FISHBOWL!

1

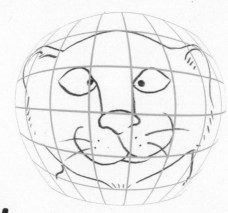

START WITH THE NORMAL PICTURE AGAIN. DRAW AN OVAL FOR THE CAT'S FACE. ADD SIMPLE SHAPES FOR ITS FACE, EARS, PAWS, AND TAIL.

2

DRAW STROKES FOR THE CAT'S FUR. SHADE INSIDE THE EARS AND NOSE, AND AROUND THE EYES. DRAW DOTS FOR PUPILS AND LINES FOR WHISKERS.

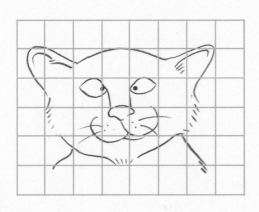

3

DRAW A RECTANGLE AROUND YOUR PICTURE, AS BEFORE. USING A RULER FOR ACCURACY, DIVIDE UP THE SHAPE INTO A GRID OF SMALL SQUARE SHAPES.

4

DRAW A CIRCLE. DIVIDE UP THE AREA WITH CURVED LINES AS BEFORE, UNTIL YOU HAVE THE SAME NUMBER OF BOXES AS YOUR RECTANGULAR GRID. COMPARE CORRESPONDING SQUARES, AND DRAW IN YOUR DISTORTED CAT SHAPE, BIT BY BIT.

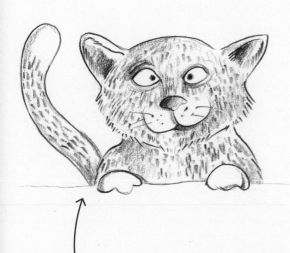

Here is the cat before he is distorted.

5

Give the distorted cat face a slightly bluish tinge to give the effect of looking through water!

DRAW THE FISHBOWL AS BEFORE. USE TRACING PAPER TO COPY THE FACE OF YOUR DISTORTED CAT INTO THE BOWL. THEN, TRACE OR COPY THE ORIGINAL PICTURE TO DRAW HIS EARS ABOVE THE BOWL, AND PAWS AND TAIL NEXT TO IT. NOW COLOR THIS CURIOUS CAT IN!

TOWERING BUILDINGS

Find a photo online to give you some inspiration. Look for buildings that have interesting architectural details.

Paint areas of darker tones to suggest blurry reflections in glass windows.

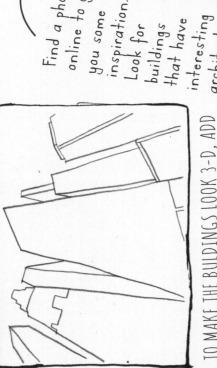

1 DRAW SOME SIMPLE RECTANGLES CLOSE TOGETHER. THIS DRAWING USES PERSPECTIVE, SO THE VERTICAL LINES NEED TO COME CLOSER TOGETHER AT THE TOP TO GIVE THE IMPRESSION OF TALL, TOWERING BUILDINGS!

2 TO MAKE THE BUILDINGS LOOK 3-D, ADD SOME EXTRA VERTICAL LINES TO THE SIDES OF THE RECTANGLES, KEEPING IN MIND THE ANGLE THAT YOU'RE VIEWING THE BUILDINGS FROM.

3 ADD ROWS OF SQUARES AND RECTANGLES FOR THE WINDOWS. THESE SHAPES NEED TO BECOME SMALLER AS YOU WORK UP THE BUILDING, GIVING THE IMPRESSION THAT THE UPPER FLOORS ARE FARTHER AWAY.

4 LOOK AT THE TEXTURES AND MATERIALS OF REAL BUILDINGS, AND TRY TO IMITATE THE DETAIL USING SIMPLE LINES. ADD SHADING BY DRAWING REPEATED HORIZONTAL, VERTICAL, OR CROSSHATCHED LINES.

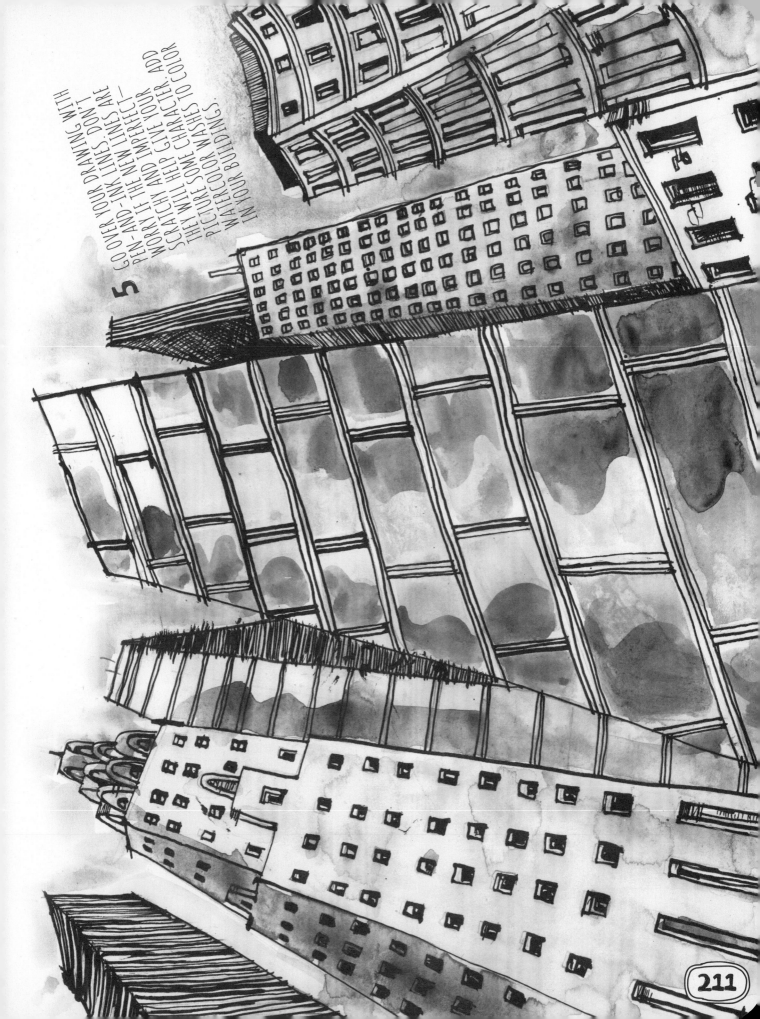

5 GO OVER YOUR DRAWING WITH PEN-AND-INK LINES. DON'T WORRY IF THE NEW LINES ARE SCRATCHY AND IMPERFECT — THEY WILL HELP GIVE YOUR PICTURE SOME CHARACTER. ADD WATERCOLOR WASHES TO COLOR IN YOUR BUILDINGS.

FRENCH CAFÉ

THIS CHIC FRENCH CAFÉ MIGHT LOOK A LITTLE COMPLICATED TO DRAW, BUT EACH OBJECT IN THE PICTURE IS ACTUALLY MADE UP OF RELATIVELY SIMPLE SHAPES. PRACTICE SKETCHING EACH ELEMENT ON ITS OWN, THEN BRING EVERYTHING TOGETHER TO CREATE A PERFECT PARISIAN SCENE!

Make the café look farther away than the people by positioning the building halfway up the page. Use a thick pencil outline for the building, picking out certain shapes in pen and ink.

For the umbrella, sketch a simple triangle, then draw a curved triangular shape on either side. Add curved lines beneath each segment. Draw a circle on top, then sketch the pole. Add more shapes to make the umbrella look 3-D.

Sketch a big ellipse for the table top, then add a vertical line running through the center of two much smaller ellipses. Draw swirly supports on one side first before sketching their mirror image on the other.

To draw an elegant café chair, sketch an ellipse, adding another line at the bottom to make it look 3-D. Draw two curved shapes for the back. Add a big U shape beneath the ellipse, then use more elegant curves for the legs.

Use different-sized ellipses and curved shapes to draw an ornate teapot and cup. Add swirly patterns to the sides to give them some old-fashioned charm!

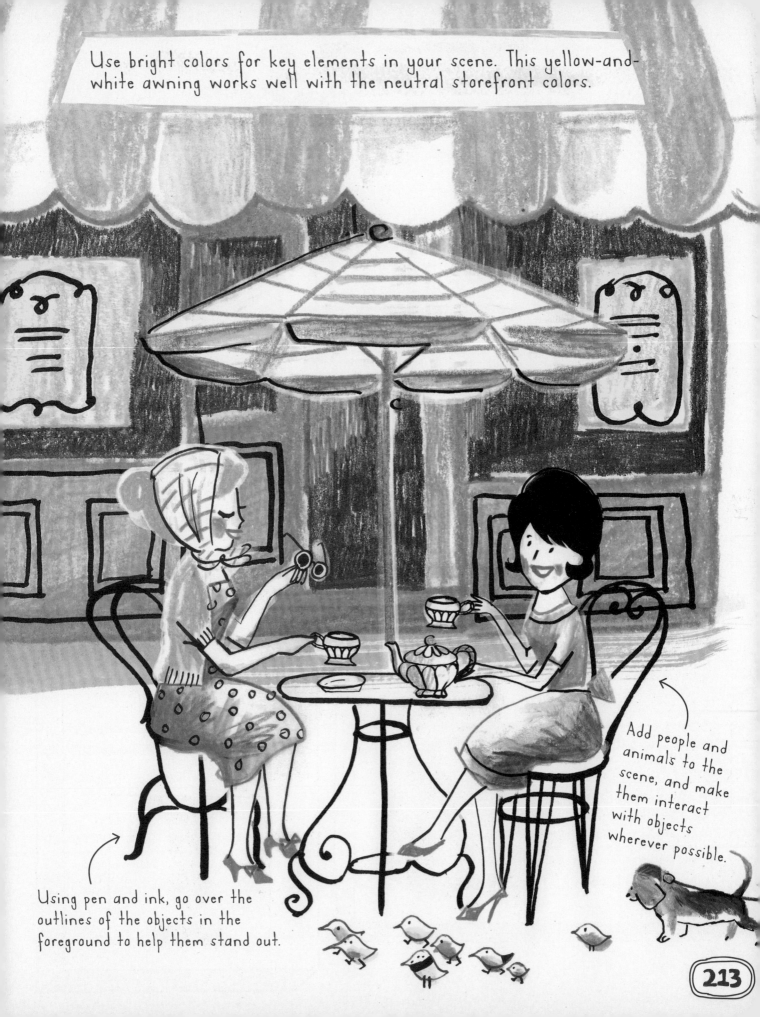

Use bright colors for key elements in your scene. This yellow-and-white awning works well with the neutral storefront colors.

Add people and animals to the scene, and make them interact with objects wherever possible.

Using pen and ink, go over the outlines of the objects in the foreground to help them stand out.

OPTICAL ILLUSIONS

OPTICAL ILLUSIONS CAN MAKE PEOPLE SEE THINGS THAT AREN'T THERE. LEARN TO DRAW THEM TO TRICK YOUR FRIENDS AND FAMILY!

CUBES

Draw a flattened diamond for the top of the cube, then exactly the same for the base. Draw vertical lines to link the corners together.

Add shading to some sides of the cube, like this. This helps gives them a 3-D look.

Draw a lot of cubes together to get the optical illusion. Are the cubes the right way up or upside down? Or maybe you see them flip back and forth!

FACE OR VASE?

Draw a simple outline of a face looking to the right, using only one smooth line.

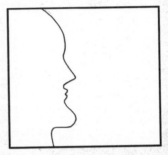

Then draw or trace the same face again, facing the first.

Darken the gap between the two faces. Some people will see the dark vase, and some people will see the faces!

IMPOSSIBLE TRIANGLE

IF YOU LOOK CLOSELY, THIS TRIANGLE COULDN'T ACTUALLY EXIST. FOLLOW THE STEPS CAREFULLY TO CREATE ANOTHER TRICK OF THE EYES!

Start with a simple triangle.

At the three points, extend the lines slightly, like this.

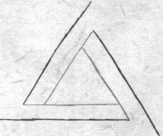

From the end of these new lines, draw parallel lines following the original triangle's sides.

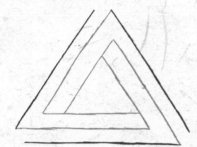

From the end of the last lines, draw three more parallel lines. Your impossible triangle should now be taking shape.

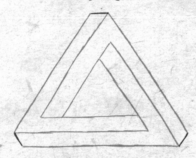

To create the illusion, link the last three lines to the rest of the triangle.

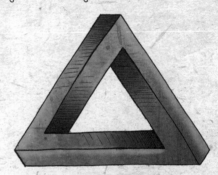

Color your image. Be careful with the shading, and you'll get the amazing effect!

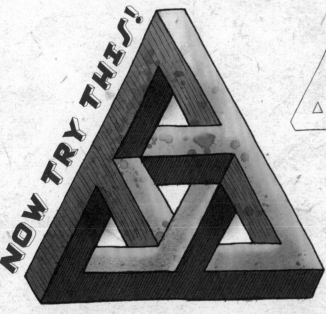

NOW TRY THIS!

Draw a simple triangle with the three tips cut off. Then draw four small triangles inside. Extend lines from each point of each triangle. Now draw in the last lines, filling in all the gaps. Then add some shading and your impossible triangle is complete and an awesome illusion!

STREETDANCER

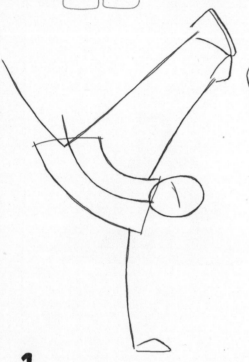

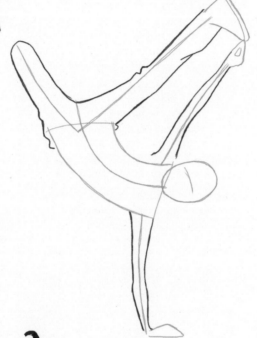

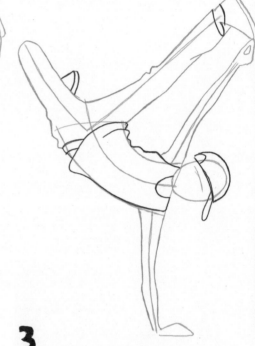

1

USE SIMPLE LINES TO SKETCH THE BASIC POSE. DRAW AN OVAL FOR THE HEAD, WITH CURVED LINES FOR THE TORSO AND ARMS. ADD A BIG V SHAPE FOR THE LEGS, AND A FOOT.

2

DRAW THE DANCER'S JEANS, USING THE GUIDES TO HELP YOU. KEEP THE LINE WORK LOOSE, AND ROUND OFF WHERE THE LEFT KNEE IS BENT. DRAW THE SHAPE OF THE ARMS.

3

SKETCH THE SHIRT AND AN ELLIPSE AT THE BOTTOM OF THE PANT. ADD A SEMICIRCLE FOR THE CAP WITH AN ELLIPSE FOR THE BRIM. DRAW A FOOT BEHIND THE BENT LEG.

SILHOUETTES

To draw cool silhouettes of streetdancers, find photos of dancers in different poses. Then simply trace over their outlines and color them in.

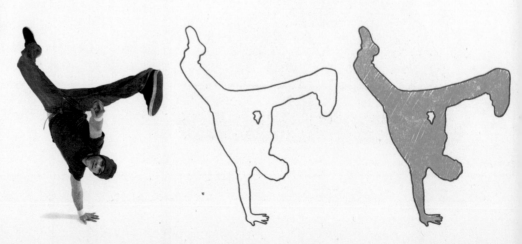

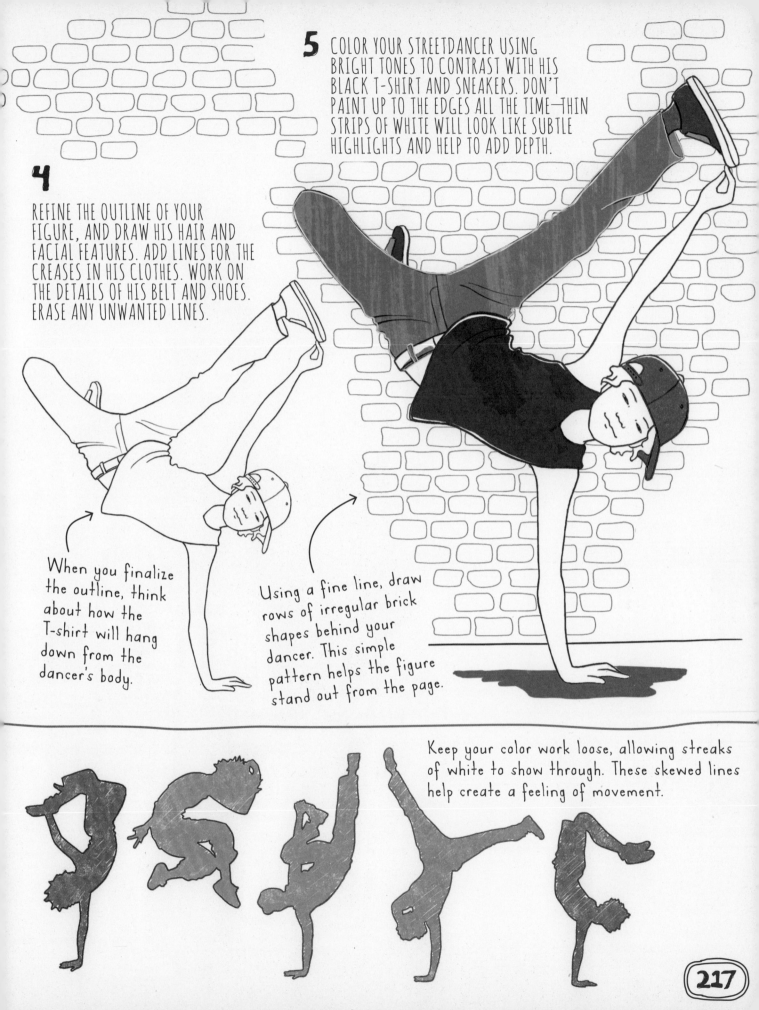

5 COLOR YOUR STREETDANCER USING BRIGHT TONES TO CONTRAST WITH HIS BLACK T-SHIRT AND SNEAKERS. DON'T PAINT UP TO THE EDGES ALL THE TIME—THIN STRIPS OF WHITE WILL LOOK LIKE SUBTLE HIGHLIGHTS AND HELP TO ADD DEPTH.

4

REFINE THE OUTLINE OF YOUR FIGURE, AND DRAW HIS HAIR AND FACIAL FEATURES. ADD LINES FOR THE CREASES IN HIS CLOTHES. WORK ON THE DETAILS OF HIS BELT AND SHOES. ERASE ANY UNWANTED LINES.

When you finalize the outline, think about how the T-shirt will hang down from the dancer's body.

Using a fine line, draw rows of irregular brick shapes behind your dancer. This simple pattern helps the figure stand out from the page.

Keep your color work loose, allowing streaks of white to show through. These skewed lines help create a feeling of movement.

CREEPY MANSION

1

DRAW A SET OF ROUGH RECTANGLE SHAPES FOR THE MAIN PART OF THE BUILDING. USE TRIANGLES FOR THE ROOF AND TURRETS AND A SEMI-CIRCLE FOR THE DOMED TOWER.

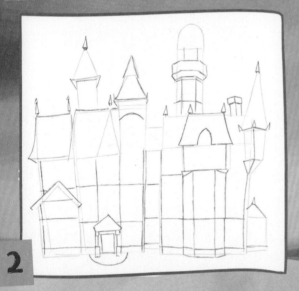

2

ADD SIMPLE LINES TO YOUR SKETCH TO DEFINE THE BUILDING. ADD SMALL TRIANGULAR POINTS TO THE ROOF AND TURRETS TO MAKE THEM LOOK SHARP. DRAW A BASIC DOOR AND BALCONY, TOO.

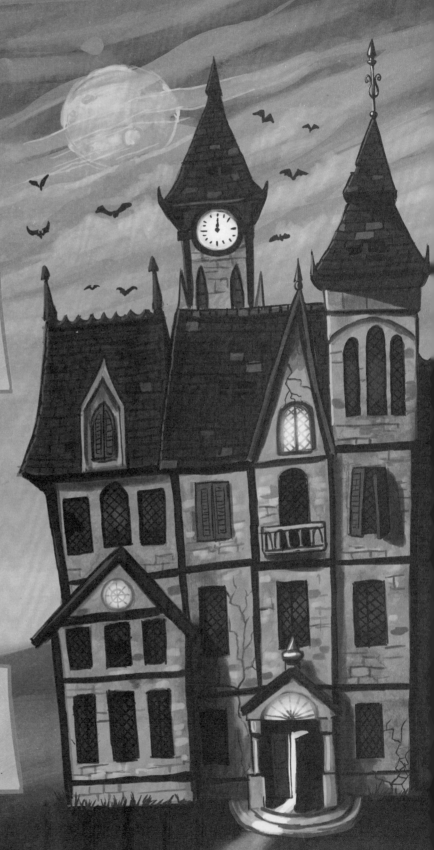

3 DRAW IN ALL THE DIFFERENT WINDOW SHAPES. THE ROUGHER THE BETTER, TO MAKE THE HOUSE LOOK OLD AND CROOKED! ADD ANOTHER BALCONY, AND WORK UP THE FRONT DOOR DETAIL. DRAW A CIRCLE FOR THE CLOCK FACE.

Draw lots of bats in solid black ink to make the picture extra creepy!

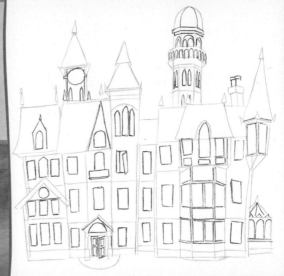

4 ADD A GHOSTLY FIGURE IN ONE OF THE BIG WINDOWS. THEN DRAW GLASS PANES, SHUTTERS, AND BROKEN GLASS. USE LOTS OF RECTANGLE SHAPES FOR THE ROOF TILES, THEN ADD SPIKES AND SPIRES TO THE ROOF AND TURRETS.

5 PAINT WITH DARK PURPLES FOR THE WALLS AND ROOF. USE GREEN IN SOME WINDOWS TO GIVE AN EERIE EFFECT AND MAKE THE SPOOKY FIGURE STAND OUT. CREATE GLOWS AROUND THE LIT WINDOWS WITH LIGHTER COLORS.

INDEx

A

airplane 80-1
aliens 50-1, 60-1
animals 12-13, 18-19, 24-5, 32-3,
 52-3, 64-5, 74-5, 82-3, 102-3,
 124-5, 154-5, 162-3, 172-3, 180-1,
 198-9

B

basketball player 142-3
beards 146-7
belts 94-5
bridge 122-3
buildings 38-9, 118-19, 140-1,
 170-1, 218-19, 210-11
bullet train 72-3
burger 130-1

C

café 212-13
cake 166-7
candy machine 136-7
caricatures 152-3
cartoons 7, 105, 188
 animals 124-5, 172-3
 explosions 98-9,
 expressions 200-1
 monsters 62-3
cat 162-3
color wheel 9
crayons
 chalk 7
 oil 7
 wax 7
crocodile 154-5
crosshatching 8, 34, 104
cyborg 164-5

D

dessert 44-5
dinosaur 112-13
distortion 208-9
diver 70-1
dog 82-3
dragon 198-9
drum kit 58-9

E

editing software 9
Eiffel Tower 76-7
electric guitar 26-7
elephant 102-3
erasers 6
explosions 98-9

F

fashion
 boys 30-1
 girls 16-17
Ferris wheel 160-1
fishbowl 208-9
frames 150-1
Frankenstein 178-9

G

giraffe face 52-3
grizzly bear 18-19
guidelines 8, 10, 14,
 16, 20, 24, 30, 31, 38, 39, 40, 47,
 50, 52, 68, 71, 72, 73, 74, 75, 76,
 82, 84, 92, 95, 101, 106, 120, 128,
 141, 152, 160, 174, 180, 181,
 188, 194
gyrocopter 196-7

H

hairstyles 78-9
hats 116-17
haunted house 118-19, 218-19
hedgehog 12-13
highlights 8, 9, 11, 13, 26,
 40, 41, 55, 62, 65, 78, 93, 131,
 135, 143, 145, 153, 163, 165, 175,
 179, 199, 208, 217
hockey player 194-5
horizon line 9, 38
hot-air balloons 14-15

I

inks6, 7, 14, 15, 18, 21, 34, 39, 43,
 51, 56, 57, 68, 69, 77, 81, 91, 98,
 99, 103, 104, 105, 108, 123, 144,
 151, 157, 169, 181, 183, 184, 185,
 191, 193, 197, 211, 212, 213, 219

J

jetpack 126-7

L

light sources ...8, 13, 26, 29, 34, 85,
 92, 96, 205
line designs 56-7, 59

M

main street 38-9
manga
 boy 188-9
 girl 120-1
map 86-7
materials 6-7
meerkats 32-3

monkeys 64-5
monsters 62-3, 158-9, 178-9
motorcycle 114-15
mountain bike 182-3
moustaches 48-9

N
ninja 46-7

O
optical illusions 214-15

P
paints
 acrylic 7
 poster 7
 watercolor 6, 7, 15, 39, 53, 61, 77,
 85, 97, 117, 139, 141, 151, 175, 211
paper types 6
patterns
 animal 206-7
 circular 132-3
 geometric 110-11, 133
 straight 184-5
peacock 74-5
penguins 24-5
pens 184, 197
 felt-tip 7, 75
 gel 171
 highlighter 7
 marker 7, 49, 85, 189
perspective 9, 38, 60, 69, 72,
 73, 88, 90, 96, 109, 160, 176, 190,
 192, 199, 204, 208, 210
pirate ship 36-7
pizza 108-9
plant 128-9
pop star 54-5
portraits 10-11, 22-3, 78-9
proportions 8, 9, 14, 32, 46, 92,
 96, 116, 142, 164, 188, 192

Q
quad bike 42-3

R
racing car 20-1
robot 168-9
rock star 92-3
rose .. 28-9

S
shadows 8, 9, 10, 11, 13, 19, 21,
 32, 34, 37, 41, 43, 66, 78, 93, 96,
 97, 112, 117, 121, 122, 131, 135, 143,
 145, 165, 178, 183, 189, 191, 205
shark 138-9
skateboarder 106-7
skateboards 68-9, 106-7
skyline 170-1
skyscrapers 140-1
sneakers 88-9
snowboarder 84-5
space rocket 100-1
 controls 202-3
speech bubbles 66-7
speedboat 148-9
spy car 90-1
Statue of Liberty 40-1
street art 104-5
streetdancer 216-17
stunt rider 114-15
submarine 190-1
sunglasses 176-7
superhero 96-7
superheroine 204-5
surfer 174-5
symmetry 8, 10, 14, 57, 80,
 90, 185

T
T. rex 112-13
T-shirts 34-5
techniques 8-9
tornado 156-7
tree 186-7
troll 192-3

U
UFO .. 60-1

V
vanishing point 9, 38, 72, 90
volcano 144-5

W
watercolor pencils6, 41, 83, 91,
 129, 193
woodland animals 180-1

Z
zombie 134-5

ABOUT THE ARTISTS

TALENTED ARTISTS FROM AROUND THE WORLD HAVE CONTRIBUTED THEIR SKILLS AND ILLUSTRATIONS TO THIS BOOK!

TOM MCGRATH always wanted to be an artist. He likes to use a mixture of pencil, pen, and the computer to finish his drawings. Tom now works as a freelance illustrator to support his addiction to ginger cookies.

PAULA FRANCO is a children's book illustrator and graphic designer from Argentina. She loves to spend her spare time wandering around libraries.

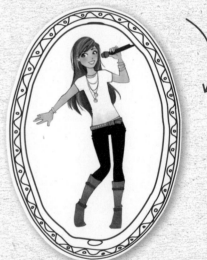

SI CLARK is an illustrator and animator. He grew up in the countryside but now lives in London, England. He started drawing at a very early age and has pretty much been drawing every day since then. Si is obsessed with drawing trees and cities, as well as finding strange textures to scan into his drawings!

YASUKO YASUKO has developed a graphic illustration style, mixing ink work, brushstrokes, and digital textures. She loves Japanese fashion, and sometimes makes her own clothes. Yasuko lives and works in Paris and loves to spend time drawing in the Louvre art museum.

LUCIANO LOCENZO got an MA in Illustration in Barcelona, Spain, and now lives in that same city. He works as a professional illustrator on books, newspapers, and magazines.

STEVE STONE is an illustrator from the Northeast of England who loves to capture the character of animals. He gets lots of help from his orange cat, Vincent van Mog.

MADDY MCCLELLAN lives in Sussex, England, and works as an illustrator and printmaker. She has illustrated many children's books, including some that she has written herself. She is happiest drawing with a lively, inky line in her studio in the yard, visited by an assortment of animals.

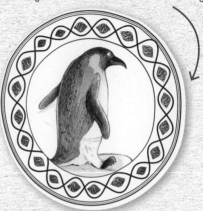

ALEX HEDWORTH works as an illustrator and is currently studying for an MA. Originally from Newcastle, England, he now lives in London. He has been drawing for as long as he can remember—his first drawings were copies of comic books!

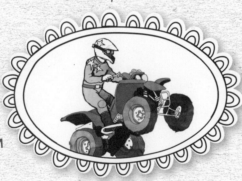

JULIE INGHAM is an illustrator and designer who lives and works by the sea in West Sussex, England. Her favorite things to draw are skyscrapers and all things decorative!

STEVE HORROCKS was born in Merseyside, England. He now lives in California with his wife, where he works at a major feature animation studio and continues to pursue his passion for creating art on a personal level, too.

DAVID SHEPHARD is a children's book illustrator and designer. He lives in the shadow of a Norman castle in Sussex, England, with his wife, children, and several pets. He loves drawing people and faces and works best in his attic, where his family slides his dinners under the door!

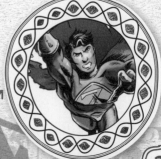

ACKNOWLEDGEMENTS

ILLUSTRATED BY
Si Clark, Paula Franco, Alex Hedworth, Steve Horrocks, Julie Ingham, Luciano Locenzo, Maddy McClellan, Tom McGrath, David Shephard, Steve Stone, and Yasuko Yasuko

DESIGNED BY
Belinda Webster at Picnic Design, Clare Phillips, and Rachael Fisher

EDITED BY
Laura Baker, Cathy Jones, Moray Laing, and Jason Loborik

PRODUCTION BY
Richard Wheeler

PHOTOGRAPHS FROM
Shutterstock, Inc.

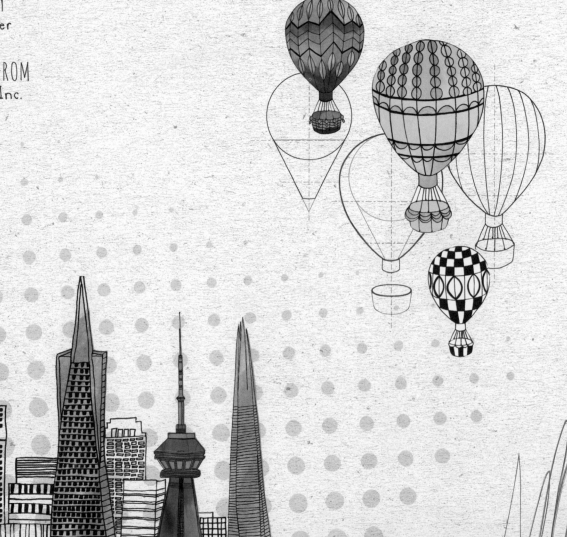